The twelve essays in this book employ a wide range of visual material from varying periods in history to explore different attitudes to and representations of the human body. Each essay serves to analyse how visual representations of the body work metaphorically and systematically to define and reinforce beliefs and social practices. Many of the essays focus on a single painting, photograph or other object to examine the wider implications of the image of the body and the body as image. An impressive range of methods and approaches is brought to bear, serving to demonstrate the intellectual vigour and breadth of the subject of the body in art, and the richness of the material with which it can be studied.

The body imaged

The body imaged

*The human form and visual culture
since the Renaissance*

Edited by Kathleen Adler and Marcia Pointon

CAMBRIDGE
UNIVERSITY PRESS

Published by the Press Syndicate of the University of Cambridge
The Pitt Building, Trumpington Street, Cambridge CB2 1RP
40 West 20th Street, New York, NY 10011-4211, USA
10 Stamford Road, Oakleigh, Melbourne 3166, Australia

© Cambridge University Press, 1993

First published 1993
Reprinted 1994

Printed in Malta by Interprint Limited

A catalogue record for this book is available from the British Library

Library of Congress cataloguing in publication data applied for

ISBN 0 521 41536 5 hardback
ISBN 0 521 44768 2 paperback

CE

Contents

List of illustrations *page* ix
Notes on contributors xiii
Acknowledgements xvii

Part I. The body of the artist I

1 Body languages: Kahlo and medical imagery DAVID LOMAS 5
2 The ambivalence of male masquerade: Duchamp as Rrose
 Sélavy AMELIA G. JONES 21
3 The forbidden gaze: women artists and the male nude in late
 nineteenth-century France TAMAR GARB 33
4 Out of the body: Mark Rothko's paintings JAMES E. B. BRESLIN 43

Part II. Bodies of masculinity 53

5 Muscles, morals, mind: the male body in Thomas Eakins'
 Salutat MICHAEL HATT 57
6 Body and body politic in Edvard Munch's *Bathing Men*
 PATRICIA G. BERMAN 71

Part III. Bodies of femininity 85

7 The fine art of gentling: horses, women and Rosa Bonheur in
 Victorian England WHITNEY CHADWICK 89
8 Blood and milk: painting and the state in late nineteenth-century
 Italy KATE FLINT 109

Part IV. The body as language 125

9 Movement and gender in sixteenth-century Italian painting
 SHARON FERMOR 129

vii

10 The in visibility of Hadji-Ishmael: Maxime Du Camp's 1850
 photographs of Egypt JULIA BALLERINI 147
11 The hat, the hoax, the body BRIONY FER 161
12 The case of the dirty beau: symmetry, disorder and the politics of
 masculinity MARCIA POINTON 175

 Notes 191
 Bibliography 199
 Index 209

Illustrations

1 Frida Kahlo, *What the Water Gave Me*, 1938, oil on canvas, 91 × 70.5 cm, Collection Daniel Filipacchi, Paris — *page* 8

2 Frida Kahlo, *Henry Ford Hospital*, 1932, oil on metal, 30.5 × 38 cm, Collection Dolores Olmedo, Mexico City — 10

3 Frida Kahlo, *My Birth*, 1932, oil on metal, 30.5 × 35 cm, Private collection, United States of America — 13

4 Frida Kahlo, *The Broken Column*, 1944, oil on canvas, mounted on hardboard, 40 × 30.7 cm, Collection Dolores Olmedo, Mexico City — 15

5 Man Ray, *Rrose Sélavy*, 1921, photograph, Collection of the J. Paul Getty Museum, Malibu, California (Accession No. 84.XM.1000.80), © 1991 Man Ray Trust/ADAGP–Paris/ARS–USA — 23

6 Jul. Hanriot, frontispiece of Book v, *Les nouvelles amoureuses*, 1883, engraving — 34

7 'Songez que vous peignez l'histoire', from the series *Pièces sur les arts*, Cabinet des estampes, Bibliothèque Nationale, Paris — 36

8 Atelier des Beaux-Arts, *c*.1885, photograph, from the series *Pièces sur les arts*, Cabinet des estampes, Bibliothèque Nationale, Paris — 39

9 'Allons Darancourt . . .', from the series *Pièces sur les arts*, Cabinet des estampes, Bibliothèque Nationale, Paris — 40

10 Jackson Pollock, Springs, New York, 1950, photograph © Hans Namuth, 1950 — 44

11 Mark Rothko, East Hampton, New York, 1964, photograph © Hans Namuth, 1964 — 46

12 Mark Rothko, *Number 10*, 1950, oil on canvas, 198.10 × 145 cm, Collection Museum of Modern Art, New York. Gift of Philip Johnson — 50

13 Thomas Eakins, *Salutat*, 1898, oil on canvas, 126 × 100 cm, 1930.18, gift of anonymous donor, © Addison Gallery of American Art, Phillips Academy, Andover, MA. All rights reserved — 61

14 Winslow Homer, *Undertow*, 1886, oil on canvas, 76 × 112 cm, Sterling and Francine Clark Art Institute, Williamstown, MA — 67

15 Edvard Munch, *Bathing Men*, 1907–8, oil on canvas, 206 × 227 cm, 72
 Ateneum, Helsinki, the Antell Collection. Photograph courtesy of
 The Central Art Archives, Helsinki, photographer Jaakko Holm

16 J. F. Willumsen, *Studio Exhibition of 1910*, 1910, colour lithograph, 74
 Kunstindustrimuseet, Copenhagen. Photographer Ole Woldbye

17 Eugène Jansson, *The Navy Bath House*, 1907, oil on canvas, 75
 197 × 301 cm, Thielska Galleriet, Stockholm

18 Edvard Munch, *A Bathing Establishment*, 1907, oil on canvas, 82
 112 × 90 cm, courtesy Jason McCoy, Inc., New York

19 Rosa Bonheur, *The Horse Fair*, 1853, oil on canvas, 244.5 × 406.8 cm, 89
 The Metropolitan Museum of Art, Gift of Cornelius Vanderbilt, 1887
 (87.25), New York

20 Rosa Bonheur, *Study for The Horse Fair*, black chalk, grey wash, 92
 heightened with white on beige paper, 13.7 × 33.7 cm, The
 Metropolitan Museum of Art, Bequest of Edith H. Proskauer, 1975
 (1975.319.2), New York

21 John Leech, 'The Nursery Four-in-Hand Club – The First Meet of 97
 the Season', illustration from *Punch*, 1864

22 Edwin Landseer, *The Shrew Tamed*, 1861, engraving after a lost original 98

23 'Exhibition by the American Horse-Tamer in the Presence of Her 100
 Majesty and the Court, at Buckingham Palace', *Illustrated London
 News*, January 1858

24 John Leech, 'Husband-Taming', from *Punch*, 1859 102

25 Attilio Pusterla, *The Blood Cure*, 1891, oil on canvas, dimensions and 109
 location unknown. Photograph from the catalogue of the 1891 Milan
 Triennale

26 Giovanni Segantini, *The Wicked Mothers*, 1894, oil on canvas, 111
 120 × 225 cm, Österreichische Galerie, Vienna

27 Giovanni Segantini, *The Angel of Life*, 1894, oil on canvas, 115
 276 × 212 cm, Civica Galleria d'Arte Moderna, Milan

28 Attilio Pusterla, *The Soup Kitchen at Porta Nuova*, 1888, oil on canvas, 116
 205 × 136 cm, Civica Galleria d'Arte Moderna, Milan

29 Raphael, *The Ecstasy of Saint Cecilia*, 1514, oil on panel (transferred to 135
 canvas) 220 × 136 cm, Pinacoteca Nazionale, Bologna. The Mansell
 Collection

30 Parmigianino, *The Foolish Virgins*, c.1531–9, fresco, Santa Maria della 136
 Steccata, Parma. (Soprintendenza per i Beni Artistici e Storici de
 Parma e Piacenza)

31 Rosso Fiorentino, *Moses Defending the Daughters of Jethro*, c.1523, oil 140
 on canvas, 157 × 119 cm, Uffizi, Florence. The Mansell collection

32 Titian, *Venus and Adonis*, 1551–4, oil on canvas, 186 × 207 cm, Prado, 141
 Madrid

33 Maxime Du Camp, *Egypt, Palestine, Nubie et Syrie: dessins* 148
 photographiques récueillis pendant les années 1849, 1850 et 1851, Paris,
 Gide et Baudry, 1852, Plate 47: Thebes, Medinet Habou, gynecium
 of Rameses Menmare, 8 May 1850

34 Maxime Du Camp, *Egypt, Palestine, Nubie et Syrie: dessins* 151
 photographiques récueillis pendant les années 1849, 1850 et 1851, Paris,
 Gide et Baudry, 1852, Plate 74: Philae, second pylon of the Great
 Temple of Isis, 13 April 1850

35 Maxime Du Camp, *Egypt, Palestine, Nubie et Syrie: dessins* 152
 photographiques récueillis pendant les années 1849, 1850 et 1851, Paris,
 Gide et Baudry, 1852, Plate 28: Thebes, view of the Temple of Khons
 at Karnak, 6 May 1850

36 Maxime Du Camp, *Egypt, Palestine, Nubie et Syrie: dessins* 152
 photographiques récueillis pendant les années 1849, 1850 et 1851, Paris,
 Gide et Baudry, 1852, Plate 65: Kom Ombo, ruins of the temple of
 Ombos, 20 April 1850

37 Man Ray, *Untitled*, 1933, photograph, Collection Rosabianca Skira, 162
 Geneva, © ADAGP, Paris, and DACS, London 1992

38 Man Ray, *Untitled*, 1933, photograph, Collection Rosabianca Skira, 164
 Geneva, © ADAGP, Paris, and DACS, London 1992

39 William Hogarth, *An Election Entertainment*, c.1754, oil on canvas, 179
 85.5 × 110.8 cm, Trustees of Sir John Soane's Museum, London

40 M. de Garsault, *Art du perruquier* ..., 1767, Académie des Sciences, 184
 Paris, Plate 2

41 Tim Bobbin, *The Flying Dragon* ..., 1819, printed for the author and 186
 Mr Haslingdon, Manchester, Frontispiece

42 Tim Bobbin, *The Flying Dragon* ..., 1819, printed for the author and 187
 Mr Haslingdon, Plate 4

Notes on the contributors

DAVID LOMAS graduated in medicine before undertaking study in art history at the Courtauld Institute of Art, London, where his doctoral thesis was 'Surrealist Painting: Questions of Identity'. His research interests are in the area of psychoanalysis and art history.

AMELIA JONES is an art historian and art writer from Los Angeles. She teaches at the University of California, Riverside, and has published articles on modernist and contemporary art, on feminist issues in film studies and art history and on theories of representation. Her doctoral dissertation was 'The Fashion(ing) of Duchamp: Authorship, Gender, Postmodernism'.

TAMAR GARB is a lecturer in History of Art at University College London. Her dissertation on the Union des femmes peintres et sculpteurs and the position of the woman artist in late nineteenth-century France is currently in preparation as a book. Her publications include *Women Impressionists* (1986), *Berthe Morisot* (with Kathleen Adler) (1987) and articles on a wide range of issues concerning women and representation.

JAMES E. B. BRESLIN is Professor of English at the University of California at Berkeley. Among his many publications are *William Carlos Williams, an American Artist* (1970), and *From Modern to Contemporary: American Poetry, 1945–1955* (1984). He is now completing a biography of Mark Rothko.

MICHAEL HATT is a research student at Birkbeck College, University of London, where he is completing a thesis on masculinity and the male body in late nineteenth-century America. He has also published on the black male body in nineteenth-century American sculpture.

PATRICIA BERMAN is Assistant Professor of Modern Art at Wellesley College, Massachusetts. Her graduate work was at the New York University Institute of Fine Arts, and she has published on a range of issues concerning Edvard Munch

xiii

and Scandinavian painting. She is currently completing a book on Munch's paintings for the University of Oslo Festival Hall and Norwegian nationalism.

WHITNEY CHADWICK specialises in modern and contemporary European and American art. Her books include *Myth in Surrealist Painting, 1929–1939* (1980), *Women Artists and the Surrealist Movement* (1985) and *Women, Art, and Society* (1990). She is a frequent contributor to art periodicals and has lectured widely on Surrealism, feminism, and contemporary art in the United States, Canada and Britain. She has taught at the Massachusetts Institute of Technology, the University of California at Berkeley and Stanford University, and is currently Professor of Art at San Francisco State University.

KATE FLINT is University Lecturer in Victorian and Modern English Literature and Fellow of Linacre College, Oxford. She has written *The Woman Reader, 1837–1914* (1992) and *Dickens* (1986); edited *Impressionists in England: Social Problems and Social Change* (1987), and published widely on nineteenth and early twentieth-century fiction, art and art criticism, and English and Italian painting.

SHARON FERMOR is Lecturer in History of Art at the University of Sussex. She has a special interest in the representation and perception of the moving body in Renaissance art, on which she has published several articles. Her doctoral thesis, 'Studies in the Depiction of the Moving Figure in Italian Renaissance Art, Art Criticism and Dance Theory' (Warburg Institute, University of London, 1990) is the subject of a forthcoming book. She is currently preparing a monograph on Piero di Cosimo.

JULIA BALLERINI is Associate Professor in the Department of Art History at the University of Hartford, Connecticut. She has lectured and published extensively on nineteenth-century French and British photography and on contemporary American photography. She is currently organising an exhibition and catalogue titled *The Surrogate Figure: Intercepted Identity in Contemporary Photography* for the Center for Photography at Woodstock, New York. She is also writing a book on Maxime Du Camp in Egypt.

BRIONY FER produced her doctoral thesis on cultural exchange and debate in Russia and France in the 1920s. From 1980 to 1990 she worked in the Department of Art History at the Open University, where she wrote for the Modern Art and Modernism and more recent Modern Art: Practices and Debates courses. She is now a lecturer in the history of art at University College London. She has published on Russian Constructivism and is engaged on research for a book on abstract art.

MARCIA POINTON is Pilkington Professor of History of Art at the University of Manchester. She has published extensively in the field of eighteenth and nineteenth-

century European art. Her more recent books include *The Bonington Circle: English Watercolour and Anglo-French Landscape, 1790–1855* (1985), *Mulready* (1986), *Pre-Raphaelites Re-viewed* (1989) (editor and major contributor), and *Naked Authority: The Body in Western Painting 1830–1906* (1990). Her study of eighteenth-century English portraiture, *Hanging the Head: Portraiture and Social Formation in Eighteenth-Century England* will be published in 1993.

Acknowledgements

This book originated with a conference, 'The Body in Representation', organised by the Association of Art Historians and the Centre for Extra-Mural Studies, Birkbeck College, University of London, in September 1990. It is to the vitality of that event and all who participated in it that the editors and authors owe the charge that has seen their book through to publication. The excitement of that event has not been forgotten and something of it has informed the preparation of these essays and the writing of the introductions.

We wish to thank all the contributors to the conference and all those who chaired sections of it. Especial thanks to Ludmilla Jordanova, who was involved in the planning and organisation of the conference from its inception, who assisted with the early stages of this publication, and who commented on and edited some of the essays here. Her knowledge and enthusiasm was a crucial factor in the development of this project. Thanks are also due to all who assisted at the conference, particularly to Fiona Paton, Madelon Lyle and Louise Purbrick; to David Bindman, John Murdoch and Malcolm Baker for their assistance with technical hiccoughs; to the University of London Union, who provided the conference accommodation; and to the Information Bureau of the Centre for Extra-Mural Studies. We are grateful to John Trevitt, formerly of Cambridge University Press, for his encouragement and support; to Rose Shawe-Taylor for her patience; and to the two anonymous readers whose comments helped shape the contributions to this volume.

The body of the artist

The relationship between the ever-present but unrepresented body of the artist and the body of work produced by the artist constitutes the common area of interest of the four essays in this section. They address not only the representation of the unrepresentable but also the question of what may not be represented. This section deals with prohibitions, with parade and masquerade, with concealment of the artist's body and with absence as empowerment.

David Lomas examines Frida Kahlo's search for a visual language to represent what had hitherto been confined to medical textbooks, the miscarriage. In her adaptation of medical illustration to personal experience, Kahlo was able in a work like *Henry Ford Hospital* to link the realms of private and public. Lomas considers Kahlo's re-presentation, too, of popular votive imagery to signify something entirely other than its original meaning: death is substituted for life, women's reproductive role is denied and the pain of martyrdom is associated with the pleasure of motherhood.

In his discussion of Mark Rothko, James Breslin examines a very different aspect of the painful and perplexing issue of what may or may not be represented. Rothko was insistent that his works were not, in some way, 'images' of something absent, and to suggest this he referred to them as 'presences', indicating plenitude and vitality in what is apparently empty. Figure painting was rejected by Rothko because he believed that artists could not use the figure without mutilating it, and his canvases are a form of representation that permits a sense of wholeness, of fullness and completion, a sense, as Breslin points out, of representing the state of being before language, before even the recognition of separateness from the mother, a state of 'not-yet-me'. Breslin discusses this in terms of the child's earliest relation with a nurturing mother, a relationship which Rothko's paintings re-evoke by their large and seductive 'presence'; this presence breaks down boundaries between painting and viewer, engulfing the viewer in a process both enveloping and discomforting. This world without boundaries sought by Rothko could also be identified with an

even earlier experience of the body, the engulfing, bounded yet boundless world of the womb. A view of the maternal body more different from that offered by Kahlo would be difficult to conceive, yet both essays treat the artists' respective images as forging new languages with which to represent experiences as yet beyond or outside the conventions of established representational practices.

It is upon another kind of prohibition in matters of representation that Tamar Garb focuses: the restrictions placed on women artists in the nineteenth century. Her essay considers a late nineteenth-century French short story by Charles Aubert which highlights the problems encountered by women artists who wished to study from the nude (male) model. Aubert's story, as Garb shows, is a piece of popular fiction which renders anxieties about the woman artist manageable by its knowing tone and its final reassertion of the patriarchal order intact. The reader is assured by the very banality of the story that there will be no surprises: the existing order will not be threatened by women's desire to possess what is forbidden to them, that is, to take command of the gaze. For Aubert's story hinges around the forbidden wish to control, to possess the world by sight, and the overmastery of this desire by the collusion of a male art dealer and a male artist turned model. The frisson of this account lies on the one hand in its hint of the forbidden, and on the other hand in the containment of any threat or anxieties that might be introduced by this narrative. The world of fiction serves here to secure those unstable boundaries that society requires in the policing of gender.

Male masquerade concerns both Garb and Amelia Jones. Garb's essay considers the duplicitous actions of the young man in the story, who poses as a model but is in fact an artist. His subordination to the woman artist is overturned in various ways, not least by his assertion of mastery in retouching the woman artist's work by night, making the painting produced the best she had ever done. Jones' essay discusses Marcel Duchamp's masquerade as 'Rrose Sélavy', an elaborate presentation of himself dressed in female attire and posing seductively for photographs by Man Ray. The essays share an interest in exploring to what extent the assumption of a feminine voice serves merely to redefine the masculine as empowered in relation to the devalued feminine – the 'Tootsie syndrome', so-called following Dustin Hoffman's role in the film of that name. In the fiction Garb examines, the male figure does not dress in female apparel – he is feminised by acting as a model for a woman painter, and this loss of power is emphasised by the pose he is required to adopt, that of Sebastian, traditionally depicted as a feminised male. The masquerade is far more comprehensive in the case of Duchamp: in addition to the Man Ray photographs, 'Rrose Sélavy' also signed and labelled objects. Jones cites Mary

Kelly's analysis of the contradiction that exists for the female artist: as woman, she is object of the look (the 'feminine position'), as artist she is the subject of her own discourse (the 'masculine position'). This is precisely the dilemma articulated in Aubert's story, but within the discourses of popular fiction such a dilemma exists only to be resolved in favour of the 'masculine position'. Duchamp's masquerade involves a more subtle shift of gender positions and, at the same time, a blatant assertion of the artificiality of such positions.

In Garb's tale of the female artist, her 'mastery' is finally denied. Duchamp, in his masquerade, retains mastery even as he adopts the feminine position. Jones considers the implications of this from a psychoanalytic, primarily Freudian, perspective. Lomas also employs a psychoanalytic reading in his discussion of Kahlo, centring on the exclusion of the feminine from language and hence from entry into the symbolic. He interprets Kahlo's representation of miscarriage as, in part, a confirmation of this exclusion, but also as a project in which Kahlo stakes her identity on an attempt to reshape the patriarchal system of representation. These are not the stakes for which Duchamp was playing, since 'Rrose Sélavy' was one of many identities he assumed, including, as Jones points out, 'Marcel Duchamp'. Both Lomas and Jones draw on the work of Luce Irigaray, Jones to confront Duchamp's masquerade as a claim for the assurance that is provided for the man by the image of the woman, Lomas to explore the idea of the repressed female imaginary characterised in terms of multiplicity and fluidity with application to the work of Kahlo.

Jones makes explicit her investment in the material she presents. Continuing to use the psychoanalytic model, she likens the process of writing art history to the transference and counter-transference of therapy. She finds useful Jane Gallop's view that the interpreter is powerfully superior to the work of art, with the power to divine and analyse what the art work is not able to express. Like all the contributors to this volume, she makes no pretence to the supposed 'objectivity' of humanist scholarship; she is clear about her position as a woman in relation to Duchamp, particularly to that 'Duchamp' who is viewed as the father of postmodernism. While Lomas' position in relation to his material is not made so explicit, his interpretation of Kahlo can also be seen to partake of this process of transference and counter-transference. He recognises the problems inherent for a man in approaching Kahlo's work, the risk that is implied by appropriating or defining the feminine as lack, and thereby reinscribing the patriarchal order. This was precisely the point of Aubert's story, and is the focus of Garb's essay. Far more self-aware than the fictional heroine of Aubert's tale, Kahlo represents her own lack (of power, of the phallus) in works such as *Self-Portrait with Cropped Hair*.

Kahlo obsessively represented her body, broken by a freak accident when she was eighteen, often encased in a corset made of steel. The contrast with Rothko, who sought as compulsively to escape from his shambling, clumsy body – in Breslin's phrase, 'to go out of the body' – is striking. To what extent might this be attributed to gender differences? As has frequently been observed, since women are assigned a position as the objects of artistic creation, their bodies may appear to be the only medium for their art. This introduces the theme of biography, crucial not only to Lomas' essay, but to Breslin's, and, to a lesser extent, to Jones' as well. Lomas insists that much of the work on Kahlo has employed biography to trivialise the work produced by a woman artist, and to relegate it firmly to the private sphere. At the same time he recognises, as have many feminist historians in recent years, that biography can be employed as a powerful tool, provided that the focus on the individual does not lead to the familiar traps of privileging (or in the case of a woman, undermining) the individual above all else. As he points out, the case of Kahlo, who represented herself constantly, and whose life, shaped or mutilated by the accident, demands our attention to the acts of self-presentation and re-presentation which constitute the work. Masquerade is a crucial element in Kahlo's work, just as it is in Duchamp's.

The quest for withdrawal from the body in Rothko's work leads Breslin to biographical speculation about the possible significance of Rothko's orthodox Jewish upbringing, with its prohibition on representation. He is also concerned with Rothko's self-presentation, notably in the Hans Namuth photographs which have often been discussed in relation to Jackson Pollock. The connection made in the Pollock photographs between the body and the work is contrasted by Breslin with the withdrawal evidenced in the Rothko photographs. In both, conscious decisions have been made about self-presentation, and about the construction of narratives which relate the body of the artist to the body of work. For Duchamp – and equally for the fictional body of the woman artist in Garb's essay – the artist's body is not only the effective element which brings the represented body into being but is itself the medium and the metaphor. The enactment of this merging of life and art, as explored in particular cases in these essays, allows for an understanding of the complex intertwining of (auto)biography and representation in imagery of the modern period.

1 Body languages: Kahlo and medical imagery[1]

DAVID LOMAS

Medical imagery is a striking and novel facet of the painting of Frida Kahlo. Through her use of it Kahlo registers aspects of experience that social convention dictates ought to remain private and concealed, as André Breton recognised, writing that 'far from considering these to be the mind's private reserves, as in some colder climates, she displays them proudly with a mixture of candour and insolence' (Breton 1972a, p. 144). This provocative breach of the divide between public and private realms exposes the limits of what can be spoken within the hegemonic culture. Evidence that her work cannot be assimilated under the terms of the dominant culture is provided by the distortions and misrecognitions of critical discourse. Breton, referring to her graphic and prosaic images of a bloody miscarriage, opts for the euphemistic phrase 'mysteries of generation', a description that is inaccurate to the point of being misleading! It is revealing, moreover, that the popular fad for Kahlo has taken the form of an obsession with her exotic persona, but has been largely silent about her imagery. The difficulty of her work, its resistance to articulation by language, points to a problematics of representation that is its fundamental, if generally neglected, theme.

Most art writing about Kahlo has, not surprisingly, taken the form of biography, a genre that seems well adapted to the task of explicating pictures whose major subject is Kahlo herself, whether formal and composed in portraits or naked and exposed in images of her body. This predominant approach to her work has several drawbacks, however. Firstly, the deluge of unabashedly lachrymose stories of her life and art lend support to the view that biography is a mode of trivialising art produced by women. At the very least, some of the disruptive force of her imagery is sacrificed in the saintly and sanitised picture that is painted. Second, and contrary to the whole impetus of her work, biography relegates it to the private domain of a singular life history. It tends to present her life as a catalogue of individual misfortune devoid of wider political import. Third, biography is essentially a realist genre and, as such, assumes the transparency of representations with respect to the real. It carries over this methodological assumption to the pictures themselves which are regarded as accurate reflections of their author. For this reason the

5

biographical perspective uniformly obscures the actual work of self-representation that Kahlo is engaged in.[2]

Only by acknowledging the constructed and mediated nature of visual images can one recognise the constraints Kahlo must contend with: namely, the absence of artistic languages or traditions adequate to her lived experience. The recourse to a medical iconography of the body can be understood as her attempt to create a semantic space where this could be represented. For Lacan the coming into being of the gendered subject is consequent upon entry into the symbolic order of language. An invidious fate awaits the female subject who is unjoined to enter the symbolic but defined within it as lacking or absent(ed): 'there is no woman who is not excluded by the nature of things, which is the nature of words' Lacan writes (1977). It seems that for Kahlo her experience of a miscarriage would serve as confirmation of this exclusion of the feminine from language. But where she can perhaps be seen to part company with Lacan is in her attempt to rework and transform the patriarchal system of representations, a project in which her very identity is at stake.

Focusing on the role of medical imagery within her *œuvre* throws these issues into relief. The term 'medical imagery' will be used here to encompass the depiction of medical(ised) events as well as the adoption of an overtly medical or anatomical iconography.[3] My earlier objections to a biographic approach need to be qualified at this point, since it is by insisting upon the specificity of her experience that Kahlo resists falsifying stereotypes in the dominant visual culture – this emerges forcefully in the contrast between her imagery and that of Rivera where Woman appears in bland allegorical guises. Wishing to redress the neglect by biography of issues of representation, we must avoid throwing the baby out with the bathwater. Pictures that relate to two biographic incidents – an accident in 1926 which had dire repercussions for her health, and the traumatic miscarriage in 1932 – will therefore provide the basis for my discussion of Kahlo and medical imagery.

Anatomical illustration flourished in the latter part of the eighteenth century as the emergent medical sciences laid increasing stress on empiricism.[4] Art lent to medicine not just the prestige of high culture but, more vitally, a repertoire of realist tropes designed to convince a viewer of the truthfulness of unimpeded sight. William Hunter in a preface to *Anatomia Uteri Humani Gravidi* published in 1774 advocates the utmost realism in anatomical illustration because only this he claims 'carries the mark of truth.' The presumed independence of realistic images from *any* visual convention leads Hunter to prefer them to diagrammatic modes of illustration. They offer science a 'universal language' and convey to the viewer an 'immediate [i.e. unmediated] comprehension of what it represents'.

The lavish engravings for Hunter's obstetric atlas set a standard for the genre and disclose with stark clarity the salient features of its empiricist vision. The putatively male anatomic gaze takes the female body as a privileged object to be unveiled, opened and penetrated. Rather than allow the edge of the engravings to crop the

figure, which might have left uncertainty about what lay beyond the margin and impugned the authenticity of the record, Hunter amputates the limbs and torso so that the artist only 'represents what was actually seen' and his visual record 'carries the mark of truth, and becomes almost as infallible as the object itself'. It is at the margins of the visual field in this brutally literal framing device that one witnesses the return of a sadistic desire for mastery disavowed by the language of scientific objectivity. Amputating – wounding or castrating – the body of the other reassures the phallic gaze of science that it alone is whole and in possession of the Logos, Hunter's 'universal language' and truth.

The iconographic formulae pioneered by Hunter were extremely durable, as can be seen from a textbook of obstetrics by Ramsbotham which was published in numerous editions from 1841 onwards (Ramsbotham 1861, Plate XXXII). Though the drawing is more stylised, the maternal body is similarly abruptly truncated to demarcate the main point of interest, the pregnant uterus, while contiguous layers of drapery and folded-back abdominal wall imply that the female body itself is a garment to be peeled away in order to unveil this essence.

Kahlo owned a copy of the Ramsbotham text and evidently culled various motifs from it.[5] However, comparison with a pivotal image by her immediately reveals a vast disparity of aims and methods. *What the Water Gave Me* of 1938 (Plate 1) ousts the unequal dichotomy that fixes male and female as respectively viewer and viewed. Kahlo portrays her body reclining in a bath as it would appear to herself; now the viewer *is* the viewed and there is no place left for the detached sovereign spectator (the implied continuity between the viewing position and the female body renders my own position as a commentator on it distinctly awkward). Nor does the naked reality of the female body yield itself up any longer to empirical scrutiny. Rather, the real of the body recedes beneath a sheet of water that is interposed between us and the body. Its reflective surface is like a screen or canvas even, upon which metaphoric analogies for the body, as well as subjective recollections and fantasies, are projected and piled up. The body surfaces in this symbolic plane as an excess of meaning that drowns out the real body, yet overlaps and intersects it at various points.[6]

Whereas the realist epistemology of Hunter seeks to elide any distinction between signifier and signified in the name of objective truth, Kahlo reopens a space between them and forces the beholder to acknowledge gender and power relations inscribed in visual representations. The contrast underlines the need to be wary of claiming that Kahlo was simply empowered by her use of medical imagery. Indeed the question might arise of why she did not simply repudiate a visual language that so nakedly enshrines a perspective alien to her own. *What the Water Gave Me* is a good example of how Kahlo is able to subvert the meaning of her ostensible source, in this case the artistic topos of a nude female bather. Through its use of metaphor *What the Water Gave Me* opens onto possible meanings of the female body other than as the specular image of male desire: bathwater becomes

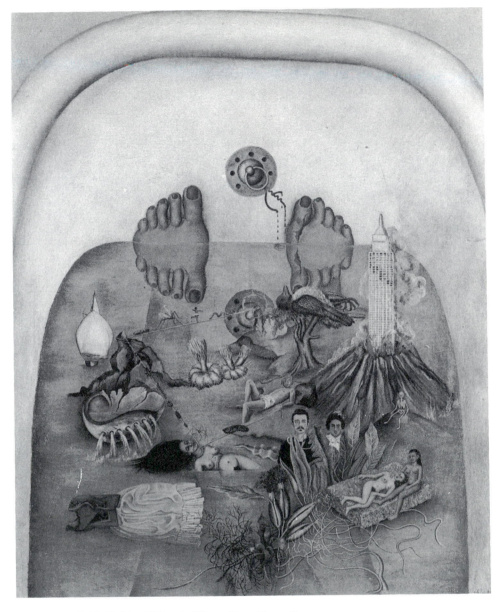

1. Frida Kahlo, *What the Water Gave Me*, 1938

amniotic fluid, setting in train a string of associations – a metaphorics of fluid – that specifically connote the female body.

Allowing that her work engages with and reworks existing visual codes, one of the fruitful ways it can be understood is as a dialogue with the work of Diego Rivera and of the Mexican muralists in general.[7] Kahlo began utilising medical sources in 1932 just as Rivera was painting the *Detroit Industry* murals that include a panel celebrating the achievements of modern science and medicine. A pamphlet gives a colourful account of Rivera perched on a scaffold 'littered with specimens of the objects he chose to represent. Strewn about him were fossils, crystals, fruits, vegetables, books on anatomy …' (Pierrot and Richardson 1934, p. 14). While Rivera may have provided the initial impetus, juxtaposing their work shows that each used medical imagery to very different ends.

Rivera painted two murals of the history of cardiology for the Instituto Nacional de Cardiologia in Mexico City in 1943–4 (Chavez 1946, Fig. 402). His brief for the project dictated that the progress of medicine be symbolised by a pantheon of 'men striving, striving in an upward march' (Chavez 1946, n.p.). Rivera employs the strict hierarchy of an altarpiece. He depicts the pre-history of modern medicine in four predella panels while above them, in two vertical compositions, he portrays the stepwise ascent of medical knowledge in the modern era. The martyrdom of a figure on the left indicates the full extent to which this secular ideology of progress was informed by a Christian teleology. (The flames that engulf this figure are reminiscent of the ventricular surface of cardiac muscle, a kind of gratuitous visual pun which so often turns up in Kahlo as well.) The murals were dedicated to a Dr Chavez who felt inspired by them to write: 'Science was not born today, nor yesterday, it has been gestated painfully through the centuries in the thought of man. The pain of birth and the Faustian joy of creation join at each of the stellar moments of scientific history when an idea, a theory or a discovery comes into being.' Kahlo, who kept a copy of this book, would no doubt have been wryly amused by its florid metaphor of gestation and birth as only a single woman is included in the panels – a patient!

Rivera depicts the 'birth' of cardiology whereas Kahlo paints scenes of actual childbirth. The former are huge and heroically masculine, whereas the latter are diminutive in scale, unheroic, and speak of female experience. In the murals artistic modernism reinforces the theme of medical progress; art and science are locked in a mutually uplifting embrace. Kahlo, as I hope to show, uses medical imagery in a disruptive way as a foreign intrusion that forces one to question the boundaries and exclusions enforced by art. She combines imagery drawn from very disparate sources but eschews the rigidly hierarchical vision of Rivera's cardiology murals. The collision of differing points of view within this heterogeneous pictorial field both relativises and undermines any stable hierarchy of authority.[8]

Frida Kahlo held her first solo exhibition in New York in 1938. Included in the

exhibition were pictures that narrated her experience of a miscarriage in Detroit where she had accompanied Rivera in 1932. An unsympathetic reviewer for the *New York Times* disparaged these works which he judged to be 'more obstetrical than aesthetic' (Herrera 1983, p. 231). His reproach intimates that the aesthetic and the obstetrical are somehow antithetical, that the sanctity of the aesthetic relies on exclusion of the other term. It is commonplace to describe artistic creation using metaphors of gestation and birth, yet actually to depict such events is tacitly proscribed. Scenes of childbirth are rarely portrayed in Western art and miscarriage never – they have been hived off into medical texts. The lithograph *Frida and the Miscarriage* (Prignit-Poda 1988, Plate 261c) contests this segregation and rudely desublimates the dominant metaphor of artistic creation. The arm holding an artist's palette is an extraneous appendage tacked onto a body in which are rejoined the mutually excluding worlds of female procreation and male artistic creation.

2 Frida Kahlo, *Henry Ford Hospital*, 1932

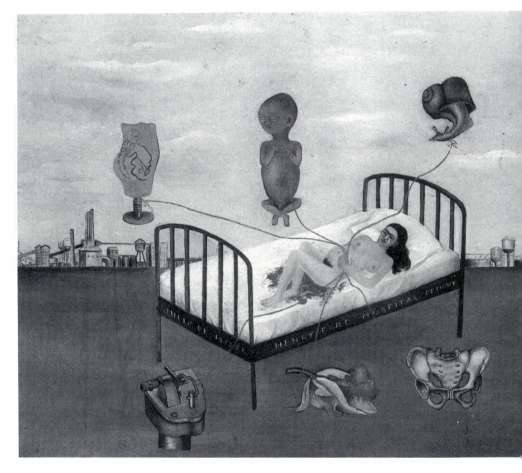

Kahlo, partly by her association with Rivera, gained entrance to an emancipated, secular milieu of artists and intellectuals where scandal was courted and that afforded her considerable latitude to confront the strictures of a traditional Catholic society. In *Henry Ford Hospital* (Plate 2) Kahlo dares to display not only her naked body but her soiled linen too. Yet her breach of decorum in *Henry Ford Hospital* is more far-reaching than this. In the culture to which Kahlo belonged miscarriage was a source of shame: the abject failure of a socially conditioned expectation of motherhood,[9] and a travesty of creation in which birth yields only death and detritus. No public rituals commemorate the loss of miscarriage, which is banished to a private domain of silent grief. The stark proximity of birth and death in miscarriage adds up to nothing, and so there is nothing to say – it is virtually unrepresentable. While reckoned to occur in some 15 per cent of pregnancies, miscarriage is an event which still goes unspoken and unnoticed.

The Lacanian concept of foreclosure from symbolisation may explain the bewildering sense of unreality reported by women who have miscarried or given birth to a stillborn child (see Lewis 1976, p. 619); miscarriage and stillbirth cannot be readily distinguished by either the nature or the severity of their psychological impact, a point that is relevant to *My Birth* (Plate 3)). A similar loss of reality occurring in psychosis is, according to Lacan, a consequence of *foreclusion* from the symbolic order. The validity of the comparison with psychosis is supported by the case history of Lacan's most famous patient, Aimée, whose florid psychosis irrupted soon after the stillbirth of her child: 'In March 192. . ., she gave birth to a stillborn female infant. The diagnosis was of asphyxiation by the umbilical cord. A sudden deterioration of the patient ensued . . .' (Lacan 1980, pp. 159–60); the concept of foreclosure was not employed by Lacan until much later, and he does not offer any comment on the stillbirth as a causal factor in the psychosis. Nor does the extensive literature on Lacan.

A rigid dichotomy of public and private functions is one mode of exclusion of miscarriage from the realm of discourse. Partly for this reason one might suspect that responses of women to miscarriage are more likely to have found expression in letters or diaries where notionally private attitudes and emotions could be explored, unlike painting which almost always entails an audience. Moreover until recently women had more opportunity to acquire and practise writing skills. But even here there are few records. Mary Carey in 'Apon ye Sight of my abortive Birth ye 31th: of December 1657' adapted for the purpose a form of lamentation poem composed by women after the loss of an infant child, a common occurrence in that era (Greer *et al.*, 1988, pp. 158–61). Kahlo of necessity also adapts existing visual genres – such as the ex-voto which is usually made after recovery from a bout of illness – and bends them, however intractable, to her subject. By speaking out, she articulates the previously unspeakable in a hybrid language partly derived from artistic traditions but also drawn from textbooks of anatomy and obstetrics. It may be that Kahlo was able to exploit the privilege of medicine to expose parts and functions of the body

normally hidden by decorum, and thereby sidestep the closures that have denied a public voice to these matters (medicine straddles the border of public and private).

Henry Ford Hospital was painted shortly after the miscarriage. Kahlo lies naked in a pool of blood on a hospital bed that has been displaced into a desolate landscape with Detroit factories in the background. Superimposed on this scene is an array of objects that are larger in scale and depicted in a contrasting, diagrammatic idiom. Soon after the miscarriage Kahlo began delving into medical texts and evidently drew the foetus and pelvis from this source. They both refer to the miscarriage in a literal and prosaic way, whereas the presence of a snail is more perplexing and has been described as a quirky private symbol. But this assumption may be unfounded as the same metaphoric conjuncture is found in Psalm 58: 'Let them be like the snail which dissolves into slime, / like the untimely birth that never sees the sun.'[10] Whatever the explanation may be for this obscure coincidence, it certainly demonstrates that Kahlo's image does not emerge *de novo* from a unique plight, but that the forms of expression she adopts are borrowed from and inscribed within culture.

Kahlo conveys poignantly enough the feeling of being a hapless victim of an event beyond her control. Yet her state of helpless isolation is partly due to, and certainly underscored by, the absence of a visual language adequate to render the experience. Indeed her distance from the spectator and displacement into an empty landscape evoke a sense of alienation that may relate to this state of 'exile' from language (Irigaray 1977). The dislocation of figure from ground, and the awkward disjuncture between two pictorial modes – schematic and naturalistic – gesture towards emotions that are representable only as discontinuity. It is the gaps and silences of *Henry Ford Hospital* that register most acutely the pain and anguish of her loss. Where the *New York Times* critic recoiled in distaste before an unsavoury spectacle one sees Kahlo striving to render visible a blindspot of high cultural vision.

It is ironic that while Kahlo languished in hospital after the miscarriage in July 1932 Rivera was at that very moment painting the *Detroit Industry* murals which include on the east wall, as a counterpart to scenes of factory production, a potent symbol of biological (re)productivity, a human child *in utero*: 'This germ – a child, not an embryo – is enveloped within the bulb of a plant which sends down its roots into fertile soil . . .' declared Rivera (1986). This syncretic embodiment of an organic vital principle is flanked on either side by images of agricultural produce and above by two cornucopian women, standard allegories of fertility. It is tempting to see the unadorned reality portrayed by Kahlo as a calculated refutation of this naïvely optimistic vision. The subject she chose to represent, miscarriage, is a powerful antidote to the fantasy of boundless fecundity which the female body represents for Rivera. By pushing the Detroit factories so resolutely to the background Kahlo negates, whether by design or not, the central motif of the Rivera murals. With hindsight, it is his pictorial conception of a Utopian synthesis of man and machine that now appears to us stillborn.[11]

My Birth of 1932 was painted after the death of her mother later the same year and conflates this loss with a distorted reminiscence of the earlier event. It shows what appears to be a stillborn child who inexplicably bears Kahlo's own adult features. It seems likely that Rivera, in 'Frida Kahlo y el arte Mexicano', has this picture in mind when he proclaims Kahlo 'the only human force since the marvellous Aztec master sculpting in black basalt who has given plastic expression to the phenomenon of birth' (Rivera 1986, p. 293). If so, his account reveals a fundamental *méconnaissance*, suggesting that Rivera could not see beyond the deeply ironic title to the work itself, which disorients cultural expectations by its weird implosion of birth *and* death. Because *My Birth* so patently rejects an ideology of (re)productivity, the attempt by Rivera to recuperate her work by connecting it with the dominant strand of Mexican nationalism – where female reproduction was the

3 Frida Kahlo, *My Birth*, 1932

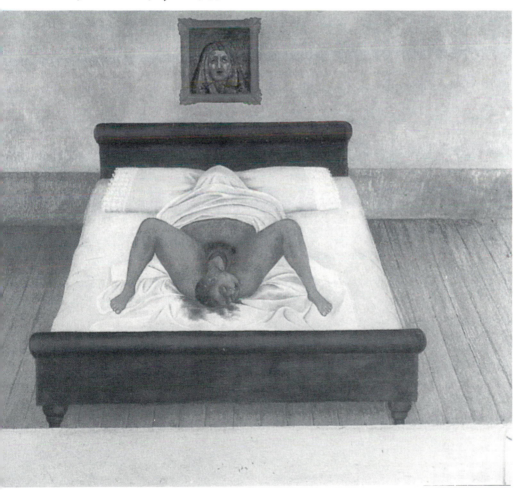

counterpart to a vision of industrial modernity – strikes a false note. Kahlo adopts the format of popular votive imagery in *My Birth*. But the scroll in the foreground, upon which an account of some miraculous cure would normally be written, is left blank by Kahlo who reiterates once more the limits of available languages. On a wall overlooking the scene is a framed image of the Mater Dolorosa whose role in Catholicism is to mediate the Passion of Christ in humanly comprehensible terms (Warner 1976, p. 211), a task of translating the ineffable akin to Kahlo's own. This may begin to explain her repeated identification with the Mater Dolorosa in spite of a framework of cultural perceptions that denied the legitimacy of her grief – for how could Kahlo, who was not even a mother, possibly mourn the loss of a son? An additional ironic association of motherhood and martyrdom (Mater–martyr) comes into play as Kahlo resorts in other contexts to an identification with the Mater Dolorosa in order to convey actual physical pain.

A letter that fails to reach its destination may, according to the *Oxford English Dictionary*, be said to have miscarried. It is precisely such a failure of the letter (of language) that Kahlo thematises in *Henry Ford Hospital* and *My Birth*. A further resonant meaning in the present context is the notion of a miscarriage of the law, since by the simple fact of representing a miscarriage Kahlo disobeys the letter of patriarchal law. Indeed one could say that she protests against a law which even *before* it has miscarried is already unjust.

It has been argued in my reading of these works that miscarriage is paradigmatic of the exclusion of female experience from a public realm of signification. For Kahlo the awareness that an event could be virtually obliterated owing to the poverty of expressive means initiates a searching interrogation of her relation to the symbolic order. It is from such an angle that I would now like to consider the body of images elaborated around the theme of her accident and its sequelae. As is well known, a freak tramcar accident when Kahlo was aged eighteen caused devastating injuries. Multiple fractures to the spine, pelvis, right leg and foot left her partially crippled, with her general health also much impaired. An unending sequence of operations ensued in mostly vain efforts to alleviate pains in her back and right leg, which was finally amputated.

The resulting scars were deeply etched. An undercurrent of anxiety surfaces in a private diary where she wrote above a frail marionette toppling from a pedestal: 'I am DISINTEGRATION.' The plaster corsets in which Kahlo was encased and which she decorated are like symbolic shields or armour warding off a hostile world. The defensive posture of *Self Portrait with Monkey* of 1940 (Prignit-Poda 1988, Plate 77), in which her blankly inexpressive face and a shallow crowded space rebuff either psychological or visual penetration by the spectator, may be referred back to the accident in which her body was impaled on a steel bar. Her working method, combining disparate sources in a piecemeal collage technique, implies analogies on an imaginative or psychical plane with the surgery that aimed at

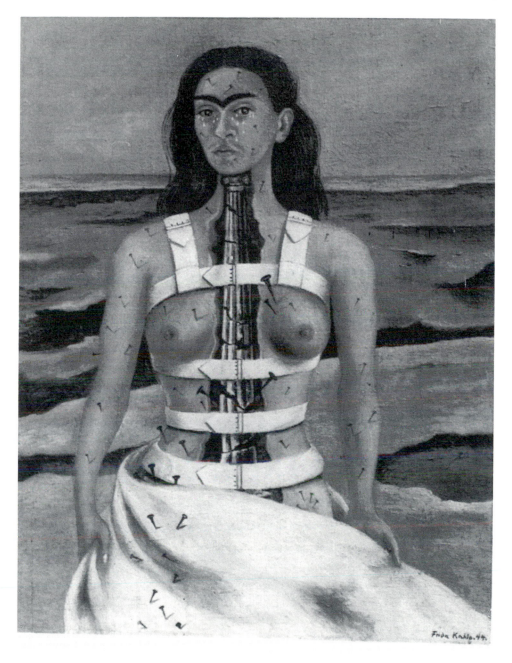

4 Frida Kahlo, *The Broken Column*, 1944

restoring her disrupted physical self: according to one acquaintance '[t]hey had to put her back together in sections as if they were making a photomontage' (Herrera 1983, p. 50).

Freud, in *Beyond the Pleasure Principle*, invokes the hypothesis of a compulsion to repeat to explain why 'dreams of patients suffering from traumatic neuroses lead them back with such regularity to the situation in which the trauma occurred' (Freud 1984, p. 304). While the model of traumatic neurosis may not be applicable to artistic production, a compulsion to repeat is certainly exhibited in the work of Kahlo since, however much it ostensibly concerns later events, it continually leads one back to the fateful moment of the accident. *The Broken Column* (Plate 4) of 1944 refers overtly to her current circumstances, to the back pain which plagued her and necessitated wearing a cumbersome steel corset. A flood of tears alludes to the Mater Dolorosa while nails pierce her skin, recalling the exquisite pain of St Sebastian. Using a format gleaned from medical texts the two halves of her body are torn apart to expose her broken spine, a crumbling classical column; the body as a temple is desecrated and laid to ruin. The picture is completed by a barren lacerated landscape that mirrors her own doleful condition. At another level, however, *The Broken Column* can be interpreted as restaging her initial trauma: the phallic column shoved in the breach between the two halves of her body can be read as a metaphor for sexual violation. In the accident, too, her body was broken and horribly violated by a metal rod that pierced right through her pelvis.[12]

Through repetition and restatement Kahlo slowly integrates her accident at both a psychical and a pictorial level. The notion of deferred action is illuminating with regard to this. Events which 'it has been impossible in the first instance to incorporate fully into a meaningful context' are subject to deferred revision, according to Laplanche and Pontalis (1973, p. 112), who add that 'the traumatic event is the epitome of such unassimilated experience'. Revising past events serves to invest them 'with significance and even with efficacity or pathogenic force'. How this occurred within Kahlo's work can be readily seen: the bar that skewered her body assumes phallic proportions, and is linked along a chain of causation with the shattered spine of *The Broken Column*.

Kahlo, who attributed (wrongly, it seems) her inability to bear children to this pelvic injury, presents as a correlative of the phallic bar, the 'lack' which is figured as a womb-shaped void in *Roots* of 1943. This picture is almost a pendant to *The Broken Column* where she is miraculously upright like the raised Lazarus. In *Roots* Kahlo lies supine in the awkward pose which enabled her to paint during long stretches of enforced bedrest, and is once again marooned in a crevassed and foreboding landscape. The tensions and disjunctures of *Roots* brilliantly denature the easy equation of woman and nature typically expressed in the motif of the reclining nude.

What might this constellation of images repeatedly invoking a traumatic moment in the past signify? Susan Gubar (1986) remarks that, owing to their assigned status

as the objects rather than the subjects of artistic creation, women who become artists may 'experience their own bodies as the only available medium for their art ... and cultural forms of creativity are often experienced as a painful wounding'. This observation would appear to be highly pertinent to the surgical wounds that Kahlo so insistently displays. These marks inscribed on her body by the hand of male authority function as a metaphoric substitute for the meaning ascribed to the female body by the patriarchal symbolic (wounded = castrated). Kahlo spells out this nexus of meaning in *Remembrance of An Open Wound* of 1938 (Prignit-Poda 1988, Plate 63), lifting her skirt to expose on the upper part of her thigh an elliptical surgical wound bleeding profusely which is clearly intended as a displaced image of the female sex. Marked ambivalence towards the tools of artistic creation is evinced in *Self Portrait with Dr Farill* of 1951 (Prignit-Poda 1988, Plate 124) where Kahlo draws an analogy between brushes dripping red paint and surgical scalpels, implying that the former are double-edged instruments of healing and mutilation. It is entirely feasible that an artist who must picture her body through the eyes of Hunter or Ramsbotham, using their visual codes as Kahlo did, might represent this as a painful wounding, or even as a more extreme violation. Hence the bar that impaled Kahlo in the accident becomes meaningful as a signifier – the phallic signifier – of her division (*Spaltung*), which is the price of acceding to the symbolic order.

Whereas biographic narratives present the accident as a singular and absolutely contingent real event, and anchor the meaning of her work in it, one can now recognise that the accident, at least as Kahlo imagines it, is the repetition of a previous more primal trauma: her entry as a female subject into a symbolic order where woman can only appear as lack or absence – 'excluded by the nature of things, which is the nature of words'. Freud viewed the symbolic repetition of a trauma as an attempt to achieve mastery over it. In the following section I will further consider Kahlo's work in its dimension of insubordination to patriarchal language and authority.

The bar which impaled Kahlo debarred her from pursuing the medical course she had as an adolescent hoped to undertake. It relegated her instead to dependency upon medical knowledge and authority. Pastiche and appropriation of medical imagery are a means of resisting her subordinate position within the hierarchical and gendered doctor–patient couple. Luce Irigaray, who argues that mimeticism is a potent subversive strategy, writes that to play at mimesis is, for woman, 'to try to recover the place of her exploitation by discourse, without allowing herself to be simply reduced to it ... *They remain elsewhere*' (Irigaray 1985a, p. 76). A letter Kahlo wrote to a friend following an operation for spinal fusion in 1946 contains a casual sketch of the surgical wounds on her back with appended captions in the schematic style and format of medical notation (Prignit-Poda 1988, Plate 238). It adopts the viewpoint of a doctor to survey her back from a position that was in reality inaccessible to her – one may safely assume an element of irony in a mimicry which

so openly declares its own impossibility. By artfully usurping *his* place Kahlo negotiates a degree of autonomy at least in the field of representation.[13]

Herrera recounts that after the first miscarriage Kahlo begged staff to provide medical texts illustrating the event but was refused (1983, p. 142). The knowledge she sought about her body was illicit, and by playing with medical imagery Kahlo commits a Promethean theft. A counterpart of the knowing and ironic mimicry of a forbidden medical genre is the transgressive parody of gender witnessed in *Self-Portrait With Cropped Hair* of 1940. Kahlo, who was estranged from Rivera, wears an oversized male suit that presumably belonged to him; its misfit corresponds to her ironic, estranged relation to the patriarchal symbolic order.[14] *Self-Portrait With Cropped Hair* angrily protests the status language assigns her as a castrated little man (a point made unambiguously by the scissors on her lap). Patriarchal discourse, Kahlo emphatically asserts, is a foreign idiom which, put simply, just does not suit.

Irigaray writes that Western discourse, by privileging unity, presence, and the visible, 'presents a certain isomorphism with the masculine sex' at the expense of a repressed female imaginary (Irigaray 1977, p. 64), which in *This Sex Which Is Not One* (1985a) she characterises in terms of multiplicity and fluidity. 'Her sexuality, always at least double, is in fact *plural*', remarks Irigaray. Kahlo articulates just such a composite identity in *The Two Fridas* of 1939 (Prignit-Poda, Plate 70) which alludes to her mixed Mexican and European ancestry and conflicting cultural affiliations. Fashioning her identity solely with the garments she is wearing, as mere surface and masquerade, Kahlo craftily embroiders into the lace bodice of her European self a stylised image of the female genitals – a witty play of doubling, concealment and exposure that draws out the many resonances of 'ce sexe qui n'en est pas un'. Kahlo establishes a parallel between the interspersed signifiers of gender identity and post-colonial identity: both are marginal with respect to the centre and citation; translation and reinscription are their joint strategies *vis-à-vis* the dominant discourse. But the constant threat of actual bodily disintegration precludes a jubilant affirmation of decentredness by Kahlo who invariably reminds one of the pain of division. A clamped artery or umbilical cord in *The Two Fridas* bleeds and besmirches the whiteness of her European dress, and the exposed sacred heart of the Madonna, depicted with anatomical precision, is sectioned down the middle – a pictorial device Kahlo adapts from medical illustration and invests with new eloquence.[15]

While clearly separating the real from the symbolic, Kahlo in *What the Water Gave Me* insists that the two orders overlap and are imbricated upon each other; her art constantly retouches the reality of her body and the truth of her experience. A consequence of drawing upon her body as metaphor is that the binary oppositions which order patriarchal language come unstuck. In *Frida and the Miscarriage* the fundamental distinction between self and non-self, inside and outside, is blurred by

the presence of the foetus which is simultaneously inside the body yet apart from it, and extruded from the body, abjected, but attached to it.[16] The plaster corsets Kahlo wore, a kind of exoskeleton, invert the usual relations of surface to depth. Against the grain of anatomical illustrations which strip away surface layers to yield an underlying essence or core, the polished meticulous finish of Kahlo's painting insists on a play of surface and masquerade.

Ludmilla Jordanova (1989, p. 57) has shown that in keeping with its empiricist premises anatomy borrowed from geology a model of tissue layers and a belief that as more superficial ones were removed an underlying core of the body would be exposed. Kahlo repeatedly brings into play this body-as-garment metaphor in her self-presentation, though the hierarchy of surface and depth is turned inside out. The self, to return to *What the Water Gave Me*, dispersed across the surface of the bathwater, is connoted at one point merely by an empty dress.

A further reversal of a most unexpected kind returns us to obstetric imagery with a jolt. The motif of the umbilical cord is part of a chain of visual metaphors – blood vessels, tendrils, roots and bandages – all of which connote healing and connection. But in *Self-Portrait with Monkey* its meaning is otherwise. Where the images considered so far openly declare their origin to underline the act of appropriation, this time Kahlo makes a more veiled reference to the medical texts she so assiduously scoured, but one which is nonetheless integral to the pictorial effect. The red ribbon that winds round her neck confers an air of foreboding and surely refers to obstetric images of cord strangulation where, by a macabre *détournement* of sense, the nurturing lifeline of a foetus becomes the instrument of its death (Ramsbotham 1861, Plate LXI). Beneath the lavishly painted surface of *Self-Portrait with Monkey* and behind Kahlo's seemingly impassive mask lurks a sense of impending doom. Small wonder the Surrealist poet André Breton would describe her art as a ribbon round a bomb.

A narrowly biographic approach defuses the bomb. By attending to issues raised by Kahlo's fraught relation to artistic and medical iconographies of the body I have attempted to retrieve this explosive force. Her body is a site where political concerns intersect with personal ones, and this is nowhere more cogently stated than in the corset Kahlo wore each day upon which she painted a hammer and sickle poised over a foetus. It is 'individual-collective', as Rivera wisely insisted.

2 The ambivalence of male masquerade: Duchamp as Rrose Sélavy

AMELIA G. JONES

> Nomination does in effect assign him a place ... He makes himself into the body of the signifier ... to a body 'remade' for and by the name: a 'harlot' formed according to the specifications of the signifier of the other ... This madness ... is *general*. It is a part of any institution that assures a language of meaning, right or truth.
>
> (de Certeau 1986, pp. 39–40).

In *Fusées* Charles Baudelaire asks the question 'What is art?' and answers, 'Prostitution'. Here I will take up Baudelaire's provocative comment, which places the artist as female and as sexually commodified object and/or subject of prostitution, to examine the photographic portraits of Marcel Duchamp masquerading as a woman.

In 1921 Duchamp dressed in feminine garb and posed coyly for a series of photographic portraits by his friend Man Ray (while these photographs show variations in pose and outfit, they all share the characteristic seductive effects to be discussed here (Plate 5)). From that time on, he also signed and labelled objects with his feminine name, Rrose Sélavy (or 'eros, that's life', in one of its possible English translations). In this way, while Rrose Sélavy is memorialised in visually seductive form in the photographed *object*, Duchamp also enunciated her as authorial *subject* while authenticating ready-made objects as art. I want to explore here what it means for a male artist – particularly one now called upon frequently as authoritative masculine source to authenticate American postmodernism – to em-body himself as a woman; what it means for the artist to produce himself *through* the photographic image and the signature as seductive feminine object but also feminine subject of desire – as the Baudelairian prostitute, whom Walter Benjamin suggestively labels 'seller and commodity in one' (Benjamin 1978, p. 157).

I will explore here the psychic and material ramifications of Duchamp's subterfuge, reactivating in a self-consciously feminist way the question of sexual difference repressed by placements of Duchamp as 'generative patriarch' of American postmodernism (Canaday 1968, p. 51).[1] Duchamp's adoption of feminine attributes in the masquerade – his choice of making a spectacle of himself as a woman rather than displaying his masculinity in a *parade* of machismo – will be examined for its ambivalence: its activation of states of contradictory and seemingly mutually

exclusive desires that are invested with intense libidinal energy (Flax 1990, p. 50).[2]

The pictures of Rrose Sélavy, a figure virtually ignored by American discourses of postmodernism, may first appear to instantiate an egregious arrogation of the feminine by a male artist. I will argue that as image and signing 'author', however, she disrupts the field of meaning generated around the paternal authorial signifier 'Duchamp'. The deliberate usurpation of the feminine in Rrose Sélavy puts to work feminine wiles of seduction, perverting the interpretive desire to fix Duchamp as masculine origin by shifting and confusing the oppositional poses of masculine viewing-and-making author and feminine viewed object. One among numerous obsessive and contradictory self-imaging strategies of Duchamp, the Rrose Sélavy character functions to confuse the desire to call Duchamp 'Daddy'.

Duchamp can be described as Jane Gallop identifies Jacques Lacan – a 'prick', a 'narcissistic tease who persuades by means of attraction and resistance' (Gallop 1982, p. 37). That is, he is both a feminised seducer, dressed in women's clothing and posing under soft lighting in a manner coded in the photograph as 'erotic', and the masculine authority whose works are taken as 'truth'. But, to follow the logic of Gallop's argument, as a seducer Duchamp reveals his own desire – exposes himself as desiring 'father' and so disrupts this father role by *feminising* himself. Unlike the phallic artistic creator heroised by Clement Greenberg or Harold Rosenberg, an artist who pretends he has no desire for the other and veils his seduction in the form of the law, Duchamp refuses to refuse seduction.

To re-eroticise the repressed sexuality of interpretation, I employ a specifically Freudian notion of transference. For Freud, transference is the locus of investment and exchange between the analyst and analysand or object/subject of analysis (Freud 1963b, p. 114). Transference and its corollary counter-transference are the sites where the struggle for meaning takes place between analyst and analysand, via the spoken or written text that 'represents' the subject for analysis. The struggle for meaning is necessarily an 'erotic exchange' for, as Freud says, 'we [know] none but sexual objects' (Freud 1963b, pp. 114,112).

There is a close relationship between art interpretation and analysis. The art interpreter, like the analyst, is empowered through his putative knowledge. The interpreter is aligned with Lacan's notion of the analyst as 'subject presumed to know' (Lacan 1981): 'powerfully superior to the work of art, [the art interpreter] would have the ability to divine and analyze that which the art work is not able to express' (Gallop 1988, p. 144). Both interpretive fields rely on the analyst/interpreter's assumption of a certain *authority* in his desire 'to understand, to possess' the object through knowledge. The authority of both analyst and interpreter is contingent upon this ostensible ability to identify with and decipher the analysand/artist. Through identification and transferential exchange, the analyst/interpreter produces himself in the position of knowledge.[3]

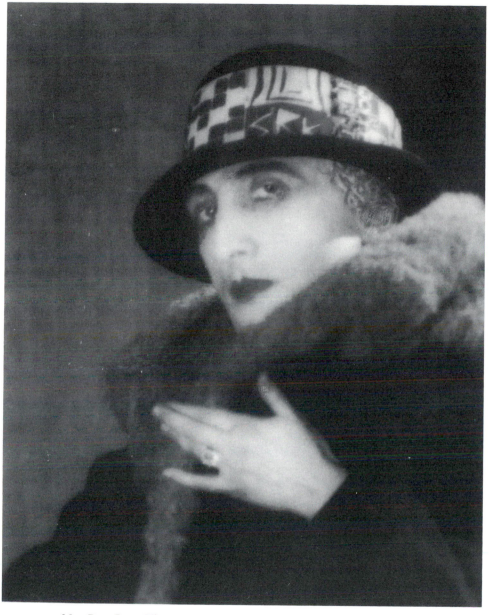

5 Man Ray, *Rrose Sélavy*, 1921

In art history, the relation of interpreter or 'analyst' to the authorially invested text is one of complex interdependencies and mutual seductions. As in the psycho-analytic paradigm, art-historical interpretation involves a constant shifting of positions – a continual remapping of power through relations of transference and counter-transference. Duchamp's masquerade opens out the radically dynamic nature of these relations of intersubjectivity in art-historical 'analysis'. By exchanging the role of masculine authorship for that of a 'woman' – a feminine subject of making *and* feminine object of scopophilic and interpretive desire – Duchamp's gesture exposes the contingency of analytic empowerment. He destabilises the identity of the authorial 'I' (of 'Duchamp') and challenges the seemingly inevitable masculine nature of modernist authorship.

I appropriate the Rrose Sélavy gesture here, then, to counteract the usual repression of the transferential nature of art-historical 'analysis', where the analyst attempts to 'master' the artist and his objects through interpretation, identifying with and desiring the artist as 'the subject supposed to know'. For Lacan, this understanding of the analyst as knowing is an integral part of the transferential, and thus analytical, process: 'As soon as the subject who is supposed to know exists somewhere ... there is transference' (Lacan 1981, p. 232). 'Knowledge' is projected onto an other out of the desire to identify oneself as knowing through transferential identification. The analyst thus carries an illusory power in relation to the desiring analysand; and, as Lacan's emphasis on transference suggests, the empowerments structuring the analytic relationship are reciprocal.

I submit my own desire actively into the equation to raise the issue of Duchamp's seductiveness as both the 'subject supposed to know' and the feminised object of desire. In doing so I recognise that, ironically, I too empower Duchamp and hence myself by claiming the Rrose Sélavy gesture as a means of refusing mastery. I acknowledge that 'I *desire* the author: I need his figure (which is neither his representation nor his projection) as he needs mine ... ' (Barthes 1975, p. 27). I make the impossible attempt to master him so I can submit myself to his mastery: we are in a reciprocal dialectic of analytical transference.

Freud's analysis of Judge Schreber, an analysis that took place impersonally via Schreber's autobiographical text, marks out this transferential relationship of interpretation as explicitly gendered and engendering, providing a model for examining the spectatorial relations the Rrose Sélavy images put into play. Schreber's autobiography is an intimate account of his neurosis, describing his desire to be a woman so that he could, in his own words, be 'fucked' by his analyst and then by the analyst's replacement, God (Freud 1963a, p. 129).

This case study is unusual in that Freud worked not from his personal professional contact with the patient, but from Schreber's autobiographical *Memoirs of a Neurotic* (1903) and from Schreber's doctors' reports. Thus, as in aesthetic interpretation, Freud knew his 'patient' only as a series of texts – and, at that,

primarily through a text where the patient himself described how his illness was manifested on/in his body as symptoms. As with the artist's public persona, with Schreber the patient becomes author of his own representation as subject: he interprets himself for interpretation.

While Schreber's self-production as feminine is aimed explicitly at constructing the analyst/viewer as holding a masculine position (able to 'fuck' him as receptive object), because of the ambivalence built into Schreber's gender identification, his desire to 'get well' and be a 'true' man, any confirmation of the analyst position as immutably masculine is precluded. Schreber's attempt to guarantee the possibility of his own wholeness miserably fails as he moves erratically from masculine to feminine sexual identifications. Schreber's self-production exposes, Lacan argues, the fact that the subject is in process, is articulated in the Other through language: 'the condition of the subject S ... is dependent on what is being unfolded in the Other O. What is being unfolded there is articulated like a discourse (the unconscious is the discourse of the Other).' As Schreber produces himself as woman, the 'veil of the narcissistic mirage' sustains an illusory subjectivity 'with its effects of seduction' and captures whatever is reflected in it (Lacan 1977, pp. 194–5).

Juliet Flower MacCannell explains that, according to Lacan, genitals are covered in our society such that '*Signifiers* carry the entire burden of gender identification – the sorting out of boys and girls: words, title, clothes, accoutrements. These are, barring the actual *seeing* of the genitals, the "essence" of the human "sexed" being' (MacCannell 1986, p. 50). The text of Schreber like the image and naming of Rrose marks out the ultimate slippage of the attributes of gender, the sexualised body as a surface on which is written 'subjectivity'. In psychoanalytical terms Rrose Sélavy can be read as a mapping out of this dynamic (sexuality *as* representation; the masquerade of femininity as an appropriable strategy for negotiating sexual differ-ence). Schreber's paranoiac projection of signifying wholeness onto his analyst/ other is ruptured by ambivalence as the two poles of identity (masculine/feminine, self/other) are riven then exchanged in a dialectic of transferential desire.

Furthermore, as for Duchamp, Schreber's masquerading as a woman takes place on two levels – in language (he enunciates himself as a woman) and through the appropriation of feminine clothing. The Schreber case is useful to suggest *metapho-rically* how the male subject's appropriation of the female masquerade confuses the gender-coded interpretive roles that situate (one could even say constitute) the art historian/analyst *vis-à-vis* the art object.[4] The dynamics of the male masquerade show an unhinging of the denial of lack – a denial that motivates the construction of the antipodal categories (masculine/feminine, subject/object) that are foun-dational to Western formations of subjectivity. By marking the unfixity of these poles Rrose Sélavy, like Schreber, illustrates the dialectic of desire that propels interpretation – the 'frightening erotic force of art, of the desire for and the resistance to meaning' (Gallop 1988, p. 144).

But in the Schreber scenario, of course, the male masquerade as woman produces

the interpreter as a *masculine* analyst, leaving the female interpreter in an ambiguous position, to say the least. As a woman and feminist I must negotiate the Rrose gesture through my own ambivalent, and highly invested, transferential exchange.

The Rrose Sélavy pictures mark lack doubly. They exploit what Eugénie Lemoine-Luccioni identifies as the photograph's castrating role. That is, first, by its nature as cropped from a continuous 'reality', the photograph pictures *lack* by acting out the cut ('*coupure*') that proves that 'man is holed whatever his sex'. Second, the photographs signify absence in that, by representing the man as woman, they illustrate how clothing works as *veiling* to fill 'the phallic function of covering that a penis, recognised right away as inferior to its task, can't fill' (Lemoine-Luccioni 1983, pp. 25, 26). The photographs expose visual determinations of identity as shifting and contingent, the visual as a realm in which *difference* is constructed tenuously on the basis of surface attributes that work through opposition to signify gender.

Rrose Sélavy acts out the seduction of the art object on several levels. She is an image of 'woman' constructed through highly sexualised period codes of desirable femininity drawn from a commercial vocabulary of gender signifiers: her clothing, her coy pose and feminine hand gestures, and the soft-focus effect of the pictures are conventions common to celebrity photographs and cosmetic advertisements of the period (Ring 1990). Because of these carefully choreographed attributes, Duchamp, like Schreber, illustrates the particular relation between seduction and the feminine. It has been argued convincingly that 'seduction . . . is exactly the set agreement of woman and image – representation to the full . . . the woman fixed, the same, the ideal body; the One-woman, that image, as a prime exchange value . . . ' (Heath 1981, pp. 186–7).

But Rrose Sélavy is also seductive because she is enunciated by the empowered, masculine author – she is legitimised as the indexical trace of Marcel produced in the world. Rrose makes explicit the particular seduction of the art object as validated by what Jacques Derrida would term the Duchampian 'trait' (a signature or idiomatic style by which art-historical discourse determines authorial identity) – signifying because she is spoken by, or because she speaks for, Duchamp (Derrida 1987).

Marcel as Rrose precipitates a reworking of the gender positions inscribed in the interpretive paradigms of art history. As a woman myself, trained in traditional art history, I identify with Rrose Sélavy *as* imaged object of viewing desire. But, through my desire to fix the Rrose Sélavy gesture as radical, I take up a masculine interpretive role offered by the photographs to empower myself as analyst (that is, to 'fuck' Rrose/Marcel). I thus identify both with Rrose Sélavy as image and feminine author and with her perpetrator, Duchamp – a dual identification that allows me to enact *my own* gender undecidability. Through interpretation, I identify with Duchamp and/as Rrose Sélavy, becoming (like Baudelaire's male

artist) the prostitute. Like Rrose, I both seduce and give in to seduction, confirm-
ing Tania Modleski's assertion that, 'in reading as in writing one is always fucked.
Never a virgin, but always a whore' (Modleski 1989, p. 10). Like Duchamp I am
implicated, through my interpretive production, in relations of desire.

These theorisations, and particularly the specifically *feminine* nature of the terms by
which erotic and interpretive vulnerability is marked, suggest that there is a danger
for the female art historian in assuming nonchalantly the 'phallus' of empowered
interpreter, and, for the Duchampian scholar, in accepting without question
Duchamp's advances. While I admire Duchamp's gesture as deconstructive, I also
recognise its presumptuousness – its overt plundering of the seductions of feminin-
ity for uncertain ends.

Recent work has examined the specific historical and psychic conditions of the
cross-dressing gesture, placing it within the early twentieth-century tendency
among male artists to attempt to mitigate and defuse an increasing feminisation and
commodification of culture through an appropriation and subsequent domination
of the feminine (Gilbert and Gubar 1989). Others have examined Duchamp's
masquerade specifically, defining it as a disruption of the early twentieth-century
tendency to align the realm of mass culture, with its frivolous and decorative
multiple objects, with the female consumer or with a certain notion of 'femininity'
as commodifiable (Ring 1990). In these latter terms, when viewed in the context of
period conventions for representing women, Rrose Sélavy becomes an explicit
parody, radically dislocating this historical alignment of femininity with the com-
modity. By appropriating feminine attributes *as* surface embellishments and
mimicking conventional constructions of femininity in an overtly fabricated image,
Duchamp exposes gender as artificial not natural.

I have already suggested that Rrose Sélavy's role as signing author further
complicates the alignment of woman with the passive objects of mass culture. By
appropriating authorship, traditionally a prerogative of the centred male subject,
and reallocating it in the province of the feminine, Rrose Sélavy's identity as
subject/author/enunciator further reconfigures socially constructed gender norms.
For Mary Kelly, the female artist brings out the fundamental contradiction that
exists for a woman under patriarchy: the woman is both object of the look (the
'feminine position') and, as author, subject of her own discourse (the 'masculine
position') (Kelly 1984, p. 5). Paralleling the duality of Schreber, Rrose parodies the
notion of woman as incapable of producing discourse, and exaggerates the arti-
ficiality of femininity by existing both as an authorial signature (implying a
masculine subject) and as an illustrated and recorded masquerade (the feminine
'subject').

Rrose Sélavy performs the transfer from masculine to feminine positions of
subject/object-ivity, signing the works – assuming authority – as a 'woman' in
disguise. She is manifested not as an androgyne but as an independent other to

Duchamp: a partner of sorts, a complete second ego. For example, she authorises Duchamp's film *Anémic Cinéma* with signature and indexical thumbprint in the last frames of the movie. And, in order to authenticate the *Monte Carlo Bond* of 1924, a share Duchamp offered for sale to provide part ownership in a gambling scheme, both Marcel and Rrose signed the image. In an advertisement for the shares published in *The Little Review* (1924–5), the signatures are valued economically as guaranteeing – through aesthetic authorship – the worth of what had initially presented itself as a business venture, confirming that art is always business and vice versa:

> they are signed twice by hand – Rrose Sélavy (a name by which Marcel is almost as well-known as by his regular name) appears as president of the company … [H]ere is a chance to invest in a perfect masterpiece. Marcel's signature alone is worth more than the 500 francs asked for the share.
>
> (Sanouillet and Peterson 1989, p. 185)[5]

The text of Rrose's authorising signature serves to legitimise the scrip along with that of Marcel. *Both* signings give the bond its full value but in fact, while 'M. Duchamp' signs the bond as one of numerous administrators (*'Un Administrateur'*), Rrose Sélavy is named as *the* 'President' (*'Le Président du Conseil d'Administration'*) and thus presumably has authority over Duchamp.

Marcel deliberately sets Rrose's identity apart from his own also by referring to her with a separate index, as in the following text from his *Rotative Demi-Sphère* ('Rotary Demisphere') of 1925: 'Rrose Sélavy et moi esquivons les eoechymoses des esquimaux aux mots exquis' (one possible translation of this would be, 'Rrose Sélavy and I dodge the bruises of the Eskimos with exquisite Language'). Through his assumption of the persona Rrose Sélavy, Duchamp produces the other through the self, the feminine through the masculine and vice versa. He exposes the contingency of the artist in history (as image and name) on his enunciated *other* (the spectator, historian, interpreter). While this other must maintain a position of opposition within the traditional system of interpretation by which art objects are defined and legitimised in Western aesthetics, here the opposition is broken down such that the (gendered) identity of the maker is shown as dependent on that of the viewer. The name and images of Rrose Sélavy suggest that identity itself is constituted by a series of shifting identifications, articulated in both linguistic and visual registers.

By using his feminine image *as* commercial logo in the 1921 *Belle-Haleine, Eau de Voilette* (this translates literally as 'Beautiful Breath, Veil Water'), Duchamp parodies the traditional equation of the mass culture with the feminine. In only one of its possible array of significations, the title subversively plays with the 'violet' of toilet water ('eau de violette'), inverting two vowels so it reads instead as 'voilette' (or 'little veil'). Interestingly, this exchange produces a direct association with *veiling*, the psychic process by which the female genitals are covered to mark them as 'absence' in relation to the fantasised 'presence' of the male anatomy.[6] Juliet Flower MacCannell describes this process as follows: 'we must drape the genitals with a phallic, Oedipal veil' (MacCannell 1986, p. 52). Veiling implies secrecy,

marking something *as* hidden; veiling itself becomes a symptom of the threat the female body provides to the phallic economy, which requires this veiling to mask the fact that, if the female body were not veiled, its *lack* of absence would be evident.

Drawing on codes of advertising practice, Duchamp, as 'woman', is imaged as/on the product label itself, promising a certain 'look' for the consumer; this promise is sealed with her signed initials 'RS' on the 'bottle'.[7] Furthermore, a reproduced image of the bottle was later used on the cover of Duchamp and Man Ray's *New York Dada* (1921). Thus a man masquerades as a woman, adopting the cultural signifiers of femininity as artifice, in order to 'sell' a commodity (the perfume) which itself is then produced as surface to sell another commodity, the magazine – in a seemingly endless regression of products through the reduction of all (gendered) identity to representation.

Along with Duchamp's other enunciative strategies reconfiguring difference – the ready-mades, the erotic objects, the interdependent sexualised zones of the *Large Glass*, and the violently sexed *Etant donnés*, the Rrose Sélavy gesture works to show that gender is a 'fantasy enacted by and through the corporeal styles that constitute bodily significations', an inscription of Law onto the body as surface effect (Butler 1990, p. 334). Like its corollary, the masculine 'parade' – where men adorn themselves with hypermasculine attributes – masquerade is a means of enacting gender, a strategy for covering up *for both genders* the fact of ultimate gender undecidability: 'if the penis were the phallus, men would have no need of feathers or ties or medals ... Display [*parade*], just like the masquerade, thus betrays a flaw: no one has the phallus' (Lemoine-Luccioni 1983, p. 124; on masquerade see Riviere 1986, Doane 1982). The phenomena of masquerade and *parade* illustrate the nonfixity of the relation of external signifiers of gender to biological sex. Through the visual and performative crossing of these social codes that represent and enunciate gender – the male producing himself as feminine, or the female producing herself as an enunciating subject, a (masculine) author – sexual difference is marked as a set of mutable terms.

Let me anticipate here discomfort with my alignment of Duchamp's larcenous gesture of taking on the figure and creative 'voice' of a woman as a 'deconstructive' strategy that undermines phallocentric modernist (or American postmodernist) claims for authorship. Perhaps, conversely, Rrose Sélavy is merely an example of the 'Tootsie Syndrome', 'in which the best woman is a man' (Schor 1988, p. 8). I have already admitted my own investment in actively reading Rrose Sélavy in such a way as to disrupt a notion of Duchamp as authorial 'father' of postmodernism. Let me once again emphasise the ambivalence built into Duchamp's gesture.

As Gayatri Spivak warns in her response to Jacques Derrida's appropriation of the feminine voice to deconstruct the patriarchal discursive fabric, feminists must continue to ask whether this metaphoric use of 'woman' is not yet another means of

producing the discourse of man (Spivak 1983). Does the 'feminised phallus' that Derrida (Duchamp) wields undo the phallocentric scenarios that structure subjectivity in the West? Or does it simply operate as a tool in a familiar phallocentric strategy of defining the masculine as empowered in relation to a devalued feminine other?

Luce Irigaray has vehemently critiqued the tendency of the masculine to appropriate and/or define the feminine as a means of figuring the latter as empty symbol or lack. She examines psychoanalysis itself as a playing out of this dynamic, in its perpetual and formative insistence on *vision* as the deciding factor of the subject's identity. Irigaray states: 'In our culture, the predominance of the look over smell, taste, touch, hearing has brought an impoverishment of bodily relations. It has contributed to disembodying sexuality. The moment the look dominates, the body loses in materiality ... The male sex becomes *the* sex because it is very visible, the erection is spectacular ... ' (Irigaray 1978, p. 161).

In Irigaray's terms, then, the masculine appropriation of the *surface attributes* of femininity in a parodic 'masquerade' could be read as a means of re-asserting the primacy of the visual as determinant of gender. By producing himself as woman (that is *as* woman *as* image), Duchamp is perhaps reinforcing 'the respective relationships between the gaze and sexual difference', illustrating patriarchal strategies of alleviating the threat of the feminine other to the phallic economy. These strategies are based on the premise that, if the male ego is to survive, 'some "mirror" is needed to reassure it and re-insure it of its value. Woman will be the foundation for this specular duplication, giving man back "his" image and repeating it as the "same"': the image of the woman is the assurance of the man (the 'anatomy' of her body should put up the security for reality) (Irigaray 1985b, pp. 47–8, 54, 55). What more thorough way to claim this assurance than by the male artist's disguising himself to produce a parodic image of woman?

However, I insist that Duchamp's disguise must be viewed in the context of his elaborate self-construction for an increasingly infatuated American public. Duchamp once said, 'My intention was always to get away from myself, though I knew perfectly well that I was using myself. Call it a little game between "I" and "me"' (Duchamp 1962, p. 83). While I do not have space here to elaborate extensively on Duchamp's multiple identities, this sentence suggests that Marcel's *masculine* identity – like Rrose's feminine one – was continually marked by him as thoroughly constructed. Duchamp's dual (sometimes multiple) authorial 'I's indicate the continual shifting of identities in his *œuvre* and in his self-presentation in the public arena, where he identifies not only with the imaged 'woman' but with various other aliases as well, including 'Dee', 'Totor', 'Slim Pickens', 'Marcel Douxami', 'R. Mutt' and 'George W. Welch', to name but a few. 'Marcel' itself becomes just another alias, marking identity itself as contingent and unfixed. Neither the 'Marcel Duchamp' of art history nor his feminine counterpart actually exists other than in language and as image.

This absence of the 'real' making subject is what the Rrose Sélavy gesture opens out. It disturbs the certainties of transferential identification that normally allow the 'analyst' to fix meaning, if momentarily, by repressing lack in her or his identification with the 'full' authorial 'I' held to be existing in the work. In fact, as Spivak concludes in her article, it may be especially fitting to perform the gesture of examining one's own identity with the name of a woman for this appropriation marks out the *double displacement* of woman from the psychoanalytical description of the social. Like the male, she is displaced by the necessity of her transference of affection outside the family; but unlike her counterpart, she is doubly displaced by the necessity of her transferring affection *away from* her own sex, even while the mother is her original object of desire as it is for the male. The woman is thus fundamentally alienated in the patriarchal structure from her identity as female and must masquerade as something other; an 'uncertain role-player', she is taken up by the male deconstructionist (here Derrida) precisely because she illustrates displacement, allowing him to theorise his alienation from his own subjectivity (Spivak 1983, p. 184).

Duchamp's gesture can be seen in this light as disrupting patriarchy's desire to fix firm boundaries defining sexual difference by appropriating the doubly displaced feminine. When viewed along with his other authorial strategies, Duchamp's adoption of femininity can be understood as exposing the instability of gender itself as a continually shifting, fundamentally unstable scaffolding of socially articulated roles and visually and psychically determined identities.

Marcel's assumption of the Rrose persona unmasks art history's desire for the spoken *other* to validate the object as art. His self-construction as feminine subject and object of making blurs the line of division that empowers the analyst *vis-à-vis* his object by parodying the sameness of this posited other – exposing the *masquerade* or *parade* involved in every act of (authorial) self-presentation. She is the 'me' with and against whom Duchamp plays his 'little game'. The non-oppositional Other, Rrose *is* Duchamp and yet, clearly, she is not. Rrose becomes author through signing and yet – like the author-function Duchamp, who is constructed in American art discourse as the 'generative patriarch' of postmodernism – she herself has been authored.

The forbidden gaze: women artists and the male nude in late nineteenth-century France[1]

TAMAR GARB

In 1883 Charles Aubert, author of mildly titillating, sometimes smutty pulp fiction, published a short story with a woman artist as its central character. This was one of thirteen tales of sex and seduction by the same author, entitled *Les nouvelles amoureuses*, which were to be collated into one volume in 1891 and illustrated by Jul. Hanriot, the engraver who had provided a frontispiece and engraving to accompany the 1883 publication (Plate 6).[2]

The story begins as a conversation between the narrator and a prim, self-righteous, older woman who expresses outrage at the request of the wealthy young Isabelle, the heroine of the tale, to see the body of a naked man. She, and the reader, are assured of the innocence of the heroine's motive by the revelation that she is an artist, incarcerated in her luxurious Parisian *hôtel* and closely guarded by her mother-in-law, while her husband, a captain, is away at sea. To pass away her time in her husband's absence she has turned to painting religious scenes and has been thrown into a state of utter confusion and distress by being offered a commission to paint a St Sebastian.

From the beginning, therefore, the story invokes a range of anxieties and potential threats. What is primarily articulated at this stage in the narrative, albeit in a disingenuous tone of concern, is the threat to the modesty of the woman artist, representative here of upper-middle-class femininity, who is caught in an impossible situation in which she is bound to be compromised. A classic staging of resistance (her piety, innocence and loneliness are stressed) and the inevitable path to seduction (beneath the veil is a rampant and unfulfilled desire) is set up. What subtends the linear narrative thrust, which in itself has only the richness of banality as its defence, are subtle and deeply rooted anxieties which invoke the power structures at stake in the scopic field as encoded in narrative and image in *fin-de-siècle* Paris.

One cannot underestimate the banal or the repetitive as historical material. For in the clichéd resolutions and cheap gratifications offered by much caricature and popular fiction, of which this story is a typical example, lies a form of cultural repression which renders anxieties manageable even as it veils and occludes them.

The potentially comic situation of the woman artist in close proximity to an

6 Jul. Hanriot, frontispiece of Book v, *Les nouvelles amoureuses*, 1883

undressed or semi-undressed male figure offered ample opportunity for smutty humour and caricature throughout the century. In an early nineteenth-century image a young woman with eyes modestly downcast is told to remember that she is painting history by her stern and rather lecherous-looking teacher as she is confronted by the full frontal nudity of the less-than-ideal male model (Plate 7). In a much later caricature from *Gil Blas* the predictable scene of seduction and deception is staged in the temporary absence of the older male chaperone/authority figure. Here the power of the woman artist to possess the world with her sight is contained by the reinscription of her as object of seduction, admired and exchanged, often unconsciously, between men. In keeping with contemporary narrative structures, the expectation which is set up in our story is that Isabelle, after some resistance, will be seduced.

The prohibition which gave Aubert's story its frisson was tenaciously defended by the art establishment during this period. But the disquiet that the prospect of a woman viewing the body of a naked man provoked is surely based on more than the protection of women's chastity required for their exchange and circulation in the interests of the bourgeois family. At any rate, even if this lies at the heart of the social order, it is not primarily the protection of women and their modesty which is at stake here but the preservation of masculinity as it is lived out in different social spheres. Discursively this may, of course, masquerade as beneficence towards women.

Aubert's story was published during a period of heated debate over women's involvement in art and their exclusion from state-funded Fine Art education. The Union des femmes peintres et sculpteurs, founded in 1881, campaigned vigorously for women's admission to the Ecole des Beaux-Arts and women journalists and artists poured scorn on what they saw as a reactionary and exclusive art establishment.[3] There were those who saw no sense in the case which apparently sought to protect women by their exclusion from the life-class whilst they were free to visit the art galleries of the world and behold, unscathed, the painted image of the male nude.[4] The debates raged in the Ecole, in the press and in the Chamber of Deputies itself. Many reasons were given for women's exclusion from the Ecole, including their ostensible innate inability to work in the higher genres because of their limited powers of abstraction. Other reasons cited were the overcrowding of the artistic profession, the expense that the provision of Fine Art education for women would entail, the need for women to contribute to the threatened industries of luxury goods, decorative arts and traditional light crafts, and even the threat of depopulation which the advent of the professional woman would, it was believed, only exacerbate, if not by her refusal to have children then by the deterioration of her reproductive capacities which would inevitably result from excessive mental stimulation.[5]

But the problem to which many commentators returned, and on which the teachers and administrators of the Ecole des Beaux-Arts and even the deputies in

the Chamber were to dwell repeatedly, was the issue of the life-class. Why was the prospect of mixed life-classes such a threat during this period and how could the anxieties they provoked be resolved? The ready-made solution of fiction, that of seduction in the interests of salacious humour, mild sexual excitation or the appeasement of anxiety, available to the predictable Aubert were, of course, not on offer as strategies of containment in the realm of public debate, however much their concerns occupied the same dialogical field.

The devices mobilised by Aubert to assure the minimum disruption to the phallic order in the face of threat are not quite as simple as one might expect. The focus of anxiety in the story centres on the problematics of looking and sight, for it is through these that power is encoded or subverted. It is through the usurping of a culturally forbidden look that the gaze, which polices looking, is momentarily threatened and rendered vulnerable. But it is not only the woman's look that is potentially dangerous. In the man's beholding of the *woman who looks* lies a much deeper threat, for it is through the unveiling of the threat of castration, linked here, as in the case of the Medusa's head, 'to the sight of something', to quote Freud, that

7 'Songez que vous peignez l'histoire', from the series *Pièces sur les arts*

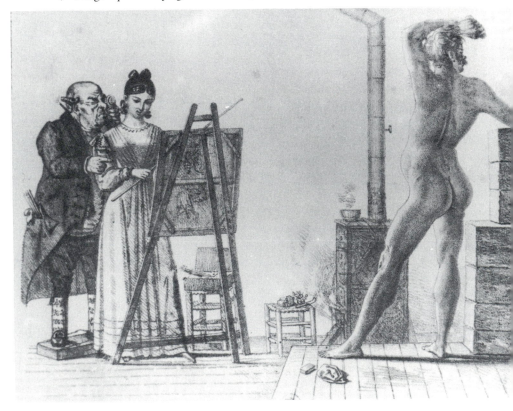

masculinity is potentially at risk. The effect of Medusa's power, her 'evil look', is that it not only kills or devours but blinds as well (Freud 1955b).[6]

Isabelle's problem when first mooted by Aubert, is framed as a problem of sight: 'elle desirait voir un jeune homme' (Aubert 1883, p. 10). The obstacles facing her seemed insurmountable. The house in which she was confined was guarded by her mother-in-law and no young man would have been allowed to enter her private quarters although she had had no problem in having women models to sit for her. More difficult even than such practical problems were the fears and resistances which she built up in the processes of thinking about the prospect of beholding a naked man. Would she have the courage to look at the model, would she dare to confront his body with her eye? Would he not triumph at her discomfort and delight in her difficulties and how would she cope with her own inadmissable desires which must be repressed at all costs? These are the thoughts, according to our narrator, which go through the young woman's mind but instead of dissuading her from her course make her obsessed by it. At this point Aubert introduces an intermediary male figure, a corrupt old picture seller from Montmartre who supplies Isabelle with equipment and models. He is brought in to resolve the conflict and promises, at a considerable cost, to smuggle a male model into her quarters for her. He is described as 'a superb young man, the ideal of beauty and elegance, gentle and well brought up' (Aubert 1883, p. 21). At first Isabelle resists resolutely but she is persuaded to accept him by the vital piece of information that, though possessed of magnificent eyes, the young man has been blind from birth. This fills her with comfort and relief: 'Elle pourrait voir sans être vue' (Aubert 1883, p. 22). This is perhaps the moment to reveal that the title of the story is, appropriately, *L'aveugle*.

Momentarily we are offered a complete inversion of traditional power relations in the visual field: a woman in possession of the gaze, a beautiful male body providing the unthreatening spectacle. But this fantasy, at least on behalf of the reader, is short lived for no sooner are we offered this vision of a world turned upside down than we are assured that patriarchy is still intact and an elaborate trick is about to be played on the vulnerable and unknowing Isabelle. The model turns out, of course, to be a starving artist called Charles Morose, in the debt of our dealer/intermediary, who is promised to be released from his debts if he agrees to pretend to be blind and be smuggled in a crate, for a period of thirty days, into the studio of the beautiful woman who is too modest to dare view a model who can see her.

It is this symbolic inversion of the natural order which the story must both play out and undermine. The tempering of Isabelle's power comes early on in this potentially dangerous scenario and is achieved by the usual means. Overcome by the young man's beauty as he strips down in order to put on his drapery, Isabelle faints and is caught in his arms, coming to with her head on his naked breast.

From very early on, therefore, the woman's power as an artist, as encoded in the

engraving at the beginning of the 1883 edition, is contained by her weakness as a woman. The model's vulnerability, his nakedness, the 'effeminate' pose which he is forced to adopt and his incapacitating blindness, is assuaged by the power beneath his masquerade which even the innocent Isabelle suspects but never admits. At the same time, however, the relationship of looks in an engraving like that in Plate 6 points to a source of anxiety which is never quite articulated in this context but surfaces, as we shall see, elsewhere. Whilst the play-acting of the model requires the adoption of the ethereal, abstracted expression of the St Sebastian, traditionally constructed in representation as a feminised male, the attention of the woman artist is firmly fixated on his covered genitals.

Which are the forbidden gazes at stake here? On the one hand the story must contain and police female sexuality, reinscribe it as lack, and subordinate it to male desire if order is to be maintained. The inevitable seduction, Isabelle's transformation from artist into amorous woman, will assure this and invest in masculinity the power which is its due. The seduction scene itself is ultimately dependent upon the reinscription of Isabelle as the object of the look. At the beginning of the story, the artist is described as being dressed formally, in black silk and firmly corseted in keeping with the laws of etiquette. Gradually, however, the heat of the studio and the knowledge that her model is blind allow her to discard the corset and to dress less formally.

This makes for her easy narrative objectification as we are treated to long descriptions of the gradual slipping of her gown off her shoulder and the slow but climactic revelation of her nipple, while she, unawares, is absorbed in her work. All that she notices is a movement in the model's drapery, the origins of which she does not quite understand, but which unsettles her. Her power is further undermined by the reinscription of the model as artist. In her absence he corrects her drawing and improves the painting so that it turns out by the end to be the best work she has ever done. The model/artist transcends his objectification by becoming master of his own image. The man transcends his humiliation by having an erection.

But the frightening spectacle of a woman who usurps power, whilst able to be diffused effectively in fiction through the fantasy of seduction, is not quite so easily contained within the discourses of art education and administration. One of the ways in which fear in men is managed, according to Freud, is via the erection: 'it offers consolation to the spectator: he is still in possession of a penis, and the stiffening reassures him of the fact'. Or put another way: 'To display the penis (or any of its surrogates) is to say: "I am not afraid of you. I defy you. I have a penis"' (Freud 1955b, pp. 273–4). The erection therefore can function as a defence in a situation where power is usurped or horror is invoked. The objectification of the male model and the empowerment of the woman artist is discursively constructed as one such situation.

The entry of women into the life-class at the Ecole des Beaux-Arts would, it was felt, lead to a major disruption. As Gérôme stated in 1890 (p. 318), it was impossible

to admit women and men into the same classes as work would suffer. Proof of this was the fact that when the art students had, approximately once a month, to work from a female model, they worked much less well. The very presence of women, even in this subordinate role, was disruptive to the high seriousness of an all-male community and its commitment to the transcendent qualities of art. But the appearance of a female art student, an equal, was potentially much more threatening than the presence of working-class women used as models in relation to whom the young male art students could unite in predictable pranks and sexual innuendos. The form of male bonding perceived to be under threat by women's entry to the Ecole is encoded in contemporary photographs of the ateliers of the Ecole. In Plate 8, for example, the young art students pose in serried ranks, anonymous in their masculine costume, together with their teacher who kneels in the front row. Behind them on the walls are their nude studies, draped or naked. In this representation, the life studies can be read as the referent to the art which ostensibly draws these men together. It was this apparent harmony which the entry of women threatened. Pedagogical principles and lofty aspirations required, therefore, that in the Ecole itself and the associated School at Rome, women be almost entirely excluded.

8 Atelier des Beaux-Arts, *c.*1885, photograph, from the series *Pièces sur les arts*

Amongst the traditionalists, what needed to be preserved was the capacity of art, conceived in this context in terms of the threatened academic doctrine of idealism to transcend the physical. What was needed to perform this transformation was serious training, developed powers of intellectual abstraction and an ability to see beyond immediate visceral experience.[7] There was serious doubt as to whether women were capable of this.[8] In their presence art risked being reduced while the model's physicality would be emphasised. In a contemporary caricature, the absurd underpants, portly figure and Venus-like pose of the model are juxtaposed with the artists, represented as shrewish wife and skinny daughter, who are rendered as incapable of transforming nature into art as the model is of evoking the great hero Achilles (Plate 9).

Supporters of women's entry to the Ecole like Jules Antoine of *L'Art et Critique* argued that the situation of the life-class 'gives a sort of impersonality to the model which becomes no more than an object to be drawn' (Antoine 1890, p. 344). In their view, the sex of the artist should not affect this. Art transformed the naked into the nude and thereby occluded its sexual connotations. It came rather to signify the pure, the ideal.

9 'Allons Darancourt, gros indécent, songez que vous n'êtes plus ici aux bains, vous representez Achille, et vous pozes devant votre épouse et Clara votre fille', from the series *Pièces sur les arts*

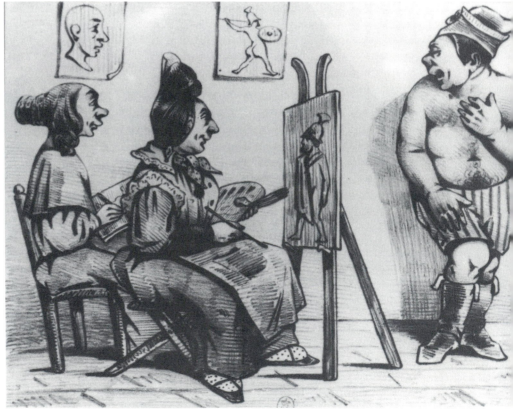

But others were not so easily reassured. They felt that for this basic but fragile tenet of academic doctrine to be sustained, the person who would need protecting was not the woman artist and her modesty, but the male model. The writer for the *Moniteur des Arts* explained the resistance to women's entry as stemming from 'a concern for the male models, who in front of the pretty little faces, blonde hair and laughing eyes of the young women artists, would not be able to conserve their "sang froid"' (Sainville 1890, p. 325). It was the gaze of the model which had to be forbidden. For if the model was to become aroused, who would testify to the transcendence of the nude over the naked? One deputy speaking in the Chamber in 1893 even alluded to an allegedly American practice of making the male model wear a mask as a way out of a tricky situation.[9]

In this context the memoirs of Virginie Demont-Breton, one of the chief campaigners for the entry of women into the Ecole, are instructive. Reporting on a meeting of the sub-commission set up at the Ecole itself in 1890 to debate the issue, the conflicting claims of the transcendent powers of Art on the one hand, and the assertion of male virility on the other, come into open conflict. Mme Demont-Breton recounts that while she was addressing the meeting the architect Charles Garnier suddenly cried out that it was absolutely impossible to put men and women under the same roof at all: 'this would put the fire near to the powder . . . and would produce an explosion in which art would be completely annihilated'. He was quickly attacked by the sculptor Guillaume who allegedly exclaimed: 'You don't know what you are saying. When an artist works, does he think about anything else but the study in which he is passionately engaged . . . ? In the school we envisage, there will be no men and women, but artists animated by a noble and pure spirit.' Garnier was not satisfied with this vision and retorted: 'It is possible that you, O Great Sculptor, you are made of marble and wood like your statues, but if I had seen a pretty little feminine face next to my easel at twenty years, to hell with my drawing. O! Guillaume. You are not a man!' To which Guillaume is said to have exclaimed: 'O! Garnier. You are not an artist!' (Demont-Breton 1926, pp. 198–9).

It is the presence of women who apparently bring this otherwise harmonious conjunction of art and masculinity into conflict. To assuage castration anxiety, male virility must assert itself. But in so doing the edifice of the already waning academic establishment and the repression on which its pedagogy is founded is at risk. Masculinity needs the erection as reassurance. Art needs an occlusion/diminution of the penis if the phallic order/ideal is to remain intact. When women were finally admitted into the Ecole in 1897, after having been hounded out of the school by some of their future colleagues with cries of 'Down with women', the ateliers still remained closed to them, and life drawing and anatomy lessons were segregated, with male models neatly tucked into their much maligned underpants.[10]

It is only in the fantasy world of fiction that resolution is potentially absolute. Scolded by Isabelle for the strange movement in his drapery, Charles is armed with one of her absent husband's arrows and told to keep still. The humiliation is too

much for him. In a dramatic gesture he wounds himself in the chest with the arrow. Finally castrated, the model appears about to become the martyr he has been imitating. But his masculinity is restored by a contrite Isabelle who prostrates herself before him and declares her love. The charade is over. The danger is gone. All that is needed now is the annihilation of the absent sea-captain. In a gruesome narrative twist which invokes the implicit violences involved in the maintenance of social order, he is conveniently devoured by a band of savage negresses. The story is ultimately haunted and framed therefore by the excessive fantasy of an untamed voracious femininity, out there on the margins of civilisation, but one which threatens to invade its closely policed boundaries. At the moment of the tale's resolution, this grotesque disposal of the final obstacle, the legitimate husband, reveals the fear of feminine power that the story has done everything to contain but which seeps out, in a displaced form, at its edges.

4 Out of the body: Mark Rothko's paintings

JAMES E. B. BRESLIN

'Out of the body' can mean to *go* out of the body, as in 'I am having an out-of-the-body experience'; or 'out of the body' can mean to *come* out of the body, as in 'the blood flowed out of his body'. Mark Rothko's paintings are out of the body in *both* senses.

> In my paintings I do not express myself. I paint my not-self. Mark Rothko[1]

A classic 1950 photograph of Jackson Pollock (Plate 10) shows him working on a large area of canvas that he has rolled out from a bolt onto the floor of the East Hampton barn he had converted into a studio. Dressed in a black tee shirt, black jeans and black shoes, his right leg twisted, his tense body leaning forward, with his left foot *on* the canvas, Pollock holds a can of black paint in his left hand, 'applying' it by rapidly swinging his brush about two feet above the canvas.

A classic photograph of Mark Rothko (Plate 11) shows him sitting in a green wooden deck chair, his back to the camera, cigarette in hand, contemplating one of his paintings in an East Hampton garage he had temporarily converted into a studio. Both artists are presented as immersed in their work, as if we have been granted a privileged look into the privacy of their studios. Depicted in one of a series of photographs that, reproduced in *Life* magazine, helped to publicise his innovative painting methods, Pollock displays a figure of intense, 'masculine' energy and dynamism. Very secretive about his working procedures, Mark Rothko did not like to have people watch, much less photograph, him while painting. Yet even in his more relaxed attitude, he too, is at work – weighing, feeling, measuring, *judging* his painting.

The difference is that Pollock's body dominates the picture, his lithe black form twisted and bent forward, straining towards and actually stepping onto the white canvas he has marked with blots and swirling lines of black paint. Rothko, casually dressed in slacks and a striped shirt, has finished painting, washed up, changed his clothes, taken a seat, lit a cigarette, and begun to *look*. Placed in the centre foreground with his back to us, his body mostly hidden by the chair, Rothko has drawn back from his painting in order to take it all in – unlike Pollock, who is too far inside his painting to see all of it. Pollock *acts*; Rothko *meditates*.

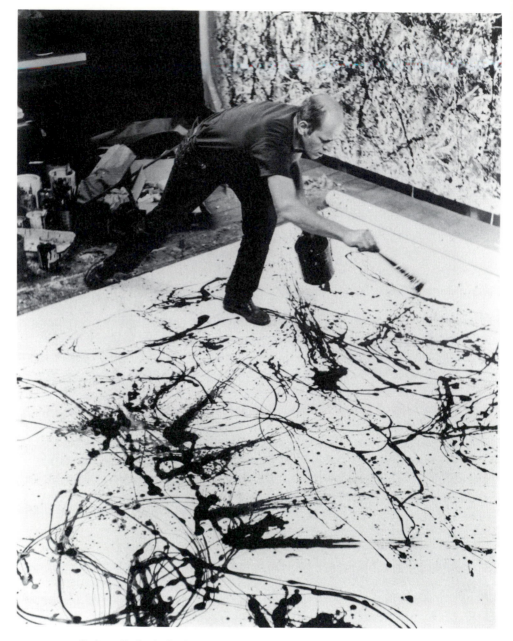

10 Jackson Pollock, Springs, New York, 1950

In reality, both artists alternated rapid application of paint with longer and more deliberate periods of rumination and study. The two photographs, taken by the same professional photographer, Hans Namuth, have been constructed to reflect, and to promote, the conventional split in Abstract Expressionism between 'action' painters and 'colour-field' painters. Yet, by dramatising a real difference, these photographs also suggest a common problem the two artists approached from opposite directions: the relation of the painter's body to the canvas in organic abstraction.

Jackson Pollock struggles for bodily presence, something that prompted him, in *Number 1*, 1948 to dip his hands into a can of paint and then to impress several blackish-red handprints across the top and down the left side of the canvas. Ironically, Pollock's desire to make painting record his physical movements also distanced him from the canvas, so that he no longer *touched* it with his brush, but poured or tossed the paint onto it. In *Number 1*, 1948, he momentarily discarded brush or stick, took his paint in hand to apply it to the canvas. Yet Pollock's 'immediacy', literally pressing part of his body onto the canvas, repeated the imprints of hands he had long before seen on the walls of Native American cliff dwellings in Arizona (Solomon 1987, pp. 32–3). So Pollock's 'spontaneous' gesture was historical, appropriating the actions of artists from another, earlier culture. When Pollock was four, his right index finger had been severed just above the last knuckle by an axe in a farmyard accident; in *Number 1*, 1948, Pollock painted in the missing section of his finger (Solomon 1987, p. 188). It's called 'filling a lack' – or altering reality to suit your own ideas of bodily integrity. Moreover, the indistinctness of several of these handprints exposes Pollock's body as a *fading* image whose mark must be made again and again in a desperate and even 'bloody' struggle for presence.

It's impossible to imagine Mark Rothko placing his handprint on one of his paintings; he once said that paint should be 'breathed' onto the canvas (personal interview with Regina Bogat in 1986), as if oil paint were spirit – or as if his thin glazes could be applied without the contaminating mediation, the *labour*, of the body. Yet, Rothko's empty canvases do not exactly struggle for bodily absence – they are too sensuous for that; they seek, rather, to transcend that *specific*, defined, bounded physical existence with which he felt ill at ease.

Tall, large-boned, fleshy, balding, with thick-lensed glasses (he was myopic) and big-boned hands with thick fingers, Rothko was notoriously clumsy. In the words of one sister-in-law, 'if Mark walked down the hall, he bumped into both walls'.[2] Rothko was physically restless so that, according to one friend, at dinner 'he would get up and wander between courses, cigarette in hand' (Ashton 1983, p. 2). Rothko was a hypochondriac, often imagining illnesses for himself; and he was accident prone, often inflicting injuries on himself. He ate with 'ravenous' appetite (Seldes 1978; p. 12); he was a chain smoker and, by the late 1950s, an alcoholic.

At the age of ten, Rothko had migrated with his family from Dvinsk, Russia, to

Portland, Oregon. When he later spoke of Dvinsk, he usually recalled anti-Semitism; he claimed that a scar on his nose came from being struck by the whip of a Cossack when he was not much more than an infant (personal interview with Herbert Ferber in 1987, p. 5). Had he remained in Dvinsk, Rothko would probably have been killed in the First World War, when the Czar's army was stationed right along the street on which Rothko had lived, facing the Kaiser's army across the Dvina River – or Rothko would have been killed in the Second World War, during which all but a few of the town's Jewish population were murdered by the Nazis.[3] Nevertheless, Rothko insisted that he 'never was able to forgive [his] transplantation to a land where he never felt entirely at home' (Fischer 1970, p. 17). Rothko resented his forced migration, his cultural dislocation. Yet, whether in Dvinsk, Portland or New York, Rothko felt constrained and restless, as if to be embodied at all were to be dislocated.

Heavy, awkward and embarrassing, vulnerable to hurt, empty, restless and desiring, Rothko's body felt like a fatality, both him and not him, something he did not invent and whose movements and appetites he often could not control. It was as if a commanding, luminous, yet delicate spirit had been placed – or *mis*-placed –

11 Mark Rothko, East Hampton, New York, 1964

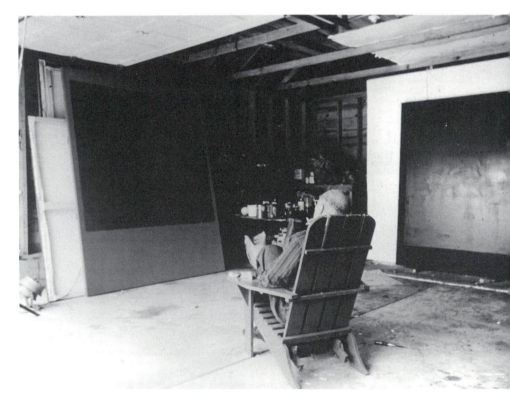

within a bulky, clumsy and unmanageable body. So Rothko painted to disperse physical boundaries and transcend the flesh. In the Namuth photograph (Plate 11), at rest in a deck chair, physically removed from his painting but absorbed by it, Rothko contemplates a large, black rectangular void placed on a bright red ground – one version of his 'not-self'.

> Rothko said he wanted a presence, so when you turned your back to the painting, you would feel that presence the way you feel the sun on your back.[4]

In Mark Rothko's paintings, the body figures as the return of the repressed: abstraction no more offered him a way to get his body *out* of painting than it offered Pollock a way to get his *in*. Rothko himself, in fact, claimed, 'my art is not "abstract"; it lives and breathes',[5] just as in his 1947 essay, 'The Romantics were Prompted', he identified the shapes in his pictures as 'organisms with volition and a passion for self-assertion' (*Mark Rothko*, 1987, p. 84). Rothko anthropomorphised his paintings, imagining them as living presences – as powerful, warm and life-sustaining as the sun.

'It was with the utmost reluctance that I found the figure could not serve my purposes … But a time came when none of us could use the figure without mutilating it' (Rothko 1958, p. 86). Actually, Rothko had never really been able to represent the human form without violating it. In the 1930s he subjected the body to Expressionist distortions. Often, bulky figures were squeezed into cramped, low-ceilinged interiors or attenuated urban travellers were trapped within the stony rectilinear architecture of a subway platform. In his 'myth' paintings of the early 1940s Rothko had invented grotesque hybrids, half-human, half-animal, which he then severed into rectangular compartments.

As a young man, Rothko had studied acting, trying to learn to express emotion *by means of* the body. When he arrived at his classic format in 1949 (Plate 12), Rothko, hypothesising an inner spirit not incarnated in his large, awkward, restless *actual* body, began to make paintings which no longer represented the body because they were themselves organisms, idealised bodies, not 'given' but of his own creation. 'I think of my pictures as dramas', he wrote; 'the shapes in the picture are the performers. They have been created from a need for a group of actors who are able to move dramatically without embarrassment and execute gestures without shame' (Rothko 1947/8, p. 83). On these vacant stages his spirit could be displayed 'without shame'. Creating diffused, fluctuating fields of intense, luminous colour, gently contained within two or three delicately edged rectangles, Rothko now painted being before it had been split into body and spirit, before it had been firmly shaped, and separated, into a specific, vulnerable and bounded 'self'. Closely identified with these works, Rothko had trouble letting them go, seeking to control their lighting, their hanging and even who purchased them.

Mark Rothko's mother, Kate Rothkowitz, died in Portland, Oregon in October

1948.[6] 'The death of his mother is the only personal thing he ever talked to me about at length', says Robert Motherwell, adding that Rothko was then 'clinically depressed'. Some time during that winter of 1948 Rothko wrote to Clyfford Still of suffering a 'break-down' (*Clyfford Still* 1976, p. 113), and Rothko later told at least a couple of his friends that as a result of his mother's death, he had stopped painting for a year and wrote an autobiographical novel.[7] There's no evidence he either stopped painting or started writing, but Rothko's statement sounds like a characteristically hyperbolic and theatrical way of conveying his experience of loss. It was in the year following his mother's death that Rothko arrived at his unique format.

By rejecting the modernist notion of the work of art as an autonomous, self-enclosed object and focusing on the interaction between work and viewer, Rothko struggled in his new paintings to recover not a lost object but a lost relation. An illusionistic painting, dividing space, say, into human figure/natural ground, assumes a world of detached, bounded and separate bodies, a world that Rothko could only experience as one of paralysing solitude: 'for me the great achievements of the centuries in which the artist accepted the probable and the familiar as his subjects were the pictures of the single human figure – alone in a moment of utter immobility' (Rothko 1947/8, p. 84).

Rothko thus renounced line, which marks boundaries, defines discrete objects existing separately in space and requires a kind of aggressive looking to fix objects *as* separate. As a boy, Rothko had been subjected, by his father, to a rigorous Jewish orthodox education, against which he finally rebelled.[8] By painting at all, Rothko was transgressing the second commandment's injunction against 'graven images'.[9] By renouncing line in paintings which he often insisted were sacred, he was deferring to the second commandment. Rothko defied, and obeyed, Jewish paternal law – as if, rebellions and migrations aside, his paintings dramatised a struggle with his Jewish origins.

To stress that his works were not 'images' of something absent, he referred to them as 'presences' – again, as if his apparently empty works were alive and full. He also refused to place these 'presences' in frames, calling frames 'coffins' because they sharply divide inside from outside and mark the painting as a bounded, self-contained object ('Stand Up, Close', *Newsweek* 5(23), 1961, p. 60). Similarly, the rectangles within Rothko's paintings are not hard-edged and geometrical, but blurred and equivocal. He wanted neither to impose fixed boundaries nor to dissolve them altogether, but to create a gently contained, mobile space – a breathing space.

Autonomy for Rothko involved loss, isolation, feelings of emptiness. Working in his studio, Rothko liked to listen to music, ideally Mozart. 'He wanted that music', says his friend, Stanley Kunitz, 'to saturate the room, to diffuse it in the same way that his paintings were diffused through a room'.[10] Painting could make an empty room – or empty self – feel full. Rothko painted loss, he painted lack, he painted

nothing – as a luminous, sensuous and diffused space large and mobile enough to surround and 'saturate' a viewer. His works thus travel back psychologically to give us subjectivity in the *process* of forming, prior to language, prior to the 'fall' into hard boundaries. Going several steps further back than he'd been willing to go with the emergent figures of his oils and watercolours of the mid-1940s, Rothko was now painting his 'not-yet-me'.

Rothko does not represent the literal mother, as he did in one of his earliest paintings; nor does he mourn her specific loss.[11] Instead, abstracting from specific persons, objects and events, he produces a kind of painting that will, through its interactions with a viewer, recreate the reciprocities, and tensions, of an infant's earliest relation with a nurturing parent. His weightless, softly edged rectangles lift off the canvas and advance towards the viewer, activating the literal space between the painting and the viewer, filling it with a large, commanding and seductive 'presence' which – enveloping and comforting, threatening to engulf and discomforting – recreates the tensions, the play between separation and absorption, of early psychic life. Rothko's 'presences' evoke the *maternal* body. His capacity to draw on such deep psychic experience provides his abstract and vacant works with the core of human 'content' (or 'subject') that he always insisted they contained.

> Paintings are skins that are shed and hung on a wall. Mark Rothko[12]

Rothko called his works living 'organisms', treating them with the same combination of solicitude and carelessness with which he treated his own body. He also called his paintings '"portraits" of states of the soul' (Ashton 1983, p. 167), and it does feel as though they offer us an intimate look inside the artist, as if opening a window on his inner spirit. Yet these windows seem to obscure as much as they reveal, and the Rothko who spoke of his works as spiritual self-portraits or as physical presences also spoke of them as 'façades', a word which suggests an imposing and *artificial* exterior behind which something remains concealed. His conception of his paintings as 'dramas', with his shapes as the 'performers', similarly suggests that his work presents a theatricalised self.

Socially, Rothko could be warm and gregarious – or aloof, wary and remote. He was a secretive person who kept large areas of his life and himself hidden in a way that both aroused and thwarted curiosity. In conversation, he liked to debate, he liked to deliver oracular pronouncements, he liked to stretch out on a couch and ponder out loud; but he was not intimate. He had clusters of friends who never knew of each other's existence; he was very secretive about his innovative working methods; he refused to be watched while painting; and once he could afford to, he worked in studios outside his home, where he said he felt under 'surveillance'.[13]

A painting like *Number 10*, 1950 (Plate 12) persistently implies the presence of something behind the surface, whether an earlier layer of paint, a dimly perceived shape or a hidden source of light. 'There are some artists who want to tell all', Rothko said, 'but I feel it is more shrewd to tell little. My paintings are sometimes

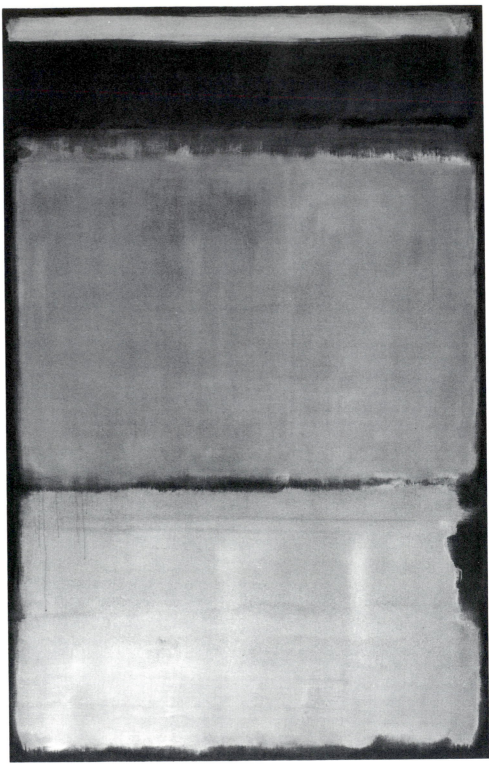

12 Mark Rothko, *Number 10*, 1950

described as façades, and, indeed, they are façades' (Rothko 1958, p. 87) – as if his paintings did not fully incarnate his spirit any more than his body did. The faces in Rothko's paintings of the 1930s had often resembled dramatic masks, just as his urban scenes of that period often resembled stage sets. Now, in Elaine de Kooning's acute formulation, 'the painting is a hiding place' (de Kooning 1958, p. 175), itself a mask, a window with its gauzy curtains or thin yellow shade drawn. Rothko holds back, tells little, remains outside, and in this sense too paints his 'not-self'. Bits of his flesh sacrificed to restore an irrecoverable unity, Rothko's 'organisms' are constructions, fabrications, substitutions for a body that must always remain outside, always generating further substitutions, new paintings in which the body asserts a dispersed, elusive and absent presence.

Bodies of masculinity

Changing definitions of masculinity and how such shifts may be represented and reinforced are the themes of Michael Hatt's and Patricia Berman's essays. Hatt's concerns are with the United States of America in the 1880s and 1890s, Berman's with Scandinavia in the early years of this century. Both examine in detail a single painting which is central to their enquiries: for Hatt, this is Thomas Eakins' *Salutat* of 1898, for Berman, Edvard Munch's *Bathing Men* of 1907. Both essays consider how representations of the male body, nude or semi-nude, carried a range of meanings which exemplify and reinforce ideas about masculinity, and which simultaneously negotiate a position in relation to artistic conventions of the idealised male nude of classicism and neo-classicism. In both the paintings examined, this relationship is crucial: in order for the images to suggest changing concepts of masculinity, they must both ostensibly relate to the idealised male nude and be significantly different from it. Berman points out in this context that in Munch's painting, the poses of the figures recall antique archetypes. However, the sun-tanned heads, hands and arms contrast with the whiteness of torsos and legs. Thus these figures are located not in some timeless space but in an identifiable contemporary moment.

For Hatt, the crucial issue to be explored concerns the shifts from the puritan ideal of masculinity – distinguished by piety, responsibility and purity – to one in which masculinity is directly connected to the male body, literally embodied. He links this change to shifts both in what constituted manliness and in what defined the American, from the East Coast gentleman to the Western pioneer. While the idea of masculinity can never be static, and must always represent a number of different views competing and conflicting with each other, Hatt argues that by the end of the century some version of the pioneer-settler was dominant in conceptions of masculinity. Above all, what was central in debates about masculinity was the increasing emphasis on a strong, muscular body, rather than on moral characteristics. Although Berman's discussion of Scandinavian painting takes place within different parameters, a similar view of masculinity is

posited. Here, the strong male body replaces the female body as the embodiment of nature, and in its athleticism is seen to convey the essential Scandinavia. Both essays share, therefore, a concern in exploring the nationalist interests at stake in a shift towards a concept of masculinity which is clearly identified with strength and muscularity.

Both authors locate their chosen exemplars firmly within a social and historical context. There is considerable interest in, and information about, the circumstances of production and the responses or lack of response which the works evoked at the time of their first exhibition. Both are concerned with a particular sporting ethos which enabled the exploration of a masculinity linked to a powerfully muscled nude or semi-nude body. In Hatt's essay, this is boxing, a sport as contested as the definition of masculinity itself. As he points out, boxing was illegal at the time, and opinions varied between those who saw it as the manly art of self-defence, and those who saw it as barbaric. It was, of course, a male sport, and the audience Eakins represents are also all male. Hatt employs the categories 'heterosocial' and 'homosocial' to examine both the homosocial and homerotic aspects of the spectacle of boxing itself, and the effect such a view of an all-male space had within the heterosocial arena of the art exhibition.

Munch's painting raises similar issues of homosocial and heterosocial arenas. The issue of the male nude was contested in Scandinavian and German painting in the years between 1907 and 1912, and Berman points out that what was at stake was not the male nude *per se*, but the 'manly' male nude, divested of the rhetorical distancing devices of classicism. The male nude was accorded a moral purpose, one of cleansing and purification, stripped of alien or parasitic elements. A sport – albeit a less contested one than boxing – is also at stake here. Swimming was promoted in the northern Europe of the 1880s and 1890s as a form of public health and hygiene, and as a cure for nervous or psychological disorders. In this it was linked to contemporary philosophical preoccupations, particularly the interpretation of Nietzsche, and to shifting definitions of masculinity.

The issue of the gaze is paramount in both essays. Most of the literature on the gaze assumes the woman is the object of the gaze, man the bearer of the look, or develops this to consider the implications when woman is the bearer of the look. But in both the paintings under consideration here, it is the male body which is the object of the gaze. The complexity of a represented male body – a body that may simultaneously convey 'masculine' heroism and 'female' vulnerability – is explored by Hatt through his interrogation of the assumed gender of the powerful and controlling gaze generated by this sporting event.

The marginalisation of a female response is also strikingly evident in

Munch's painting, and in other images of the male nude linked by Berman to the resurgence of Scandinavian nationalism and the cult of the (male) body. Berman raises the question of the viewers' position in relation to the sexualised poses and confrontational gazes of the figures represented, but she is concerned primarily with contemporary reactions to this work and to related paintings in which the homoerotic element was recognised, rather than with questions of gender. The homoeroticism of such works is marked: Berman contends that the linked discourses of public health and cultural identity made it possible to retrieve such images from the margins of propriety and locate them centre stage. The figures represented appear to have appropriated power for themselves, by virtue of their identification with national and cultural ideals. The ambiguities present in Eakins' representation of boxing appear to have been pushed aside – despite the similar queries that are raised by the juxtaposition of the bronzed (sculptural) flesh of heads and arms, and the vulnerability of the white flesh of the torsos and legs. By their identification with nature and their inversion of the familiar female/nature model, as well as by their nationalistic appeal, images such as Munch's *Bathing Men* are seen to inscribe and reinscribe a view of masculinity which excludes the feminine. This account offers, therefore, a contrast with the ambiguities of gender positionalities explored for example by Amelia Jones in Part I and by Sharon Fermor in Part IV of this volume, signalling something of the range and variety of aims and interests on the part of the contributors.

Muscles, morals, mind: the male body in Thomas Eakins' *Salutat*[1]

MICHAEL HATT

M is for muscles, for morals, for mind –
These three go together you always will find.

Through the second half of the nineteenth century in America a new ideal of masculinity came to the fore: an ideal concisely, if clumsily, summed up in the quotation above from 'The Physical Culture Alphabet', published in the journal *Physical Culture for Boys and Girls* in 1905. At mid-century the dominant masculine exemplar was the Christian gentleman, whose perfect manhood was evident in his maturity, his purity and his pious and responsible attitude, but by the end of the century this descendant of the Puritans was no longer the unimpeachable paragon of manliness. The patriarch whose manhood was, above all things, a question of spiritual uprightness found himself contending with a new model: the man whose masculinity was literally embodied, the man for whom gender was a question of the body (Dubbert 1973; Filene 1986; Rotundo 1983).

The words 'manhood' and 'manliness' recur repeatedly in nineteenth-century American discourse, shaping debates on such diverse topics as religion and aesthetics. However, the concepts of gender they represent are never fully defined. Instead, the idea of masculinity is apparently self-evident, a set of behaviours and values that needs no further elaboration (Mott 1980, pp. 27–8). Of course, this lack of definition is a necessary absence, allowing a number of different gender identities and roles to be validated; if there is any sense in which these identities and roles might be contradictory or incompatible, those contradictions can be disavowed through their subsumption by the undifferentiated notion of 'manhood'. Masculinity can thus be deployed as a unified field rather than as a set of diverse gender positions. But although at any given historical moment we are dealing with the issue of masculinit*ies* – of male gender as a field of difference – certain definitions may predominate, being cited more frequently as the masculine exemplar. In mid-nineteenth-century America, the dominant paradigm was organised around the ideals of control, self-reliance and Christian civility, but was already beginning to be supplanted by the male figures who were seen to be leading the nation's westward expansion, the pioneers and backwoodsmen whose ruggedness and primitive toughness came increasingly to be characterised as authentic American

manliness. In the East, this model inflected masculine identities in the rapidly expanding urban world, and hard work was less important for its own sake than for the fact that it led to achievement and success, as demonstrated by the many heroes of Horatio Alger's popular novels in which ragged boys struggled upwards to attain riches.

Importantly, while these different masculinities were widespread, none of them was stable. This is evident from the way in which they were mutually inflecting, different discourses overlapping as in the narrative of struggle and success which marked both the Westerner and the city boy made good, and in the attempts of contemporary writers to endorse contradictory masculine attributes. Nonetheless, a broad pattern of normative definitions does emerge, and in spite of the complexity of the process of the definition and redefinition of manhood, the pioneer does seem to replace the descendant of the Puritan as the symbolic American man; the geography of masculinity shifts, and the settler, forging a brave new world in New England, is replaced by the figure who represents America's expansionist vision.

What was seen to unite all American men by the end of the century was a shared physiology. East or West, any man could be masculine as long as he had a strong, muscular body. This is an ideal for which, *prima facie*, Thomas Eakins' painting *Salutat* (Plate 13) could serve as an illustration. Would this picture not have provided Americans with a glorious image of their new manly ideal? Does the figure at the centre of the painting not represent a paradigm of masculinity as embodied? In this essay, I want to examine the meaning of the body in this painting, in order to trace the shift in the definition of masculinity and the contradictions inherent in it.

The starting point for this analysis, and fundamental to this new paradigm of gender construction, is the increasing popularity of sport and physical culture through the 1880s and 1890s. From the end of the Civil War, more and more American men, of all classes, began to practise sport of one kind or another, be it yachting, baseball or simply exercising (Grover 1989; Mrozek 1983). Sport became a typically manly pursuit with social functions whose ramifications extended far beyond the mere promotion of health. It was seen to inculcate courage, and to prepare young men for the strife that awaited them in their adult years. It provided them with the opportunity to learn the martial virtues that their fathers had absorbed while fighting in the Civil War. Furthermore, it was highly desirable from the point of view of eugenics, since it strengthened American stock (e.g. Roosevelt 1901, pp. 1–21).

The possible causes of the widespread encouragement of and interest in these activities, insofar as it is possible to locate causes for such a complex social phenomenon, are many. It may have been a response to the problems of urbanisation, enabling men to assert power and to sense control in a lifestyle that was increasingly the product of external administration. It provided the rugged active image that sedentary office or monotonous factory work could neither offer nor

realise; unable actually to be the pioneer American men who featured so impor-
tantly in the mythology of gender, men could at least, through sport, engage in
activity that depended on the same qualities of physical strength, stamina and
courage. In this way, men could ostensibly separate themselves from the culture
around them, viewed by so many as overcivilised, overgenteel and overfeminine.
Sport, then, represented the recuperation of the masculine by men in a culturally
emasculated America.

But whatever the fundamental causes of sport's ascendancy, two factors are
crucial in regard to its role as a means of defining gender. First is this concern to
stabilise masculinity, to maintain traditional American virtues and identities as
exemplified by frontiersmen and pioneers. In 1893, the same year that Frederick
Turner advanced his famous thesis that the frontier was finally closed, Theodore
Roosevelt wrote, in an essay called 'The Value of an Athletic Training':

In a perfectly peaceful and commercial civilization such as ours there is always a danger of laying
too little stress upon the more virile virtues – upon the virtues which go to make up a race of
statesmen and soldiers, of pioneers and explorers . . . These are the very qualities that are fostered
by vigorous, manly sports. (Quoted in Twin 1985, pp. 199–200)

The frontier, that yardstick of American ruggedness, was no longer a geographical
feature to be conquered, but an internal limit to be crossed, the limit of a man's
toughness and self-control. In the absence of the kind of challenge that faced Daniel
Boone or Kit Carson, men needed some other structure to hold their masculinity in
place.

Secondly, as the century progresses, the body becomes a central concern. Not
only does masculinity come to be understood as coterminous with the physical,
something that can be read unproblematically from the physique of a man, but this
physical prowess becomes conflated with the mental and the moral – these three go
together, and the body signifies the intellectual and moral worth of a man. To quote
a by no means exceptional article published in *Harper's Weekly* in 1895, 'The
budding athlete, as he measures his biceps and notes a fraction of an inch of
increase, is really measuring his mind also' (quoted in Dubbert 1979, p. 169). Thus,
morality and masculinity become synonymous, and the Christian gentleman's
spiritual manhood is embedded in physical strength. The weak body was a deviant
body; 'Weakness is a crime' declared the cover of the first issue of *Physical Culture* in
1899. Size, it seemed, really did matter.

However, while there was broad agreement on the value of sport and the
superiority of the muscular body, this ideal presented men with enormous difficul-
ties. The apparently monolithic concept of masculinity was riven with a profound
contradiction. Nowhere is this contradiction more evident than in the arena of
boxing.

Boxing was not simply another sport. Though immensely popular, boxing was
illegal, and the subject of a fierce moral debate in the pages of newspapers and
journals, in colleges and in lawcourts (Croak 1979; Gorn 1986). In one corner, there

was the pro-boxing lobby, represented by such diverse institutions as the respectable Teddy Roosevelt and the less than respectable newspaper *The Police Gazette*. They emphasised the way in which boxing taught traditional male virtues, made men self-reliant, and was governed by a set of rules which constituted an ethical code of sorts. But this view of the sport was severely compromised by the image of boxing presented by their opponents in the opposite corner, who characterised the sport as brutal, animalistic and demeaning. Essentially, there is a tussle here over the question of masculinity – the older paradigm of the gentleman is slugging it out with the new butch symbol of natural, uncivilised man. The problem was to resolve the incompatibility of these two masculinities, and thereby maintain the sense of masculinity as unified and singular. Interestingly, though, what both sides shared was a desire for a regulated masculinity. Even the adherents of the uncivilised man resisted the merely violent and emphasised the masculinity they presented as socialised; the important issue was to allow a vision of socialised man that accorded with masculine principles, rather than the femininity of the urban milieu. As Duffield Osborne put it in his article 'A Defence of Pugilism', what was needed was 'a saving touch of honest, old-fashioned barbarism, [so] that when we come to die, we shall die leaving men behind us, and not a race of eminently respectable female saints' (Osborne 1888, pp. 430–1).

This debate also operates a distinction between definitions of pugilism itself. Roosevelt and his upper or middle-class company discuss the sport in terms of the manly art of self-defence, an educational activity to be undertaken by young middle-class men in a private gymnasium such as the expensive and exclusive New York Athletic Club, or at Harvard. The anti-boxing crowd, meanwhile, refer to the prize-fight, a bloody leisure activity, setting a dreadful moral example to the working-class fans who gathered in public arenas and saloons. But the intersection of class with these positions is far more complex than this would suggest. John Boyle O'Reilly, spokesman for the working-class Irish in Boston, entitled his book on pugilism *Ethics of Boxing and Manly Sport* (O'Reilly 1888), and, like Roosevelt, insistently drew the reader's attention to the moral qualities of boxing; while, as we have seen, Osborne, in the solidly bourgeois *North American Review*, was, albeit polemically, promoting the value of 'old-fashioned barbarism'. The point to be made here is that gender identities are being validated through the false notion of cross-class reconciliation. That is, class differences are subsumed and effaced under the definition of masculinity. Issues around ethnicity and class in O'Reilly's book, for example, disappear as the notion of manliness is understood as binding men together in a fraternity of gender. I shall return to this crucial point later.

As boxing became more and more popular through the 1880s and 1890s, and as O'Reilly's work testifies, the bourgeois definition of the sport supervenes not only on writings about, but also on the institutions of boxing, displacing the sport, at least discursively, as part of the masculine working-class subculture. To some extent this was a process of making the sport more acceptable, transforming it from a

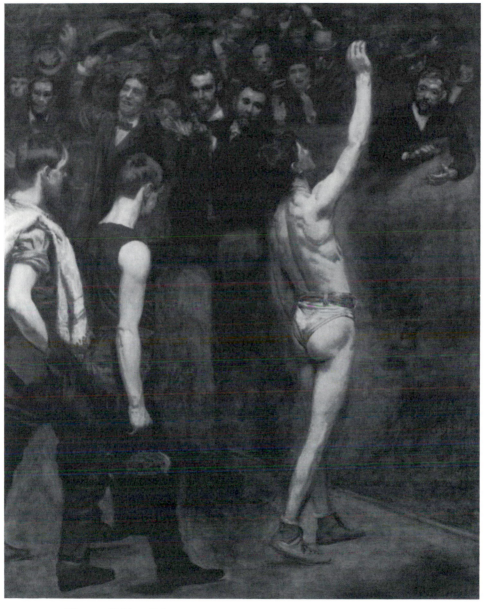

13 Thomas Eakins, *Salutat*, 1898

criminal to a commercial leisure activity. Those involved in the sport, or those who had some interest in it, attempted to transform the sport from brutal to manly.

This shift is acutely evident in representations. The earliest representations of boxing that work to redefine pugilism in this way are dime novels and boys' weeklies, where the activity associated with drunkenness and alcoholism, with immigrants and gambling and with violence inside and outside the ring is transformed into a sport with all the positive connotations that label implies. While this transformation may have been unproblematic for writers of juvenile fiction, in the more culturally loaded and valuable realm of art the validation of pugilism was anything but straightforward.

Salutat was painted in 1898. Exhibited at the Pennsylvania Academy's annual show in Philadelphia in 1899, it received no comment from many critics and, at best, a half-hearted response from others. Eakins had always been a controversial figure, and his status had, at least since the late 1870s, always been unstable, not least because of his insistence on the nude both in teaching and in his practice. This picture must have presented its audience with the same difficulty that had marked the reception of his better-known *The Gross Clinic* (1875, Jefferson Medical College, Philadelphia) or *William Rush Carving His Allegorical Figure of the Schuylkill River* (1877, Philadelphia Museum of Art). But the reason that *Salutat* was problematic is not simply the use of the male nude. It is a question of the use of the male nude within a subject which highlights difficulties in the field of gender and the concomitant moral ambiguities.

In his image of this arena, Eakins makes us acutely aware that this is an exclusively male site. An audience composed entirely of men watch the boxers, and here applaud the victor as he leaves the ring. It is in such homosocial spaces that masculinity is most forcefully enacted or produced. While the Victorian notion of separate spheres may tempt one to think of the social world as divided between male and female spaces (e.g. Pollock 1988), I would contend that, in nineteenth-century America at least, a division between heterosocial and homosocial is both far more useful and more accurate. Men move in both public and private spaces, at work and in the home. The crucial difference is that some of these spaces only men (or, less frequently, only women) may enter. Moreover, it is in the homosocial realm that young men are inculcated with the ideals of their gender roles: in gymnasia, colleges, workshops, saloons and so on. The transmission of masculinity is dependent on the visual economy of these spaces. Eakins' emphasis on the gaze of the audience on the body of the boxer points up the importance of men watching men. The bulk of theory around gendered looking has begun from the notion of man as the bearer of the look, women as the object, and seems to have gone on to define a female gaze. A more precise analysis of the male gaze, as a differentiated field, has not been attempted to any great extent. Consequently, it is too often asserted that for the male body to be the object of a male gaze is disruptive to protocols of

looking (an important exception is Neale 1983). In fact, though, the stability of masculinity depends upon the visibility of the male body; to be learnt or consolidated, masculinity requires a visual exchange between men.

So, the ring is a homosocial space where the male body is a legitimate object of a male gaze. To capitalise on the economic metaphor, there is another economy structuring the scene: an economy of power. Two forms of power coexist in a reciprocal relationship: the physical power of the boxer, marked by careful attention to musculature, to pose and to the victorious salute, and the economic and social power of the audience, able to pay their way into the space of male leisure, a space bounded by the money of entrance fees, prize money and illicit gambling. While the boxer's power is evident in his nakedness, theirs is to be read from their dress. But nakedness, at the same time, signals vulnerability, particularly in the context of this duality of clothed and unclothed which connotes the crowd's power over the boxer, as does the provision of their pleasure by the fighter. The audience's recognition of the hero's prowess is as much an acknowledgement of the power of their own gaze. Although the representation of the boxer as an heroic performer simultaneously produces the audience as mere men, the authority of the consumers' gaze and their conspicuous consumption of the hero constitutes a position of power too.

What, though, of class difference and the power embedded there? As we have already seen, the most apparently straightforward visual exchange is structured by, and produces, power relations; clearly, once class difference becomes a factor, these power relations will be seen to be yet more complicated. While the working-class associations of boxing were never entirely avoided, audiences such as the one Eakins depicts were characterised more by uniformity of gender. The significant character of the crowd was not its class status but rather its exclusive masculinity. While the physical ideal may have had slightly different meanings for different classes – for example, physical strength as symptomatic of moral strength for the middle class, or as the means to obtain labour for the working class – the new insistence on corporeality was not class specific, and boxing became less a ritual of class and more a ritual of manliness. Again, though, as we have seen, this depends upon a false reconciliation of class, an ostensible transcending of class interests and identities that forges an essential masculine American identity. What all these enthusiasts were encouraged to share was a dream of a strenuous life where they would be free of the genteel, the feminine and the bureaucratic. In the same way that the power relation between boxer and fan is complicitous, so the audience, at least as represented, is contained by a homosocial mutuality.

The homosocial visual economy, then, in certain circumstances, has to efface differences in favour of an ideal and universal masculinity; but, of course, this process actually constructs or consolidates difference. Who, for instance, deploys definitions of the masculine? Is the masculine ideal one which emerges from working-class or bourgeois discourse? What power or class relations are already in

place in the homosocial arena? In *The Rough Riders*, his account of his experiences in the Spanish-American war of 1898, Teddy Roosevelt insistently maintains that, although his men come from different regions of America, in geographical, ethnic and class terms these differences are effaced once they don their uniform and recognise their common masculine purpose; and in many of his other essays and speeches he points to this sense of fraternity in social life (Roosevelt 1897, particularly pp. 15–34; 1899; 1901, particularly pp. 63–87 and pp. 261–76). Significantly, to efface those differences requires that they be articulated; and the common pursuit of Roosevelt's soldiers is very much the outcome of national policy, shot through as it is with class interests. In the same way, the representation of boxing, as in Eakins' work, offers a mythology of a natural gender identity, a classless masculinity which precedes its institutional formation and, therefore, its specific class derivations.

The notion of homosocial complicity is also fundamental to a further idea that the image explores: spectacle. The *Oxford English Dictionary* offers among its several definitions of the word a pair of distinct ideas that seem to me to be helpful in analysing the complex way that spectacle is treated in Eakins' image. On the one hand, a spectacle is simply a display or entertainment, something to be passively consumed by a viewer. This is the boxing match. But, on the other, spectacle can also demand something of the viewer in terms of a judgement as to whether the spectacle is to be marvelled at or scorned. In this second sense, the body is a self-contained spectacle. Not simply a component of the evening's entertainment, it is a discrete object requiring the scrutiny of the active viewer.

The spatial order of the painting makes this clear. The space is divided between a watching mass of men in the background and the exposed body of the boxer in the foreground. They are not applauding the masculine act of fighting but the agent or vessel of masculinity. It is the body itself which is on display. Moreover, the viewer, whilst not set squarely in the crowd, has a similar position, thus creating an arena in which the body can be displayed.

The economy of spectacle is clearly bound up with the economy of power, the structure of the arena, in highly complex ways. In her book *The Body in Pain*, Elaine Scarry describes the room – the fundamental unit of shelter – as having a dual function in the construction of corporeal meaning (Scarry 1985, pp. 38–40). First, the room is a magnification of the body; metaphorically, it houses the body just as the body houses the self, and so creates the limits of safety. It protects the body physically and culturally. Thus, the space around the body is a part of the meaning of that body – and, of course, we can extrapolate from this to make the same claim about represented bodies. This much may seem obvious, but Scarry then goes on to point out that the room is at the same time 'a miniaturization of the world' (p. 38). It isolates the body as a discrete object, and so marks the possibilities of the intrusion of the world or the extrusion of the body.

Scarry's insight is applicable to many social spaces, including the boxing ring. In

Eakins' image, the body of the boxer fills the arena; the homosocial boundary prevents undifferentiated contact with the world, it regulates movement in and out of the space, and creates a consonance between the cheering crowd, the metaphorical body of the masculine audience and the body of the boxer that they are applauding. The conjunction of these bodies offers a prospect of stability.

However, just as the space of the arena is always shifting between an image of the body and the civilisation that gives meaning to that body, so the audience vacillates between consonance and confrontation, between an identification with the body of the boxer – literal or metaphorical – and separation of the body of the boxer under scrutiny. It hardly needs be said that these operations are largely inseparable.

Is the boxer, then, protected or isolated; part of a single masculine body or separate within the bounded space of civilisation? The force of this uncertainty in Eakins' painting is perhaps best expressed by comparison with another of Eakins' pictures, *The Gross Clinic*.

In *The Gross Clinic* we can see many of the elements visible in *Salutat*: an arena, a site of masculine homosociality, a male audience, male spectacle. Indeed, each of these seems to be more graphically represented in the painting of the clinic. The masculine nature of the scene is emphasised by the figure of the patient's mother, turning away, removing her gaze from the scene;[2] and the violence of the scene – albeit a benign violence, as Gross performs an operation for osteomylytis, removing a piece of dead femur – is shockingly apparent in the bloodied scalpel. Gross is an heroic figure, both literally, in terms of his reputation, and figuratively, in his portrait. He towers above his associates, the light striking his head at the apex of a triangle. In contrast to the supine, passive, incoherent and unclothed body of his patient, he is erect, active, coherent and clothed in a way that signifies his status. Implicit in this heroic authority is the gender identity of the normative middle-class professional man; in addition to the parameters of class, age and race, he is a public figure in a paternal role. This figure does much to define the social space of the clinic. The space is almost constructed around Gross, just as the boxing arena encircles the boxer. Gross embodies a central authority which draws the gaze, directing the looking of the audience.

But again, this central power coexists uneasily with the other principal parameter marking out the clinic. Against the arrangement of the patient and the surgeon is set another physical, corporeal system. The clinic, too, is a theatre. On banks of seats, men sit and watch the action in the arena. Authority demands recognition; in order to function, it needs to be looked at. But this is exactly what constitutes a threat. The spectacular paradox – the body as active agent and passive object of the gaze – is particularly marked here. Just as Gross physically discloses the patient's body, so he discloses his own body, making it an object of scrutiny; these are the two foci of light in the painting. The relation between Gross and his patient is reproduced between the audience and Gross; in each case a male body is placed under the disciplining gaze of another man.

Contracting the structure of *The Gross Clinic*, the boxer is, in a sense, both doctor and patient. His nudity signals both heroism and vulnerability. The identity of the physical and the moral was already at work in the male nude of academic painting, and this tradition is immediately invoked by *Salutat*. The nude, and particularly the male nude, was by no means an uncontested field in late nineteenth-century America, and it was only in neo-classical sculpture and allegorical academic painting that it was generally permissible. The most obvious academic comparison to make is with the work of Eakins' master, Gérôme, and particularly the paintings of gladiatorial combat that he and many of his followers made. Eakins' title and inscription on the frame – DEXTRA VICTRICE CONCLAMANTES SALUTAT, or 'The victorious right hand salutes the shouters' – both refer to the gladiatorial contest. Not unconnectedly, 'gladiator' was a word commonly coined for the boxer. *The Police Gazette* and other newspapers used it frequently, and it crops up again and again in books on boxing and the biographies of fighters. In this one term are concentrated both the moral debates of sport and art, and the means of legitimising certain views or practices. In boxing, the battle for respectability is comprehended by the reference to a classical tradition; in art, the battle for the nude similarly appeals to this cultural paradigm. In *Salutat*, the male nude is legitimised by the idea of the classical, a strongly gendered tradition with its connotations of nobility, strength and masculine virtue, and boxing, in turn, is legitimised by this art.

The value of the term gladiator can be unpacked a little further. First, the sense of victory, particularly clear in the painting, is crucial. The nude male body acts here as a paradigm of the victorious and strong, and as gender definitions shifted, particularly with the notion of the rags-to-riches self-made man, winning came to be equated with manliness. As Roosevelt remarked, 'We admire the man who embodies victorious effort' (Roosevelt 1901, p. 2). To win was to be manly, but, not forgetting the Christian gentleman still moralising in his corner, winning had to be tempered with a sense of moral righteousness. Brutishness was offset by displays of comradeship, of fraternal bonding, after the contest; this is a narrative that recurs again and again in sports journalism. Thus victory included within its scope a sense of the noble, just as Eakins' boxer does. (In practice, however, according to the autobiography of 'Gentleman' Jim Corbett, post-fight displays of sportsmanship almost never occurred (Corbett 1910, p. 73).)

The idea of the gladiator, then, mediated through traditions of classical and academic art practice, accommodates the brutal and the civilised within an encompassing notion of achievement. Masculinity could be both violent and moral, and the division between the gentleman and the fighter semed to be healed. The classicising vocabulary also inscribes a history of masculinity as an unchanging ideal, naturalising it as an essential and ahistorical category. To deny differences between the modern pugilist and the athlete of classical antiquity is to see an unchanged manliness that crosses the centuries. But for this category to be

stabilised, others have to be blurred. As differences between diverse masculinities are effaced, so are the divisions between other cultural categories – art and sport, past and present, violence and civility. It is through this process that boxing is moralised.

This blurring extends to Eakins' practice insofar as his image straddles the academic and the popular, gladiator and prize-fighter, Gérôme and *The Police Gazette*. These ostensibly incommensurable spaces may have widely differing cultural values, but they can be made to support the same definition of masculinity. Eakins' negotiation of these differences, however, is not unproblematic, not least because there is also a blurring of art protocols or styles, failing to provide contemporaries with the distinction they so prized between realism and academicism. The male nude of the *académie* is usually dark-skinned; like John L. Sullivan in *The Police Gazette*'s reports of 17 September 1892, he is 'as brown as a berry' and 'as though made of bronze' (Smith and Smith 1972, p. 157). The male body should be as hard and impermeable as a sculpture, but, under the glare of the new electric light Eakins' figure is pale, the vulnerable shade of the passive female nude who adorned the wall of every bar-room, usually next to a picture of the hero Sullivan. But while the dissolving of the boundary between academy and ring could be supported, the same could hardly be said of the boundary between male and female nudes.

14 Winslow Homer, *Undertow*, 1886

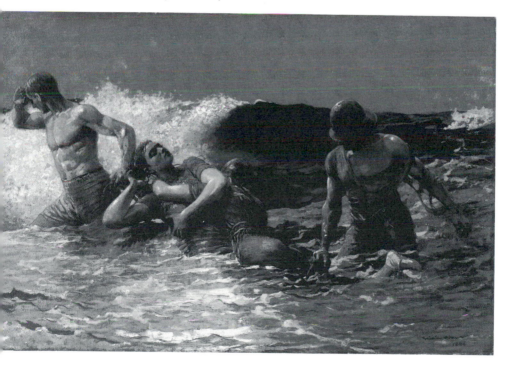

The depiction or description of the body as sculptural was a way of stabilising the male nude and mitigating the threats it posed, as well as denying the weakness of the male flesh. For instance, Winslow Homer's *Undertow* (Plate 14) was widely praised when exhibited at the National Academy of Design in New York in 1887. For the critic of the *New York Tribune*, the figures were 'like sculpture', 'bronze heroes of the sea', while for another 'the figure is modelled as cleanly and solidly as sculpture' (Gerdts 1974, p. 118). Nude, not naked; bronze, not flesh; strong, not weak; clean and solid, participating in culture without displaying the characteristics of femininity and over-refinement that were invoked by the use of the word 'civilisation'. In addition to being a means of consolidating the definition of masculinity as strong, invulnerable and heroic, this analogy also provided a frame which allowed the scrutiny of the male body by the male gaze. Male delight in the male form was validated, both permitting the articulation of homosocial pleasure while providing an object which concealed the possibility of that pleasure; that is, the aesthetic pleasure of sculpture distanced the problem of the erotic pleasure of the body.

To end with a little speculation on the reception of Eakins' painting, I suspect that it is in this respect that the work failed for its audience. Because the boxer is not sculptural, but pale, mobile flesh, the brushwork emphasising the corporeal, confirming for the audience that such realism represented an unmediated representation of the world, and because the image stresses the flesh and leaves open the possibility of erotic delight, particularly in the emphasis on the buttocks framed by the jockstrap, the male gaze becomes dangerous. It may be that Eakins is being deliberately provocative here; it seems more likely that, in public fights, boxers would have worn tights or leggings. But as with *The Agnew Clinic* (1889, University of Pennsylvania School of Medicine) and the *William Rush* paintings, Eakins may be using the nude here in what would have seemed to his contemporaries a purely gratuitous manner; after all, William Rush's statue wears light drapery, and a mastectomy would have been performed by Agnew with only the breast revealed, and the rest of the body covered. Similarly, *Salutat* reveals more of the male body than is strictly necessary, exploring an unhealthy interest in the pleasures of the male nude.

To counter the threat of the eroticisation of the male body, *Salutat* requires an imaginary female viewer, a device used by male writers and journalists when they wished to discuss the appeal or beauty of the fighter's body. Jack London, for instance, in his story *The Game* of 1905, articulates the 'beautiful nakedness' of the hero's body by describing the response of his fiancée: 'His masculinity, the masculinity of the fighting male, made its inevitable appeal to her . . .' (London 1905, p. 23). But, of course, a painter cannot specify a viewpoint in quite the same way. Moreover, a female gaze is not appropriate here. This is a male space, the painting itself seems to prescribe the male viewer; and yet, in placing this homosocial world before the heterosocial audience of the Pennsylvania Academy, Eakins ensures the

presence of the transgressive female gaze in addition to the problematically eroti-
cised gaze of the male homosocial realm.

What I am suggesting is that the critical silence or negative reaction that greeted
the painting in 1899 was not a question of the subject matter and its moral position
in any straightforward way, for the crisis of the definition of masculinity that
boxing epitomised could be adequately negotiated. The problem seems to be the
body itself, which, rather than providing a symbol of consonance, draws attention
to dissonances in the visual economy of the homosocial realm. Instead of resolving
the tensions of spectacle, the boxer's body emphasises them, pointing up the
fragility of the new masculine ideal and the precarious equilibrium of the muscular
and the moral. Moreover, it threatens the definition of gender that physical culture
works to maintain with its suggestion of the erotic, that emerges from the problem-
atic structure of viewing. While Eakins' boxer may have tried to demonstrate how
muscles, morals and mind always went together, the order of representation and
the ambiguities of homosocial viewing made it painfully clear exactly how unstable
an alliance this was.

6 Body and body politic in Edvard Munch's *Bathing Men*[1]

PATRICIA G. BERMAN

In the years after the turn of the century, images of virile athletic male nudes, removed from conventionalized narrative settings, appeared throughout Scandinavian painting. The febrile images of women that populated the work of the 1890s were replaced by representations of strong, intact, mature male figures as embodiments of nature. Nature was defined as masculine, active and biologically connected; the image of the athletic male nude, normally residing on the margins of social acceptability, became legitimised through its association with this masculinised concept of nature. This legitimisation was supported by the nationalist literatures of the Scandinavian countries, as well as the German philosophical discourses that informed them. While in many ways a pan-Northern phenomenon,[2] the appearance of the male nude, which served as a link between masculine athleticism and national myth, was also locally interpreted. This paper examines some of the circumstances of this redefinition of the male body's symbolic function, and its implications for a regenerationist approach to nature in the North, by focusing on Edvard Munch's painting *Bathing Men* (Plate 15).

Edvard Munch broke with the normative vision of the male nude in nineteenth-century art when he painted *Bathing Men* in the summer of 1907. The monumentally scaled composition (the canvas measures 206 × 227 cm), painted in the village of Warnemünde on the German Baltic coast, depicts a community of men posing on a sandy beach and moving through the ocean's waves. Two of these men seem specifically to have challenged the convention of the feminised male adolescent bodies familiar, for example, from the classical landscapes of the Berlin Secession painter Ludwig von Hofmann, which served as exemplars of male beauty in contemporary European art. Cloaked in the authority of classicism, Hofmann's nude males were respectable and intellectualised; their erotic availability was controlled through the distancing realm of historical narrative.[3]

Although Munch likewise acknowledged the tradition of classicised male nudity in his painting – the rigid postures of the figures recall athletic Antique archetypes – any direct reference to a classical ideal is negated by the striking contrast that Munch creates between the figures' bronzed heads, necks and hands and the whiteness of their torsos and legs. It is clear from their localised suntans that these

male bodies are normally clothed. Their heroic postures and incongruous pigmentation thus collide. Through the assertion of their newly unclothed bodies, the figures remain distanced from the rhetoric of Antiquity.

The images of their bodies also run against passive representations of a feminised masculinity; rather they are, in their maturity and muscularity, emblems of virile male authority (see Saunders 1989, p. 27). They are also caught between motion and carefully contrived stasis. The coiled tension of their muscles suggests that they are striding actively forward towards the spectator. Yet their arms, held stiffly out from their sides, and the axis of their hips, which runs parallel to the ground, indicate that they are holding self-consciously athletic poses. We are made aware of ourselves

15 Edvard Munch, *Bathing Men*, 1907–8

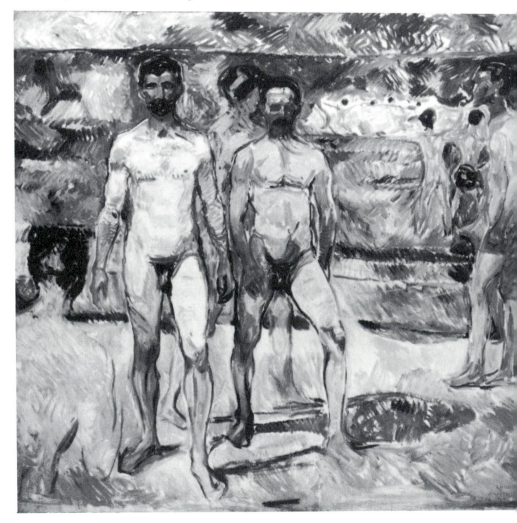

as viewers of this male spectacle by the figure appearing on the lower-left corner of the composition, over whose shoulder we view the two frontal figures. Munch's figures are active; their muscles are clearly articulated by shadows from the blazing sun and their torsos are framed by bearded faces and taut stomachs curving upwards from darkened groins. Posing, flexing, holding the spectator with their confrontational gazes, these figures are decidedly sexualised.

Few representations of such eroticised male bodies were given exhibition space in the early years of the twentieth century. Not surprisingly, *Bathing Men* was sufficiently disquieting to be rejected for exhibition in Hamburg in 1907 (Eggum *et al.* 1987, p. 259). However, when the Ateneum Museum in Helsinki purchased the painting in 1911 for a high price, *Bathing Men* was shown to be more than a marginal work by a major painter.[4] In the ensuing criticism found in the Finnish popular press, oblique references were made that locate the image within a specific discourse. Referring chiefly to the painting's style but also to its theme, the *Nya Pressen* identified *Bathing Men* as 'the representative of a style of art that exercises a strong influence on the modern imagination' (*Nya Pressen*, 12 April 1911), and its author as a representative of the 'furthest Left', his painting an example of a 'passing fad' (*Morgenbladet*, 1911). Ten years later, Munch's biographer Curt Glaser noted that the canvas presents a male sphere of activity, and, as he and other critics of the period suggested, it represents the crystallisation of a new definition of Nature (Grimschitz 1921, pp. 57–8). Eschewing the earlier critical allegations of radicalism, Glaser located *Bathing Men* in a simpler dialogue between man and nature: 'Men, bathing, that is the theme' (Glaser 1922, pp. 125–6).

This transformation of the male body into a nature emblem occurred throughout the North and can be charted by two exhibition posters by the Dane Jens Ferdinand Willumsen that display contrasting approaches to the male nude. The first is an announcement for the 1902 Free Exhibition in Copenhagen, a composition that displays the image of a classical male youth (an artist) mounted on the back of a winged horse, riding through the sky over Denmark (Willumsen 1953, p. 145). In contrast, the second, a lithograph announcing Willumsen's Studio Exhibition in 1910 (Plate 16), portrays Willumsen in a dandified white suit standing before and gazing at his model, a powerfully built athletic male whose body is nearly caricatural in its virile athleticism. The two posters circumscribe a phase of Willumsen's career, extending from 1902 to 1910, during which time he worked on *Sun and Youth* (Gothenburg Art Museum), a vast canvas representing a group of youths ecstatically bathing in the sea. When Willumsen first conceived the painting, he described it as an ambitiously synthetic work, 'a grand monumental painting that will show Man in open Nature' (Willumsen 1953, p. 147). When exhibited, critics saw in the painting the roots of a new tradition, 'the love of life, health and sunlight' (Sørensen 1981, p. 26), which was a reaction to the languid quality and feminine content of *fin de siècle* painting; the visceral response to nature illustrated by the painting was viewed as inherent in the Nordic character. The nude model in

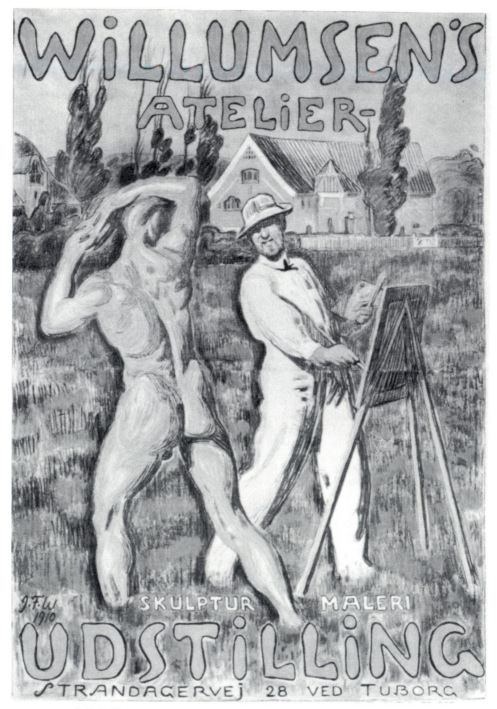

16 J. F. Willumsen, *Studio Exhibition of 1910*, 1910

Willumsen's studio poster emblemised this transformation. Willumsen himself described this type of imagery as 'ethical' (Willumsen 1953, p. 160). By this he undoubtedly meant that its purpose was to transmit cultural values and provide a model for social evolution throughout the North.

Other Scandinavian painters had been crafting images of male nudes using many of the same stylistic and informational devices as Munch and Willumsen – the vibrant palette and the muscular body types inscribed with lines that seem to derive from the linear patterning of Art Nouveau. Among these were the Swedes J. A. G. Acke and Eugène Jansson. Acke had been one of the first artists to focus on the male nude in 'open nature' as primary subject matter. This coincided with his organisation of a nature colony on Stockholm's outer archipelago in the 1890s. The purpose of the colony was to provide a setting for artists and intellectuals in open nature, away from urban distractions. They saw nature as an agent of purification with which man was spiritually and materially linked, but from which he had become alienated. By re-engaging with open nature, man's creativity and intellectual life could be freed (see Lagerlöf 1959). Acke's paintings of male nudes stretching in the sun or warming themselves on the rocks gave form to this idea.

Eugène Jansson, admired for his moody nocturnal views of Stockholm, ceased painting in 1904 and re-emerged as a chronicler of the athletic male body in 1907.

17 Eugène Jansson, *The Navy Bath House*, 1907

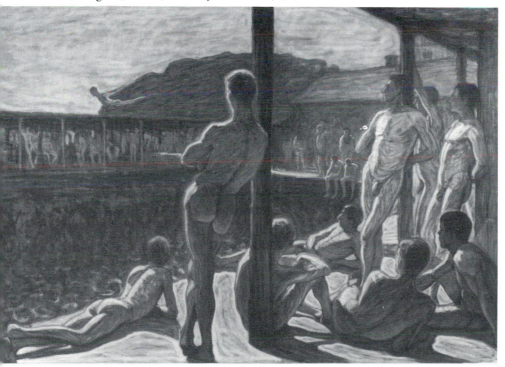

Between 1907 and his death in 1915, Jansson painted and sketched in the Navy Bath House in Stockholm and in his studio. Jansson's new subject matter was disturbing to several of his colleagues in the light of his homosexuality (Moser 1983, n.p.). However, Jansson's patron, the Swedish collector Ernest Thiel, purchased one of his early compositions of male nudes. *The Navy Bath House* (Plate 17), a panorama of young nude men posing in the foreground of the painting, gazing at the background figures across the blue gulf of a swimming pool. When Munch viewed the painting in early 1908, he noted the similarity in subject in a letter to Thiel, who was also Munch's patron.[5]

When Jansson exhibited his paintings of male nudes at the Konstnärsförbundet's summer exhibition of 1912 (which coincided with the Stockholm Olympic Games) the National Romantic poet Tor Hedberg wrote, 'By means of this exhibition the male form, boldly and supremely, has made its entry into Swedish painting' (Moser 1983, n.p.). What seems crucial in this statement is not the fact that the male form was new to Swedish art in 1912 – certainly male nudes had 'entered' Swedish painting previously – but that the degree of 'maleness' defining the form was unconventional. This is perhaps the first time that masculinised male bodies were accorded serious critical value in Swedish art circles. Similarly, when Munch's *Bathing Men* was rejected for exhibition in Hamburg in 1907, his German friend and collector Gustav Schiefler posed the rhetorical question, 'Why should male nudes be more shocking than naked women?', answering, '[n]aked men are unfamiliar' (Eggum *et al.* 1987, p. 259). By that he was certainly invoking the customary ban on male frontal nudity. Yet here again what is at stake is not the male nude *per se* – nude male bodies were clearly prevalent in allegorical contexts in German art – but the 'manly' nude, the naked body of a mature man unencumbered by rhetorical distancing devices. Paintings such as Munch's or Jansson's point out the mobility of the masculine ideal and attempt to locate a new meaning for the male body through a reconsideration of its form and display.

For Munch, the naked male body served both as a mirror of the self and as a stage on which to enact both private drama and the broader public issues that constituted and confirmed the self. In the private sphere, the ideal of male potency portrayed by his 1907 *Bathing Men* is embedded in Munch's attempts to combat health and 'nerve' problems within his own body in that year. Munch painted the composition while taking a 'bathing cure' on the Baltic coast of Germany. Prior to Munch's trip to Warnemünde, he had been engaged in the creation of theatrical sets and a decorative frieze for Max Reinhardt's new theatre, the Kammerspiele, in Berlin. The projects had proved difficult. In 1906 Munch had written to Ernest Thiel, 'The work for the theatre in Berlin completely destroyed me and I thought perhaps that I could find a saner place outside of Stockholm – Maybe with [the art collector] Fåhræus in Saltsöbaden' (Munch to Thiel, 1906: Munch Museum archives). By August of 1907, while creating a version of his controversial 1886 painting *Sick Girl* on commission for Ernest Thiel, Munch reported to Thiel, 'The "Sick Girl" is being

painted by a sick painter'.[6] Over committed, travelling widely, exhibiting throughout Europe, drinking heavily, Munch was, in the year that he painted *Bathing Men*, approaching exhaustion.

As several photographs attest, Munch painted *Bathing Men* directly on the beach in the sunlight (Eggum 1989, pp. 132–3), using bathing attendants as his models (Eggum, *et al*. 1987, p. 259). His choice of Warnemünde as a setting, and the nudist male beach as a stage, placed him in an environment of healing, perhaps in reminiscence of the summer of 1904 when he had painted an earlier composition entitled *Bathing Men* (Munch Museum) in Norway. Munch's friend Christian Gierløff, one of the models for the 1904 *Bathing Men*, wrote of that summer: 'The sun had been scorching all day, and we just enjoyed it. Munch painted for a short while on his bathing scene; but most of the day we were lying down, overwhelmed by the sun, in deep sandpits at the edge of the water, between the big stones, absorbing all the sun we possibly could. Nobody asked for a bathing suit' (Eggum 1989, p. 112). The security of male affinity reflected in that reminiscence was offered by the Warnemünde beach: men creating and operating within a male community. The nudes that Munch painted, in their athleticism and their muscular vigour, supported a fantasy of the body as a fixed and stable image, intact, resistant to decay. This fantasy of resistance serves as a counterpoint to the numerous images of vulnerable and fragmented males in Munch's work, most especially his self-portrait as the martyred Marat in *Death of Marat I* (Munch Museum), also painted in 1907.[7]

The image of the strong male body was also commonly used to promote bathing, a sport that gained increasing attention in the 1880s and 90s as a form of public health and hygiene throughout the North. While bathing was promoted in 'open nature' by a burgeoning back-to-nature movement, it was also introduced into urban settings, beginning in Stockholm in 1883, through the proliferation of bath houses and swimming schools. In Norway, bathing culture was most energetically promoted by E. Leonard Hasvold, who opened swimming schools for men and boys in 1893, and then for women at the turn of the century. According to Hasvold, swimming was the perfect exercise because it strengthened the lungs, articulated the muscles, increased vigour and well-being, and provided the opportunity to assist others (Hasvold 1905, p. 8). Bathing also increased in popularity at this time as a cure for nervous or psychological disorders in both men and women. According to such handbooks as Dr E. Kruse's 1893 *Ueber Seeluft- und Seebadekuren bei Nerven-Krankheiten* ('On Sea Air and Sea Bath Cures for Nervous Conditions'), which Munch owned, open-air bathing was an optimal solution to nervous disorders in both sexes. For the male, contact with the sea acted as a restorative of confidence and masculinity (Kruse 1893). It also assured a greater sense of community through the fluid contact that bathing created between individuals. Beachside athleticism was thus inserted into the realm of both social renewal on a collective scale and individual healing.

This image of an intact masculinity was conditioned by broader discourses as well. As the historian George Mosse and others have observed, man was repositioned in Northern European social theory at the turn of the century as an extension of unspoiled nature. The pre-industrialised natural setting was viewed as the embodiment of an ahistorical primal state, untouched by the materialism of the modern urban environment. As such, virgin nature, or 'open nature', serviced the need for a palliative to the corrupting influence of oversocialisation (Mosse 1985, pp. 48ff). The nature colonies that appeared throughout the North in the later nineteenth century provided settings where males, freed from the artificial constraints of urban family life, could re-engage with their instincts through an unfiltered exposure to the elements. Nudism, *Nacktkultur*, emerged concomitantly as a mechanism of moral enhancement through physical release. Central to the culture of nudism – originally called 'the culture of sun and light' (Mosse 1985, p. 50) – were athletic development, the enhancement of physical strength through exposure to the sun and a sublimation of libidinal energy into collectivity and camaraderie. This camaraderie served as an affirmation of manliness, of life lived outside of the feminising influence of city and family (p. 50). Thus man was relocated from a state of culture to a state of nature in such colonies, and, in an elastic inversion of the nature/culture duality (see Ortner 1974), nature became a male sphere of activity.

In contrast, domesticity, the family, was viewed by many social theorists as a specifically feminine social sphere. The oppositions that characterised post-Darwinian gender theory in the late nineteenth century reinforced this view (Richards 1983, especially pp. 64ff.). Theories of sexual difference which stressed woman's sole function as procreative proliferated at this time. Most notorious among them was Otto Weininger's 1903 study *Sex and Character*. Weininger, one of the most widely read gender theorists operating within a pseudo-scientific framework, promoted a cosmological gender theory in which man was attributed intellect, spirituality, self-knowledge and the power to change society, and woman was defined as being materially bound and preoccupied solely with her sexual body. For Weininger, domesticity, characterised by these feminine traits, exerted a corrupting influence on the individual male, and, by extension, on social development. Weininger viewed the culture of the family as distinct from the culture of the state: 'men, and not the family, form the beginnings of society' (Weininger 1906, p. 205). In fact he did not view the family as an intact entity at all, but rather as a formless idea that ultimately exerted little influence on male camaraderie: 'the family itself is not really a social structure; it is essentially unsocial, and men who give up their clubs and societies after marriage soon rejoin them' (p. 205). Finally, he noted that the family was essentially disruptive: 'the family . . . is feminine and maternal in its origin, and has no relation to the state or to society' (p. 310). Real society, as defined by Weininger, operated outside of the realm of domesticity. This duality of female family and male state underlay many of the impulses behind the back-to-nature and

Nacktkultur movements in Germany, of which Munch's outdoor bathing experiences were a part.

As George Mosse points out, the emergence of nudism coincided with a reification of national symbolism (Mosse 1985, p. 53). The most ardent advocates of nudism in Germany claimed for it a moral purpose – to cleanse and naturalise the body.[8] This, in turn, was paradigmatic of the cleansing and naturalisation of the modern state. The purification provided by the body's contact with sun and light initiated a return to a condition in which undesirable, 'foreign' or parasitic elements were eliminated (p. 48ff.). The masculine state could thus be retrieved. The recovery of the male body, in contact with this pre-civilised nature, therefore suggested the consolidation of a national ideal, one in which masculinity and femininity were at variance. One of the preconditions of this recovery was the idea that man and nature were both spiritually and biologically connected.

Confirmation of the linkage between man and nature was provided in part by Monism, or 'Vitalism', a popularised movement in science and philosophy at the turn of the century that posited the interrelatedness among all living things. In Germany, the doctrine of Monism was defined in the popular imagination by the zoologist Ernst Haeckel who introduced his ideas to the lay audience through the Monistic League in Jena, and through his lectures and publications. Rejecting theistic interpretations of nature, Haeckel espoused a celebration of nature's material manifestations as the basis for a moral interpretation of the universe, and he proposed man to be biologically and spiritually linked with all other forms of life. In *The Riddle of the Universe at the Close of the Nineteenth Century*, Haeckel's most popular book,[9] the author attempted to rectify 'the great enigma of "the place of man in nature" and of his natural development' (Haeckel 1900, p. 5) by proposing 'one sole substance in the universe, which is at once "God and nature"; body and spirit' (p. 20). In this book, as in a popular biography of Haeckel that Munch probably read in the summer of 1907,[10] Haeckel attacked academia, the clergy and public bureaucracy for stunting and perverting natural human growth, and identified his doctrine of Monism as a route by which man could rediscover himself. He proposed sweeping educational reforms in which 'man shall learn a correct view of the world he lives in; he will not be made to stand outside of and opposed to nature, but will be represented as its highest and noblest product' (p. 363). Accordingly, through a rediscovery of the unified natural body, man could redirect culture towards a positive reconsolidation: 'We can only arrive at a correct knowledge of the structure and life of the social body, the state, through a scientific knowledge of the structure and life of the individuals who compose it, and the cells of which they are in turn composed' (p. 8). This pairing of body and body politic, which played a key role in social theory around 1900,[11] became a significant validating force behind the Northern European nature communities and their reassessment of the role of nature in human society.

Like the body, landscape assumed the increasingly important role as the bearer of

indigenous cultural values throughout Scandinavia at this time (see Nasgaard 1984). The link between topography and culture was specifically important in Norway, which re-emerged as an independent nation in 1905, following five centuries of Danish domination and a period of Swedish protection that had been initiated in 1814. Under Danish rule, Norway lost its economic autonomy, many of its independent cultural institutions and its spoken language. Throughout the nineteenth century, after Norway was ceded to Sweden, a programme of extensive cultural reification was conducted that defined and retrieved an indigenous Norwegian culture as distinct from the cultures of Sweden and Denmark. The lexigraphic studies, folk tale collections, histories of the Middle Ages and collections of folk art that were published from the 1840s to the turn of the century were directed towards this reconsolidation of a Norwegian national identity (Falnes 1933; especially chapter 3). Images of nature were central to many of these studies as a crucible for culture: mountain farmers and coastal fisherman, viewed as survivals of an uninterrupted native culture, were accorded the physical and spiritual characteristics of their respective environments; the Norwegian temperament was likened to the seasons and weather, etc. The image of the land as an assertive and unified force, and an image of its people as both spiritually and physically connected to it, supported the political initiative to form an independent Norwegian state, and helped to forge its national paradigms (Falnes 1933, pp. 67–9).

The identification of the athletic male nude with such a national paradigm, as incorporated into *Bathing Men*, became further strengthened in Munch's paintings for the University of Oslo Festival Hall, begun in 1909 and completed in 1916. Munch turned to these national myths as the foundation of his iconography. The eleven canvases that form the Festival Hall decorations include images of Norwegian peasants as well as heroic nudes that, like his *Bathing Men*, are reminiscent of classical archetypes. At the centre of the painting cycle is a giant image of the sun, blazing in the front of the hall, casting its rays into the paintings flanking it. In this, the first significant national painting commission since Norwegian independence, Munch brought together classical and folk images, binding them with a representation of the sun. These signs for cultural atavism are emblematic of an uncorrupted nation.

As many scholars have suggested, Munch's symbolism for the University of Oslo Festival Hall, like *Bathing Men*, can be traced to his reading of the work of Nietzsche (see Svenæus 1973). Munch's familiarity with Nietzsche's work was established as early as 1893,[12] when he lived in close contact with Germany's, and Scandinavia's most ardent interpreters of Nietzsche in Berlin. He came into intimate association with Nietzsche's legacy again in 1905–6 when Ernest Thiel, who translated *Thus Spake Zarathustra* into Swedish, commissioned a posthumous portrait of Nietzsche from Munch (1906; Thielska Galleriet, Stockholm), and when Elisabeth Förster-Nietzsche, the philosopher's sister, commissioned a portrait of herself. In the years prior to his creation of *Bathing Men*, Munch worked in close

contact with the Nietzsche archive in Weimar (Sørensen 1981, pp. 29ff.), and as many of Munch's biographers have suggested, this activity seems to have been decisive.

It seems clear from Munch's correspondence with Ernest Thiel that he had read *Thus Spake Zarathustra* (Eggum 1989, pp. 84ff.), and that, like numerous artists and literary figures in Scandinavia generally, he found application for Nietzsche's ideas in his work. Nietzsche's writings were highly influential in Scandinavia from the late 1880s until the turn of the century, where they were subject to numerous interpretations and distortions.[13] Nietzsche's description of individualism, his belief in the power of irrationality and his resistance to and critique of modernity confirmed important directions in nationalist literature throughout Scandinavia. The community that J. A. G. Acke founded in Sweden included the writers Gustav Fröding and Verner von Heidenstam who were among Scandinavia's most important interpreters of Nietzsche and who invoked Nietzsche's writings to assert their identity as both mediators of nature and arbiters of culture. They also used Nietzsche's aesthetic principles, extracted from *The Birth of Tragedy*, as elements in the programme through which they founded a Swedish national literary movement (Borland 1956, pp. 94ff.). In Norway, Nietzschean philosophical influence could be traced from the pages of the leading radical journals to parliamentary debates (Beyer 1958, vol. I, pp. 168–99). The critique that Nietzsche brought to bear on modern culture and the use of ancient Greek thought as an agent of this critique became components in the discourse that the Norwegian secessionists used to justify their independence (Beyer 1958, vol. I, pp. 39ff., and 178ff.). Nietzsche's gendered interpretation of society, and of society's renewal through the acts of visionary individuals, confirmed the Fatherland ideal into which Munch, Willumsen and Jansson directed their work in the first decade of this century (Gavel 1985, especially p. 89).

Munch's paintings for the University of Oslo crystallised ideas and motifs familiar from Nietzsche's texts (Svenæus 1953). The image of the sun at the front of the hall, and the nudes flanking the sun particularly suggest the cleansing of mankind through light, a recurrent motif in *Thus Spake Zarathustra*. This was also the programme suggested in *Bathing Men*, a painting which serves as a prelude to the Festival Hall iconography. In fact, in the winter prior to his trip to Warnemünde, Munch painted *A Bathing Establishment* (Plate 18) in Berlin. In it, the artist overlaid a modern bath house with Antique associations by locating an obvious reference to Lysippos' *Apoxyomenos* in the foreground of the scene. By cloaking a contemporary male bather in the guise of this archetypal athlete, Munch translated modern bathing activity into the realm of atemporal athletic ritual. Between 1909 and 1916, when Munch prepared his mural cycle for the University of Oslo Festival Hall, he translated this figure and gesture into monumental and public format. In this way the figure became institutionalised as a national emblem by its incorporation into a programme that promoted Norwegian cultural unity and continuity. It

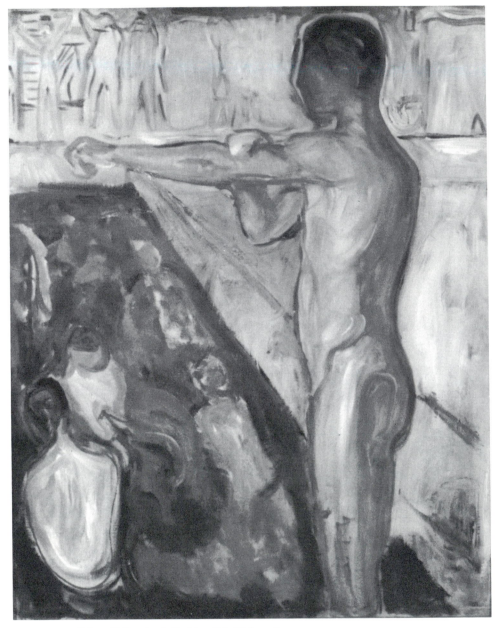

18 Edvard Munch, *A Bathing Establishment*, 1907

suggested that modern athleticism re-enacted archetypal rituals of cleansing and purification. It also signalled an apotheosis of the sexualised male image from the private masculine space of the nudist beach and the bath house to the public realm of national didactic art. *Bathing Men*, which incorporates some of the same associational collisions between Antique archetype and contemporary life, is bound up in the refinement of national and natural stereotypes that translated male athleticism into a conduit of cultural identity.

Thus, in 1912, the year in which Jansson exhibited his images of sexualised male athleticism, one year after the Finnish museum purchased *Bathing Men* and two years after Willumsen's Studio Exhibition, the mature sexualised male nude had been retrieved from the margins of propriety by its uses in sociological and scientific discourses. The nude became the basis for social theorising in art-historical literature in the following year when Wilhem Hausenstein's *Der nackte Mensch in der Kunst aller Zeiten und Völker* ('The Nude Figure in the Art of All Eras and Cultures'), published in Berlin in 1913, positioned the painted and sculpted nude, particularly the modern (secular) nude, in direct relation to social theory. Hausenstein argued that, when disengaged from the narrative bequests of Christian or classical iconography, the human figure becomes a conduit for social meaning, its form representing the increasing acculturation of man (Hausenstein 1913, pp. 160ff.). Artists such as Munch and the expressionists, he suggested, gave form to this locus of meaning in their work. While Munch's male nudes were not examined in Hausenstein's book, his method suggests the ways in which the body was being redefined as a conveyer of critical meaning as well as an object of visual pleasure.

As the paintings by Munch and Jansson or the poster by Willumsen testify, the representation of the eroticised athletic male nude came to be accepted as emblematic of health and sunlight. While these images challenged the appropriate display of the male body, they also contributed to – or could be identified as engaging – broader philosophical discourses. When in dialogue with a landscape setting, the representation of the male nude signified athletic aspiration. When positioned in relation to others in the sunlight, this image was emblematic of masculine community, engaged in the purifying search for identity and health. Moreover, the representation of the male nude could be viewed as a Nietzschean and Vitalist hero, funnelling the primal energies of sea and sun into the urban art gallery or living room. Through these cultural constructions, the sexualised male nude became politicised and was appropriated by Northern European painting. The private realms of beach and bath house were thus accorded significance as emblems of a collective, public return to a natural state as the precondition for national cultural health.

Bodies of femininity

The contributors to this book are individually and collectively concerned to test categories like gender, nature and culture in relation to the body, both as site of particular historical processes of physiological identification and as site of myth and discourse. Where, then, are the bodies of femininity constructed and construed? In her study of *The Horse Fair* by Rosa Bonheur, Whitney Chadwick looks at woman as producer of certain kinds of images deemed innately masculine which, on examination, turn out to serve in the construction of definitions of the feminine. She examines the gendered consumption of one image in particular in one specific place – London in the 1850s – exploring the associations that a large-scale academic animal painting set in train. Kate Flint, on the other hand, looks at the relations between two apparently very different images of woman and explores contradictions in the definitions of femininity with which these images were (and are) associated. The narrative content of *La Cura di Sangue* ('The Blood Cure') and *Le Cattive Madri* ('The Wicked Mothers') is seen in this account to intersect with a range of discourses around the female body in Italy in the last decade of the nineteenth century.

In Bonheur's case, as well as in that of the two Italian texts, questions of style (particularly of various realisms) are addressed in terms of cultural politics. Flint offers an analogy between divisionism as a style of painting and dissection as a method of acquiring knowledge of the human body. The mimetic qualities of Bonheur's *Horse Fair*, in Chadwick's argument, facilitate rather than impair its contribution to discourses of the feminine. These discourses are understood to assimilate Bonheur, as subject, as well as the subject of *The Horse Fair*. And for both authors, style as intrinsic to the analysis of content poses also, by extension, the issues of nationalism and national identity that are such a major question in Europe at this period.

Paris, London, Milan – we move in this section from the gynaecological clinic to the stable and from the international exhibition to the slaughter-house. While London and Paris are, for English-speaking readers, familiar

territory in the history of nineteenth-century art, Italy is far less known. In close intertextual readings, Flint enables us to understand how the (already startling) paintings of bodies by Pusterla and Segantini participated in what was understood to be political rebirth in a unified Italian state.

The factual and documentary – whether it be horse-breaking or the drinking of fresh blood for the cure of chlorosis – are explored in this section not merely as a social history of representation of the low, the extraordinary or the bizarre, one more manifestation of what might be understood as a nineteenth-century search for ever-more-novel subjects. Rather they are analysed as procedures and rituals which assume profoundly mythicising functions through a range of representational practices verbal and, more particularly, visual. These practices transform documentary reportage – one of the ostensibly overwhelming features of middle-class urban experience in the second half of the nineteenth century – into layers of myth within which the contradictory definitions of femininity (as at one and the same time reassuring and disturbing, confining and liberating) can be anchored. Animals, as Chadwick points out, serve as important intermediaries in urbanised society. Moreover, one of the sites in which the perceived damage of urban culture was understood to be registered was the body of woman, whose fertility and maternalism (as Flint demonstrates) were feared to be at risk.

The special position occupied by the body of woman in a binary opposition between nature and culture is now a familiar (and arguably oversimplified) trope. Some of the important anthropology-based literature in which this gendered dyadic construction has been explored has informed the essays in this section and is listed in the bibliography. By addressing particular case studies in meticulously researched detail, Flint and Chadwick consider the relationship to nature and culture of the historically specific constructed category of 'the feminine' as visually predicated. In particular, the authors of this section consider animality and the feminine. How, for example, they ask, does the animal world through metaphor become a means of elucidating and articulating notions of how the body of woman should (must) function physiologically, socially and symbolically?

Animal painting has been a relatively neglected area of art-historical study; the energised and potentially explosive imagery of horse-taming, selling and riding, and the political implications of Pellizza's *Lo Specchio della Vita*, with its endless line of sheep, are presented here in ways that invite us to understand the representation of the animal world in this period as part of a network of imagery rather than as a separate genre. Here questions such as the cultural correlation between animal bodies and human bodies, and the apprehended similarities between humans and animals are addressed. Thus onto the horse's mane (as Chadwick shows) is

displaced the sexual fantasy of an ultimately desirable but intrinsically dangerous femininity. Similarly in Flint's essay we are invited to contemplate a spectacle in which, it is proposed, the physical health of nubile females is restored through ingestion of the blood of recently slaughtered animals.

Woman's body in these historically grounded texts is associated with incipient violence: the violence of sexual desire, of parturition and of punishment. The 'Wicked Mothers' of Segantini's painting of that title are unnatural and a threat to social order. So too, albeit in different ways, are those young women whose equestrian exploits in Rotten Row in the 1850s provoked the popular press to identify them as the daughters of stablemen, and deserving of whipping. In both cases discourses of uncontrollable animality, of the medical and of pathological aversion are mapped onto the woman's represented body. At the same time, we are reminded that what is under discussion here, as with the works discussed by Berman and Hatt in Part II, are paintings shown in academies and large-scale public exhibitions. Through a series of powerful elisions that leave little untouched, we are shown how a regime of proverbs which so often involves the animal estate penetrates the discourse of science (as with Lombroso's work discussed by Flint) and how it furnishes a field of humour in the cartoons of Leech and others in *Punch* (discussed by Chadwick). This alerts us to the survival of ancient forms of encoding in what may at first sight seem discourses primarily of the modern.

The female body whether at one with (because mounted on) man's best companion, the horse, or opened up to clinical examination and speculation, precipitates a series of slippages in meaning that can be seen to render uncertain the boundaries of gender and class. So the idea of the equestrian woman with its powerful and dangerous sexual connotations must be inverted into the woman as mastered and bridled, the body in thrall. Comparably the menstruating female body, as Flint points out, while it marks out the human female as a higher evolutionary form than the animal, also hints at her capacity for monstrosity. The identification of virtue or vice via the female body as sign is, as has now been extensively acknowledged, a major preoccupation of the mid to late nineteenth century. The visibility of prostitution and the fear of contamination were major determining factors in the cultural and political life of the nineteenth-century city. Bearing in mind the legislated structural relationship between the bourgeois body and the female body as item of exchange value, the authors here examine how the impossibility of securing woman's body within social and philosophical boundaries generates a struggle for the mastery of metaphor. It is this struggle that is the topic of this section.

The fine art of gentling: horses, women and Rosa Bonheur in Victorian England[1]

WHITNEY CHADWICK

By the end of the 1850s Rosa Bonheur's *The Horse Fair* (Plate 19), first exhibited at the Paris Salon of 1853, was the most famous animal painting in England and America. Loosely based on a range of sources – from the rearing horses of Géricault and the Parthenon frieze to the rural scenes of Paulus Potter and Jacob Cuyp – Bonheur's spirited procession combines the romantic naturalism of the Barbizon painters, the realism of seventeenth-century depictions and the traditions of English sporting painting (Ashton and Hare 1981, pp. 82–9). Although unrivalled in its depiction of the power and beauty of the draught horse in motion, the painting is far more fanciful than traditional readings indicate. Bonheur constructs her subjects less as plodding beasts of burden than as mountains of horseflesh, their muscles rippling under a dappling play of light from above, their attendants straining to control the composition's centrifugal thrust (Sterling and Salinger

19 Rosa Bonheur, *The Horse Fair*, 1853

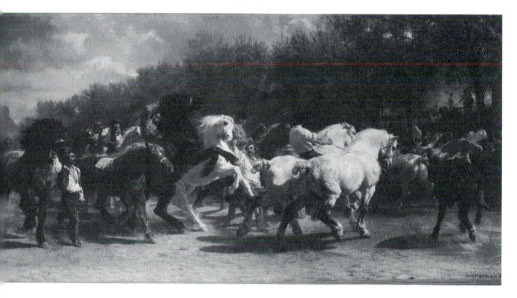

1966, pp. 160–4). Behind the struggling men and horses, the tower of the Salpêtrière Asylum rises against the early-morning sky above the Boulevard de l'Hôpital, site of the Paris horse market where Bonheur had begun drawing from life in 1851.[2]

There is little here that can account for the multiplicity of readings that finally secured the painting's reputation as the foremost animal painting of its day, and Bonheur's reputation as the most admired woman painter of the nineteenth century. Bonheur's artistic success has been 'explained' in a variety of ways: as a result of the popularity of animal paintings in mid-Victorian England and the appeal of her accessible realism to middle-class audiences; or by the growing middle-class demand for reproductions of sentimentalised scenes of children and animals for domestic interiors and the canny manipulation of the new market by the London art dealer Ernest Gambart who in 1854 purchased the painting and supervised its engraving; or by Bonheur's exceptional status as a female painter of monumental canvases. Yet none of these explanations can account for the complex ways that critics and public formulated and conveyed their responses to the work when it was exhibited in England in 1855. Nor do they illuminate what set Bonheur apart from other well-known and respected animal painters, such as Edwin Landseer, or other gifted and exceptional women, like the American sculptor Harriet Hosmer.

My interest in the painting centres less around issues of artistic intentionality at the site of its production (Paris, 1852) than in how audiences constructed its meanings at one of the sites of its consumption (England, 1855). My main argument is that Bonheur's images of horses, first praised for their naturalism, underwent dramatic shifts in signification as they circulated within broader social formulations. Rather than reflecting a given reality, they instead reveal how representational practices function to mediate cultural ideologies and social meanings. I am using the term 'ideology' in its Althusserian sense, as a set of beliefs reconciling the imaginary relationship of individuals to their real conditions of existence, in order to show how visual images become embedded in cultural ideologies, practices and institutions. I am concerned with what roles these, and related, images of horses played as symbolic sites at which struggles for authority occurred in mid-nineteenth-century Britain. And I want to explore how the image of the horse – by means of metaphor or synecdoche – assumed a place within ideological struggles aimed at securing cultural control over a nature understood as unrestrained and violent, and including the potentially disruptive sexuality of women. Without claiming for Bonheur conscious knowledge of the sexed, classed and gendered meanings assigned to the painting by an English public, it can nevertheless be shown that Victorian audiences were prepared to assign a wealth of complex, and often contradictory, meanings to images conflating horses, men and/or women. Moreover, such images are seen to gain currency precisely because their meaning is not fixed or determined, but instead allows a symbolic playing out of the narratives through which social meanings are constantly negotiated.

Images of horses as metaphors were indispensable in an age dependent on the horse for everything from labour and transportation to recreation. Even today, in an era which has banished the horse to the fringes of recreational life, metaphors that have their roots in such nineteenth-century commonplaces as the expression 'seizing the reins of power' are reformulated in images like the one that opened a *New York Times Week in Review* article in 1990 with the words 'This is an extra-ordinary summer in international affairs, a summer when the leaders of the West are trying to keep the mighty steed of change from galloping away from them, trying to tame it and guide it' (8 July, p. 1). The use of metaphor encourages a loosening of fixed meaning and an acceptance of ambiguity. The ability of meta-phor to open up a linguistic space within which renegotiations between the self and the external world may take place depends, however, on choosing images with broadly shared social meanings. Within nineteenth-century culture, images of horses had multiple significations in reality. They were beasts of burden *and* signs of affluence and status. While they might evoke images of human brutality (when, for example, they appeared in parliamentary inquiries into the horrible conditions of London cart horses), they also functioned as signs for compassion and humanity in the tradition of Swift's houyhnhnms in *Gulliver's Travels*. Changing contexts identified them variously with repressed sexuality – or moral standing – or instinct, passion and/or control of the senses. Moreover, the often-repeated anecdote concerning Napoleon III's response to *The Horse Fair* in 1853 suggests that images of horses and images of women were closely identified in the male imagination, and that sexuality was readily displaced from representation of woman to represen-tation of horse to mental image of both. According to the anecdote, as the Emperor turned from admiring *The Horse Fair* to contemplating Courbet's provocative *Nude Bather*, he rapped the offending buttocks with his riding crop as if the flesh of woman and the flesh of horse were one and the same under man's controlling gaze. 'Is she a Percheron mare too?' inquired the Empress, making yet another set of assumptions about horses and sexuality (Riat 1906, p. 104).

That Bonheur's imagery functioned ideologically from the beginning is clear from the painting's reception in France.[3] Its appeal to a Utopian socialist vision glorifying nature and the harnessing of animal power for productive rural labour has been well documented (Boime 1983). The painting also had more personal meanings for its creator, and Bonheur herself offered insights which move us from its ideological connotations for a politically and artistically conservative regime to initial considerations of gender and the nature of subjectivity. Like Géricault, whose paintings of horses she admired, and whose *Race of the Barberi Horses on the Corso* (1817) also develops the theme of bodily conflict between man and beast (Eitner 1983, pp. 98–135), Bonheur identified the horse with the passions. Asked towards the end of her life whether her father's impetuous temperament was recorded in her paintings, she responded in the affirmative: 'This reflection of my father's cast of mind is quite evident in my picture *The Horse Fair* . . . and [again in]

The Duel . . . An artist may become the victim of his [*sic*] nature, but I know how to resist and dominate my mood. I try to bend and compel it, and make it subject to the claims of the picture I am painting' (Klumpke 1940, p. 60).

Comparing the finished painting with its preliminary drawings (Plate 20) provides a representational analogue to Bonheur's verbal description of how an artist 'bends' nature to 'the claims of the picture', revealing the means through which the artist transformed the horses' undramatic trotting gait into a romanticised expression of coiled energy and motion. In the drawing, the motion is forward and extended as in nature; in the finished work, the horses' hooves spring higher from the ground and the upward thrust is expressed in the taut musculature of croup and shoulder. This degree of flexion and elevation through the hock is something normally induced artificially by a rider to store energy within the frame of a horse. Here it serves to articulate the power of these labouring beasts under a play of light that sculpts and etches muscles and tendons.

The linking of passion, horses, masculinity and artistic practice is, however, confounded by the fact that here the artist is not a man, but rather a woman who has assumed that aspect of a socially constructed masculinity associated in her mind with artistic agency. James Saslow's convincing argument – based on photographic comparisons – that the mounted figure in blue at the centre of *The Horse Fair* is a self-portrait of the artist points towards the radical nature of Bonheur's intervention into nineteenth-century visual and cultural constructions of femininity and masculinity (Saslow 1992). Shown in repose, the face shadowed by a visored cap, the artist who donned male dress in order to work unmolested in the public, and masculine, spaces of the horse market, assumes the central and controlling position both inside and outside the frame, as compositional anchor and as commanding artistic presence.

20 Rosa Bonheur, *Study for The Horse Fair*

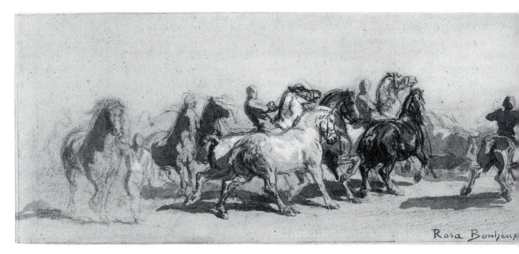

The Horse Fair arrived in London on 16 July 1855, accompanied by the 34-year-old artist. Already situated within a web of meanings, it would acquire still more in London where it was met by a public that believed itself uniquely qualified to render decisions on representations of equine life. The painting was destined for Ernest Gambart's exhibition of French painting which had opened in May. There it remained until 5 September when Queen Victoria ordered it to be brought to Buckingham Palace for a private view. It then began a tour of provincial cities that included Glasgow, Birmingham, Manchester, Liverpool and Sheffield (Maas 1975, p. 76). At each stop large crowds gathered to marvel at the display of equine energy and at the fact that a woman had dared to paint so 'masculine' a picture. 'It consists of a group of horses, of the cart breed', noted the critic of the *Morning Advertiser* (23 July 1855) (Bois-Gallais 1856, p. 50), 'and is painted with a truth, spirit, and power, that would be wonderful in a man, but coming from the pencil of so young a woman is truly marvellous.'

It is clear that, unlike many British horse paintings of the eighteenth and nineteenth centuries, Bonheur's draught horses signified neither the wealth and social status of their owners (as did the horses of George Stubbs and Francis Sartorius) nor the leisured pursuits of a landed gentry amusing itself at racing or hunting (George Morland and George Morley). And although contemporary British painting included representations of the horse market – among them genre scenes like Edward Walter Webb's *Barnet Horse Fair* (1849) or, slightly later, placid rural depictions by Benjamin Herring, Junior (*Going to the Horse Fair* (1960)) and J. F. Herring (*The Horse Fair on Southborough Common* (1957/8), both reproduced in S. Mitchell) – it was not with this tradition that English audiences identified Bonheur's painting. Instead they saw it as an epic struggle, one in which man's battle to secure control over powerful beasts symbolised a more generalised contest aimed at asserting cultural domination over untamed nature. It was into this conflict, initially understood within the polarities man/beast, nature/culture, that the term woman would soon be inserted.

An anonymous poem, privately published in 1857 under the title 'The Critic Foiled at Rosa Bonheur's Great Horse Fair', details its author's progression from scepticism to awe at the artist's ability to elucidate 'every characteristic belonging to, and every *passion* [author's italics] of which the horse is susceptible'. He (?) then returns to the central dilemma posed by the painting: the complex interrelationship between man and beast, understood as a battle between nature and culture resolvable here through the artist's ability to transform matter (nature) into art (culture):

> Yet this same brute, to Nature true,
> Was stubborn proof what Art could do!
> For though no *rein* could curb his nature,
> Or *gentle* make a vicious creature,
> Full many connoisseurs would buy
> This wilful *chestnut* for his *eye* . . .

Near him a wayward stallion rear'd,
By all (save by the rider) fear'd –
His up-tossed head – his hoofs in air,
Suffic'd to show what he would dare
If once he burst from man's control,
And roam'd at large with fiery soul?[4]

Execrable verse it may be, but the image of rampaging horses about to terrorise the land unless subdued by man emerges with apocryphal clarity. The narratives which this and other writers and spectators wove around *The Horse Fair* reinforced dichotomies whose sources lie in Plato's distinction between the white horse of reason and the black horse of passion, and which are reiterated throughout Western literature from the Renaissance to the nineteenth century in traditional images of the mind as a horse and rider in which the dominant will enforces its desires on its steed, the physical body (Shuttleworth 1986, p. 274). The place of the horse within the binary oppositions of Western culture made this image particularly susceptible to nineteenth-century insistence on models of difference and opposition (man/beast, nature/culture, masculine/feminine); at the same time, the use of the horse as metaphor often served to destabilise these same pairings, opening up an imaginative space in which reformulations might take place.

Terms like nature and culture are historically specific (Pilkington 1986, 51–85). Behind each of them lies a complex set of meanings through which cultural hierarchies and relations of power were produced, reinforced and sometimes contested in the nineteenth century. Alex Potts has demonstrated the ways in which nineteenth-century scholarship was characterised by the radical separation of the natural and the social orders (Potts 1990, p. 16). Positivist science constructed 'nature' as an untamed biological reality distinct from human culture (p. 12). Aesthetic theory produced a social being (the artist) whose skill could mediate between nature, constructed as untamed but malleable, and culture, the latter bound up with ideas of human perfection; 'The animals, although full of life and breed, have no pretensions to culture', noted one critic of *The Horse Fair* (Bois-Gallais 1856, p. 46).

Other critics emphasised the contrast between horses unrestrained in nature and those brought under the hand of a 'master', an artist with 'touch as firm as it is masterly' (Bois-Gallais 1856, p. 45).[5] Contrasting 'rebellious' and 'vicious' horses with 'mounted horses in good training, well-disciplined', critics returned again and again to the fact that although the horses were all either ridden or led into the market-place, the scene conveyed an ever-present threat of disruption, of loss of control. 'The spectator is attracted first by a superb black horse rearing in the centre of the group . . . the fiery eye and the quivering haunches of this powerful creature indicating a fierce struggle for mastery with this rider, whose raised arm and heavy whip shew that the contest is not yet over' (Bois-Gallais 1856, p. 45).

Initial responses to the painting in England seem to confirm Alex Potts' conclusion that in the nineteenth century animal paintings functioned as a symbolic arena

in which 'irrational social and psychological forces repressed by the dominant ideology of the period could find indirect expression' (Potts 1990, p. 20). Critical reception of *The Horse Fair* in England reveals that nineteenth-century belief in a social order constantly threatened by powerful external forces found a perfect metaphor in images of the horse, an animal at once large and powerful, physically stronger than man and socially productive only when bent to human will.

Critical readings of *The Horse Fair* were complicated, however, by the fact that the interplay of oppositional pairs through which its meaning was produced, and on which the category artist/masculine depended, were made unstable by the fact that the artist was a woman. Shifts in the critical language occasioned by this fact are everywhere apparent. 'It is not only a complicated representation of animal life', wrote the critic of *The Sunday Times*, 'executed with wondrous force and precision, but it is a grand composition, pervaded by a manly thought, which could hardly be conceived possible in a work executed by a female hand' (Bois-Gallais 1856, p. 55). 'The composition . . . has an ease, a vigour, and a variety nothing short of masterly', noted *The Athenaeum*; while *The Morning Post* pointed to 'an elevated feel for nature, and a well-practised and an obedient hand of masculine power' (Bois-Gallais 1856, pp. 56, 44).

That nature (passion/temperament) might be brought under control by a 'feminine' hand was inconceivable within an aesthetic discourse in which masculinity served as the agent for the transformation of nature into culture. Bonheur may have been a woman who painted like a man (Boime 1981), but critics were quick to surround her person with images of middle-class femininity, as if to reassure a middle-class public that her assumption of agency was only a masquerade. During her London visit, she was frequently commended for her modesty, her reserve, and her small and delicate hands and feet (Eastlake 1895, vol. II, pp. 42–8).[6]

Sorting out the place of the woman artist within ideologies that naturalised artistic creation as masculine was only one of the challenges facing a public enthralled by *The Horse Fair*. The representation of domesticated animals at mid-century was also inextricably bound up in rapidly changing social attitudes towards relations between humans and animals. Ruskin's criticism of Bonheur for failing to establish a link between human and animal through the representation of affective bonding ('if she cannot paint a man's face, she can neither paint a horse's or a dog's', *Works*, vol. XXXIV, p. 641) reveals his debt to social ideologies embedded in the changing relationship between the natural and the social orders at mid-century. Stressing the innate nobility of animals when they have not been sentimentalised or manipulated by invasive breeding practices like those which emphasise single characteristics such as speed in the race horse (*Works*, vol. IV, p. 161), his call for a natural order enhanced and ennobled through the artist's hand became a cornerstone of mid-Victorian aesthetics. As urbanisation, accompanied by technological and scientific advances, transformed previously rural lands and economies, animals like the horse became essential intermediaries between humans

and the natural order. As nature became increasingly romanticised in the light of its rapid transformation through industrial expansion, animals assumed ever greater value as emblems of feeling linking humans with nature (Ritvo 1987).

The complex relationship between sympathetic concern for animals, the assumption of moral responsibility for their welfare and the manipulation of human feelings formed the basis of a series of mid-century reform campaigns from that of the humane society to anti-vivisection and women's rights. As both Harriet Ritvo and Coral Lansbury demonstrate, women and children were directly implicated in the new social location of concern for animals, and the new identification with animals on the level of sympathetic feeling.

Projecting human feelings onto animals represented one way of relocating animal nature within the social realm. It was, as we shall see, a small step from symbolically bringing animals/nature into this arena to using animal images (especially horses) as metaphors – in discourses ranging from gynaecology to pornography – for the reinforcing of unequal relations of power privileging 'culture' (male) over 'nature' (female).[7] At the same time that critics were responding to *The Horse Fair* as an expression of conflict between man and nature, reformist campaigns were presenting the humane treatment of animals as a sign of the individual's ability to control the baser animal instincts. Animal exemplars became increasingly implicated in the ideological processes through which women and children were socialised and femininity constructed as distinct from, yet dependent on, the masculine sphere of influence. In the years that witnessed the founding and consolidation of the British Society for the Prevention of Cruelty to Animals (1824 to 1835), children were insistently pursued by exhortations on the duty of kindness to animals.[8] Women were also constantly urged to rise above their animal natures and supplied with a variety of animals with which to identify their instincts. Poems like Elizabeth Barrett Browning's 'Aurora Leigh' (1856) and paintings like Walter Deverell's *A Pet* (exhibited at the Royal Academy in 1853; Tate Gallery, London) made explicit the structural relationship between caged birds and domesticated femininity. The ideological production of middle-class femininity around notions of control over the instinctual life, and the social construction of woman as the opposite and other of man, depended on images that symbolically secured femininity as both dependent and needing the control of the dominant social group.

The 'scientific' language that in the nineteenth century positioned the horse in a new relationship to man's control (Potts 1990, pp. 15–16) bears an uncanny similarity to the language which constructed gender around the ideology of 'separate spheres' described by Leonore Davidoff (1976) and Catherine Hall (1979). Thus Thomas Pennant, in *British Zoology* (1812, vol. I, p. 11), explains that the horse 'is endowed with every quality that can make it subservient to the uses of mankind, including courage, docility, patience, perseverance, strength, benevolent disposition, and a certain consciousness of the services we can render them' (Ritvo 1987, p. 20). The ideal middle-class woman, we are assured over and over again,

should be docile, patient, persevering, benevolent, etc. Or, in the words of *The London Review*, 'High-minded, noble, delicate, trusting to her instincts ... glad to live in her affections – glad to be the recipient of strength and the giver of purity ... loving, giving, self-devoted' (Nead 1988, p. 24).

The ideal woman, like the ideal child or the ideal horse, is a fiction. Yet within mid-Victorian culture, social order rested in part on a belief in the wisdom of curbing all three – horses because they were strong and often unpredictable (and economically useless unless trained to the bit), women because their powerful reproductive forces were often linked to nature, children because their maturation and assumption of gendered roles within culture depended on control over an infancy dominated by the instinctual life and often identified with the animal.

Often it was play and/or fictive identities which allowed the symbolic expression of the processes through which such control was believed to be secured. John Leech's cartoon, 'The Nursery Four-in-Hand Club – The First Meet of the Season', published in *Punch* in 1864 (Plate 21), combines images of nature, domesticity, women, children and horses to produce a strong, but coded, social message. What makes this cosy domestic scene – with its little boys and girls playing horses and

21 John Leech, 'The Nursery Four-in-Hand Club – The First Meet of the Season', illustration from *Punch*, 1864

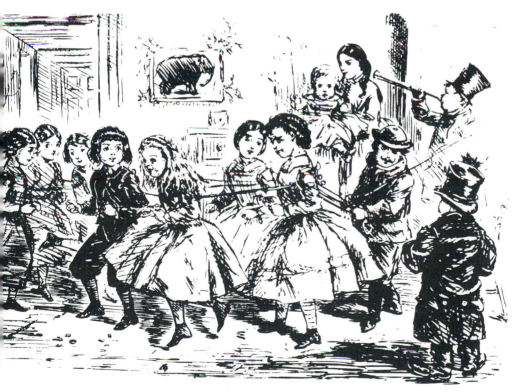

coachmen – remarkable is its peculiar verbal and visual combinations. The text ('Here, James, just stand by that bay filly – she's rather fresh this morning') places a playful scene within a discourse of disruption/order and control in which the bodies of horses and women are collapsed under the sign of masculine dominance. Signs of the well-ordered household – site of socialisation and moral training – abound, but the enthroned image of domesticated femininity is juxtaposed with a print or drawing of an elephant, a wild animal by this date known primarily in London through the containing and reconstructing of the natural realm in social spaces like the zoo at Windsor Park.

Leech's cartoon speaks directly to the role of children's games as rituals of socialisation defined through assertions of control over the instinctual life; it speaks also to the importance of horsey imagery in the symbolisations of Victorian fantasy life. That the cartoon appeared just three years after the exhibition of Edwin Landseer's *The Shrew Tamed* at the Royal Academy in 1861 (Plate 22), one of the nineteenth century's most ambiguous, sexualised images of women and horses, hardly seems coincidental.

It may seem to require a fair leap of faith to get from Leech's nursery to Bonheur's horse market, and from there to Landseer's odd reverie. But Bonheur herself was not unaware of the multiple meanings assigned to the horse in its

22 Edwin Landseer, *The Shrew Tamed*, 1861

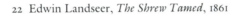

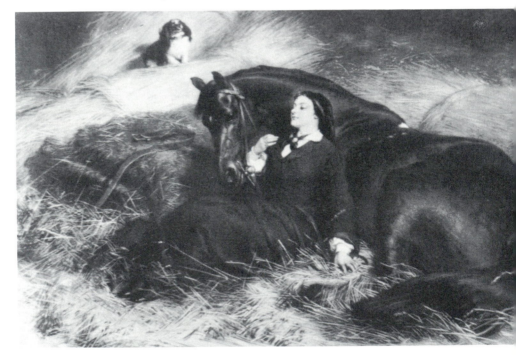

identification with human life. Not only did she inscribe herself at the centre of *The Horse Fair*, she was an avid collector of the horse paintings of Alfred de Dreux, the nineteenth-century French painter who appears to have most fully explored the symbolic identification between women/horses/sexuality (Doin 1921; *Alfred de Dreux* 1988). Among the works in Bonheur's collection at her death were twelve by de Dreux, including several on the theme of the mounted equestrienne, or *amazone*, and her horse (*Atelier Rosa Bonheur* 1900). De Dreux, like Géricault, had lived and worked in England, and was both influenced by, and in turn influenced, the course of British horse painting in the nineteenth century. The theme of the mounted *amazone* was often little more than an excuse for depicting a fashionably dressed young woman out riding (see, for example, Géricault's *Amazone* (c. 1820), The Metropolitan Museum of Art). In other cases, however, the theme is elaborated into a courtship narrative or implicit sexual encounter often wrapped in a romantic fantasy evoked through castles, love letters, lonely waits and sorrowful partings. Bonheur's collection of *amazone* paintings by de Dreux included *The Meeting*, *The Lady of the Castle on Horseback* and *The Amazon on a Rearing Horse*. In some of the many variations on the theme, women and their horses, often accompanied by dogs, wait in hidden copses and forest glades in attitudes of dreamy anticipation. In others, however, the work's sexualised content is more heavily underscored. In de Dreux's *La Fuite* (Coll. Joseph Reinach), a mounted couple race side by side across a field. As they lean towards one another to exchange a kiss at full gallop, their horses do likewise. Passion and excitement converge in the fury of the race and the somewhat ludicrous embraces.

De Dreux's *amazones* also provide the most likely artistic source for Landseer's *The Shrew Tamed*, which repeats the convention of woman/horse/dog captured at a moment of dreamy reverie. One of the most popular and controversial works in the Royal Academy exhibition of 1861, Landseer's painting, however, also points towards shifting relations within the social territory of gender relations, female sexuality and masculine dominance at mid-century. Moreover, it identifies the image of the horse and its sexuality as a fluid sign – at times masculine, at others feminine – within mid-century constructions of gender. The painting, now lost and available only through the engraving, depicts a glossy chestnut horse lying docilely on a bed of straw in a stable and turning trusting eyes towards the young horsewoman who reclines gracefully against its flank.

The Athenaeum described the work in terms immediately recognisable from earlier critical elaborations of the imagery of *The Horse Fair*:

The mighty agile sweep of the animal's limbs, his glossy muscle-binding hide, all a-shine with health and horsehood; the powerfull hoofs, the eye of subdued fire, the strong, unmastered neck, that turns, graceful in its vigour, towards the slender lady reclining fearless among the dreadful feet as if there were no more harm in them than in her own, that peep, daintily brodequinned, beneath the blue riding-robe's edge. (Nead 1988, p. 59)

While the *Athenaeum* critic saw the horse as male, others refer to a young woman

with her 'mare'. Setting aside the sex of the horse for a moment, however, if the battle is really over and we are looking at a tamed version of Bonheur's painting, then something must have changed in relations between horses and humans between 1856 and 1861.

It is the critic for the *Annual Register* who provides the first clue, referring to the painting as 'a master-work of that skill in animal painting which has placed Landseer at the head of his art ... just tamed by Rarey's system ...' (1861, pp. 65–6). The reference was to the sensational American horse-breaker, James Samuel Rarey, who arrived in England in 1858, the year of the publication of his *The Art of Taming Horses*. Rarey's method consisted of immobilising the horse by raising one of its forefeet off the ground by means of a leather harness or strap, then casting it into a bed of deep straw. The horse was then 'gentled' by a combination of voice and touch known only to Rarey (but later available to paid subscribers; this stage was always conducted in private). The previously vicious or unmanageable horse was then shown to the audience (Plate 23), subjected to loud noises and other distractions and proved to be totally under Rarey's control. Rarey's methods caused a sensation in a culture in which the more common method of horse-breaking

23 'Exhibition by the American Horse-Tamer in the Presence of Her Majesty and the Court, at Buckingham Palace', *Illustrated London News*, January 1858

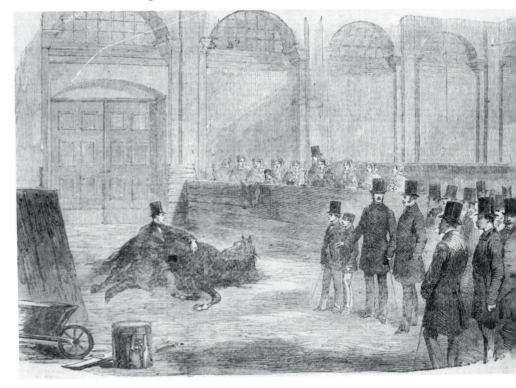

involved riding the untamed horse until it was subdued, or 'broken' and 'mastered' in common parlance. During his stay in London, Rarey demonstrated his technique on stages before large audiences of incredulous viewers, as well as at Buckingham Palace for a smaller, though equally rapt, royal gathering.

Rarey's exoticism can be traced in part to the fact that the sources of his method lay outside Western European conventions, deriving instead from the practices of Native American tribes who had long depended on 'gentling' rather than 'breaking' horses. Nevertheless, the spirited debate over his method in the popular press indicates the extent to which many were unwilling to concede the need for brute strength and a strong will in animal management. An article in *The Illustrated London News* in January 1858 underlined the fact that Rarey's system was innovative in its treatment of the animal: 'The principle on which Mr. Rarey goes is one of extreme kindness and tenderness towards the animal, the object being to convince him that man is his natural master and friend, and to elicit his confidence and kindly regard.'

Rarey's challenge to the conventional master/slave relationship between man and horse resonated uneasily within a culture that was also witnessing increasing challenges to male authority in other areas of social relations. During this period of rapid social change, when middle-class women were beginning to gain access to professional training and higher education, and assume more active public roles through their growing participation in social reform movements, Rarey's challenge to normalised relations of dominance and submission between men and horses was quickly transferred to the domestic arena. Popular illustrations, many of them anticipating themes set in motion by suffrage campaigns which begin in the 1860s and peak during the Edwardian era, make vividly clear the disorder sure to result in the middle-class home if men abandon positions of authority which they have secured through institutionalised relations of power. One 'Result of Allowing Ladies to Witness Rarey's Horse-Taming Exhibition' is a *Punch* cartoon of 1858 in which the household is in an uproar when the wife refuses to stay at home; in another (*Punch*, 1859) (Plate 24), titled 'Husband-Taming', the application of 'Rarey's method' at home leads to role reversal as two young women in riding habits prepare to abandon a spouse to the vicissitudes of child-care.

Relations between man and horse had long been a subject of popular cartooning and social commentary. 'Poor Tom Nobby', whose misadventures at the hands of his mounts were a regular feature in *Punch* during the 1850s and 1860s, is a constant figure of humiliated masculinity as he is kicked, thrown over fences ahead of his horse and ignominiously dumped in ditches in the presence of attractive young women. But if Tom Nobby was the eternal poor fool at the mercy of his horse, by the 1860s popular illustrations were regularly recording the threatening aspects of women's expanding social roles. As middle-class women began to participate in leisure activities like recreational riding and fox-hunting, images of horses and women increasingly spoke of perceived threats to the construction of gender along

clearly separate and demarcated lines which emphasised feminine passivity and timidity. Membership in hunts grew dramatically in the late 1850s and 1860s as fox-hunting became a weekend activity attracting the newly wealthy from urban centres (Davidoff 1973, p. 29). As young women began taking an active part in hunts rather than just appearing on the hunt field as spectators, cartoonists like John Leech began to project the threatening spectre of women leaping social and sexual barriers as if they were fences. In 'Across Country' (*Punch*, 1864), a young woman spurns her father's offer of an open gate with the words, 'All right, Papa Dear. You go through the Gate. I think "Crusader" prefers the fence.' 'Crusader' is, of course, no name for a lady's mount and the woman who masters him may be less a woman than the spectre of the cross-gender figure against which Queen Victoria inveighed in a letter to her daughter reporting that Lady Charles Ker had been gravely injured in a riding accident. 'May it be a warning to many of those fast, wild young women who are really unsexed', she noted repressively. 'And to the husbands, fathers and brothers who allow their wives, daughters and sisters to expose themselves in such an unfeminine way' (Fulford 1976, p. 30).

Riding was an exception to the fact that sports which took place in public were

24 John Leech, 'Husband-Taming', from *Punch*, 1859

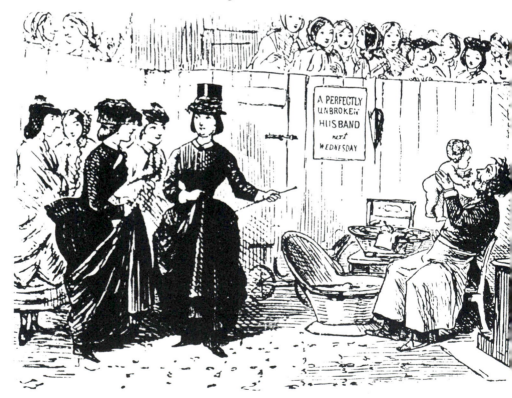

almost exclusively male (Wolff 1990, p. 22); and it was one area of social life in which young women often found release from restrictive social ideologies. Nevertheless, should they embrace the freedom it offered too wholeheartedly, they risked incurring the label of deviant that pursued women in public spaces throughout the nineteenth century. Women who rode too boldly were not only in danger of being labelled 'unfeminine'. The metaphoric slippage between women and horses was also elaborated in terms of that aspect of women perceived as most in need of control, i.e. their sexuality. To the extent that female sexuality was understood as animal nature in need of control, it also provoked powerful identifications with the image of the horse as sign of a nature viewed as productive only when it was submitted to the control of man. Lynda Nead and others have pointed out that the sexualised content which contemporary audiences perceived in Landseer's *The Shrew Tamed* derived from a widespread belief that 'the pretty horsebreaker' was none other than 'Skittles', or Catherine Walters, one of London's best-known courtesans and a respected horsewoman.

By 1861, when *The Shrew Tamed* was first exhibited, Catherine Walters was one of the most visible of the prostitutes known as 'the pretty horsebreakers' who rode in Hyde Park's Rotten Row (Blythe 1970). Barred from circulating in the park on foot during the day, they joined the growing numbers of suitably attired women who displayed their equestrian skills along the so-called Ladies' Mile. Opinion was divided as to whether the 'horsebreakers' were a harmless part of the spectacle of young urban Londoners astride, or a sign of the social evils of prostitution. It was clear, however, that at least as far as Rotten Row was concerned older class and social distinctions were no longer so easily maintained at the visual level. The fact that prostitutes could not always be distinguished from respectable women on the basis of dress or equestrian skills, that sexuality was often displaced onto images of horses, and that images of horse and woman often raised the spectre of uncontrolled female sexuality, led to a body of images rich in provocative meanings.

The narrator of a prose piece which appeared in *London Society* in 1862 is an English *flâneur* wandering in Hyde Park and recording the sights that pass before his eyes. Pausing to admire a young woman whose appearance draws admiring glances, he evokes her beauty through comparisons with her mount: 'She has rich wavy hair – this lady on the chestnut, hair of a light golden-tinted brown – something like her horse's – with a long undulating wave in it; not knocked up and down in abrupt hillocks, as if it had been plaited up tight overnight to its own destruction, but just undulating gracefully in long waves . . . ' (February 1862, pp. 1–8). More is being evoked here than fashion; hair as loose as a horse's mane becomes a telling synecdoche for unrestrained female sexuality.

Alfred Austin, in a satirical poem entitled 'The Seasons', also relied on the tropes of hair/mane/restraint/abandon to invoke, and then condemn, the immorality flaunted along Rotten Row:

With slackened rein swift Skittles rules the Row;
Though scowling matrons champing steeds restrain;
She flaunts propriety with flapping mane. (*London Society*, February 1862)

Scowling matrons, holding their horses to a respectable pace, reappear in 'Groundless Alarm', a *Punch* cartoon of 1861 in which a stout, middle-aged and irrefutably respectable equestrian holds a hat up to her female companion with the words: 'Do you know, love, I'm rather sorry I got this hat; for suppose I should be taken for a Pretty Horsebreaker!'

The evocation of unrestricted female sexuality through images of horses and women incensed many guardians of public morality and they responded much as had Napoleon III the previous decade. When horses test the limits of human mastery, they are often beaten; there seemed to some critical imaginations no reason why women or youth whose behaviour offended should not meet with the same fate. Youthful excess seems to have been the crime for which Alfred Austin was chastised in *The Athenaeum* (20 April 1861), though in this case it appears to be the poem which is about to be flogged. 'We do not deny', bristled the critic, 'that many vices of "The Season" [*sic*] may need lashing with a whip of fire, and that it is very tempting to see them stripped almost naked for it . . .' An editorial in *The Daily Telegraph*, addressing the scandal of women flaunting propriety on Rotten Row, was even more pointed. Its author explained that despite the fact that many of 'these shameful creatures' were handsomely dressed and mounted by their male patrons, most were rural young women, often the daughters of stablemen, and deserved nothing less than the whippings handed out to recalcitrant women 'in the old Bridewell days' (Blythe 1970, p. 92).

The fact had not escaped reformers at mid-century that in places like Bridewell women offenders were treated very much like animals; and that middle-class woman's relationship to man was one of economic, legal and ideological dependency (Nead 1988, p. 14). The independence of the courtesan, who controlled her spirited horse with style and also earned her own income, was a threat not only to the moral order, but also to a social order that depended on being able to identify and contain her through widely understood and shared visual codes.

As women became the subjects of increasing, and often controversial, observation and scientific theorising, their sexuality became the link between a nature constructed as 'wild' and 'instinctual' and a subjectivity understood as 'sensible' and sympathetic. The language of a pornographic fiction that identifies women's bodies with horses in order to articulate them as sites for the exercise of male control bears an odd resemblance to the vivid imagery which emerges in the new medical science of gynaecology/obstetrics in order to naturalise a new relationship between male medical doctors and their female patients' bodies and sexuality at mid-century. Bonheur's fame in Britain thus coincided with a period of impassioned debate over medical control of women's bodies in gynaecological and obstetrical practice. The 'professionalising' of medicine as a branch of science at mid-century, pioneering

experimentation in female diseases, the emergence of gynaecology as a new medical speciality, the lengthy and often bitter battle between midwives and doctors for control over childbirth, first use of anaesthesia in childbirth, and the adopting of surgical procedures of hysterectomy, ovariotomy, perineal repair and other conditions all contributed to linguistic and metaphoric reformulations of the relationship between women and medical men. The many excellent studies that make up a growing body of feminist literature on women and science in the nineteenth century lie outside the present study.[9] My concern here is only with how its new metaphors functioned ideologically within the relations of dominance and submission I have been discussing. At the centre of the debates around childbirth lay the question of whether women in labour properly belonged to the realm of nature, which is governed by God, or to culture, where nature submits to man (Poovey 1988, pp. 137–68). Nowhere is this interdependence of body and spirit more forcefully expressed than in Dr J. G. Millingen's *The Passions; or Mind and Matter*, published in 1848:

If the corporeal agency is thus powerful in man, its tyrannic influence will more frequently cause the misery of the gentler sex. Woman, with her exalted spiritualism is more forcefully under the control of matter; her sensations are more vivid and acute, her sympathies more irresistable. She is less under the influence of the brain than the uterine system, the plexi of abdominal nerves, and irritation of the spinal cord; in her, a hysteric predisposition is incessantly predominating from the dawn of puberty. (p. 157)

A tendency to conceive the Victorian middle-class woman's body as a site of oppositional forces locates the body within the polarities of nature and culture. A debate over whether female sexuality should be understood as organised around ovaries or uterus raged through the 1850s in the British medical journal *The Lancet*. Arguing for the uterus rather than the ovaries as the seat of disease, Dr Henry Bennett assured his readers in 1856: 'The uterus is not a mere receptacle, a mere bladder, as has been asserted. Hippocrates was much nearer the truth when he called the uterus "animal in animali"' (22 March 1856). The question then became what is medical man's relationship to this uterine beast? It was not only men who conceptualised a female body at the mercy of nature. Queen Victoria, looking back on the experience of childbirth, was repelled by the image of an animal nature. In a letter to the Princess Royal, written in March 1870, she notes: 'What you say of the pride of giving birth to an immortal soul is very fine, dear, but I own that I cannot enter into that; I think much more of our being like a cow or a dog at such moments; when our poor nature becomes so very animal and unecstatic' (Wohl 1978, pp. 24–6).

A language of restraint invested in symbolic mastery over woman's 'animal' nature quickly developed among medical practitioners. Searching for images, they often turned to the familiar trope of the wild versus the submissive steed. Surgery on women that centred on the reproductive system with its potential for disruption was often performed with the stated goal of 'taming' a highly strung woman, while

the debate in *The Medical Times* in 1850 over ovariotomies referred to surgeons who performed the operation as 'gelders' (Ehrenreich and English 1972, p. 36). And although there was considerable debate over the most advantageous position for the woman's body in childbirth and gynaecological examination, by 1860 specific immobilising devices such as 'stirrups' were in use.

Immobilised (sometimes with restraining straps though these were most often used with working-class patients), her feet firmly planted in stirrups, the recumbent woman was not only at the mercy of the medical man, but of a medical imagination which found its metaphors as often in the stable as in the laboratory. Such formulations were not restricted to England; the American surgeon Augustus Kinsley Gardner, describing the causes and cures of vaginal tissue ruptured during childbirth in an article published in 1874 in *The Medical Times Union*, vividly communicates his feelings about gynaecological surgery on women:

How many of us have practically felt the strained perinaeum under our hand, and we have urged upon our patient to refrain from all voluntary expulsive efforts. But the jaded uterus, with a sudden burst of energy – like a fagged horse near to home, that takes the bit between its teeth, and spite of all attempts at restraint, rushes impetuously to finish its journey – defies all our efforts and the mother's uncertain will . . . (Barker-Benfield 1976, p. 288)

The widespread assumption that the bodies of women, like the bodies of horses, required frequent reining-in also aligns the language of gynaecology with that of pornography in their respective uses of metaphor. Pornography's most consistent motif is female emotion/sexuality expressed as an anonymous spirit 'whose curbing confirms the male user in enjoyment of his mastery' (Padel 1980; Lansbury 1985). An extensive genre of nineteenth-century flagellation literature equating the bodies of horses and those of women is not firmly in place until the 1870s and 1880s to judge from the publication of new works and the reissuing of a number of eighteenth-century 'classics'. Nevertheless, it is worth noting in passing that during the second half of the nineteenth century, flagellation increasingly focuses on young women whose hair and comportment is often compared to that of horses. And the images of horses are central to a fantasy which is as much directed towards the immobilisation and control of the female body as it is towards the flogging itself.

Among women known in London for running houses specialising in the practice of flagellation in the early nineteenth century, none was better known than Mrs Theresa Berkeley of Portland Place who lent her name to a device she invented and made in 1828 which came to be known as 'The Berkeley Horse'. Designed to immobilise the victim, it reappears, illustrated, later in the century in one tale printed in *The Pearl, A Monthly Journal of Facetiae and Voluptuous Reading*, a popular serial published between July 1879 and December 1880 (Dawes 1943). Moreover, the charges brought by the Society for the Protection of Females against a Mrs Sarah Potter in 1863 for flogging a girl 'against her will' led to an *exposé* which quickly circulated in the underground press. Mrs Potter apparently specialised in procuring young girls for her clients; the activities of her household are detailed in

Mysteries of Flagellation, or a History of the Secret Ceremonies of the Society of Flagell-ants, published in 1863 (Dawes 1943). Their bodies saddled, bridled, horsed and otherwise inscribed within the fictive arena of stable block and carriage, the submission of these young women is insured through the very methods overthrown by Mr Rarey in 1858.

The language of the new medical science of gynaecology, like that of the old fictional language of pornography, used metaphors of horses and women to position women and their bodies within specific and unequal relations of power. Images of horses and women consistently reinforced, or challenged, a dominant social order in which both were assumed to be subservient to man's will. At the same time, the exercise of power relations necessary to the maintenance of social order was not absolute or fixed. Continuous challenges had to be internalised and reformulated within its discourses, and metaphor played a critical role within these spaces.

During the 1850s and 1860s, Rosa Bonheur's *The Horse Fair* became embedded within debates that concerned the changing relationship between the natural and the social orders in Victorian England. English audiences saw in the painting a battle between animals wild and tamed. The process of bringing horses under the control of man also functioned as a metaphor within ideologies aimed at insuring the submissiveness of women and children. The means to this end, however, was open to challenge; new techniques for horse-taming – like that advocated by Rarey – intersected with new debates about gender and representation at mid-century. Dominant ideologies often constructed female sexuality around notions of its disruptive potential. For this reason metaphors of horses, and the need to control them, also entered discourses centred around female sexuality, such as those of gynaecology, prostitution and pornography. Imagery like that of *The Horse Fair* was concrete and also functioned metaphorically to express beliefs which could not always be directly articulated. The fact that when its metaphors reappeared in discourses like gynaecology and pornography they did so bearing the same meanings confirms that social meanings may intersect and be reinforced at a variety of points. The painting's critical reception, and the persistence of its metaphors within other discourses, also reveals the central role of visual images – including those of painting and sculpture – in opening up the symbolic spaces within which social meanings circulate and are constantly renegotiated.

8 Blood and milk: painting and the state in late nineteenth-century Italy

KATE FLINT

Attilio Pusterla's *La Cura di Sangue* ('The Blood Cure') (1891) (Plate 25) and Giovanni Segantini's *Le Cattive Madri* ('The Wicked Mothers') (1894) (Plate 26) are instantly striking pictures. In Pusterla's work, a group of young women visit a slaughterhouse to drink fresh blood as a remedy for their chlorosis. Its subject matter aligns it with other Italian Realist canvases, since it depicts a contemporary scene which implicitly criticises actual social conditions. Drawing on the domain of specific fact, it invites analysis in relation to current medical debates concerning women's bodily health. Segantini's painting, by contrast, is a fantasy. The women it shows hanging from trees, their apparently dead or dying babies at their breasts, seem simultaneously symbolic of those who would neglect their maternal instincts

25 Attilio Pusterla, *The Blood Cure*, 1891

and duties, and a projection of a desire to punish unnatural womanhood by exiling it from society to inhospitable snowy wastes.

Initially, these two works may be taken as symptomatic of the context for artistic values which took place in later nineteenth-century Italy (see Damigella 1981; *Arte e Socialità in Italia* 1979). Since the country's unification, essentially effected in 1861 and completed in 1870, the rhetoric of successive governments had emphasised the importance of developing identifiable Italian (as opposed to regional) styles within specific cultural practices. Simultaneously, artists were looking outside national boundaries to see what could be imported into their own methods of working in order to revivify painting at a time when the larger art schools taught little other than a tired academicism, and where the most popular pictures in exhibitions continued to be idealised genre scenes, portraits and traditionally treated historical and religious subjects. In particular, the technical theories of Chevreul and Rood, which also lay behind French Pointilliste developments, were introduced into Italy by the dealer, patron and artist Vittore Grubicy following his visits to Paris. These theories underpinned the development of Divisionism, a movement to which both Pusterla and Segantini could be said to belong (see Quinsac 1972).

The Divisionists were themselves something of a divided body. The primary concern of one grouping lay in how the eye sees light, and how human perception may be translated through the separation, juxtaposition and overlayering of colours on the canvas in order to represent the structuring of the visible world. This is how Pusterla and others such as Giuseppe Pellizza da Volpedo, Angelo Morbelli and Emilio Longoni employed their new scientific understanding. Yet divisionism could also be used to suggest certain mystical qualities, or to intensify a spectator's emotional response through indicating the luminous, atmospheric quality of a scene, and this was how both Segantini and Gaetano Previati used the division of tones. Individual artists, in other words, adapted the innovatory technique to the type of picture which they were already painting. As Pellizza remarked in 1896: 'Some people confuse the modern *Divisionism* with a school: it is not a school, it is closely linked to naturalism and forms part of it; it is nothing other than a technical means for reproducing, with colouring materials, the luminous vibrations of rays which go to make up light' (Pelissero 1977, p. 30). Vittore Grubicy worked tirelessly to convince both the public (through his journalism) and those in charge of government cultural policy (through his personal contacts) that those artists practising Divisionist techniques were showing a new direction in art which befitted an attempt to develop a new national consciousness. In the *Cronaca d'Arte*, he employed the fighting rhetoric of the Risorgimento as he urged artists to stop following traditional formulae and to employ new methods 'for the battles which art must fight in order to assert everything that is truly of our own time' (21 December 1890). But a case which rested almost entirely on technical innovation ensured that the subject matter represented still remained a critical area for debate.

There were plenty of works on show at these exhibitions which treated

traditional subjects in traditional ways. In 1894, for example, *Le Cattive Madri* could be considered alongside Amerino Cagnoni's *Gioie Materne* ('Maternal Joys'), in which a respectable, but not stylish young woman sits sewing, with her eyes fixed on the cradle at her side, the plants on her windowsill testifying to her genius in cultivation; or Alfonso Muzii's *Gioia mia!* ('My Darling!'), showing a young mother clasping her little son close to her in the corner of a leafy bower. But these were not the type of picture which received any great share of the critical attention paid to the paintings on show. Interest in new tendencies, and in the direction that Italian art should take in future, was far more pronounced. The 'battle for art' in 1890s Italy, therefore, was not so much a clash between old and new, but, more importantly, a struggle within what might be called the avant-garde itself.

What was alleged to be at stake was the future path for painting in a country actively concerned with developing a public sense of identity, and the artistic choice was conceived as one between *realismo* or *idealismo*; between dealing with pressing social issues as directly as possible, or provoking emotional responses believed to have a more poetic, avowedly 'timeless', 'universal' appeal. Thus on the one hand Morbelli documented both the exhausting conditions in the ricefields of the Po valley (*In Risaia*: 'In the Ricefield', 1901; *Per 80 Centesimi!*: 'For Eighty Cents!', 1895) and the dispirited elderly men massed together in a Milanese institution, the Pio Albergo Trivulzio (*Giorni Ultimi*: 'Last Days', 1883; *Giorni de Festa*: 'Holidays', 1894; *Un Natale al Pio Albergo Trivulzio*: 'Christmas at the Pio Albergo Trivulzio', 1909). Pellizza da Volpedo, in one of the enduring works of the period, *Il Quarto Stato*: 'The Fourth Estate', 1901), which has become a cornerstone of twentieth-

26 Giovanni Segantini, *The Wicked Mothers*, 1894

century Italian socialist iconography, shows agricultural workers powerfully advancing into their future.

Yet Pellizza also produced pictures in which his political allegiance was not apparent, suggesting that the distinction between the two types of artist was not necessarily an absolute one. These include *Lo Specchio della Vita* ('The Mirror of Life', 1898), depicting an endless line of sheep, their reflections glittering up from a stream (although the subtitle, 'What one does first, the others follow', and the presence of one black sheep, encourage an interrogative reading of the painting's meaning); and a study of light, shade and mystical quietness, *La Processione* ('The Procession', 1894–5). Such works link him to Previati, who was highly influenced by Symbolist and Secessionist art in his illustrations to Poe, and who showed a painting entitled *Maternità* ('Maternity', 1890–1) at the 1891 Triennale which, despite its conventional subject matter – a mother and child surrounded by adoring angels – excited a great deal of comment as a result of the boldness of its Divisionist technique. Many of Segantini's works, too, can be grouped within this Symbolist tradition. Divided in this way, the choice of subject matter for Divisionist artists can be seen as a political one, connected with competing systems for analysing and understanding human life and behaviour. The first group of works is allied to a new enthusiasm for Marxist historical materialism; the second to more conservative forms of religion and mysticism.

The Blood Cure (or *Le Bevitrici di Sangue*, 'The Blood Drinkers', as it was also known) and *The Wicked Mothers* were exhibited within three years of each other. Pusterla's painting, now lost, and only known through the murky reproduction in the exhibition catalogue, was shown at the inaugural Milan Triennale in 1891; Segantini's went on view at the following one, in 1894. Both these art shows were themselves part of far larger exhibitions. According to the education minister, Pasquale Villari, who delivered the inaugural speech in 1891, they were explicitly modelled on Britain's Great Exhibitions of 1851 and 1862 (Villari had himself been a special commissioner to the 1862 Exhibition). They aimed not just to demonstrate art's potential to influence industry and commerce, but to encourage art to manifest a national character rather than being an expression of individual whims or outdated practices. 'Art which is limited to purely individual creativity will not any longer have a part to play in the overall heritage of the nation ... Art had freed itself from academic conventions by studying the effects of nature', proclaimed Villari. 'Why should not we, who have created so many works of art, recognise that art may be the means whereby the Italian genius can powerfully exert its influence over the whole world?' (*Corriere della Sera*, 7–8 May 1891). Such attitudes fed via a direct line into Fascist artistic propaganda: Villari's son Luigi (who published a study of Segantini in 1901) became a noted spokesman for Mussolini's regime. The status of these exhibitions as national symbols can be gauged by the presence of royalty and top governmental figures at their openings, and by the choice of the inauguration of the second as an occasion for an organised demon-

stration by socialists and republicans against the policies of Crispi's administration.

In this essay, I wish to develop an approach which may enable one to understand Pusterla's and Segantini's paintings not just as counters in the contemporary aesthetic debate, but as relating to the wider anxieties concerning national identity which lay behind the conception of the exhibitions. Reconstructing responses to these art shows is particularly problematic, however, owing to the state of the Italian press in the 1890s. Four-page news-sheets had limited space for the detailed discussion of art. Moreover, different types of intellectual discussion were often segregated. Thus a correspondent in the *Corriere della Sera* wrote: 'a political daily is not the place to discuss [artistic] schools and methods' (7–8 June 1894). And the artistic journalism which did exist, in *La Cronaca d'Arte*, for example, or in *La Riforma*, was dominated by the Divisionist publicist Vittore Grubicy. Together with his support for experimental techniques based on optical theory, he echoed ministerial sentiments in his demand for 'good, healthy painting' (*La Riforma*, 30 June 1891). All these factors combine to make impossible what can be done for French or English art of the time: the drawing of parallels between the language of art criticism and that of other contemporary discourses.

Both these paintings, press comments tell us, attracted much attention and controversy when exhibited. Given their subject matter, as well as the challenge posed to traditional techniques by Divisionism, this can come as no surprise. Yet lacking evidence for a range of ways of seeing, to reconstruct the terms of this attention must become, initially, an act of establishing a variety of potential contexts of explanation. In the final part of this article, I shall link some of the socio-medical ideas circulating in late nineteenth-century Italy which can be directly related to the subject matter of the paintings, with twentieth-century anthropological observations, in an attempt to connect the representation of the female bodies by Pusterla and Segantini with contemporary concern about the body of the state.

On the surface, it would seem difficult to bring Pusterla and Segantini's paintings together except, obviously enough, as representations at the boundaries of the 'normal'. Their contrasting attitudes towards the choice of subject matter reveal allegiances which stretch beyond Italy's national boundaries. Giovanni Segantini (b. 1858) started as a painter of naturalistic scenes celebrating the countryside and way of life around the Trentino, where he was born, but his rural subjects quickly became the vehicle for the expression of more abstract concepts, such as the power of maternal love. During the early 1890s, he was increasingly influenced by a range of Symbolist ideas, and took to painting allegorised figures set in idealised versions of natural settings. *Le Cattive Madri*, bought by the Viennese secession, and hanging in Vienna since late 1894, typifies his work in the early 1890s, and may be placed alongside more women suspended in a snowy Nirvana in *Il Castigo delle Lussoriose* ('The Punishment of Lust', 1891). In both, the dominating colours are

unsympathetic whites and greys, painted over a bluish ground to give a cold hardness to the light; the use of strong horizontals emphasises the sense of space, emptiness; the leafless trees suggest sterility. The expression on the face of the most prominent woman in *Le Cattive Madri* is unmistakably one of sexual ecstasy, eyes closed, mouth partly open. She is leaning backwards in self-absorbed abandonment, her body curving away from the baby's head which is attached to her right breast. Though the woman can hardly be said to be revelling in her situation, there is a close resemblance between her posture and that of the woman in another of Segantini's paintings of 1894, the blood-red reclining figure portrayed in his *Dea d'Amore* ('Goddess of Love'), which confirms her posture as that of a woman in a swoon of sexual pleasure.

Segantini's reading in Eastern spiritualism (not to mention in Schopenhauer's mystical misogyny) unmistakably lies behind these paintings. Particularly relevant is the Indian poem *Panghiavahli*, popular in Italy at the time through Luigi Illica's translation, which contained the phrase 'la Mala Madre' (the bad or wicked mother, incorporating an echo of 'la mala femmina', or prostitute) to describe those women who have refused the responsibilities of maternity. This poem enables a reading of the picture which is not apparent without access to the underlying mythology: it locates the scene in Nirvana, where mothers ranging across the snowy wastes encounter the spirits of their abandoned children, who have been locked up in trees and call out to them:

> 'Come! Come to me, o mother! Come and offer me
> Your breast, life.
> Come, mother! . . . I forgive you! . . .' The apparition
> Flew to the sweet cry
> And offered to the quivering branch
> The breast, the soul.
> Oh, a miracle! Watch! The branch trembles!
> The branch is alive!
> Look! It's a child's face, and it suckles the breast greedily
> And kisses it.
>
> (Arcangeli 1973, p. 114)

The poem thus suggests the possibility of regeneration: the bad mother may eventually find her natural instincts blossoming again, just as an apparently dead wintry tree will bring forth leaves as the seasons move towards spring. This belief ties in easily to a Christian tradition of redemption, and Segantini's faith in the connection between motherhood, holiness and arboreal fertility is seen in another of his paintings of 1894, *L'Angelo della Vita* ('The Angel of Life', 1894, Plate 27), in which the snows have melted in the mountain landscape, the birch tree is bringing forth young shoots, and the mother, taking up the pose of the Madonna, is bent lovingly over her baby. She is framed by curving branches, the composition stressing unity and security rather than the disorientation of endless space.

La Cura di Sangue, on the other hand, is overtly concerned with modern life. It is unmistakably secular, even a perversion of transubstantiation rituals, with the

27 Giovanni Segantini, *The Angel of Life*, 1894

young women drinking real rather than symbolic blood. In comparison with Segantini, we know little about Pusterla. Born in Milan in 1862, the son of an iron-worker, his early paintings seem to have alternated between works of social comment and those with a more sentimental or allegorical slant. After his marriage in 1892, he turned almost exclusively to frescoes, book illustration and portraits, and financial pressures caused him to emigrate to the United States in 1899.

La Cura di Sangue may be linked, in its implicit concern with social conditions, to one of Pusterla's very few known surviving works, *Le Cucine Economiche alla Porta Nuova* ('The Soup Kitchen at Porta Nuova', 1888, Plate 28), which shows a less disturbing type of ingestion. Whilst, under Grubicy's influence, he adhered to Divisionist principles, the choice of subject matter links him with a European tradition of Realist painting. He may, even, have fulfilled Villari's aim of new Italian painting coming to influence the art of other countries: the composition of the figures in the Frenchman Joseph-Ferdinand Gueldry's *The Blood Drinkers* (1899), another work set in a slaughterhouse, with a couple of attendants handing out beakers of fresh blood from the bull who lies in a pool of gore in the foreground, is highly similar to the organisation of Pusterla's picture.

But more immediately, *La Cura di Sangue* can be set alongside other paintings

28 Attilio Pusterla, *The Soup Kitchen at Porta Nuova*, 1888

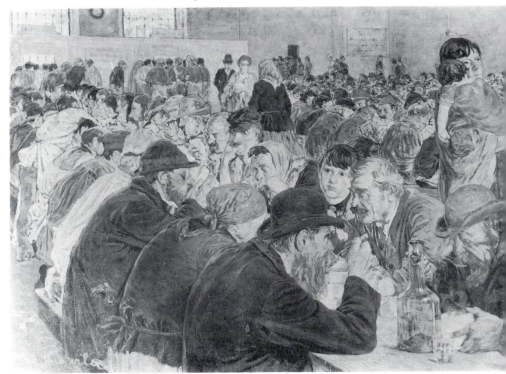

dealing with contemporary Italy which were also on show in 1891. Notable among these were Emilio Longoni's depiction of an orator addressing workers in Milan during one of the growing number of strikes in Northern Italy in the late 1880s and 1890s: *L'Oratore dello Sciopero* ('Addressing the Strike'). Also Divisionist in execution, it attracted a certain amount of discussion on account of both its style and its topic, the radicalism of the subject matter providing a useful handle for the critics who simultaneously wished to express their disapproval of a revolutionary technique. Ferragutti's huge *Alla Vanga* ('Spadework'), the winner of the 1891 prize for figure painting, was less controversial, since it appealed to the spectators' compassion rather than to explicit political allegiances. Celebratory of human labour on the one hand, it is also highly critical of a supervisory system which reduced labourers, right down to small children, to slaves.

But neither Pusterla's nor Segantini's canvases are as easy to read as *Spadework*. Segantini's wide white spaces invite the inscription of meaning by the observer, yet contemporary critics were unsure what to make of it, calling it 'an extraordinary picture'; 'a pictorial hieroglyph'; writing of 'the enigma of the title and of the painting'. They found it an uncomfortable change from the painting which Segantini had shown at the Triennale the same year as *The Blood Cure*, *Le Due Madri* ('The Two Mothers', 1891). Here a mother and child, again in the posture of madonna and son, sit on a stool in a stable, together with a brown and white cow and her calf. Yet a similar message, that of the importance of maternity, underlies both. He wrote: 'I wish that man should love the kindly animals, those that provide them with bed, and meat, and skins; therefore, I painted *The Two Mothers*' (Villari 1901, p. 67). 'When an animal bears an offspring, a possessive love for the newborn develops within it, and love acquires a second level of beauty, the most beautiful of beauties, the sentiment of maternal love' (Budigna 1962, p. 101).

Pusterla's work similarly raises interpretative difficulties. In the slaughterhouse which he painted, animals are not close companions, but are killed for human gratification. If the comparison to be drawn between cow and calf, woman and baby in Segantini's *Le Due Madri* seems relatively straightforward, how are we to understand the juxtaposition of female bodies with dead meat? Is the woman on the right of Pusterla's painting reacting against the stench and violence of the slaughter, the unaccustomed sight of animal blood? Or would she prefer not to acknowledge the unabashed curiosity of the young girl? And is this curiosity, in its turn, directed at the spectacle of death, or at the murderous potency of the slaughterer, sitting triumphantly on the beast he has despatched, as though some of its male power has been transferred to himself? Is the man on the right-hand side present as a chaperon? How might one interpret the relationship of his dressy presence to that of the informally dressed workers: is he, under the surface, a powerful, brutal man like them, or does he belong to a different social order, further away from an animalistic world? Pompeo Bettini, in one of the few contemporary critical comments which went beyond a brief deadpan description

of the scene, was at a loss how to take it, asking 'Did the artist intend some social or satiric comment?' (Bettini 1891, p. 23)

Social commentary can, indeed, be provided via the contemporary, internationally circulating literature on chlorosis (for the history of diagnosis, description and prescription of this medical condition, at the time often though not invariably believed to be a form of anaemia, see Stransky 1974, Hudson 1977, Figlio 1978, Loudon 1980). This literature dwelt on two separate facts: that chlorosis was particularly considered to be a disease of girls and young women, and also that it was frequently associated with sedentary occupations, poor diet and cramped accommodation. These were the conditions of developing urbanisation, and hence highly pertinent to 1890s Milan. The commonest treatment for chlorosis prescribed in the late nineteenth century involved arsenic-laced remedies. But Pusterla, in representing an attempt at self-healing, does not share in the medical orthodoxy about 'correct' treatment. Rather, he aligns himself with observations which circulated at a more accessible level – in Realist fiction, for example – where chlorosis was frequently associated with strange appetites, especially the unwomanly consumption of large quantities of meat (see Starobinksi 1981). His interest in popular practices means that he had more in common with contemporary writers who considered pathological symptoms, whether of disease or behaviour, from a point of view which linked sociological and behavioural investigation with a physiology based on generalised assumptions rather than on forensic evidence.

It is through the influential work of Cesare Lombroso, in particular, that conclusions about the pathology of female bodies took on something of the status of self-perpetuating mythology (for the career and influence of Lombroso, see Pick 1989, Spackman 1989). Above all, the work which Lombroso published together with Guglielmo Ferrero in 1893, *La donna delinquente: la prostituta e la donna normale* (*The Criminal Woman: The Prostitute and the Normal Woman*) blends empirical detail – statistics, physiognomic measurements – with material taken from folklore, proverbs and literary representation. Just as artists at the time could move from *realismo* to *idealismo*, from factual observation to the invention of mythic scenes, so this study may been seen as symptomatic of a lack of consensus in late nineteenth-century Italy about how to go about examining the pathology of woman.

Pusterla's and Segantini's paintings, one preceding, one postdating *La donna delinquente*, may both be related to Lombroso and Ferrero's text. The connection with *Le Cattive Madri* is the more overt. In the volume, excessive lust and exaggerated sexuality are presented as rendering women 'cattive madri' (they use the very words), leading them to seek abortions or driving them to infanticide. All the energy of such women is directed towards the fulfilment of their sexual needs, whereas in 'normal woman … sexuality is subordinated to maternity' (p. 437). But when one looks at *La Cura di Sangue*, too, alongside Lombroso and Ferrero's work, certain disconcerting parallels with their argument become apparent. They

argue that woman is distinguished from other female mammals by her menstrual function. To re-instigate the menstrual flow which, as was well documented, habitually ceased with chlorosis was to re-affirm one's sexual identity as a woman. It was also to suggest one's difference from animals, since by the late nineteenth century it was being claimed, as Ornella Moscucci has explained, that menstruation indicated a higher evolutionary stage of the reproductive function in the human female as compared with other mammals, something which could be attributed to an increase in the frequency of oestrus due to the action of civilisation (Moscucci 1990, pp. 25–6). At the same time, it is worth remembering that until well into the twentieth century menstruation was considered to be the time of the month at which women were most capable of conceiving, a belief which was partly developed by analogy with the regularity with which animals come into season.

Yet if to menstruate 'normally' was to exhibit one's difference from biological males and (so far as the physical manifestations of the activity goes) from animals, when this physiological sign of difference was present in an exaggerated form, it hinted at woman's capacity for monstrosity, and returned her to the level of the animal. Thus, Lombroso and Ferrero maintain, aggressively sexually active women (their prime means of characterising prostitutes) tended to have heavier or more frequent periods than an average woman. Moreover, a menstruating woman not only was the focus for a range of taboos against her alleged uncleanliness, but, as Lombroso and Ferrero pointed out, was likely to be hysterical, irrational, capable of killing her husband, salting and eating his body, or poisoning her child. Women were, indeed, trapped in definitions which ensured that any perceived abnormality might lead to their being classified as hysterical: blood*less*ness was no escape. Dr V. Aducco wrote in the *Archives Italiennes de Biologie* in 1890 that 'Medical practitioners know ... that anaemic individuals are those who most frequently are very excitable' (Aducco 1890, 136). Such an assumption reaches right back to Hippocrates, who claimed that chlorotic pallor was a sign of amorousness (Starobinski 1981, p. 120). Infanticide and lustfulness thus not only are present in the glacially cold, willed infertility of Segantini's paintings of unnatural mothers, but potentially lie both within the blood-heat of Pusterla's slaughterhouse and within the behavioural unpredictability of those visiting it. Seen in this light, to drink blood is transgressive in a way which links woman to animal (since animals are by nature, according to Lombroso and Ferrero, without moral qualms when it comes to killing their offspring): it is a form of cannibalism. 'Very often', we are told in *La donna delinquente*, 'cannibalism is found in conjunction with infanticide' (p. 183).

To take the chain of associations of women and blood as far as cannibalism is not as far fetched as it might initially sound, if one takes into consideration the relationship between Pusterla's painting and a contemporary literary analogue, even possibly a source: the Neapolitan Salvatore di Giacomo's short piece *Le bevitrici di sangue* ('The Blood Drinkers'), published in 1887. He describes the early-morning visitors to the Poggioreale slaughterhouse in the Neapolitan

suburbs, and details the sanguinary horror of the scene with a considerable show of compassion towards the animals. Simultaneously, he invests the slaughterhouse employees with a certain machismo in referring to them as *toreadores*, who not only kill the beasts but run across to the chlorotic girls with glasses swimming over with blood, which they swallow in one gulp, their lips and chins staining a deep red. Di Giacomo makes it clear that these are working girls, and draws a contrast between their elegant clothes and their dismal living and working conditions, hence implicitly questioning their priorities as well as condemning their cramped housing and airless workshops. In his final paragraph, he exchanges his ostensibly detached description for more pointed commentary. He writes of the girls going out at night, in their finery, on the fashionable Via Toledo, wearing black silk stockings and little patent leather boots, parasols in hand:

they are those who yesterday were bravely drinking the freshest possible blood. Now look at them: they have got two *soldi* in their pockets for a snack, but the lips are caressing the stem of a flower, or smiling deliciously at a young man of the ruling classes driving his carriage, who smiles back and threatens them with his stylish whip . . . (di Giacomo 1946, p. 700)

In this atmosphere of calculated sexual play, the girls take on something of the role of vampires, a popular image in late nineteenth-century cultural mythology (see Dijkstra 1986, chapter 10). Di Giacomo's 'Realist', Zola-influenced narrative slides easily into the sensationalism and extravagance of decadent writing, so that there is no very clear dividing line between the circumstantial and the metaphoric (or in this case, the metonymic, for the girls could be said to stand for a generalised picture of hungry female sexuality).

Pusterla's and Segantini's canvases represent images of ingestion and secretion: of milk and blood. There appears, however, to be an immediately apparent difference, since although both issue from corporeal orifices, blood carries the connotations of a pollutant, and hence its representation evokes a range of superstitions and taboos (for a study of popular Italian beliefs about blood, see Camporesi 1984). It bears associations of violence, wounds and the shedding of a waste product. Furthermore, it differs from the other major category of pollutant, the excremental, precisely because of its relationship to sexual difference. The threat which it presents has been summarised by Julia Kristeva in *Powers of Horror* (1982, p. 71):

Excrement and its equivalents (decay, infection, disease, corpse, etc.) stand for the danger to identity that comes from without: the ego threatened by the non-ego, society threatened by its outside, life by death. Menstrual blood, on the contrary, stands for the danger issuing from within the identity (social or sexual); it threatens the relationship between the sexes within a social aggregate and, through internalization, the identity of each sex in the face of sexual difference.

Kristeva's analogues to excremental pollution allow one to read both of the works discussed in this essay as representations of threats to the identity of the symbolic body, as well as the actual body. Yet in each case, the origin of this threat lies within: more specifically within gender, whether represented by the chlorotic

sufferer or the self-indulgently sensual woman. Kristeva's two categories thus are themselves less easily separable than they seem at first sight.

Nor are the distinctions between the two bodily fluids implicit in the paintings' subject matter as clear cut as they initially appear. Milk might be thought to carry with it positive connotations of nourishment: life-giving, rather than life-threatening. But long-lasting classical tradition placed the two fluids in close relation to one another, and, indeed, to sperm. Moreover, anthropological research has shown the widespread occurrence of beliefs concerning bodily functions which closely link the two (see Harrell 1981; Héritier-Augé 1989). Aristotle's argument, put forward in his *Generation of Animals*, that blood, sperm and milk are all residues of the transformation of food which take place within the body has been summarised succinctly by Françoise Héritier-Augé (1989, p. 162):

Essentially cold by nature, women never manage to make semen, the only bodily fluid with fecund power. Out of their substance, they obtain a less perfect product, but one that nevertheless taxes all of their capacity for heat. This explains the disappearance of the menses, at least during the first months of nursing. All of the heat and all of the substance available goes into milk-making. And though they continue to produce enough blood to cover their own needs, women have none to spare. Man alone has enough heat and potency to produce two distinct body fluids, simultaneously and plentifully.

Such theories were refuted by the late seventeenth-century discovery that the epigastric vessels leading to the breast did not originate from the uterine vessels, with the concomitant fact that there was no logical argument in favour of blood from the womb. But as Thomas Laqueur puts it: 'a novel bit of plumbing paled in the face of clinical and folk wisdom stretching back to Hippocrates' (Laqueur 1990, p. 104), and such wisdom endured the far wider overturning of the Galenic understanding of medicine, of which this theory formed but a small part, which had taken place by the late seventeenth century. The fear of women indulging in their 'natural' coldness, turning their heat into lustfulness rather than lactation, surfaces again in Segantini's painting.

The importance attached to bodily fluids in these two paintings and the resultant set of associations leads me, finally, to draw on the familiar anthropological theories of Mary Douglas to suggest how these paintings may be brought together, not just by virtue of their sensationalised subject matter, but as highly relevant to concerns both about the female body and about the unity of the nascent Italian state. Arguing that anxiety about the maintenance of rigid bodily boundaries is most intense in societies where the external boundaries are under attack, Douglas writes in *Purity and Danger* (1966, p. 121):

Any structure of ideas is vulnerable at its margins. We should expect the orifices of the body to symbolise its specially vulnerable points. Matter issuing from them is marginal stuff of the most obvious kind. Spittle, blood, milk, urine, faeces or tears by simply issuing forth have traversed the boundary of the body. So also have bodily parings, skin, nail, hair clippings and sweat. The mistake is to treat bodily margins in isolation from all other margins.

Douglas' ideas, combined with those of Kristeva (who draws considerably on

Douglas), offer a range of ways of considering these paintings within their context in the Italy of the 1890s: ways which draw on, but seek to go beyond, the readings of their subject matter which may be developed from examining contemporary sources and analogues. First, the method of Divisionism itself can be understood as a form of dissection, since it offers a scientific understanding of human perception of light and colour, and of solid forms in relation to these unstable elements. The separation of colours on the palette, the filaments, specks and dashes of juxtaposed and overlaid colour which appeared on the canvas surfaces, remind one that the assimilation of visual information and its retransmission in artistic form is far from unproblematic. Yet such theories met with a degree of scepticism, contradicting, as they did, traditional notions of the representation of the natural world. At the most extreme, the paintings produced were themselves considered the products of a diseased retina, most famously by Max Nordau, in *Entartung* (1892–3, translated as *Degeneration* 1895). This book enjoyed considerable circulation in Italy: it drew, in its turn, on the researches of Cesare Lombroso in its definition of degeneration as a morbid deviation from the 'original type' (indeed, it was dedicated to Lombroso), and claimed that artists who painted in a Divisionist style suffered from hysteria and neurasthenia, thus developing diseases of the eye which were in accordance with their condition of lassitude and exhaustion. They exhibit, for example, '*nystagmus*, or trembling of the eyeball', which 'will, in fact, perceive the phenomenon of nature trembling, restless, devoid of firm outline'; they will experience gaps in their field of vision, leading them, in their paintings, to place 'in juxtaposition larger or smaller spots which are completely or partly dissociated' (Nordau 1895, pp. 27–8). Concern about innovation in art, in other words, could itself be expressed in the terms of threatening disease. That contemporary Italian critics could react to Divisionist painting in this way is shown by the correspondent in *L'Illustrazione Italiana* (6 May 1894), commenting that Previati's method was very similar to that of Puvis de Chavannes, 'whose manner has been sufficiently described in its tendencies by Max Nordau, in his volume *Degeneration*', and by the efforts of those who were sympathetic towards the Divisionists to explain that, in the execution of Segantini, his 'genius' ensured that there was nothing of the 'morbid' (*Vita Moderna* 1, 1892, 5.).

But the official rhetoric of the exhibitions did not pick up on these fears. In that inaugural speech of 1891, Pasquale Villari stressed the importance of art manifesting a 'national spirit'. He desired a culturally united Italy just as it had been – he would have his audience believe – in the Renaissance. Since his first book, the *Introduzione alla storia d'Italia* ('Introduction to Italian History', 1844), the historian and politician had been asking the same questions: did the fall of the Western Empire and the barbarian invasions really submerge all traces of the unity which Rome had forged between the people living in the peninsula? Could one not trace in the growth of the Italian *comuni*, or city states, the re-awakening of a national conscience? However, even as he spoke, circumstances, as journalists were quick to

point out, showed him up as being over optimistic, since most artists from Naples and further south had chosen to show their work at the simultaneous exhibition in Palermo. Nor was the Milan exhibition itself a great success, for despite the publicity surrounding its opening, attendances soon dwindled, and sales of the works were not high. Yet these facts did not dampen the rhetoric with which Villari continued to promote the importance of Italian unity. He foregrounded a comparison between nation and body in the speech he gave when accepting the Italian Presidency in 1896. As he exhorted his listeners to cultivate national pride, he warned against uncontrolled emigration as a solution to the country's pressing economic and labour problems, since it meant the destruction of part of the living corpus of *italianità*. Nations were like organisms, he claimed: some lived, some died, and Italy must ensure that she put herself on the path for a healthy future (Villari 1933, p. 4).

With hindsight, Villari's optimism can be called into question on the grounds which draw on the subject matter of Pusterla and Segantini's pictures, the approaches to painting which they represent (similar in style, divergent in genre), and the intersecting range of intellectual, medical, literary and anthropological positions which relate to them. Bodies are not self-contained entities: they have margins, yet because they both ingest and exude substances they call the absoluteness of these boundaries into question. The reliability of their internal functioning cannot be guaranteed; they are vulnerable to disease caused by both environmental and psychological factors. Moreover, as Thomas Laqueur has shown, since the bodies of women and men have been acknowledged, from the eighteenth century, as having fundamental rather than superficial physiological differences, and since they have long been subject to different myths, expectations and prejudices, to employ the human body as an analogue for the nation was, by the 1890s, to use an extremely unstable metaphor. Understood in this light, the pictures, and the reactions they called forth, can be seen as symptomatic of the anxieties concerning the uncontrollable, self-willed and potentially unpredictable body of the adolescent Italian state.

PART IV

The body as language

In this final section four authors look at the extent and nature of legibility in relation to the body, constructed as, or through, artifact. The body is here both an object represented in two dimensions (photograph, painting, print) and an organism that is organised to represent concepts and desires (the dancing body, the body clothed or unclothed, the body in motion or posed for an audience). Two systems of representation intertwine and overlap. Language is here understood to mean a system of signs produced in a particular historical set of circumstances and involving repetitions and encodings of the kind to which societies attribute specific meanings either consciously or unconsciously.

Attempts to apply semiotic theory to the visual arts have met with mixed success and the authors of the present book are not seeking to renew those attempts. What is acknowledged is the impact of semiology on art-historical practice during the past two decades, and the ways in which it has informed textual analysis. The readings of many of the texts examined in this book testify to this. Semiology has been equalled in its importance for cultural analysis, perhaps, only by psychoanalytic theory which also deals with language, the symbolic language of the unconscious.

The essays in this section take on some of the concerns emerging out of these methodologies without rehearsing a commitment to a single approach. Insofar as semiology and psychoanalysis underpin some of the writing in this Part and in Part I, it is always within the framework of historical enquiry, with attention necessarily paid to the particular social and economic conditions of the production of sets of images. As a group the essays evince an engagement with the ways in which visual signs (outside an historical system of emblematic reference) can stand in for (and therefore signify) things other than the elements of the 'real' world which they serve to re-present. They also importantly show how the study of rhetoric, one of the longest-established scholastic disciplines, can be productively appropriated to a wider study of visual culture.

Rhetoric involves a deliberately contrived and regulated practice of

persuasion, subject not only to established rules but also to social laws and the unwritten drama of living communication. Moreover, rhetoric frequently serves to mask or assimilate the uncomfortable truths of difference which constantly threaten individuals and societies with destabilisation. We are aptly reminded in Fermor's essay, both of the overwhelming importance of rhetorical strategies inherited from antiquity *and* of the ways in which languages of social comportment, functioning intertextually in the Renaissance, were perpetually understood to be dangerously undermining and threatening that very *status quo* of gender they sought to secure.

The importance of visual forms of rhetoric have perhaps never been adequately appreciated, particularly with regard to the early modern period. It may seem a far cry from Renaissance dance technique and its relationship to languages of criticism – the topic of Fermor's essay – to Maxime Du Camp's photographs of the Middle East, about which Ballerini has written. Here, however, the very issue of language is problematised in relation to the body. The body photographed by Du Camp is simultaneously both a silent language and a denial of legibility. The rhetorical strategies of the photographer – a shot from this angle, a focus on this or that – invite us to understand the visual language of this imagery as a transparent communication of difference: racial, geographical and temporal. But the very legibility of this project is, as Ballerini establishes, cast into doubt and perplexity by the represented body of Du Camp's unintelligible Nubian servant superimposed upon the super-legible text of photography.

The photographed body with its connotations of visual plenitude (photography's apparent propensity to show all), the photographed non-European body insinuated into the West's view of the East in Du Camp's images, may rhetorically confirm perceived difference. But it simultaneously challenges the very order that photography here seeks to communicate. Similarly the ordered language of Renaissance dance depends on the physical body for its socially significant performance but, whatever the written or taught instructions, that body (sexualised, gendered and above all visible) threatens to break out and disrupt the social regime of which it is a part. This ordered language of dance possesses such a powerful purchase on the imagination that it informs the configuration of contemporary pictorial imagery and determines aspects of the critical analysis of visual culture.

In Fer's close reading of two photographs by Man Ray in the light of Freud's psychoanalytic work, the question of the symbolic language of the unconscious is raised. Like Pointon writing on wigs, Fer is concerned with body-parts and adjuncts, with substitutes or prosthetic items of apparel. The relationship of these elements to the biological and psychically

envisioned body forms a network of language, linking manifest and latent, and raising questions concerning absences and occlusions. Ballerini points out that visuality is a formulation of knowledge where the ability to visualise almost becomes synonymous with understanding. Fashion photography may work in similar ways but it also connects with long-established traditions of representation which invite particular concentration on (and/or obsession with) separate parts of the body and their adornment. While the object of desire in Fer's analysis is the hat, Pointon establishes the head, and particularly the male head and its hair, as a site of powerful discourses of gendered authority from the seventeenth to the early nineteenth century.

These essays explore, therefore, questions of how symbolic languages function in visual representation and how body-parts (denotative of sexual difference) can play out meanings even in (or perhaps because of) the absence of a depicted body. Hats and wigs, in Fer's and Pointon's essays, are parts that associate with, or even may look like, the original (the head or the hair). They therefore raise the question of fetish and hence also of castration. Pointon and Fer ask what the sexual identity of the body is, and where it is manifest. In examining sexual difference and its signs in and on the represented body – the way the body displays itself and how that display is imaged – they demonstrate how the elements shift and transform to be appropriated and reappropriated across sexual boundaries.

The instability of sexual boundaries is germane to all four essays. In theological terms (in Pointon's study of English discourses of the wig) the struggle to define and maintain sexual boundaries reveals the interconnections between fashion and the politics of ordered society in a post-lapsarian world. The qualities that connote masculinity in the wig as sign are those which stand in danger of reversal, rendering its wearer effeminate and castrated. Fer, on the other hand, describes Tzara intrigued by hats which took the basic form of male attire yet took on the form, the metaphorised form, of the female genitalia. As Fermor establishes, Renaissance dance, when performed by a person of one sex, could be read as defining the dancer in terms of attributes connotative of the other sex, leading to an uneasy and unstable equilibrium. All these are questions also, at the social level, of propriety and decorum, of what is proper in language to the specifics of race, class and gender: Boswell bereft of his wig unable to leave his room, Ishmael photographed in a classical Greek pose, Titian's Adonis gesturing in ways that might be deemed womanly.

In many ways this Part addresses the ways in which the arbitrary or apparently trivial becomes meaningful and the margins display the centre. The tiny figure of the Nubian, Ishmael, imaged in the nineteenth-century European's photographs of the great monuments of the Middle East; the

way a person of either sex kicks up the legs in a dance in sixteenth-century Italy; the cut and shaping of a hat; or the manner of wearing a wig in eighteenth-century London; these slight traces are what allow access to the historical body as an interlocking network of signs, the legibility of which is contested and the meaning of which was, and is, open to interpretation.

In chronological terms we move, in this section, from the sixteenth to the early twentieth century. This takes us from the unified body of academic theory and classical proportion (an imaginary yardstick ever-present in cultural formation), and the Christian body made in God's image, to the standardised body of consumer culture. What is shared is the recognition that the past is always there/here in the present and that one of the roles played by the body is to objectify a problematic relationship of the past to the present. This is clearest in Ballerini's examination of orientalist discourse but it is also implicitly important to the other essays in this Part.

There is no conscious attempt to produce here a sequential historical account, nor are the cases discussed presented in any sense as paradigmatic. Nonetheless, the reader may remark that there is ample evidence that the body is an historically specific entity, invested in ideology, and not a biological constant. We open with Fermor's consideration of an implicitly harmonious Renaissance body, invoking in the contemporary spectator words like gracefulness and lightness. Fer's study of the 1930s invokes Le Corbusier's model of a similarly harmonic but now functional and inconspicuous body against which a culture of ornament and embellishment is to mount its challenge. Pointon offers an account of the role played by an item of masculine attire in the symbolically powerful economy of the body, and Ballerini interprets images in which a dark-skinned man serves as a gauge to architectural proportion.

Movement and gender in sixteenth-century
Italian painting

SHARON FERMOR

Ludovico Dolce, the art critic and theorist, wrote a letter in 1554 or 1555 to the
Venetian statesman and patron Alessandro Contarini, in which he included an
elaborate description of the figure of Adonis in Titian's *Venus and Adonis*, com-
pleted in 1554 (Plate 32). In Dolce's account, Titian's Adonis is a boy of sixteen to
eighteen years, whose beauty partakes of both masculine and feminine traits. He is,
writes Dolce:

ben proporzionato, gratioso, et in ogni sua parte leggiadro ... E vedesi, che nell'aria del bel viso
questo unico Maestro ha ricercato di esprimere certa graziosa bellezza, che participando della
femina, non si discostasse però del virile: vuo' dire, che in Donna terrebbe non so che di uomo, et
in uomo di vaga Donna: mistura difficile, et aggradevole ... Quanto all'attitudine, egli si vede
muovere, et il movimento è facile, gagliardo, e con gentil maniera. Perchà sembra, ch'ei sia in
camino per dipartirsi da Venere, con disiderio ardentissimo di gire alla caccia.

(First published in Dolce 1559; Roskill 1968, pp. 212–17)

well proportioned, graceful, and *leggiadro* in every one of his parts ... And one sees that, in the air
of the head, this unique master has sought to convey a certain pleasing beauty which, partaking of
the feminine, does not, however, depart from the masculine: I mean to say, that in a woman it
would suggest something of the man, and in a man a touch of the beautiful woman: a difficult and
pleasing mixture ... As for the pose, one sees Adonis move, and the movement is easy, *gagliardo*
and delicate in its manner, so that it seems that he is already stepping out to depart from Venus,
burning with desire to go hunting.[1]

Historians of Renaissance art have paid relatively little attention to such passages in
contemporary theory and criticism, and have been particularly reluctant to examine
in detail their use of descriptive terms. This is partly, perhaps, because accounts of
specific works of art in texts like Dolce's letter, or in Vasari's *Lives of the Artists*, are
often thought to be imprecise, their uses of terms such as *grazia* or *leggiadrìa*
assumed to be rather unthinking references to a vocabulary which itself appears too
vague or too conventionalised to bear detailed scrutiny (Boase 1979, pp. 119–48,
and in response, Baxandall 1980). Such descriptions have thus rarely been taken as
accurate responses to visual experience, and it is frequently assumed that they say
relatively little about the actual perception of an image.

Where the language of art criticism has been discussed in detail, scholars have
focused primarily on its relationship to that of other types of literary text, and to its
borrowings from the theory and vocabulary of rhetoric, poetry or philosophy

(Barocchi 1960–2; Summers 1981). Here, the assumption is often that the choice of terms in descriptions of works of art is governed more by the demands of literary convention than by a direct response to the image (Alpers 1960). This emphasis on the literary or philosophical background of art-critical terms, rather than on their relationship to the social discourses of manners or behaviour, has tended to conceal their descriptive precision, while also obscuring their wider cultural and ideological significance.[2]

In the description of movement, however, writers such as Dolce and Vasari can be shown to have been drawing on a discourse which was both quite precise and largely gender-specific, and which was widely diffused in texts on behaviour, on manners and on polite dance. It is no accident that the terms most common in debates about movement and its implications in this wider social context are also those which appear most frequently in descriptions of movement in art, most notably in Vasari's *Lives of the Artists*. When considered against this background, terms such as *leggiadrìa* and *grazia* as used in art criticism may appear not only descriptively rich and precise, but dense with ideological significance. Dolce's description of Titian's painting, for example, when looked at in this way appears not just as a display of verbal agility, an exercise in antithesis or *contrapposto* designed to match Titian's own, but as a complex and subtle analysis of the visual qualities of Titian's figure, one which acquires its meaning by reference to notions of sexual difference in movement and behaviour. As we shall see, for the contemporary reader the resonance of Dolce's account would have derived largely from the knowledge that, within this wider context, the term *leggiadrìa* or more specifically *leggiadro*, here used of Adonis' physique, was usually used of women or young children, while *gagliardezza*, used to describe his movement, was usually used of mature men. The notion of a *gagliardo* movement being executed with a feminine *gentil maniera* was also, in some senses, a contradiction in terms.

In this essay, I shall examine the terms *leggiadrìa* and *gagliardezza* as used by Vasari and Dolce in relation to specific figures, and suggest how their connotations can be unravelled by reference to writings on dance and behaviour. My aim is to show how a consideration of this background can give us a more precise and historical purchase on art-critical texts which have too often been dismissed as unspecific and uninformative, and to point to some of the ideological connotations implicit in their use of terms.

Of all the terms used in the description of movement, *leggiadrìa* and *gagliardezza* are among the most precise. They are also two of the most gender-specific, and together feature prominently in discussions of sexual difference in movement and behaviour. The Renaissance was a particularly significant period from the point of view of a language of sexual difference, especially as regards movement; in the numerous courtesy manuals and books on manners which emerge in Italy from the fourteenth century onwards in both aristocratic and sub-aristocratic circles, the proper roles and etiquette of men and women, in relation both to each other and to

others of the same sex, were discussed and codified in increasingly explicit and complex ways (Jones 1987; Bryson 1990). As part of this process, gender roles and notions of proper male and female behaviour were defined and articulated with growing minuteness and precision, and in ways which, almost inevitably, focused on those qualities which rendered them different and distinct.

During the sixteenth century, these discussions of behaviour focused increasingly on the presentation of the body, and particularly on the body in movement. In writings on manners, and also in the growing number of books on the beauty of women which appear during this period, movement and deportment are seen as the primary means of defining and expressing the social and moral self, especially, although not exclusively, in the context of the court (Kelso 1956; Jones 1987; Cropper 1976; Rogers 1988).

Since Antiquity, it had been accepted that physical movement revealed the inner self. In medical and physiological writings from Aristotle onwards, movement is seen as an index of the emotions; it is also perceived as a guide to an individual's character and moral or ethical state, since these are defined in part in terms of control over the irrational passions. The notion that deportment was an index of character, and thus also of social status, was not new to the Renaissance. What was new was the view of deportment as something to be cultivated rather than simply observed, and the location of movement at the centre of discussions of ideal social behaviour (Bryson 1990). In the sixteenth century, for both courtiers and members of the socially aspiring bourgeoisie, physical movement became a continuous index of the social and ethical self, and subject to intense scrutiny. Texts such as Castiglione's *Libro del Cortegiano* thus present a complex and clearly articulated coding of movement and behaviour and a set of rules for proper deportment, within which gender roles and notions of masculinity and femininity appear ever more polarised and distinct. In Book III of the *Cortegiano*, for example, Castiglione stresses that, in every aspect of her behaviour, her manners, words, gestures and deportment, a woman should be very different from a man:

perché come ad esso conviene mostrar una certa virilità soda e ferma, così alla donna sta ben aver una tenerezza molle e delicata, con maniera in ogni suo movimento di dolcezza feminile, che nell'andar e stare e dir ciò che si voglia sempre la faccia parer donna, senza similtudine alcuna d'omo. (Castiglione, p. 341)

for just as it behoves him to display a certain firm and steady virility, so it is fitting for her to possess a soft and delicate tenderness, with a feminine sweetness in her every movement, so that everything in her walking, standing, and speaking whatever she will, pronounces her a woman, with no resemblance at all to a man.

Such texts can provide important insights into the meaning of terms like *leggiadrìa* and *gagliardezza*, and to the connotations which they carried when used in relation to art. Even more illuminating are the theory and practice of contemporary dance, which constitute particularly precise interpretative tools. Dance was perceived as a vital social accomplishment, a central part of the presentation of self, and formed an

essential part of the education and qualifications of both the courtier and the urban middle class. It was often described as a form of mute rhetoric, through which the dancers could persuade the onlookers of their worth, and writers on behaviour often used the example of dance as a paradigm, a means of making a general point about movement or deportment. Castiglione, for example, having stressed the importance of a woman not being more like a man, continues:

non solamente non voglio ch'ella usi questi esercizi virili così robusti ed asperi, ma voglio che quegli ancora che son convenienti a donna faccia con riguardo, e con quella molle delicatura che avemo detto convenirsele; e però nel danzar non vorrei vederla usar movimenti troppo gagliardi e sforzati, né meno nel cantar o sonar quelle diminuzioni forti e replicate, che mostrano più arte che dolcezza. (Castiglione 1964, p. 341)

not only do I wish her not to engage in these vigorous and boisterous masculine pursuits, but I wish her to practise even those which are fitting for a woman with the most careful regard, and with that soft and delicate refinement which we have said becomes her; and therefore in dancing I do not wish her to use movements which are too *gagliardi* and *sforzati*, or in singing or playing those strong and repetitive diminutions, which display more skill than sweetness.

Castiglione's concern with gender differences and the precision and self-consciousness with which he discusses the appropriate movements for women are characteristic of much of the contemporary debate about movement. But developments in dance practice during this period made definitions of the masculine and feminine in dance a matter of quite particular urgency.[3]

The polite dances of the fifteenth century were choreographed primarily, if not exclusively, for small groups, with three and four being the most common numbers. While many of these dances revolved around the theme of love, within that they explored a wide range of quite subtle themes such as patience, jealousy or temperance. Within these dances, male and female roles and movements were not always very distinct, men and women performing virtually identical sequences. In the sixteenth century, however, while these small group dances persisted in different modified forms, there developed alongside them a range of new dances designed specifically for couples. Within these, the thematic aspect of the dance centred almost entirely around simple notions of courtship or display, with the gender roles becoming much more clearly distinguished. Usually, the emphasis was on male virtuosity, for which the woman acted as a foil. This was particularly true of the galliard, the most popular and contentious of the new dances;[4] while the woman still danced, her steps were less energetic, less complex and less physically demanding than those of her male partner, for whom she provided an audience, as described in a late sixteenth-century French dance treatise, Thoinot Arbeau's *Orchésographie*. In the following passage Arbeau describes the way in which the galliard was danced in the days of his youth:

après que le danceur avoit prins une damoiselle, e qu'ilz s'estoient plantés au bout de la salle, ilz faisoient après la reverence, un tour ou deux par la salle, marchans simplement. Puis le danceur laschoit la dicte damoiselle, laquelle alloit en danceant iusques au bout de la dicte salle, ou estant,

elle faisoit une station en danceant en ce mesme lieu. Cependant le danceur qui la suyoit se venoit presenter devant elle, et y faisoit quelque passage en tornant s'il vouloit à droit, puis à gauche. Ce faict, elle marchoit danceant iusques à l'aultre bout de la salle ou le dict danseur l'alloit chercher en danceant, pour faire devant elle quelque aultre passage. Et ainsi continuants ces allées et ces venues, le dict danseur faisoit passages nouveaux, monstrant ce qu'il scavoit faire, iusques à ce que les ioueurs d'instruments faisoient fin de sonner.　　　　(Arbeau 1967, Book II, pp. 182b–183a)

when the dancer had chosen a woman, and they had placed themselves at the end of the hall, after making the reverence, they circled around the hall together once or twice, simply walking. Then the man would release the woman, who danced away to the other end of the hall, where she would continue dancing on the spot. Meanwhile the man, having followed her there, would present himself before her, carrying out certain variations, turning now to the right, then to the left, as he saw fit. This done, the woman danced to the other end of the hall, where the man would follow her again, dancing all the while, so as to perform more passages in front of her. And continuing in this way, the man would keep introducing new passages, showing what he could do, until the musicians stopped playing.

Thus, in addition to the focus on the couple in the new choreographies, we find a growing emphasis on virtuosity and overt skill which served to accentuate the distinction between the male and female dancer. While in the fifteenth century writers on dance stressed that dance should be an extension and refinement of the body's natural movements, in the new sixteenth-century dances movements departed increasingly from 'normal' motion, developing steps which stretched the body's natural capacity. Often, the emphasis was on movements which were spectacularly different from those of the everyday, and which demanded physical agility and strength, as well as a highly developed sense of rhythm.

This emphasis on virtuosity and skill was not unproblematic, however, and was the subject of attack in a number of contemporary anti-dance treatises (Zuccollo 1549; Morello 1553). Since movement was seen as an index of inner states, as well as of moral and social composure, vigorous movement could signal a lack of physiological control and, most important, of moral and social fastidiousness. The dancer who displayed too much skill also risked comparison with the professional entertainer, traditionally a person of low social status. Castiglione is one writer who warns the courtier against exhibiting too much expertise. If he is dancing in public, the courtier is advised to maintain a certain dignity, tempered, however, with a *leggiadra ed aerosa dolcezza di movimenti* (a light and airy sweetness of movement). Even if he feels himself to be very nimble and light on his feet, he should not engage in *quelle prestezze de' piedi e duplicati rebattimenti, i quali veggiamo che nel nostro Barletta stanno benissimo e forse in un gentilom sariano poco convenienti* (those rapid steps and repeated beatings of the feet, which we find most pleasing in our Barletta, but which are perhaps less seemly in a gentleman) (Castiglione 1964, pp. 205–6).

This issue was especially sensitive for women. The more athletic movements became, the less appropriate they were considered for women, and overt displays of skill were thought especially unseemly. Thus the galliard, for example, was held by some to be wholly unsuitable for women. In an essay entitled *Della Ostentazione*, written by Vincenzo Calmeta between 1497 and 1500, a woman, well-born and

otherwise praiseworthy and exceptional, is condemned for allowing herself to be cajoled into performing the dance. Persuaded by certain flatterers that she is *la più 'niversal donna del mondo*, the woman took to fencing and dancing the galliard, and was thereby unsexed:

s'è data per questa vana boriosità a schermire, ballar la gagliardia ... e molte altre operazioni che dal sesso muliebre si doveriano non solo fuggire ma abominare. (Calmeta 1959, pp. 40–1).

she applied herself, as a result of her foolish conceit, to fencing, dancing the galliard ... and many other activities which, on the part of the female sex, should not only be avoided, but also detested.

According to Calmeta, *imperocchè, essendo la venustà e la continenza quelle che sopra l'altre cose il muliebre sesso adornano, ogni volta che la donna da quelle si aliena, contrafà la sua natura, né più donna ma nuovo mostro si doveria appellare* (Calmeta 1959, pp. 40–1) (since beauty and restraint are those things which above all others adorn and become women, every time a woman abandons these, she is false to her very nature, and should no longer be called a woman, but a new and monstrous creation).

As Castiglione confirms, *gagliardezza*, the connotations of which relied increasingly on its association with the galliard, was the province of men, not women who should display sweetness and restraint rather than skill. That is not to say that women did not perform these dances, for there is ample evidence to suggest that they did. But whatever its practical repercussions, the debate about skill which these dances engendered, and the increased emphasis on courtship dances, both reflected and helped to consolidate an ideology of movement, and notions of the masculine and feminine, which impinged on the perception of movement in both social and artistic spheres. It also led, significantly, to the formation of a gendered and highly specific vocabulary of movement which influenced both the perception and the description of movement in art. If we turn now to Vasari's use of the terms *leggiadrìa* and *gagliardezza* in the description of specific figures and figural styles, and examine it in this context, we can see this process at work.

Gagliardezza was, as we have observed, a quintessentially masculine quality, while *leggiadrìa* was essentially, although not exclusively feminine, and was often used in opposition to it. *Leggiadrìa* appears frequently in the *Lives*, and Vasari uses it specifically of the figure of the Magdalen in Raphael's *Ecstasy of Saint Cecilia* (Plate 29), executed in 1514, which he describes as standing in *un posar leggiadrissimo* (Vasari 1878–85, vol. IV, p. 350). He also uses it with particular reference to Parmigianino, as a way of describing the artist's figural style, of which I shall take as an example the figures of the Foolish Virgins in his fresco decoration of Santa Maria della Steccata in Parma, executed *c.* 1531–9 (Plate 30). Vasari writes that Parmigianino *diede alle sue figure ... una certa venustà, dolcezza e leggiadrìa nell'attitudini, che fu sua propria e particolare* (gave to his figures a certain beauty, sweetness and *leggiadrìa* in their attitudes, which belonged to him alone) (Vasari 1878–85, vol V, p. 218).

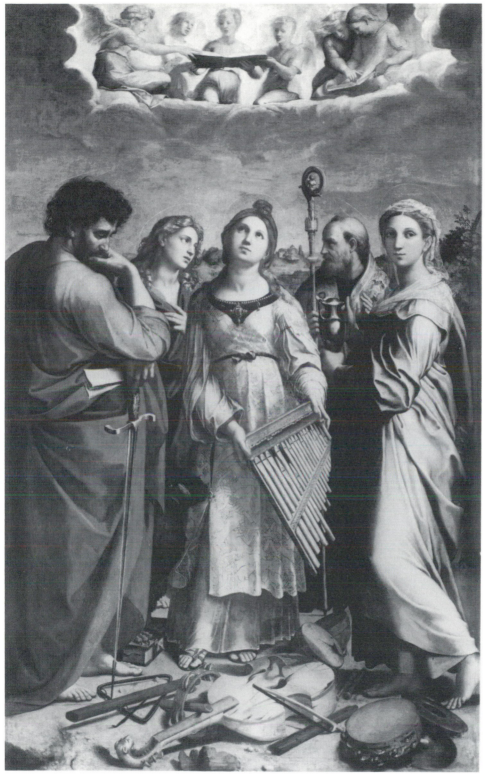

29 Raphael, *The Ecstasy of Saint Cecilia*, 1514

30 Parmigianino, *The Foolish Virgins*, c.1531–9

Vasari himself does not define *leggiadrìa*, a further indication, perhaps, that he assumed his readers would understand its reference from their knowledge of the wider discourse of movement. A definition does appear, however, in Agnolo Firenzuola's *Dialogo delle bellezze delle donne* of 1541, although in relation to movement in general, not specifically to dance; indeed, as Elizabeth Cropper has pointed out, the qualities of *grazia*, *venustà* and *leggiadrìa* which Vasari praises in Parmigianino are precisely those to which Firenzuola devotes most attention in his text, and, as will become apparent, the two were almost certainly working within a common set of assumptions and terms of reference (Cropper 1976, p. 376). Firenzuola writes:

La leggiadria non è altro . . . che una osservanza d'una tacita legge, data e promulgata dalla natura à voi donne, nel muovere, portare, e adoperare cosi tutta la persona insieme, come le membra particolari, con gratia, con modestia, con gentileza, con misura, con garbo, in guisa che nessuno movimento, nessuna attione sia senza regola, senza modo, senza misura, ò senza disegno: ma come ci sforza questa tacita legge, assettata, composta, regolata, gratiosa. (Firenzuola 1548, 83r)

Leggiadrìa is nothing other . . . than the observance of a tacit law, given and divulged by nature to you women, that the individual limbs and the whole body alike should be moved, carried and deployed with grace, with modesty, with refinement, with measure and with charm, in such a way that no movement and no action is without rule, without method, without measure or without design but, as this tacit law demands of you, contained, composed, regulated and graceful.

For Firenzuola, *leggiadrìa* thus denotes a movement which is carefully composed, a deportment in which every action appears considered and controlled. The body should be held upright and contained, but not rigid, so that it retains a measure of grace.

The term is used in a similar way in Pietro Bembo's *Gli Asolani*, first published in 1505, where Bembo discusses the delights of observing a loved one at her various pastimes, such as wandering with her companions through the gay grasses of the meadow, or perhaps:

carolando e danzando muovere agli ascoltati tempi degli strumenti la schietta e diritta e raccolta persona, ora con lenti varchi degna di molta riverenza mostrandosi, ora con cari rivolgimenti, o inchinevoli dimore leggiadrissima empiendo di vaghezza tutto il cerchio.

(Bembo 1961, pp. 102–3)

singing and dancing in a circle, moving her pure and upright and collected form to the sound of the instruments, now with slow steps showing herself worthy of the greatest reverence, now with endearing turns, or bowing pauses, filling, *leggiadrissima*, with beauty, all the circle.

In this instance, it is difficult to be sure how much of what Bembo says, and which of his other terms, relate to his idea of the woman as *leggiadrissima*, but his description does appear strikingly consistent with that of Firenzuola. *Leggiadrìa* is again connected with a movement that is deliberate and carefully measured, with the body collected (*raccolta*) or composed. Both writers suggest as an essential part of this composure an erectness of bearing and an uprightness suggestive of poise and control. Both also suggest that the body should appear contained, with the limbs held close to the body. Alongside these descriptions, Vasari's reference to

Raphael's Magdalen, and to the figures of Parmigianino as *leggiadre* appears anything but loose or jargonistic; rather, in deploying this term Vasari is respond-ing to their visual character in a very precise way.

The uprightness and apparent composure of Raphael's Magdalen have, in fact, often been remarked upon by art historians, but without reference to the historical language of movement.[5] It is a quality which derives partly from Raphael's subtle transformation of the mode of conventional *contrapposto*, wherein the free foot functions as a static repository of weight, into a pose in which the free foot appears to act as a lever, pushing the figure gently upwards. The composure of the figure, the sense of weight actively suspended rather than merely relaxed, is increased by the levelling of the hips and shoulders, rather than the use of opposing diagonals which marks a *contrapposto* stance. The figure of the Magdalen appears composed and alert, the torso erect and held in a straight line, the limbs close to the body, the curve of the arm and turn of the head adding grace and variety without disrupting the composure of the whole.

Parmigianino's figures likewise conform neatly to the accounts of Firenzuola and Bembo; they also have marked similarities with Raphael's Magdalen, allowing for the differences necessitated by their different narrative roles, particularly the exten-sions of the arms as they hold out the lamps which are their attributes. They have a similar uprightness of bearing, and a similar appearance of lightness, of weight held in suspension, and although the movements are rendered more various by the turns of the head and extensions of the limbs, the torsos are held straight, with no sharp twists or turns in the middle of the body.

It is also interesting to recall here Firenzuola's insistence on measure or control, for what could be more expressive of the smoothness of a well-considered move-ment than the ease and equilibrium with which the figures appear to carry the vases which the artist has placed on their heads? As Arthur Popham remarked in his catalogue of Parmigianino's drawings, the figures appear to be engaged in a kind of stately dance which is hardly compatible with the balancing of vases (Popham 1971, vol. I, p. 24).

These figures are additionally interesting for the present discussion since, as Popham hinted, their movement was originally intended to be one of dancing. A number of preparatory drawings for the figures show them, rather than holding the lamps which they carry in the fresco, clasping each others forearms in a formation clearly suggestive of the dance (Popham 1971, vol. I, cat. nos. 450, 451, 663, 719; vol. III, Plates 342, 343). The nature of their movement in these drawings is essentially the same as in the final version, and it is thus not implausible that Parmigianino's virgins would have been seen as dancing with the soft and airy sweetness of movement which Castiglione recommends.

Gagliardezza as a term had long been in use by the sixteenth century, especially in the chivalric epics, and at its simplest denoted qualities of physical strength, vigour and robustness thought appropriate to mature men. But our understanding of

Vasari's deployment of the term depends on our recognition of the new and more specific connotations which it acquired by its association with the galliard as a dance form.

First, *gagliardezza* was associated with conspicuous difficulty and skill, as Arbeau's account of the dance might lead us to expect. Castiglione explicitly equates *gagliardi* movements with movements which are *sforzati*, difficult or forced, and which thus involve overt displays of skill. Second, the dance was considered to be ornate, and is often described as *ornato* or *adorno* in contemporary literature.[6] The question then arises as to the nature of this ornateness: what was it, in other words, that created this impression of elaborateness and visual complexity?

The basic unit of the galliard was the *cinque passi*, or five steps, actually four sprung steps and a jump, followed by a *cadenza*. The sprung steps, which required great deftness and agility, as well as a good sense of timing, comprised a jump from one foot to the other, with the free foot kept in the air, and held away from the body in a variety of different positions (Caroso 1986, Book I, p. 11a).

Much of the dance therefore consisted of steps in which the legs were thrust away from the body in a series of quick and highly elaborate kicking movements, during which, according to theorists, the legs themselves had to be well stretched out, and Castiglione almost certainly has the galliard in mind when referring to the 'rapid steps' and 'repeated beatings of the feet' which the courtier should exercise with caution, so as not to appear too proficient. In his *Trattato dell'arte della pittura* of 1584, the art theorist Giovan Paolo Lomazzo includes a vivid account of the Italian way of dancing, which must also refer to the galliard:

l'italiano quasi istrionicamente salta con sforzi, storcimenti, lanciar le gambe, con levarsi in alto, affrettare i passi e rallentarli, ha sue ricercate di cinque passi, di sette, di nove, di dodici, e di quindici. (Lomazzo 1584, p. 152)

the Italians dance in an almost theatrical way, with strong and difficult movements, turning themselves around, flinging out their legs, leaping, and quickening and lengthening their steps; and then they have their variations of five steps, of seven, nine, twelve and fifteen.

The galliard thus broke up the line of the body by extending the limbs outwards into space, a device which would certainly have created an appearance of visual complexity, and it is partly in this, I suggest, that the dance's ornateness resides. In considering Vasari's use of the term *gagliardezza*, we should, I think, bear these characteristics of the dance in mind.

Two artists whose figures Vasari characterises as *gagliardi* are Andrea del Castagno and Rosso Fiorentino, and in the light of the preceding discussion, the male figures in Rosso's *Moses Defending the Daughters of Jethro* of 1523 (Plate 31) illustrate particularly clearly the precision with which Vasari chooses his terms (Vasari 1878–85, vol. II, pp. 667–82; vol. XI, pp. 155–74). Seen in relation to the discourse of dance, the *gagliardezza* of the figures may consist not just in the evident speed and vigour of their movement, and the physical strength which that suggests, accentuated here by the exaggerated rendering of anatomy. It may also imply the way in

31 Rosso Fiorentino, *Moses Defending the Daughters of Jethro, c.*1523

which their limbs extend into space, diversifying the body and creating a complex outline which simultaneously suggests an inner spirit and bravura. The movements are clearly suggestive not just of strength but also of difficulty, and thus of skill – on the part both of the movers and of the artist himself.

At this point we can return to Dolce's account of Titian's Adonis (Plate 32), bearing these other examples in mind. Dolce begins by describing Adonis' physique as *leggiadro*, although when used specifically of the body the term is most often applied to women and young children. For both Leonardo and Vasari it denoted, in this context, a form in which the flesh appeared soft and delicate, with little apparent musculature (Leonardo 1956, vol. II, 114r; Vasari 1878–85, vol. IV, p. 9). Dolce then goes on to describe Adonis' face through a series of carefully constructed

32 Titian, *Venus and Adonis*, 1551–4

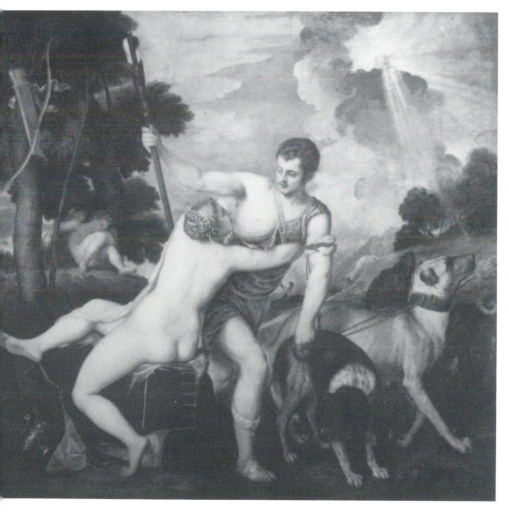

antitheses – his face has a touch of femininity, while not forsaking the masculine, and according to Dolce it is in this combination of opposites, this touch of the feminine in the masculine, that Adonis' attraction resides.

This antithesis, or more precisely this combination of opposites, is then extended, in a more subtle and less explicit way, both in the relation of Adonis' physique to his movement and in the description of the movement itself. While his body is *leggiadro*, his movement is *gagliardo*, a combination which is antithetical insofar as a *leggiadro* form, as well as being primarily appropriate for women, was generally associated with movements which were soft and gentle, rather than *gagliardo*. Conversely, a *gagliardo* movement usually required, and demonstrated, a strong and robust form.

The movement itself is described as *facile, gagliardo, e con gentil maniera* (easy, *gagliardo*, and with a refined or delicate manner), reiterating the antithesis, here almost an oxymoron, in a slightly different register. In the discourse of dance, *gagliardezza* is consistently associated with movements which are difficult and *sforzati*, rather than easy or *facile*; thus, in terms of movement, *faciltà* and *gagliard-ezza* are in one sense contradictory, a point which was made by Dolce himself in his *Dialogo della pittura*, although here in terms of an opposition between *leggiadrìa* and *sforzi*. Discussing the depiction of movement, Dolce writes:

Ma queste movenzie non debbono esser continue e in tutte le figure: perché gli uomini sempre non si movono; né fiere si, che paiono da disperati: ma bisogna temperarle, variarle et anco da parte lasciarle, secondo la diversità a condizion de soggetti. E spesso è più dilettevole un posar leggiadro, che un movimento sforzato e fuori di tempo. (Dolce 1960, p. 180)

But these movements ought not to be continuous, or in all the figures alike, since men are not always in motion, nor should the movements be so violent that the figures appear deranged; rather, you should temper them, vary them, and even in some cases leave them out, according to the diversity and circumstances of the subjects themselves. And often a *leggiadro* pose is more pleasing than a movement which is *sforzato* and out of time.

Thus Dolce, like Castiglione, sets up an opposition between movements which are violent and forced and those which are *leggiadro*, and, by implication, easy or *facile*.

Of course movements which are *gagliardi* and *sforzati* may still be performed with facility – a point made repeatedly by writers on dance and behaviour, as well as by Vasari – and this may well be the thrust of Dolce's remark. The movement is *gagliardo*, the performance or execution easy and fluent, a characterisation which must apply to Titian's painting as well as to Adonis' perceived movement. The very resonance of the remark, however, depends on the basic contradiction or tension between *gagliardezza* and *facilità*, and on the recognition that the idea of move-ment which is both *facile* and *gagliardo*, like the difficult and allied mixture of masculine and feminine, is based on an antithesis.

In Titian's Adonis, then, a difficult, vigorous and robust movement is made in an easy and delicate manner, by a man who is *leggiadro* in every part, a description which, in the light of the texts discussed above, would have had for the contempo-rary reader an extraordinary complexity and resonance.

Most important, Dolce's description matches quite precisely the visual quality of Titian's figure and its movement. Adonis moves away from Venus with an energetic stride, suggesting, as Dolce indicates, his eagerness to hunt. The vigour of the movement is apparent from the disposition of the limbs, and is also implicit in Adonis' resistance to Venus' embrace, his ability to stride forward against the pressure of her arms. The limbs extend strongly into space, diversifying the body around a central axis; the right leg is thrust far out in front of the body, the left leg, although partly concealed, being pushed out behind. The raised right arm creates a further vigorous movement away from the torso. This outward motion of the limbs conveys Adonis' vigour and spirit, his desire to engage in manly pursuits. Most important, it gives the figure a visual complexity, an ornateness, which is an essential component of a *gagliardo* movement.

The *gagliardezza* of the movement is additionally clear if we compare it with that of Rosso's figures discussed above. While Adonis' body is less muscular, and the movement less pronounced, as signalled in Dolce's choice of words, Titian's figure shares with those of Rosso the same essential features, namely the diversification of the figure around the central axis, and the strong extension of the limbs to produce a complex outline. In both cases, the movement is suggestive both of physical agility and strength, and of an inner determination and spirit.

If the language of dance can help us to restore to art criticism something of its original descriptive precision, it can also alert us to the ideological connotations underlying its use of terms, for aesthetic categories such as *leggiadria* are in large measure translations into stylistic terms of ideological beliefs.

As we have seen, an important aspect of *leggiadria* as employed by both Firenzuola and Bembo was the upright carriage of the body, which was seen as indicative of poise and control. The significance accorded to this quality may reflect in part the fact that women were considered to have less potential for control than men. In medical and physiological theory from Antiquity onwards, women were represented as physiologically and psychologically less stable, more subject to the irrational passions, such as lust, and apt to be lacking in self-control of all kinds (Maclean 1980). The appearance of physical poise, indicative of moral and physiological composure and restraint, while also valued in men, was thus particularly important in women.

More important, but also connected with this, is the fact that an upright carriage was taken as a sign of chastity. Indeed, uprightness and an appearance of containment arising from control of the limbs were almost emblematic of the physical and mental purity deemed essential in well-born women. In descriptions of dancing, it is made clear that bending of the body and extensions of the limbs were considered highly seductive, as in an account by the Venetian chronicler Marin Sanudo of some Turkish women dancing in Constantinople in 1524. After a banquet, the women entertained the company by singing and dancing in certain very lascivious ways. Sanudo describes them:

comenzorono a ballare ... con alcuni gesti di testa, incrozamenti di braze, movimenti di lavri, con capelli sparti per li humeri ... poi ... butorono molti belli salti schiavoneschi, con certe forteze di schena che fu bellissimo veder, et sopra tutto gesti e moti tanto lassivi, che faceano liquefar li marmi; et credete a me che vedea scolare la neve giù per l'alpe della vechieza non che alli giovenili anni. (Sanudo, vol. XXXVI, 1893, pp. 118–19)

they began to dance gesturing with their heads, crossing their arms, and moving their lips, with their hair spread loose over their shoulders ... then they sprang into many beautiful leaps in the Slavic manner, arching their backs, so that it was very beautiful to watch, and their gestures and movements above all were so lascivious that they could have turned marble to water; and believe me, I saw the old men melting to the very core, let alone the young ones.

Lastly, and closely linked with the question of chastity, the uprightness and containment of *leggiadrìa* betokened an admirable simplicity, a lack of overt display which was the very opposite of *gagliardezza*, for as I suggested earlier, virtuosity in women was considered undesirable. Not only did it betoken a lack of modesty and restraint, it also suggested a loose nature, and was seen as sexually provocative, as suggested in a satirical letter by the Venetian writer Andrea Calmo, dating from the 1550s, and addressed to a fictional female dancer of great skill:

Madona piena de lizadria, de agilità e de velocitate, quanto pi e' stago a vardar la vostra gaiardezza, tanto pi stupisso, me maraveio e resto confuso, che int'una femenela ghe sia tanta destrezza ... Et cusì chi a un muodo e chi per diverse vie: mi quando ve visti a balor, restiti un cogumaro da menestra, perche vu menavi tanto presto le gambe e si scolarvi tanto ben la vita, che moriva de voia de cognoscerve. (Calmo 1888, p. 293)

Oh lady full of *leggiadrìa*, so agile and so swift of movement, the more I contemplate your *gagliardezza*, the more I wonder, marvel and remain bewildered that there should be so much dexterity in a woman ... And so each man to his own; for my part, when I have seen you dance, I have ended up in turmoil, because you move your legs so fast, and shake your body so excellently, that I could have died with longing to know you.

Like verbal eloquence, with which it was frequently compared, and which was also censured in women, virtuosity in dancing was a sign of unchastity and also of immodesty. Conversely, *gagliardezza* in men was a sign of physical vigour and robustness, as well as of confidence of spirit. The obvious difficulty of *gagliardi* movements made them a fit means for a man to display his athleticism, courage and bravura. Most important, they were a means to impress, the means by which the dancer could dazzle and astonish his audience, in a way which was quite inappropriate for women. In Giovanni Maria Cecchi's comedy *Gl'Incantesimi*, for example, first performed in 1547, Trinca asks Niccolo whether he had not once been a skilful dancer: 'Skilful?', retorts Niccolo, 'I should say so! ... If you had seen me in my short jacket ... performing the galliard, I would have made you marvel' (*Destro? ... Sta bene! ... se tu mi vedessi in giubbone, ballere' ... di gagliarda ... io ti farei stupire*) (Cecchi 1883, p. 135). It is thus significant that, in Vasari's Life of Castagno, who Vasari describes as *gagliardissimo nelle movenze delle figure* (*gagliardissimo* in the movements of his figures), the painter is said to have been adept at the difficulties of his art, and his works are reputed to have made fellow artists marvel (Vasari 1878–85, vol. II, pp. 66, 672).[7]

That is not to say that men were expected to indulge in immoderate displays of skill. A degree of restraint was also essential for the courtier, as Castiglione points out. Conversely, for women, dance remained important as a means of social display. Here, however, the situation was more complex, for while men were permitted, indeed expected, to demonstrate their virtue through displays of artifice and skill, however lightly worn, the woman showed her worth through naturalness and simplicity, in which the artifice was nonetheless assumed. The woman who danced with *leggiadria* was thus staging, or representing, her naturalness and reserve, and displaying her chastity, in a way which also endowed her with a requisite grace and charm.

The changes in dance practice which I have outlined, and the discussion of masculine and feminine qualities in terms of exteriority and display on the one hand and passivity and restraint on the other, can thus give us a more precise and historical purchase on a body of art criticism which has too often been considered as neutral, generalised, and at best purely aesthetic in meaning. The critical languages of dance and of painting were closely interdependent. The examination of their interrelations provides a more secure understanding of the way in which Renaissance viewers read the body in movement. It also reveals a network of gendered reference, focused on the moving body, on which writers such as Castiglione and Vasari drew, and to which they contributed in their turn.

10 The in visibility of Hadji-Ishmael: Maxime Du Camp's 1850 photographs of Egypt[1]

JULIA BALLERINI

> Our very clear and precise French spirit demands above all to be shown things that are comprehensible at first glance ... and quickly tires of vast scenes which seem like those rebuses where one doesn't want to bother to figure out the word.
>
> Du Camp 1867 (Salon of 1863)

Returning to Paris from Egypt and the Near East in 1851, the writer Maxime Du Camp brought back over 200 photographs, most of which he had taken during his sojourn in Egypt. There is a dark-skinned man in many of his pictures, placed there, Du Camp wrote, in order to establish a measure of scale for the architecture (Du Camp 1855, p. 327). This common device is never merely utilitarian; it always has its implications according to who is serving as a gauge of proportions and how that figure is situated in relation to the monuments and to the person who has placed it there.

Du Camp's model, often a mere corpuscular speck in his photographs but a major character in several of his literary works related to this Egyptian trip, becomes a locus for many interwoven issues. Among the most central are those of race, sexuality, the uses and abuses of colonial power, the relation of author to authored, and the relation of the figure living in the present to the architectural ruins of the past among which he has been placed. This essay examines primarily one strand of this web of issues: the ways a photograpahic visualisation of this figure comes to objectify a problematic relation of the past to the present for the French at mid-nineteenth century and for Du Camp as a subject within such a problematic.

The large, elegant album containing 125 of Du Camp's photographs was the most noted result of his journey, then and now, it being the first major travel album to be illustrated with photographs. Published in 1852 in an edition of approximately 200 under the title *Egypte, Nubie, Palestine et Syrie: dessins photographiques récueillis pendant les années 1849, 1850 et 1851, accompagnés d'un texte éxplicatif*, it earned the ambitious, young Du Camp the medal of the French Légion d'honneur.

The reputation of the album has rested almost entirely on its status as a pioneering accomplishment in the history of photography, and not on its inventiveness or originality. Du Camp's long introduction, the *texte éxplicatif*, is in

147

33 Maxime Du Camp, *Egypt, Palestine, Nubie et Syrie: dessins photographiques récueillis pendant les années 1849, 1850 et 1851*, 1852, Plate 47: Thebes, Medinet Habou, gynecium of Rameses Menmare, 8 May 1850

actuality a suite of quotations, many of several pages without interruption, from the two most eminent archaeologists of his era, Champollion the Younger and Richard Lepsius. These lengthy passages provide an historical context for the monuments as well as detailed descriptions of them – front, back, sides, interior, exterior – often accompanied by lists of measurements and maps of the major sites, indicating the positions of the monuments. The photographs are commonplace, clearly legible views of major sites, the monuments centred and evenly lit by the noonday sun. In general, they are well within the conventions of travel book illustrations in other media.

As a whole, the album is a testimony to the characterisations of Du Camp as an obsessive chronicler: driven, ambitious, anxious and unimaginative. Gustave Flaubert, who accompanied Du Camp on this trip, thought it 'smelled a little too much like a commissioned book, a patchwork book' (Carré, 1956, vol. II, p. 125). The album is also testimony to a nineteenth-century empiricist belief in what Johannes Fabian has termed 'visuality', a formulation of knowledge whereby the ability to visualise almost becomes synonymous with understanding. The album, as well as Du Camp's more informal travel book *Le Nil* (published at the same time but without illustrations), can be understood within Fabian's terms as symptomatic of 'a cultural, ideological bias toward vision as the "noblest sense" and toward geometry qua graphic-spatial conceptualization as the most "exact" way of communicating knowledge' (Fabian 1983, p. 106).

Photography, its images dependent on the presence of its referent and its vision organised according to the laws of perspectival geometry, appeared as the ideal aid for such a visual and spatial formulation of knowledge. Du Camp, like most of his contemporaries, was a strong believer in the mechanical, objective authority of the new medium. He wrote that he took along a camera because he 'drew slowly and incorrectly' and, he added, because his travel notes were often confused. 'I understood that I needed an instrument of precision in order to bring back images which would allow me exact reconstructions' (Du Camp 1882–3, pp. 422–3). Within such a system of visual, graphic cognition photography appeared to provide a certainty no writing could give. As Roland Barthes has written, photography 'ratifies' what it represents, and 'the misfortune of language [is] not to be able to authenticate itself' (Barthes 1981, p. 85).

Du Camp's apprehension over the possible 'confusion' of his travel notes and his desire for 'exact [photographic] reconstructions' was typical of his generation and of his particular subjectivity within that generation. He departed just after the French revolution of 1848, one in which he had participated. The revolution marked yet another change among the many that had transformed Western society during the first half of the nineteenth century. Du Camp was twenty-seven years old, an orphan since childhood, especially vulnerable to the threats of a loss of continuity of the past into the present and the present into the future. Unnerved by the radical upheavals taking place around him, he was prey to the pervasive anxiety

over what seemed an inability to control and order not only the present but also the past. The many changes in the social, political and productive structures of modern life appeared so extreme as to preclude the formation of a continuous chain of logical development from the past to the present. The gradually disfranchised upper bourgeoisie, of which the parentless Du Camp was a member, were most strongly affected by such a concern to recuperate a threatened historical continuity.

Egypt, known as the 'land of the origins of Western civilisation', as well as its 'mother,' was a major site for the French to play out such anxieties. To Western eyes, Egypt seemed a past on the edge of total rupture from the present, a pending breach made visible by the deteriorating monuments which Du Camp so assiduously photographed. Visible traces of an originating past civilisation were literally vanishing from sight owing to natural deterioration and, not the least, the vandalism of Europeans and Egyptians alike. These vanishing monuments and their statuary, reliefs and inscriptions threatened the reconstruction of a past and consequently its connection to the present.

Du Camp's need to establish a logical order of things, both temporal and spatial, manifested itself in a reliance on the quantitative and the quotable. Like many nineteenth-century travellers, he made extensive bookish preparations for this journey, one he had planned for many years. He read from a range of literature on Egypt and the Near East, much of it illustrated. He copied verbatim long extracts from the travel accounts of the Greeks and Romans as well as passages from eighteenth and early nineteenth-century orientalist writings of all kinds, from the scholarly to the travelogue. He also kept abreast of the most recent archaeological discoveries of his day, while at the same time steeping himself in the Romantic writings of Chateaubriand, Lamartine and Hugo.

Du Camp is a typical example of a nineteenth-century traveller caught in the paradoxical institutionalisation of an 'unknown' Orient, an Orient that had become 'impregnated by a textual network so dense that the writing threatened to exhaust its own referent completely' (Terdiman 1985, p. 31). To Terdiman's definition can be added an equally dense visual network that also threatened to deplete any direct visual experience of its referent. Du Camp's photographic album and the other books resulting from his trip all have the characteristics of a dutiful, plodding recording of sites already visited many times before in texts and images. Although it was Flaubert who wrote that 'everything I discover here I re-discover' (Terdiman, 1985, p. 31), it is Du Camp's writing that most insistently recycles quotations, paraphrases and clichés. Rarely is there a hint of discovery, surprise or astonishment. The photographs, at first glance, contain little of the unexpected and appear to most viewers 'as silent, almost unfeeling studies analogous to the text that accompanies them' (McCauley 1982, p. 26).

Yet, despite all his transcribed measurements, his borrowings from authorities past and present, and 'safe' points of view (both textual and photographic), Du Camp's sense of disorder and disjunction did leave its traces. One such trail

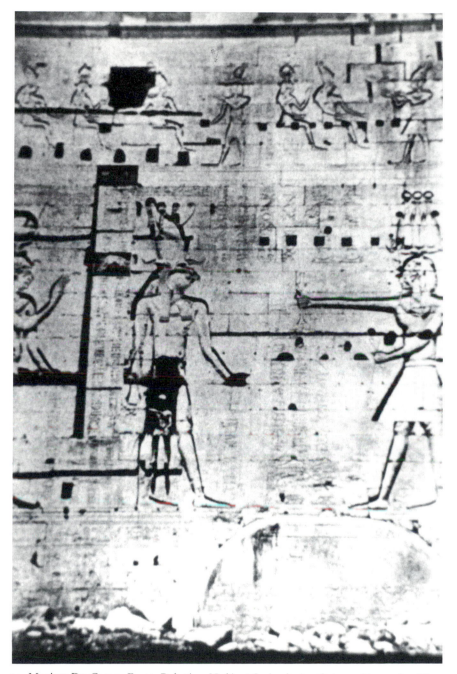

34 Maxime Du Camp, *Egypt, Palestine, Nubie rt Syrie: dessins photographiques récueillis pendant les années 1849, 1850 et 1851,* 1852, Plate 74: Philae, second pylon of the Great Temple of Isis, 13 April 1850

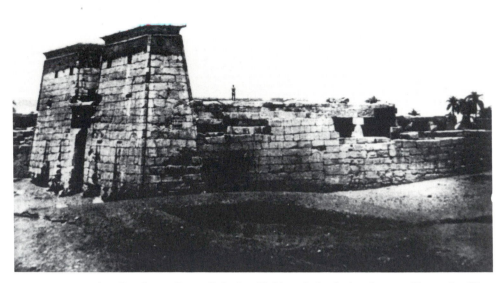

35 Maxime Du Camp, *Egypt, Palestine, Nubie et Syrie: dessins photographiques récueillis pendant les années 1849, 1850 et 1851*, 1852, Plate 28: Thebes, view of the Temple of Khons at Karnak, 6 May 1850

36 Maxime Du Camp, *Egypt, Palestine, Nubie et Syrie: dessins photographiques récueillis pendant les années 1849, 1850 et 1851*, 1852, Plate 65: Kom Ombo, ruins of the temple of Ombos, 20 April 1850

appears intermittently throughout the photographs, a cypher that appears, disappears and reappears again in unexpected places. It is in the form of a dark-skinned man, usually clothed only in a white loin cloth and head-wrap, who inhabits many of the images of Egypt. At times he is clearly visible, standing kouros-style in front of a monument. In other pictures he is posed within the wall of a monument, an adjunct to the ancient friezes and inscriptions, as at Philae (Plate 34). In some photographs he seems to have strayed from the walls onto the summit of a temple, as at Karnak (Plate 35). Often he is framed by the architecture, as at Medinet Habou where he has also been placed on a pedestal in a classic Greek contrapposto stance (Plate 33). In other photographs he is so nestled among the nooks and crannies of the ruins as to be almost invisible, as at Kom Ombo.

In his book *Le Nil* Du Camp situates this figure within a general system of visual measurement and order. 'Every time I visited a monument I had my photographic equipment carried along and took with me one of my sailors, Hadji-Ishmael. He was a very handsome Nubian; I sent him climbing up onto the ruins which I wanted to photograph and in this way I was always able to include a uniform scale of proportions' (Du Camp 1855, p. 327).

The human figure was a frequent and common indicator of architectural scale throughout nineteenth-century European travel illustration. Populating almost all the architectural prints and lithographs of both Western and non-Western sites are scattered little people to give the viewer a sense of the size of the monuments, although often an erroneous one. Within this tradition they also serve another function. They provide an instant, visible commentary on the scene. They become a visualisation of the attitudes and beliefs of their producers and, within a system of visual knowledge, they transform opinion into fact. Most of the illustrations of monuments in the famous twenty-four-volume *Description de l'Egypte* contain figures. The *Description*, which published the findings of Napoleon's army of scholars and artists between 1809 and 1828, became a model for orientalist studies of all kinds. The monuments are usually shown swarming with human activity: Frenchmen energetically studying the monuments, and the indigenous inhabitants for the most part lounging in the shade, smoking narghiles.

Modifications are made as the tradition continues. In 1839, a year crucial to Franco–Egyptian diplomacy, the economist, functionary and military man Baron Taylor published *La Syrie, l'Egypte, la Palestine et la Judée*, in which the lounging 'natives' have been diplomatically banished from the illustrations (which were copied directly from the Napoleonic *Description*). Two years later, from the other side of the channel, the English painter David Roberts had few such compunctions. In his version of the same scenes the autochthonous inhabitants of Egypt reappear in all their picturesque languor, a rendition that can be construed, and was, as a commentary on their neglectful, lazy nature.

However the Egyptian characters may become visible or invisible according to the revised Western script of the times, and however critical or laudatory the

implications of their presences, the prints and paintings of Egypt clearly indicate them as separate from the monuments. A grouping or pairing of figures is the norm, rather than the exception, in this nineteenth-century illustrative tradition. The result of such groupings and pairings is to make the figures more visible and legible *as figures* separate from the architecture. They cannot be overlooked or misread for a bit of archaeological debris, as can Du Camp's model. However tiny, they are clearly delineated from their architectural background by their doublings and groupings.

Aside from their visibility, the pairing or grouping of figures inevitably relates the people in the scene to one another and in so doing provides a psychological distance to their relationship to the architecture and to the draughtsman or cameraman who has depicted them. Within the narrative of the picture they are coupled or grouped with someone else. In the rare instances when such a figure is alone, it is shown as briefly pausing, a water-carrier perhaps, leaning a jug on a ledge for a short rest. The monuments act as a massive, overwhelming backdrop, against which are played out the daily lives of the surrounding inhabitants. In visual terms, each is a separate spatial foil to the other, graphically contiguous, but otherwise unintegrated. The consequent implication is of a separation between the present life of the Egyptians and the architecture of their past.

With the first photographs of Egyptian monuments there was an attempt to continue the tradition of man as an indicator of scale despite the long exposure times. Although some photographers chose to omit the human figure entirely, others continued to include paired and grouped figures, and only occasionally a single figure, even when the exposure times were as long as fifteen minutes. Some of the thirty-six daguerreotypes made in Egypt in 1845–6 by the customs officer Jules Itier contain legible figures. In examples by other photographers the figures result as half-consumed in blurs of emulsion, as in the 1859 photographs by Louis de Clercq, taken almost a decade after Du Camp. Others tended to pose highly visible figures in receding spatial positions, obedient to the rules of perspective, to indicate a three-dimensional as well as a two-dimensional scale. This is a strategy typical of Francis Frith, photographing in the mid-1850s.

Du Camp was familiar with many of the illustrative prints and photographs that preceded him. Yet, despite his tendency to rely on established modes of representation, Du Camp did make several unusual choices. Primary is his consistent choice of a solitary figure. Unlike the occasional loner in other series of travel illustrations, the figure in Du Camp's photographs is always alone, with one exception. Also, according to Du Camp, it is always the same figure. In *Le Nil* and in his unpublished travel notes he writes of only one person as his model: the sailor and member of his crew, Ishmael, although, in fact, Ishmael was not the only one to pose for Du Camp. In a few instances, at the beginning and end of his trip, Du Camp's unmentioned models were Gustave Flaubert and probably his European manservant Louis Sassetti, but Ishmael is the only one Du Camp *indicates* as having posed.

For Du Camp, Ishmael is not an extra on the set, but the only character in his photographic scenario. Ishmael's poses and positions are very different from that of Flaubert, photographed by Du Camp in the garden of a hotel in Cairo. Flaubert is apparently strolling across the space of the view-finder, seemingly oblivious to the presence of the camera (which was, of course, impossible, given the length of time necessary to take the photograph). In this view by Du Camp Flaubert is presented, literally, as a 'passing character'.

Ishmael was not merely 'passing by', he was sent scrambling up and around the monuments. Du Camp writes in *Le Nil* of ordering him to climb up to certain locations, but even without Du Camp's words, Ishmael's highly unusual locations suggest some purpose, however enigmatic. Ishmael did not just 'happen' to be seated eight feet high in the crevice of a sheer wall in the course of his daily activities (Plate 34), or on top of a mammoth column (Plate 36). It was not happenstance that placed him on a makeshift pedestal, centrally framed by a doorway [Plate 33]. Unlike the poses of other human 'measures of scale', Ishmael's locations tell of a picturing eye/I. In assuming his unusual framings and juxtapositions, Ishmael was already a picture *before* the photograph was taken.

Ishmael's mode of undress is also unusual. He is wearing only a loincloth which was neither his indigenous costume, nor that of his occupation, nor was it the way any other sketched, painted or photographed staffage figures were pictured.

Du Camp's official purpose in travelling to Egypt was not to photograph its inhabitants, not even primarily its monuments, many of which had already been photographed. Du Camp went to Egypt on assignment from the Academy of Inscriptions under the aegis of the Ministries of Education and Fine Arts and his main directive was to photograph as many inscriptions as possible.

The preservation, transcription and decipherment of the Egyptian hieroglyphs as they were at the time, often still indecipherable and partially obliterated, was a major concern of the West. In fact, the accurate transcription of hieroglyphs was one of the first uses proposed for photography when the daguerreotype was introduced to the public in 1839. The desire to have a record of all possible inscriptions was so strong that the Academy indicated even those on the rocks of the cataracts as subjects for Du Camp's camera. Although well aware of the unwieldiness of the cameras of the day and of the landscape of the cataracts, the academicians' eager expectations were such that they could ignore the difficulties of placing a bulky camera on a tripod among a tumble of slippery rocks and flowing waters and photographing slanted, uneven inscribed surfaces.

Du Camp's photographic activity was prodigious and intense; Flaubert wrote home referring to 'Max's photographic rages', wondering why he hadn't 'cracked up with this mania for photography' (Flaubert 1971, p. 32). But even with all his maniacal effort, Du Camp was unable to return with more than general views of the cataracts. In fact, he brought back very few photographs of inscriptions at any site. Like many travellers of his time, he found that 'squeezes' (impressions made with

damp papier mâché) were more effective. And it seems, from his and Flaubert's accounts, that he was squeezing just as much as he was photographing.

Often he was squeezing and photographing traces of what had already been lost, preserving inscriptions that had been rendered illegible by the erosion of time, or legible inscriptions that had been rendered indecipherable by the erosion of a collective memory. Moreover, the hieroglyphs that were clearly legible and decipherable presented yet other dilemmas to Du Camp and his contemporaries. The different ancient writings – early hieroglyphic, hieratic, demotic and Greek, layered with the graffiti of the just-yesterday in English, French, Turkish and Arabic – presented an historical development quandary. There was an agreed assumption that the figurative and symbolic signs represented an earlier, more primitive state of writing and the phonetic signs a later, more complex state. But among the many issues at stake was the value of simplicity (by implication a return to an ideal purity of origins) or complexity (by implication a build-up of a storehouse of information constituting progress) (Irwin 1983, p. 173). This debate over the various forms of ancient languages was part of a more general conflicted attitude towards the about-to-be-lost Egyptian past, a debate that implicated the developing disciplines of anthropology, both biological and cultural, and related researches in physiology and phrenology.

Within this network of discourses the indigenous inhabitants of non-Western countries were, like the languages of their ancestors, another location for a Western questioning of the present as related to the past. It was the Europeans who, because of their technological advancement, journeyed to far-off lands and made their occupants objects of study and expropriated their artifacts to display in European museums. It was the Europeans who built scholarly reputations on studies of 'native' cultures, past and present. In so doing they considered themselves inherently superior to those who were being studied and who, moreover, were ignorant of their own history. But such a gesture was not without its discomforting ambiguities. From a progressive point of view there is the illogic upon which the superiority of Western man is based. The discontinuity in knowledge between the earlier and the later inhabitants of the same region undermines the concept of a progressive human development based on the gradual accumulation of knowledge throughout the course of history. The notion that the ancient Egyptians had achieved a high level of cultural and scientific development and that the contemporary native was naïve and ignorant implies that at some point there was a radical break in the continuity of historical memory, a collective act of forgetting (Irwin 1983, p. 174). From a regressive point of view, a return to 'native purity' implied a return *from* a state of knowledge, and thus a purity that was not and could never be originary or original, a purity whose innocence was tainted by forgetfulness.

These ambiguities can be read in Du Camp's verbal accounts of Ishmael. In *Le Nil* he is described as 'a very beautiful Nubian' but Du Camp's unpublished notes qualify, and even contradict, this image of native beauty: 'Hadji-Ishmael: of all the

sailors he was the one I liked best. He was sweet natured, with an ugly face, one eyed, superb muscles. He posed perfectly: I always used him as a model, to establish the scale in my pictures. He jabbered a kind of gibberish that he had learned [from] a French businessman ... he was rather slack and easily discouraged. He was a Nubian' (Steegmuller 1972, p. 225). As described by Du Camp, Ishmael – inarticulate, obedient and superbly muscular – is both the ideal, innocent, pure native *and* the failure of that purity and innocence in terms of Western progress and, Du Camp implies here and elsewhere, perhaps *because* of Western progress. It is from a Frenchman that he has learned a garbled language.

The novel and short stories by Du Camp that are set in Egypt also locate 'the native' at the crux of an ambivalence between the regressive and the progressive. In every tale by Du Camp the pure and noble native son undergoes some form of cultural humiliation and failure. The most extreme example is the story *The Black Eunuch* (*L'eunuque noir*) in which the brave young Nubian man ends up castrated, obese and grotesque. The last scene shows him as an obscene entertainer in a public square in Cairo as he parodies sexual acts his body no longer permits him.

Especially when viewed in the light of such texts by Du Camp, Ishmael's positions within the photographs can be seen as a visual statement of such an ambivalence between progression and regression, past and present. In a photograph such as Plate 34, for example, Ishmael is seated in the cavity of a relief of Osiris, his legs dangling down between those of the ancient god. The placement of his body suggests a re-placement of the missing generative organs of Osiris. Ishmael becomes an ambivalent em-bodiment of the potence – or impotence – of a past in relation to the present. This equivocal visual metaphor becomes more suggestive when this photograph is seen in its context in Du Camp's album. It is in the centre of a sequence of fourteen photographs of Philae and it introduces six images of reliefs and inscriptions from the temple of Isis. Following this image of Ishmael as a bas-relief are three photographs of demotic writings – among the very few taken by Du Camp – and after these an image of Toth, the god of letters. The last of the pictures at Philae is a general view of the temple from a distance. It shows, as Du Camp notes, the ruins of raw-brick native huts which were often attached, barnacle-like, to the temples. Ishmael again marks the site, but here he is a mere scratch of emulsion, invisible among the foreground rubble to all but the searching eye.

In the two images of Ishmael that bracket the photographs of inscriptions and of the god Toth, Ishmael moves from a state of visibility to near-invisibility as Du Camp approaches and distances his camera to and from the monuments. The repeated sequencing of general views, details and a final general view, moving from the whole to its component parts and back to the whole is a conventional one, intended as an efficient, unbiased description of a site and its monuments. But when coupled with Du Camp's use of a solitary dark figure which, from a distance, tends to blend with its background like a camouflaged insect, a descriptive instability is brought into play, that of the human body as a visual measure.

Ishmael's flickering presence describes the many levels of ambivalence and insta-bilities of meaning that characterise the project of recuperating the vanishing and often illegible inscriptions of Egypt. It also finds its verbal parallel in Du Camp's own texts as, for example, when he refers to Plate 79 of the series, that of the god of letters, Toth: 'He [Toth] has a serious, sad expression as if he were thinking of the question of the propriety (*propriété*) of writing' (Du Camp 1855, p. 199). The question of propriety becomes doubly unsettled through Du Camp's choice of a typically ambivalent word – *propriété* – signifying propriety/suitability and/or property/ownership. This shifting instability of language finds its visual echo in the shifting visual unreliability of Ishmael as a suitable measure of scale and proprietor of language.

In another photograph (*Egypt . . .*, Plate 47; this volume, Plate 33), Ishmael's pose raises a different issue. He is positioned in a classical Greek contrapposto stance in the portal of what Du Camp identifies as the gynecium of Rameses XI at Medinet Habou. His is a pose Du Camp knew well and one that was very much a part of the conservative aesthetics of the Paris Salons. The imitation or *translatio* of classical models was still considered an indispensable part of an artist's academic education. The values of a classical Greek paradigm are apparent in Du Camp's own Salon reviews of the 1850s and 1860s where he repeatedly insists that the human figure, specifically the *male* figure, be the main subject for artists. He complains that 'man seems to have become just any old boring accessory' (Du Camp, 1867 (Salon of 1864), p. 104). The importance of the male body for Du Camp was twofold: first as a compositional device to provide a point of focus in a picture and, secondly, as a kind of ideal abstraction in itself. The male body was, in Du Camp's words, 'a type of perfect balance' (*un type de pondération parfait*) (Du Camp 1867 (Salon of 1863), p. 39). *Pondération* is another of Du Camp's characteristic word choices in its duplicitous reference to both physiological and psychological balance, to both literal weight and abstract thought.

In the balance of such an aesthetic was also poised a question of a progressive versus a regressive account of origins. By the middle of the eighteenth century the emerging paradigm of 'progress', with its presupposition that later is better, was being used to promote Greece as the site of the origins of Western civilisation at the expense of Egypt (Bernal 1987, p. 27). For eighteenth and nineteenth-century Romantics and racists (and Du Camp was both) it was intolerable that Greece be the result of the mixture of native Europeans and colonising Africans. This resulted in the turn-of-the-century formulation of what Martin Bernal has called the Aryan theory of Greek origins (as opposed to the multi-racial Ancient model). As the Aryan paradigm rose, particularly from 1830 to 1860, ancient Egypt was 'flung into prehistory to serve as a solid and inert basis for the dynamic development of the superior races, the Aryans and the Semites' (Bernal 1987, p. 29). Nonetheless the concept of Egypt as 'the cradle of Western civilisation' still persisted in all its contradictions, contradictions made visible as the dark body of the Nubian Ishmael

assumes a classical Greek pose on the threshold of the ruins of a gynecium, embodying neither and both sources of origins.

In his writings, Du Camp takes credit for Ishmael's presence in the photographs, and Ishmael's positions and poses themselves speak of an authoring eye/I. With one exception (where he is posed sideways, a rigid bas-relief at the base of a column), Ishmael is always facing the camera. He never ignores the camera by facing the architecture, his back to the viewer, as do many solitary figures, especially if they are Western. The solitary human presence of Ishmael does not participate in any narrative within the picture, unlike the coupled or grouped figures dictated by tradition. In its lone, frontal state Ishmael's presence can be said to refract back to the camera and its cameraman Du Camp. Yet, because the camera is never close enough to represent his face clearly, Ishmael is never *looking* out from the photographs. If his photographic presence can be said to relate to that of the invisible Du Camp, it is by means of his body, not his one-eyed gaze. It is Ishmael's *body* that is coupled with Du Camp's gaze.

Such a linking of the seeing photographer to his model would have been invisible (and it was) to a nineteenth-century viewer for whom photography's authority as a mechanical witness depended on a foregranted *absence* of the photographer. It was Du Camp's very common denial of the possibility of creativity or authorship of a photograph that was the very source of its credibility. Photography was supremely convincing in positing the impossible presence *and* absence of the eye witness demanded of travel narrative. In their written form, such narratives both assert and efface the presence of their authors by a use of the first person singular (*I* was there, *I* saw) along with apologies for distracted, hastily scribbled notes as a sign of the unmediated directness of their 'impressions'. Du Camp makes full use of this common strategy in his writings, and his photographic impressions allowed him an even greater invisibility. In this sense, Du Camp's unusual choices were made possible by photography as it was thought of in 1850.

Du Camp's declared absence as the author of his photographs has temporal as well as physical implications. During the four months of photographing, Ishmael was a living subject in Du Camp's present as well as a measure of the monuments of the past in his photographs. Throughout these months, Ishmael flickered from the immediacy of a present to the past tense of the pose, of the *already* a picture. He and Du Camp (Abu Muknef, 'The Father of Thinness', as Du Camp was called by his crew: Du Camp 1855, p. 328), were constantly together. Du Camp: tall, skinny, intense, workaholic, no sense of humour, ambitious, cautious, snob, anxious, meticulous, manipulative, making full use of his colonial networks and privileges, ordering Ishmael to scramble here and there, continually looking at him through the camera lens, and ordering his immobility by telling him that the camera is a cannon that will kill him if he makes the slightest move. Ishmael (as we know him through Du Camp and Flaubert): obedient, muscular, speaking a composite language almost unintelligible to Du Camp. The two swim across the Nile together. In

Du Camp's autobiographical novel, *The Posthumous Book: Memoirs of a Suicide* (*Le Livre posthume: mémoirs d'un suicidé*), set in Egypt and published at the same time as his photographic album, Ishmael, as the protagonist's brutish, one-eyed servant, is given his discarded native mistress.

Ishmael was a disturbing carnal subject in Du Camp's physical, immediate present, one that lures and repulses at the same time. Photography provided Du Camp with the ideal means to consign the immediacy of Ishmael's presence to an ordered visual scheme alongside his textual re-placements of Ishmael. Situated as an object within a visual tradition of a measure of scale, Ishmael could be moved out from Du Camp's present into an ambivalent temporality that oscillated between past and present. Ishmael's body could be placed by Du Camp in an intermediary position between himself and his surroundings, and between himself and his own past, present and future. As a photographed body in representation, Ishmael could secure uncertainties as Du Camp attempted to ground his anxiety, like a bolt of lightning, in this Nubian body.

As he is posed within the eclectic but conservative context of Du Camp's photographs, travel writings, diaries, stories and novel, Ishmael's photographed and textualised body (textualised both by Du Camp's writing present and by his juxtapositions to the inscriptions of his Egyptian past) becomes a balancing pin-point of the historiographical as it is located in a particular subjectivity. Ishmael comes to embody the irreconcilable drives towards progression and regression, rupture and continuity, towards past and future, signification and its collapse. He becomes a living, muscular cipher balanced on the threat both of the invisibility and illegibility of the past *and* of its legibility and decipherment. As he marks both the collapse and the development of language, he marks a connection to and a rupture from a threatened past. As such Ishmael's viewed body situates and grounds historical and subjective paradoxes. In so doing, it is also momentarily constituted and grounded *by* such paradoxes.

The hat, the hoax, the body[1]

BRIONY FER

'The language of symbolism . . .', wrote Freud, 'knows no grammar', by which he suggested that it was elusive, obeyed no fixed rules but marked out a shifting ground (1955a, p. 212). In this essay, my interest is not so much in the symbols of sexual difference as in the language of that symbolism, in how meanings are made and how symbols operate in representation; the way, in a series of photographs, sexual difference may be played out, even in the absence of a depicted body. The photographs which concern me (Plates 37 and 38) are by the Surrealist photographer Man Ray. In these photographs of women's hats, of a kind fashionable in the early thirties, a less than noticeable edge or outline becomes a pronounced, even insistent, contour; the grain of the fabric becomes a shadowy terrain, not unlike Man Ray's treatment, elsewhere, of the female body as an overwrought screen of textures and contours. In these photographs, the camera has focused on the hat, as an adjunct or extension of the head, but has also isolated it, set it apart; the hats are lit, the heads in shadow; the camera has lurched, it almost seems, from the face to focus on and to dramatise the hat by the high angle from which the picture is taken. Focus, then, is displaced onto a part, an adjunct, which both extends the head and encloses it.

These two images appeared together in the magazine *Minotaure* at the end of 1933. They were taken by Man Ray to illustrate an article by Tristan Tzara called 'D'un certain automatisme du goût' ('On a certain automatism of taste', *Minotaure* 3–4, 1933). Tzara's article discussed the contemporary fashion trends in women's hats for the fedora (originally a man's soft felt hat with a brim and a crown creased lengthways, like a trilby) and the permutations on the close-fitting hat, often with a split crown, sometimes with a rim, sometimes a tip. 'Les chapeaux', he wrote, 'que, récemment encore, les femmes portaient, les chapeaux à forme fendue qui, à leur début, devaient imiter ceux des hommes, les chapeaux dont, au cours de leur évolution, la ressemblance avec le sexe féminin est devenue non seulement frappante, mais significative . . .' ('the hats which women were wearing only recently, hats with a split crown which must at first have imitated those of men, hats in which, in the course of their evolution, the resemblance to the feminine sex has become not only striking but significant . . .', *Minotaure* 3–4, 1933, 82). Tzara was

intrigued by the way these hats took the basic form of male attire – the designs imitated those of men's hats – yet took *on* the form, the metaphorised form, in the split crown fedora of Plate 37, of the female genitalia. For Tzara, a seemingly banal, inanimate object engendered a symbolic vocabulary of both male and female sexual identities – to thematise, in psychoanalytic terms, the ever-presence of sexual difference, always at work yet always shifting. The main point of Tzara's article was that fashion provided a constantly changing set of signs for the body, and for the sexual identity of the body. 'Il semble', he wrote, 'que ce monde est charactérisé par une *mise en valeur* des différentes parties du corps pour lesquelles les embelliss-ements servent en même temps *d'enseigne* et *d'appel*' ('It seems that this world [of fashion] is characterised by highlighting the different parts of the body for which ornaments serve at the same time as a *sign* and a *call for attention*', p. 82). Clothing was embellishment which drew attention to the body, but which also stood for the

37 Man Ray, *Untitled*, 1933

body, as a shifting set of signs for its parts. Both Tzara's essay and Man Ray's photographs have been called a 'direct enunciation' of the principle of 'fetishisation' by Rosalind Krauss in her compelling work on Surrealist photography (Krauss 1986, p. 91); whilst she identifies here a fundamental aspect of May Ray's work, this paper is concerned with a critical transformation, a rupture perhaps, that occurs between text and image, where Tzara's theme was not fetishism but femininity.

The subject of Tzara's discussion was the woman consumer of fashion. Whilst recognising that fashion is in large part economically determined, he was interested in taste, in the kinds of choices women made between garments, and the kinds of desires those choices revealed. Extending a familiar idea in Surrealism, he believed that women were somehow closer to the unconscious than men, nearer that realm of unreason, of madness, which the Surrealist group sought to occupy.[2] For Tzara, the choices women made revealed their unconscious desires and fears, and revealed these 'automatically', that is, without mediation by the conscious mind: 'L'automatisme du goût', Tzara wrote, 'agit chez elle en dehors de toute raison et la transformation des désirs en symboles existants, au moyen du transfert, s'opère avec une suprême habileté', ('The automatism of taste acts in her outside all reason and the transformation of desires onto existing symbols, by means of transfer, operates with supreme skill', *Minotaure* 3–4, 1933, p. 83). Fashion, in these terms, was a means of expression, analogous to automatic writing or automatic drawing, techniques which the Surrealists developed to achieve what Breton called the 'arbitrary to the highest degree' (*Manifesto of Surrealism*, 1924, in Breton 1972b, p. 38). To identify this process with women's fashion recalls the old idea that women are *like* artists in the ways that they dress themselves, an analogy which served of course to reinforce their exclusion from actually being artists. Charles Blanc, for instance, was one of many in the nineteenth century, in *Art in Ornament and Dress* (1877), to claim that in their dress women were artists *par excellence*. More recently, the final words of René Bizet's 1925 book on fashion were 'Le chic est à la femme, ce que le génie est à l'artiste' ('Style is to [the] woman what genius is to [the] artist', p. 94). The more remarkable aspect of Tzara's formulation is the claim that it is in becoming a consumer, in exchange, that these unconscious desires are displayed in spectacular forms; in short, that consumption had a psychic as well as an economic and social structure. This argument is similar to Flugel's, whose book *The Psychology of Clothes* was published in 1930, though the interest of Tzara's text, for my purposes, is that he is concerned with the operation of these structures within a field of representation.

In Plate 38, the focus is on the pointed cap, and its different segments, its cut, its weave, its texture, are played off against the smooth waves of hair it fits tightly around, and against the incomplete, shadowed part-image of the face, cut off by the frame, which seems almost to fall out of the picture, so marginal is it made to appear; viewed from above, the eyes look closed, as in a dream, the eyelash breaking the sinuous contours of the whole. In this way, Man Ray sets up a metonymic chain

38 Man Ray, *Untitled*, 1933

of association, in which adjacent parts inflect each other, and displace each other. The hat is an accessory to the head which usurps the frame and envelops the head – conventionally the site of Mind, and of Reason, but here the realm of the unconscious mind – that place 'outside all reason'. The physical proximity of the hat and the head suggests an almost aphasic lurching from one to the other. In Plate 37 the hat almost entirely conceals the face, obliterates it – acting as a mask which keeps the face secret. The layers of concealment, of masking, are part of the bluff, for what is revealed, by substitution, is nothing less than the form of the female sex. The body is not pictured, but is figured metaphorically.

By focusing on the part, the hat stands in for the whole, where the body is substituted by a token or attribute. Man Ray skews the normal subordinate position of the accessory by his focus and by his use of camera angle, which has the effect of decentring the image. It is a device which works by twisting the conventions of other representations and which works against the grain of the notion of a centred body by reversing the role ornaments conventionally played in its construction. To emphasise the point let me refer again to Blanc's model of the 'centred' body, where ornament was seen to enhance the body's basic symmetry: 'The order in a woman's toilet', he wrote, 'results from the symmetrical arrangement of correspondent parts, and above all of the ornaments that balance, such as earrings; and of the place in the axis of the head-dress or in the central line of the figure . . .' (Blanc 1877, p. 117). Blanc thought that dress should conceal any defects in the individual human form; a checked material made into a dress is unbecoming, wrote Blanc, particularly in the bodice, because large squares make the least disparity in the human form conspicuous (p. 141). The large stripes of a third photograph by Man Ray (not illustrated here) draw attention, on the other hand, to off-centredness, as the form of the hat pulls back from the head. For Blanc, the angle of a head-dress obeyed the same rules that he had outlined earlier in *Grammaire historique des arts du dessin*: 'placed horizontally, it gives an idea of order and calmness' (Blanc 1877, p. 118); what he calls the 'oblique style', the hat tipped forward on the head, expresses independence and originality. For Blanc, the purpose of adornment was to bring the proportions of the human body into harmony. Women have an innate sense of this, and always try to establish, in their dress, equable proportions – whether it be the leg-of-mutton sleeves and hooped skirt, confining women to a sedentary life, or the coiffure and bustle of the figure in profile, whose mobility threatens, for Blanc, to carry away even the 'guardians of our homes'. In this model of adornment as correction, and of women as intuitively self-correcting, decoration compensates for defect and disunity. Conventionally, then, accessories were meant to regulate and unify the female body, and thus render it legible. The Surrealists, on the other hand, were interested in accessories, or fragments of parts, as signs of dysfunction, of a deviant principle not a corrective one.

By the 1920s, the currency of associations which had conventionally attended

upon the unified body, guided by classical proportion and academic principle, had taken on new forms and Blanc's model of the unified body had become the standardised body. The correspondences here were with modern industry and mass production. A prerequisite of mass production in the fashion industry was the standardisation of sizes, which classified consumers into types. As Paul Nystrom, an American observer, wrote in 1928, 'Factory production was impossible without size standardization' (p. 452). Mass production required a more systematic approach to standard body types than had ready-to-wear manufacture in the nineteenth century, and Nystrom related the trend towards the straight silhouette in women's clothing directly to the shift to mass production after the First World War. In this way the language of standardisation and efficiency came to permeate, and regulate, social life in general. The application in French industry of methods based on F. W. Taylor's ideas on the organisation of production also entailed an increased division of labour, where the production process was broken down into parts, and where each part of the whole had to work at maximum efficiency. One of the aims of the system was to separate as far as possible manual work from intellectual work, the 'département qui pense', as the sociologist Friedmann, writing in the thirties, paraphrased Taylor (Friedmann 1936, p. 72). According to this method, the systematic organisation of the working process was taken away from the individual and restructured on the basis of separate tasks and functions, in a way which ensured the greatest efficiency.

The individual, then, was not only a producer of standardised goods, but, as a standard body, a product of that larger system of which he or she was but a component part. This idea was central to the Purist aesthetic as it was elaborated by Le Corbusier in the magazine *L'Esprit Nouveau* in the early twenties.[3] Le Corbusier discussed the standard body, with limbs as standard parts, and human-limb objects as prosthetic additions which extended and aided the logical functions of the body – for example chairs to sit in, tables to work at, machines to write with (the idea of prosthesis in Le Corbusier's writing has been discussed by Forty 1990, pp. 124–5). '*Human-limb objects*', Le Corbusier wrote, are 'in accord with our sense of harmony in that they are in accord with our bodies' (Le Corbusier 1987, p. 76). Discussing the standard sizing of paper required by modern typewriters, he made the point that establishing sizes is based on the 'anthropocentic mean', the mean centred in man. His view of the body denied the role of ornament as decoration or embellishment, likening the body to other logically functioning objects, such as the machine. Whilst keeping a basic model of harmonic proportion, then, Le Corbusier differed from Blanc, not only in the obvious contrast in their views of decoration but also in the way he situated objects as functional extensions of the body – rather than as corrections to its natural defects. Le Corbusier's model of the functional body drew on the ideas of the Austrian architect Adolf Loos who had argued that 'The evolution of culture is synonymous with the removal of ornament from objects of

daily use' (Loos 1920). For Loos, modern male dress was paradigmatic, and its reductive simplicity and inconspicuousness in the crowd was the mark of the modern man – to be dressed correctly and in a modern way 'is a question', Loos wrote, 'of being dressed *in such a way that one stands out the least*' (Loos 1982 p. 11). This refusal of surplus ornament was clearly important to the protagonists of the Purist magazine *L'Esprit Nouveau*, but another version of Loos' interests might be expected from Tzara, who commissioned his older friend Loos to design a house for him in the Avenue Junot in Paris in 1925. The design of this house characteristically used different materials, symmetry and asymmetry, and Tzara saw in Loos' architecture 'a perfection which excludes neither microbes nor dross nor the impurities of life' (Tzara 1930, in *The Architecture of Adolf Loos* 1985, p. 78) – clearly a differently aspected Loos from that which informed Le Corbusier. Tzara's sense of a house's essential impurity, if we can call it that, could live happily with the collection of art and of African masks with which he adorned the interior. It perhaps even excluded Loos from Tzara's claim in 'D'un certain automatisme du goût' (1933) that modern architecture was founded on an aesthetic of castration. There was, of course, a long-established view of the analogy between architecture and clothing that architecture was an extension of some of the ideas of covering, enclosing and enveloping that Tzara had applied to the hat.

For Le Corbusier, on the other hand, the importance of Loos was that he had made a virtue not of impurity but of extreme reduction and the struggle against ornament. In his writing on fashion, for example, Loos had argued that male dress manifested an advanced state of civilisation in its lack of ornament, whereas women's dress marked an earlier state of development; the simplicity of male dress contrasted with the variety of decoration and ornament typified in women's clothes, whereas for Tzara it was exactly the shifting nature of women's fashions that functioned as a series of signs for the body. What Loos had seen as 'uncivilised' about women's dress was exactly what Tzara interpreted positively as nearer the unconscious. Modern dress is taken not as emblematic of a rationalised modern culture, but as an index of what Freud called the 'prehistory' of women, where the modern is taken to be a category of myth. And historically these different views of the modern, these conflicting currencies of association, depended on one another for their force; as Roger Caillois put it, the Surrealist desire to discredit reality can only be made sense of dialectically, if its antithesis is considered, where Surrealism valued everything that 'le pragmatisme industriel et rationnel' ('industrial and rational pragmatism') had tried to suppress (Caillois 1933, p. 31). Tzara's use of terms such as 'ornament' and 'embellishment', in this context, take on a strategic meaning, as a deliberate move away from a language of logic, precision and efficiency; the use-value of a hat, and any practical function it may have as a covering for the head, is rendered irrelevant in a fashion accessory, in favour of the symbolic possibilities which accrue to its commodity status and its function, here, as a site of exchange.

We can identify a similar strategy at work in a text by André Breton (1964). In *Nadja*, first published in 1928, the topography of the city of Paris was mapped onto the unconscious. As Breton wanders the city, aimlessly, as a latterday *flâneur*, and like Baudelaire's model of the modern dandy whom he mimics, he seeks the chance encounter. He observes, distractedly and without wishing to, the crowd – 'ses visages, ses accoutrements, ses allures' ('its faces, its garb, its gait') – and out of the crowd he fixes on a young woman, Nadja, of whom he later writes 'Je suis, tout en étant près d'elle, plus près des choses qui sont près d'elle' ('I am, even whilst close to her, closer to the objects which are close to her', Breton 1964, p. 104).[4] On a further meeting, Breton writes about Nadja by describing these displaced objects of his desire, substituting for a description of her a description of her hair, her hat, her stockings: 'en noir et rouge, un très séyant chapeau qu'elle enlève, découvrant ses cheveux d'avoine qui ont renoncé à leur incroyable désordre, elle porte des bas de soie et est parfaitement chaussée' ('In black and red, a very fetching hat which she takes off uncovering her oaten hair abandoned to its unbelievable untidiness, she wears silk stockings and has perfect shoes', Breton 1964, p. 83). The displacement onto parts, and onto the trappings of femininity, corresponds with Breton's broken, collaged and fragmentary language. The photographs which are reproduced in *Nadja* by, amongst others, Boiffard, also work as part of the collage effect; on their first meeting, Nadja is on her way to the hairdresser – according to Breton, a ploy to evade him – on the Boulevard Magenta, which we encounter in one of Boiffard's photographs which appears later in the text, below the sign of the Hotel Sphinx. Male desire, in Breton's text, is constantly displaced onto things – hair, a hat, stockings or a glove, which hover around the woman, who is enigmatic, like the Sphinx, delivered up as a sign of a hotel – just as desire is also mapped onto the sites and circuits of the city itself. The text of *Nadja* pursued what Freud called 'the topography of mental acts' through parts and fragments (Freud 1984, p. 173). Mentioning trips to the 'marché aux puces' at Saint-Ouen, Breton remembers his search for objects 'démodés, fragmentés, inutilisables, pervers enfin . . .' ('old-fashioned, fragmented, unusable, ultimately perverse . . .', Breton 1964, p. 62) and he refers to the Porte Saint-Denis – 'très belle et très inutile' ('very beautiful and very useless', Breton 1964, p. 38). The urban environment – particularly those aspects which are not-so-new, the almost obsolete – is a site of fantasy, a kind of subterranean world to be explored by the psychic *flâneur*, as a strategic response to the celebration of rationalisation. In this respect, *Nadja* is similar to Aragon's earlier novel of the city, *Le paysan de Paris* of 1926, which, despite its more obvious hallucinatory quality ('Hair pulsing with hysteria', for example) also looked to the outmoded aspects of the city, like the old arcades around the Opéra which were about to be demolished.

For Tzara, on the other hand, metaphors of sexual difference lurk in the up-to-date, the smart even, rather than the not-so-new. The meanings of 'chaque signe dont vous ornez votre passagère apparition' ('each sign with which you ornament

your fleeting appearance'), by implication, glanced, happened upon, transient rather than fixed, were the products of the unconscious, where sexual difference is given symbolic representation in modern fashion and its consumption. Because fashion is constantly being renewed, it constantly revises the image of the body which it clothes. This reading of the symbolic currency of fashion as shifting and unstable is reinforced, for Tzara, by the bisexual nature of the symbolism. The female sex in 'la fente' (the split), the male phallic form of the covered head, the encircling tie or rim, precludes a reading of the symbolism as *either* masculine *or* feminine, but suggests instead that there is an oscillation between the masculine and the feminine in play. For Tzara to write about symbols in this way shows him addressing Freud's ideas on sexual symbolism where the male and female genitals may be substituted in certain dream contexts by quite ordinary objects (in a projecting form, for instance, or an enclosed receptacle). But Freud had also stressed the shifting gendering of symbols and had proposed the hat as an example of an ambiguous symbol, 'with a male significance as a rule, but also capable of a female one' (Freud 1971, p. 191). It is in the midst of this symbolic duality that the female genitalia are exposed, like a scar, revealing the inferiority complex that women have – learning to live with the realisation of castration, the symbolic terms for learning to live without power. The scar-like crack stands for the wound, the necessary acknowledgement of lack – symbolically, the entry of the little girl into sexual difference. The phallic form of the hat serves to compensate for the sense of loss, a sort of reconstitution of a fundamental human bisexuality. Fashion was subject to alternating masculine and feminine phases, suggesting a certain irresolution of conventional categories, a fluctuation between the masculine and feminine tendencies, and an insecurity of sexual identity.

Tzara's article was published at the end of 1933. Freud's now famous essay on 'Femininity' had been published in German at the very beginning of that year, and there is little doubt, I think, that the 'Femininity' essay formed the basis of Tzara's use of psychoanalytic material in his article, although Freud had been concerned with the specific problems of female sexuality from 1924. Here, for Freud, 'the riddle of femininity' was a problem that was not just the mirror image of the boy's sexuality but different from it. Repeating a point he had made several times before, Freud insisted that what constitutes 'masculinity' or 'femininity' is not pre-given in biology but acquired in culture. Freud discussed the girl's particular difficulties in making the transition from the mother to the father in her own experience of the Oedipal situation. The original myth of Oedipus, whose desire for his mother leads him to kill his father, was taken by Freud as a classic psychic scenario of early childhood, and is linked to his theory of the castration complex. For Freud, girls as well as boys have a castration complex and this involves the girl's realisation of her lack and subsequent envy of the penis, which Tzara identified in the phallic form of the hat as symbolic compensation for the woman consumer. Where the essay on 'Femininity' differs from the work Freud had done on the subject since 1924 was in

a final section where he added a few points on adult female sexuality, taking as his starting point the 'prehistory' of women he had already outlined. He noted regressions to the fixations of the pre-Oedipal stage and the 'repeated alternation between periods in which masculinity or femininity gains the upper hand' in the lives of some women – the point which Tzara took up and related to fashion in general – and which for Freud was an expression of bisexuality which men often read as the 'enigma of women'. There were two strata to that prehistory – the pre-Oedipal attachment to the mother and the attachment to the father brought about by the Oedipus Complex – both of which remain with her and unresolved, the decisive one being the pre-Oedipal phase. Freud refers to the relationship of narcissism to femininity, claiming that the girl's sense of lack 'has a share, further, in the physical vanity of women, since they are bound to value their charms more highly as a late compensation for their original sexual inferiority' (Freud 1971, p. 596) – again the point taken up by Tzara.

This suggests that Tzara applied Freud's views on femininity to fashion. But citing this as a source for Tzara's text seems to raise far more questions than it answers, not least in the context of the problematic character of Freud's account of female sexuality, which has been foregrounded by feminist psychoanalytic studies. The interest of Freud's discussion of the Oedipus Complex and castration, in both sexes, can be thought of as acting as an organising metaphor for the power relations as they exist between men and women, because the Oedipus Complex marks the point of entry *into* sexual difference, and has been seen to stand as a metaphor for the origins of patriarchal power and the way sexual differences come into being – psychically, socially and culturally – and are played out in representation.[5] In 'D'un certain automatisme du goût' the origin of a text is also at issue, highlighted by what I take to be the key element which Tzara appears to have drawn from Freud, the central poetic metaphor, which I have not yet mentioned. For Freud began his essay by quoting from a poem by Heinrich Heine, one of the poets to 'knock their heads against' the riddle of femininity:

> Heads in hieroglyphic bonnets,
> Heads in turbans and black birettas,
> Heads in wigs and thousand other
> Wretched, sweating heads of humans . . .

The enigma gains force in the term 'hieroglyphic', in that blurred line between legibility and illegibility. And it is that metonymic chain – between hats, heads and the unconscious mind – that Freud raises at the start of the essay and which Tzara seems to have seized upon in thinking about contemporary fashion. Mary Ann Doane has made the point that in Heine's original poem the question was not 'What is Woman?' but instead '. . . what signifies Man?' and the question Freud poses is 'a disguise and a displacement of that other question'. In a text which ostensibly deals with femininity 'the question of the woman reflects only the man's own ontological doubts' (Doane 1982, p. 75). This has interesting implications for

the Tzara article, which also raises issues about the circulation and exchange of images and texts. It deals, after all, with women as consumers of fashion, where the 'automatism of taste' is revealed in exchange, but takes no account of another kind of exchange system into which women are placed, as objects of desire and fear; it masks Tzara's position in the latter, as a consumer, a spectator, who fixes his regard on the former.

In order to pursue this question of where the woman consumer of fashion figures in a system of psychic exchange, I want to turn again to look at Man Ray's photographs and to look elsewhere in Freud's theory of sexual difference. For I would suggest that whilst Tzara's essay represents aspects of Freud's view of female sexuality and relates them to a woman consumer of fashion, Man Ray's photographs represent something quite different, transforming the terms of symbolic representation. Where Tzara claimed that these hats corresponded with women's unconscious desires, Man Ray's photographs necessarily imply an imagined spectator. His use of a high camera angle means that the hats are viewed from above to show the crown – a position from which the woman cannot see herself; they display the metaphorised forms of the female sex for the benefit of others rather than herself.

In a short paper of 1916, Freud had discussed the hat as an unintelligible symbol, but 'it may be', he wrote, 'that the symbolic meaning of the hat is derived from that of the head, in so far as a hat can be regarded as a prolonged, though detachable head' (Freud 1957, pp. 339–40), and he linked it to a fear of beheading and of castration. What interests me here is the way a metonymic association of hat and head is drawn, which can stand for castration and as a metaphor for the relations of power between men and women. Here the relation depends to some extent on shape, but primarily on contiguity; elsewhere, it may be an angle or a formal relationship (a diagonally placed pillow, for instance, in another case he cites); or a texture. Rather than a matter of definition, the language of symbols depends on a context and on associations. It may have no fixed rules of grammar but it corresponds with the structure of the unconscious. Of particular consequence for visual representation, Freud's theory of the language of symbolism hinges on sight, on looking, where the terror of castration, for example, is linked to the sight of something. One of the key symbols invoked by Freud in which this terror was played out was that of the Medusa's head, where the symbol of horror was worn upon Athene's dress (Freud 1955b, p. 273). The displacement of one part of the body onto another in this example can be compared with the process of displacement I pointed to earlier in Man Ray's photographs. We might even suggest that there is some movement, or transition, between the two photographs, where Plate 37 entails the recognition, the 'happening upon', the 'scar' or crease, focusing on the enclosing hat which appears to obliterate or 'decapitate' the head, whilst Plate 38 shifts to another moment in the symbolic scenario, where the sinuous weave of the hat and the wave of the hair draw attention to the surface and grain of the

photograph itself, as a modern Medusa, 'in the form of snakes', akin to Aragon's invocation in *Le paysan de Paris* of 'Serpents, serpents … lazy coils of a python of blondness' (Aragon 1987, p. 52).

In Freud's 'language of symbolism', there is always a split or rupture between the appearance of an object and the meaning behind it, that between manifest and latent meanings. And in the way Man Ray photographed the hats, the connection between symbol and symptom appears to be located not in female sexuality or narcissism but in what Freud identified as the male drive of fetishism. In the fetish, an object serves as a sign for something else – for woman's castration and more generally sexual difference itself. The photographs isolate an object, or a part of an object, disconnect it from surrounding context, give it undue attention, and use unfamiliar angles to focus compulsively upon it; all this makes photography a prime site for the process of fetishism to be acted out.[6] By focusing on texture, by making of it an exquisite, nuanced surface, Man Ray dramatises the process of transition from touch to sight, from touching to looking, which for Freud becomes perverse if the pleasure in looking supplants other types of pleasure (the perversion he calls scopophilia, Freud 1977c, p. 70), as it does in the fetishist. That movement from touch to sight is central to fetishism, where Freud had talked about the conno-tations of fur and velvet as the 'fixation of the sight of pubic hair' (Freud 1977c, p. 354). Fetishism relies on looking – and it may entail, as here, the angled look – as much as it is to do with any actual object. Concealing the body, in these terms, can be taken as a measure of revealing its hidden parts, where the textures (of surface, of clothing) stand in, metaphorically, for what is hidden, the latent meanings. Tzara had suggested something of this when he proposed that a key aspect to the elaboration of metaphor was the capacity imaginatively to transpose the sensations of touch to sight; but it is left to Man Ray to draw the conclusion, and to draw it in a way which reproduces the compulsive effect.

Surrealism dramatises fetishism as its main drive and, by extension, the main drive underlying the production of images in contemporary culture. Tzara revealed the 'looked-at-ness' of the commodity as a ritual object of exchange and consump-tion; Man Ray reveals its basis in fetishism. In this context, the photographs can be seen to be 'in the act of' transforming that material into fetishism. The hat, as a shadowy terrain of textured cloth coalescing with the grain of the photograph, reflects back on the desires and fears of the male unconscious. The fixation of the sight of the hat, which conceals the face, reveals the body of the woman, in a frozen fragment. The minimal nature of the image, its formal rigour, its urbanity even, explodes into sheer symbolic excess. The hoax, then, is on several levels: the hat is not what it appears, nor is it about female sexuality but about male desire and fetishism. The hat, in these terms, acts as both an alibi and a lure, an evasion and an invitation, entrapment and seduction, where the masking of femininity slips irresis-tibly into the conditions of male spectatorship. Surrealism seeks out those aspects of objects, and of commodities, where the social and the psychic meet; it courts

imaginative projection of a kind which weaves sexual difference through the apparently indifferent world of objects, in a way that is inappropriate in competing versions of what is required of modern spectators; and arguably, it calls into question the metaphors of sexual difference at work elsewhere in modern culture, even in the supposedly resistant and indifferent realm of a modern aesthetic.

The case of the dirty beau: symmetry, disorder and the politics of masculinity[1]

MARCIA POINTON

In 1677 John Mulliner, an established Northampton wig-maker, summoned his two apprentices and in their presence ceremonially burnt a wig. His action was the result of a prolonged inner struggle in which, by his own account, he thought 'there is hardly any man but is desirous of a good head of Hair and if Nature doth not afford it, if there be Art to make a decent Wig or Border, what harm is that?' (Mulliner 1677, p. 8)

Mulliner's wig-burning was a testimony to God on his conversion to Quakerism, but the relationship between art, nature, gender and power that is the site of his struggle is one that was troublesome not merely to a small group of dissenters at the end of the seventeenth century. This chapter is about hair and, more specifically, about wigs. While wigs were not exclusively a masculine item of apparel, in discursive terms they are highly gender specific; wigs are identified specifically with masculinity in cultural discourse. However, as symbolic systems are rooted in social practice, it is important to pause to recognise the actual differences in men's and women's dress in the eighteenth century. A treatise on hair of 1770 claims that:

Women study dress only to add to their beauty; whereas men should dress suitable to their various ranks in life, whether as a magistrate, statesman, warrior, man of pleasure, &c. for the hair, either natural or artificial, may be dress'd to produce in us different ideas of the qualities of men, which may be seen by actors, who alter their dress according to the different characters they are to perform. (Ritchie 1770, p. 78)

Men and women were instructed how to combine the natural hair of the head with toupees and half wigs but it is clear that for ladies additional hair is recommended chiefly when their own hair is too thin or short or for convenience when out of town. Men who were going bald could disguise this by various forms of top-piece, tower or half-wig (Ritchie 1770, p. 80) but gentlemen who wore bag wigs would need to have their hair shaved or very short.

Rowlandson's *Six Stages of Mending a Face* of 1791 shows a woman, with shaved head, putting on a wig but this should not be construed as evidence that the wig was associated equally with male and female identity; it is precisely its masculine connotations that work here to reinforce the unnaturalness of 'mending the face'. The woman's action is proper to a man, not a woman. When men are represented in

their own hair and appear in public places – and the portrait would be one such place – without a wig they are clearly defined by that absence. Such, for example, are *Alexander Pope* portrayed *c.* 1737 (attrib. J. Richardson, London: National Portrait Gallery), *Dr Johnson* in Reynolds' portrait of 1769 (Houghton Library, Harvard) or the dishevelled and melancholy *George Romney* in an unfinished self-portrait of 1782 (London: National Portrait Gallery).

While the fashionable man often covered his entire head with a wig and had his own hair shaved off better to accommodate the false hair, women added to their own hair as prescribed by Ritchie or for special occasions. When Mary Welch married the sculptor Joseph Nollekens in 1772 she was extremely grandly turned out; high coiffures for women were the height of fashion and the bride's 'beautiful auburn hair, which she never disguised by the use of powder, according to the fashion of the day, was ... arranged over a cushion made to fit the head to a considerable height, with large round curls on either side; the whole being sur-mounted by a small cap of point lace, with plaited flaps to correspond with the apron and ruffles' (Smith 1920, vol. 1, pp. 16–17).

It was recognised that masculine authority was vested in the wig. Wigs thus feature prominently in one of the popular live entertainments in London in the late eighteenth century and were evidently a recognised subject of satire and humour directed at fragile masculinity. Edward Beetham, in a performance that allegedly ran for three hundred successive nights before crowded audiences, used to tell how the 'modern custom of embellishing the whole head' came from 'the ancient custom of adorning the temples' and 'hence arose the wig manufactory'. The consequences of this are then demonstrated using wood and pasteboard models:

No. 6. Here is a head [a counsellor's head] and only a head; a plain, simple, naked unimbellished appearance; which, in its present situation conveys to us no other idea, than that of a bruiser preparing to fight at Broughton's. Behold how naked, how simple a thing nature is! But behold how luxuriant is [a large tye wig upon the head] No. 7. Art! What importance is now seated on those brows! What reverence the features demand! (Beetham 1780, p. 3)

Beetham's humorous exposure of human vulnerability through the contrast between the familiar, bewigged authority and the naked, exposed head suggests not only that the wig was (as Ritchie also asserts) necessary to the establishing of masculine identity but also that a man without a wig was an object of universal humour rather like the man who has lost his trousers who later would become familiar through Music Hall culture.

The seemingly unproblematic formality of eighteenth-century male portrait representations with their repetitive be-wigged figures can therefore be understood as a formality defined within the period by implicit contrast with that to which it is other, a formality constructed by its hieratic and symbolic separation from the grotesque disorder into which – without the perpetual replication of these ordered and dignified representations of the idea of social man – it would disintegrate. It is this grotesque disorder that I shall examine. By referring to the wig as a discursive

formation I mean it has a life of its own as a language beyond questions of dress and manners. It is invested with a powerful symbolic significance and becomes widespread currency in ways that cannot be summed up by the material object of the wig to which, however, it always ultimately refers.

The recurrence of the wig across a range of visual imagery – from society portraiture to Hogarth's *A Midnight Modern Conversation* (engraved March 1732/3) – overrides the autonomies of artist, genre or mode of production. It is at the symbolic level of communication that the rhetorical language of the body most clearly articulates power; the surfaces of the body are as backgrounds upon which items of apparel as objects in themselves are inscribed. When the body is understood to be an artifact, the distinctions between self as represented in visual imagery and self as mobile representation no longer apply and imagery may be seen to inform the production of meaning in life as well as vice versa.

The *Oxford English Dictionary* defines 'wig' as a shortened form of periwig. It describes it as 'an artificial covering of hair for the head, worn to conceal baldness or to cover the inadequacy of the natural hair, as part of a ceremonial, or formerly fashionable, costume (as still by judges and barristers, formerly also by bishops and other clergyman) or as a disguise (as by actors on the stage)'. By elision the word can come to mean the head of natural hair, as with calling a child 'curly-wig' and as with a scolding or wigging from someone whose authority is symbolised by their wearing a wig, and being a 'bigwig'. Etymology signals here a rich metaphoric history around questions of authority and the exercise of power. Wigs were commonplace in ancient Egypt and were also worn in Roman society but the peruke, as it is most familiar in Western culture, was first worn in France and Italy about 1620 and introduced into England around 1660 where it was in very widespread use until about 1810. Although women at Elizabeth I's court wore wigs, it was overwhelmingly an item of male fashion from the late seventeenth century.

Our knowledge about wigs comes from anecdotal and documentary sources and from a number of treatises on wig-making. The third edition of Diderot's *Encyclopédie* (1771), for example, systematically illustrated not only the art of wig-making but also all the wigs available at the time including knots and spiral curls, earlocks and pigtails, Abbés' wigs with a tonsure left open in the crown and bag wigs (which included a rectangular bag with drawstrings at the back in which the hair was contained). M. de Garsault's *Art du Perruquier* ... published in 1767 (p. 140) offered an authoritative account of an art and a fashion in which France was well established by the 1720s. Hogarth's famous parody of the Vitruvian orders (*The Five Orders of Periwigs*, first state November 1761) plays off systematising representations like these and, more immediately, parodies earlier English representation systems like *The Exact Dress of the Head, drawn from the Life at Court, Opera, Theatre, Park &c by Bernard Lens in Years 1725 & 1726 from the Quality & Gentry of Yᵉ British Nation*.[2]

Like all forms of personal adornment subject to the laws of fashion, the wig was a

powerful signifier capable of extremely diverse and contradictory connotations. The wig held, it seems, a special place in the economy of the body and possessed as a consequence powerful symbolic values. It offers the historian a register of socialised masculinity from the seventeenth to the beginning of the nineteenth century. As such it was also heavily ideologically invested. The seventeenth-century legal wigs which Hogarth isolated in order to critique the pretensions of the legal profession were, like the orders of classical antiquity, archaisms. But, coupled with wealth, eloquent speech and the power of death, they were also the visual embodiment of a historic and established exercise of power. It has been pointed out that the courts were platforms for addressing 'the multitude' and contemporaries asserted that 'in the court room the judges' every action was governed by the importance of spectacle' (Hay 1975, p. 27). The language of the head extended into many terrains, however. The powder for wigs was made from flour and when, in 1795, a tax was introduced on hair powder, the wearing of an unpowdered wig became a sign of Republicanism. When Walter Savage Landor and Southey adopted this stance they were engaging in a highly complex form of ritualised self-presentation.[3] Throughout the eighteenth century wigs were unmistakably associated with French court fashion so to parade an unpowdered wig as a sign of Republicanism was to hedge your bets in no uncertain terms. The term 'crop' or 'cropper' was introduced for those who wore their own hair cut short as a sign of their radical allegiances; as Amelia Opie wrote in 1800 'almost every man was a *beau* and a sloven, at some time of his life. Charles Fox once wore pink heels; now he has an unpowdered crop' (Earland 1911, p. 149).

Once it became normative for gentlemen to wear wigs, to be seen without a wig was to identify oneself as deviant. Wearing a wig, as we have seen, involved shaving the head to make it fit well and Hogarth often produced effects of anarchy by introducing the naked shaved head into the crowd. The wigless head is, moreover, a recurrent theme in literature and in art connoting loss of masculinity and potency. Loss of a wig in real life, usually by theft, caused very serious inconvenience as the owner could not appear in polite society without one. In August 1789 Boswell was obliged to share a room in an inn and next morning found his wig was missing. 'I was obliged to go all day in my nightcap, and absent myself from a party of ladies and gentlemen.' He had to send to Carlisle twenty miles away to get a replacement (Boswell 1924, vol. II, p. 377).

In the punning painting *An Election Entertainment* (*c.* 1754, Sir John Soane's Museum; Plate 39) Hogarth exploits the powerful analogies between loss of wig and loss of political power. In the foreground a whig has his injured shaven pate treated – he is wigless – while the Whig Attorney who was registering votes in a book has just been knocked senseless by a brick and his wig is falling from his head. Bewick, in a tailpiece showing a rider falling from his horse, makes a point of depicting the man's loss of his wig for in that is imaged his loss of dignity.[4] Whether biblical authority in the form of the story of Samson's loss of hair or Freudian psycho-

analysis is invoked, it is clear that the loss of hair – like the loss of teeth – has powerful meanings in the nexus of sexuality and power.[5]

As a literary topos, the removal or loss of wig and consequent revelation of the naked head is synonymous with exposure, causing a breakdown of social order and the threat of unleashed sexual disturbance. In Fanny Burney's *Cecilia* Mr Briggs arrives at a ball in Portman Square to mix in society with his ward, Cecilia. As he is very hot he takes off his wig to wipe his head 'to the utter consternation of the company'. Captain Aresby tells the offending Mr Briggs that he is quite *assommé* to disturb him but begs that he will cover up his head for 'the ladies are extremely inconvenienced by these sorts of sights, and we make it a principle that they should never be *accablées* with them' (Burney, *Cecilia* 1986, pp. 315–16). The action of removing the wig is not only antisocial, it is quite gender specific and the shock caused derives from the act committed in mixed company and in a public (social) space.

39 William Hogarth, *An Election Entertainment*, c.1754

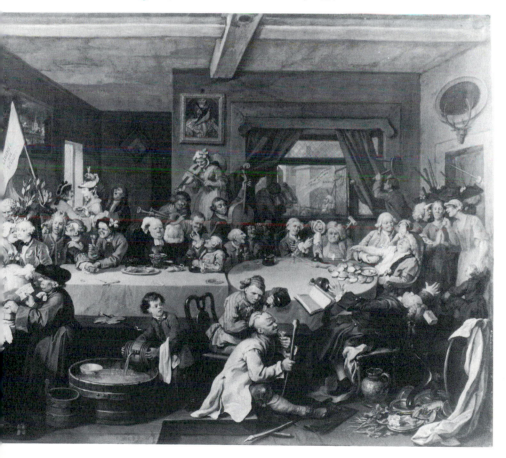

Captain Aresby's French affectations open up a certain ambivalence towards the standards of manners that are implied by his defence of the ladies' sensibilities. This ambivalence indicates that the wig was capable of connotations other than those of the strictly respectable and the maintenance of national order. Indeed, at the other extreme, wigs could represent not upright masculinity but the very reverse: 'flaring, flounced periwigs, low dangled down with love-locks' were derided by Thomas Nash in 1593[6] and although the wig worn by Mr Briggs would have been a very different affair, wigs constantly posed the danger of excess and, particularly, of effeminacy. Beetham's lectures included a Macaroni (the name given to fops with gigantic wigs) called Sir Languish Lisping who adorns the outside of his head in order to attack ladies' hearts. Men like him, we are told, become tea-cup carriers and fan-bearers.

They smile and simper; they ogle and admire every lady alike. Nay they copy the manners of the ladies so closely, that grammarians are at a loss whether to rank them with the masculine or feminine, and therefore put them down as the Doubtful Gender; – These wigs, from the quantity of powder that is lavished upon them are called Amunition Caxons. (Beetham 1780, pp. 4–5)

Wigs were not confined to adults, nor to the head. Children also wore wigs, and although evidence concerning the use of the merkin or pubic wig is not readily available it is interesting to note that its very existence suggests hair and counterfeit hair as a focus of particular sexual attention in the eighteenth century.[7] The presentation of the head in its wig covering was a measure of the maintenance of social order. The appearance of the Polynesian Omai (who was so brilliantly portrayed by Reynolds, Royal Academy 1776, in 'native' habitat) wearing a bag wig at court in 1774 must have been a memorable moment in the ritual annexation of the oriental 'other' and the affirmation of Western metropolitan order (Burney 1889, vol. I, p. 322). The wig was crucial to conformity but simultaneously capable of subverting its own orthodoxy and being presented as a site of considerable danger both actual and symbolic.

The contradictions around questions of function – the wig as visible sign of order, an order which is gendered, *and* the wig as the site of disturbance social and sexual – are manifest also in the issue of manufacture. While various attempts were made to produce synthetic wigs (Lady Mary Wortley Montagu's son wore an iron wig purchased in Paris and Dr Lettsome wore a wig made of glass wool[8]) most wigs were made either from horse hair (the cheapest) or from human hair (the most desirable). Greatly in demand was the hair of country girls as it was regarded as untainted by the miasma of the city. The transference of human detritus from one individual to another, as well as the elision of class and gender boundaries implied by the manufacture of wigs from the hair of poor country girls for the heads of city gentlemen, lent the wig a power of association despite the fact that artistry and fashion united to disguise it. Fear that one might be wearing a wig made from the hair of harlots or plague victims was common. Pepys describes putting on a new periwig which he had bought a while since but dared not wear because the plague

was in Westminster: 'Nobody will dare buy any haire for fear of the infection – that had been cut off the heads of people dead of the plague' (Pepys 1972, vol. VI, p. 210). Moreover wigs, worn by many including Pepys to avoid the troublesome business of keeping a clean head, could themselves after long use become more loathsome objects than any item of dress, an encapsulation of human filth and a carrier of disease.

The fears were not completely unfounded; the famous Quaker surgeon, Dr John Fothergill, used to tell in 1778 of a medical wig that had conveyed smallpox from London to Plymouth. Another doctor is said to have failed to fumigate his wig after visiting a smallpox hospital and consequently to have given his daughter the disease (Hingston Fox 1919, p. 96). Describing an antiquarian of some eccentricity whom she is obliged to entertain at her dinner table in 1739, Miss Talbot describes the gentleman's ancient suit of clothes and a great-coat transmitted from generation to generation ever since Noah. But her greatest opprobrium is reserved for his wig:

He came to dine with us in a tie-wig, that exceeds indeed all description. 'Tis a tie-wig (the very colour is inexpressible) that he has had, he says, these nine years; and of late it has lain by at his barber's, never to be put on but once a year, in honour of the Bishop of Gloucester's birthday.

(Nichols 1966, vol. VI, p. 205)

The capacity of the wig to symbolise human filth and corruption was widely exploited. One account, for example, tells of a journey in a stage coach in the company of a pretty young Quaker woman 'in all the elegance of cleanliness', the whiteness of her arms taking advantage from the 'sober coloured stuff in which she had cloathed herself', and a dirty beau, dressed in a suit covered in old powder and a costly periwig cast over his shoulders 'in so slovenly a manner that it seemed not to have been combed since the year 1712' (*The Spectator*, no. 631, 10 December 1714). The structural relationship between the failed masculinity of a dirty, uncombed wig and the purity of unadorned femininity points up the function of the wig as a register of social and political power. The wig functions metonymically – the part standing in for the whole body not only of the individual but of the body politic. When a drayman described John Wilkes in 1768 as 'free from cock to wig' it is not only an indication that every action of the person of Wilkes had, of necessity, a symbolic or public character, it is also evidence of the correlation between cock and wig, or between male potency in sex and power in politics (quoted by Sennett 1977, p. 103). It is this connection that empowers Hogarth's engraved portrait of Wilkes as ambiguous upholder of Liberty (*John Wilkes, Esq.*, first state, May 1763); Wilkes, claiming status as a gentleman, wears a wig but it is formed into a shape that suggests a pair of horns connotative of both the devil and the cuckold.

The sexual connotations of the wig open up a considerable range of possibility for innuendo, and the metonymic relationship of the wig to the body as a social vehicle endows it with powerful resonances for a remarkably long period. At the beginning of the wig's reign of popularity, the prologue to *The Ordinary* (1670/1) offered this view of the audience:

Some come with lusty burgundy half drunk,
't'eat Chine Oranges, make love to Punk;
And briskly mount a bench when th'Act is done.
And comb their much-lov'd Periwigs to the tune
And can sit out a Play of three hours long,
Minding no part of't but the Dance or Song.

(quoted Stallybrass and White 1987, p. 91)

When John Thomas Smith was writing *Nollekens and his Times* (completed 1828) wig-dandies were a phenomenon still within living memory; it was possible for his older readers to recall the rearranging in public of large, expensive wigs with the aid of precious tortoise-shell combs (Smith 1920, vol. I, pp. 379–81). Such forms of public preening are, perhaps, always to be seen as analogously auto-erotic. In representation these associations are reinforced: in the passage quoted the play on possible ambiguities between act as in a play and sexual act is sustained by 'mount a bench' and then by the combing of 'much-lov'd Periwigs'. Long after wigs had ceased to be worn except on ritual occasions by members of the professions, the wig stood for corruption and social distortion. For Ruskin the wig was one of a series of unnatural excrescences that epitomised the banishment of beauty by the eighteenth century 'as far as human effort could succeed in doing so, from the face of the earth and from the form of man'. In *Modern Painters*, vol. IV (1856) he proclaimed that powdering the hair and patching the cheek, hooping the body and buckling the foot, 'were all part and parcel of the same system which reduced streets to brick walls and pictures to brown stains. One desert of ugliness was extended before the eyes of mankind; and their pursuit of the beautiful, so recklessly continued, received unexpected consummation in high-heeled shoes and periwigs, – Gower Street, and Gaspar Poussin' (Ruskin 1904, vol. V, p. 324).

The focus of psychic and social attention on the head – not for its physical features but as a field of inscription – augmented the fundamental ambivalence towards image-making in Western Christian culture. The first commandment, 'thou shalt not carve images, or fashion the likeness of anything in heaven above, or on earth beneath, or in the waters under the earth, to bow down and worship it' (Exodus 20, 3–5), apparently designed to prevent idolatry, could be read literally as a prohibition upon the manufacture and the very existence of any image of any type. The iconoclasm of the sixteenth century was fresh in people's minds. Painting the face could mean portraiture or face-painting, that is, the use of cosmetics which were, of course, commonplace in the eighteenth century as well as medically extremely dangerous.

Therefore, the chaotic and anarchic narratives of wigs need to be understood within a theological as well as a social framework. *The Loathsomeness of Long Hair*, published in 1653 (Hall 1654), typifies the problematics of bodily excrescence in which the eighteenth-century discourse of the wig is grounded. While Thomas Hall's diatribe is directed against the excessively elaborate hair-styles of the Stuart court, the text typically sets out the equation between hair and sexuality and the

consequent correlation between the corruption of the individual body and the condition of the body politic. The State is threatened by dissipation and 'unnatural' fashions and that threat is mediated in particular through any practice that confuses the division between genders. 'The Lord expressly forbids the confounding of Sexes . . . by wearing of that which is not proper to each sex' (Hall 1654, p. 25). The threat that fashion – and especially the fashion in hair – poses to the stability of society is formulated in the preface:

> How many do I daily see
> Given up to Muliebritie!
> A female head for a male face
> Is marryed now in every place.

The duty of those at the head of the body politic is to present an exemplary head to the inferior part of the body:

> Shall you my Counsell practise then
> Ile say you have the Heads of men
> Then being from that Cumb'rance freed
> You may attend the parts that need
> Your utmost care, the Heart and Brain;
> Then also will that numerous Train
> Of your Inferiours suddenly
> Be cured of their deformity.
> For whatever you Gallants doe
> They Gallant think, and follow you. (Hall 1654, p. 25)

Those who ignore these warnings may find themselves afflicted with a plague coming from Poland which, by reason of 'a viscous venomous humour, glues together (as it were) the haire of the head with a prodigious ugly implication and intanglement; sometimes taking the forme of a great snake, sometimes many little serpents: full of nastiness, vermin and noysome smell'. This dreadful disease is said to have spread from Poland and 'all that cut off this horrible and snaky haire, lost their eyes, or the humour falling downe upon other parts of the body; turned them extremely' (T. Hall, marginal gloss, preface).

Hair carries the symbolic potential for unleashed and disordered sexuality – and the Medusa-head threat from foreign lands clearly implies this correlation – it must therefore be strictly regulated in the interests of the body politic. The wig carries a further danger; that of inverting the natural order. Not only do people turn white hair into black by powdering it (turning age into youth) thus forgetting that bodies are themselves dust or powder, they also wear the hair of another and – most dangerously because it challenges gender distinctions and raises questions of sexuality – that other may be a woman and may be a whore for, 'as no man may weare his owne haire excessively long, so he may not weare the long hair of another, be it of a man, a woman, or it may be of some harlot, who is now in Hell, lamenting there the abuse of that excrement' (Hall 1654, p. 15).

Notions of decency, respectability and the fear of ridicule function socially as a

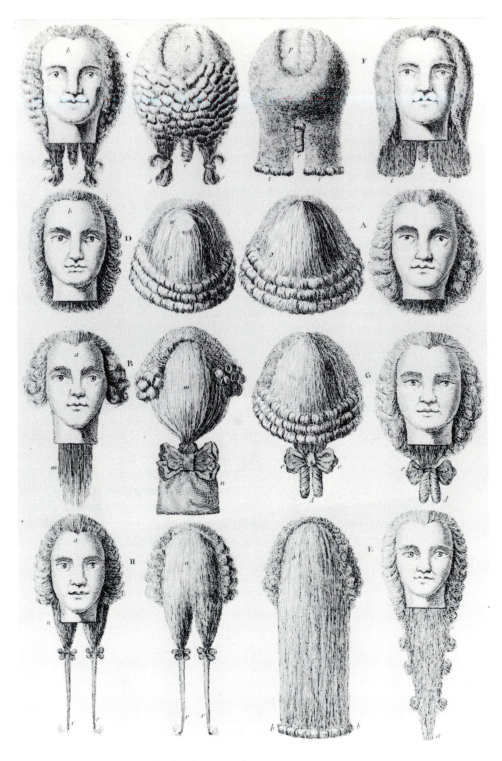

40 M. de Garsault, *Art du perruquier ...*, 1767

means of effectively policing the boundaries of gender and class. In *The Flying Dragon*, a story written by the Lancashire dialect poet, Tim Bobbin, towards the end of the eighteenth century, the wig is separated from its rightful context (on the head of a person of the appropriate gender and class) and exposed as an absurd object (Plates 41–2). The discourse here is patriotic rather than religious but it is nonetheless underpinned by definitions of the natural. The loss of wig is a familiar topos but in this fanciful narrative the wig takes on a life of its own; it assumes a different appearance according to the class of person observing it. The argument runs as follows:

> A Lancashire beau being at London, fell in love with the large pig-tails and ear-locks, and consequently brought the French toys with him to Lancaster; business calling him to Sunderland on that day being uncommonly boisterous, he mounts his courser, dressed in the pig-tail, ear-locks, &c a-la-mode françois. The toy rolled on his shoulders till the blasts blew away both that and the ear-locks, they being fastened to the tail with black ribbons. A countryman coming that way, and seeing them blown about in the lane, takes the French medley for a FLYING DRAGON, and after mature deliberation, resolved to kill it. This produced three battles; at the latter end of which (the wind ceasing, and the pig-tail lying still) he thought he had manfully performed. Elated with the exploit, he twists his stick in the ear-locks, and carries all before him aloft in the air, as boys commonly do adders; till meeting the Rector of Heysham, he was with much ado convinced; and then in great confusion sneaked away, leaving his reverence in possession of the monster, who still keeps it at Heysham, and often shews it with much diversion to his friends.

Much of the humour of Tim Bobbin's story depends upon sexual innuendo; the beau falling in love with large pigtails, bringing French toys to Lancashire, mounting his courser and so on until the moment when he is unmanned and his pigtail blows away. The countryman manfully performs and twists his stick, carrying all aloft. And the reference to snakes here links the text with the dreadful plague from Poland so feared by Thomas Hall.

To some extent this phallic imagery is to be construed as commonplace bawdy yet, like all jokes, it indicates a power structure at work. The story of the beau at one level concerns a young man from the provinces being seduced not only by London life but by French fashions. But the powerful connotations of hair in relation to gender and sexuality are here exploited to the full in a discourse of class. The young man loses his pigtail (is unmanned) by visiting the city corrupted by foreign fashion. The Old Man of Heaton, of a lower order of humanity, encounters the wig which is the hallmark of high society. He attacks the earlocks in a symbolic violation of the ruling class, setting out to kill it and concluding with a Medusa-like ritual that hints at the dangers of such actions whatever the absurdities that provoked them. The impropriety of the situation is tempered by the fact that the beau retains the basic wig, losing only the 'French' excrescences and by the fact that the Church becomes guardian to this socially and politically dangerous object. In overcoming the dragon the countryman overcomes foolish French fashion without knowing it. But in topsy-turvy style, the reversed order that has served to expose folly has to be righted again by good sense and religion. And so the Old Man of Heaton is left as foolish as the beau who lost his pigtail.

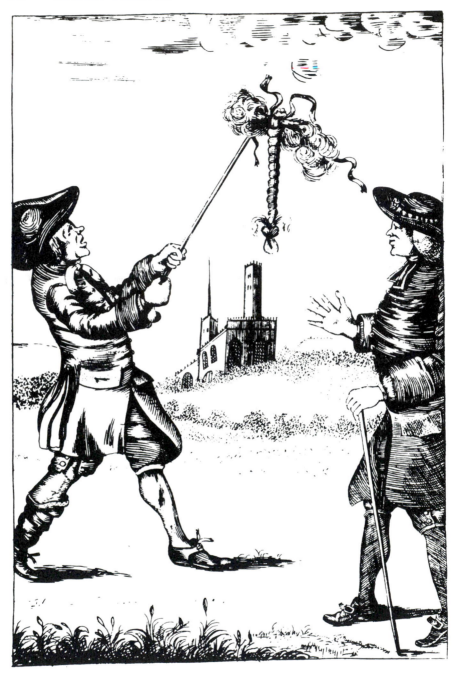

41 Tim Bobbin, *The Flying Dragon ...*, 1819

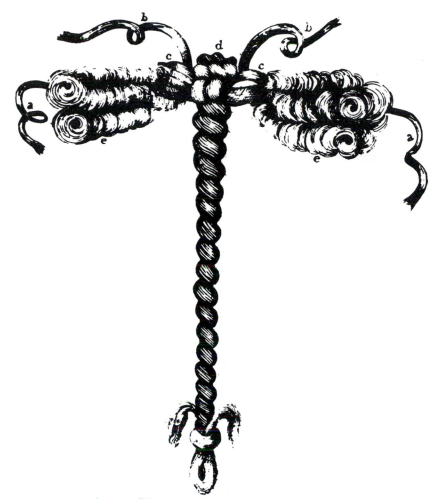

aa Reprefents a filken ftring that goes from the Locks round the fore part of the Head under the Hat.

b b The ends of the Ribband platted with the hair of the tail, and faftens it to the hair of the Head.

cc A thread that goes to y̆ back of the Head to fix the Locks

d The end of the Tail which is ty'd to the hair of the Head by the Ribband b b. ee The Ear-locks.

42 Tim Bobbin, *The Flying Dragon* ..., 1819

Tim Bobbin's wig is simultaneously 'a tawdry thing' and, like Hall's threatened disease, a beast with a sting in its tail ('a long, black thing, with wings and tail'). The fetishised wig is an object capable of such transformations. The preserved pigtail in Tim Bobbin's story might be said to remain as 'a token of triumph over the threat of castration and a protection against it' (Freud 1977c, p. 353). *The Flying Dragon* thus encapsulates the dilemma which has surfaced frequently in this essay; it is the dilemma of a masculinity which required the artificial covering of the head as a sign of virility, station and decency but which was simultaneously threatened by the connotations – religious, moral and sexual – of the only item that could secure that signification. In actuality the dilemma manifests itself in the fact that by 1760 many men were wearing their own hair while using grease, tongs and powder to make it appear as though they were wearing wigs (Piper 1978, p. 193).

In representation the function of wig as fetish – like the genuine head of hair but not it, of the body but separable from it – becomes apparent. The overt similarities of appearance between the penis and the pigtail, as well as between the shaved head and the glans – similarities that are exploited (consciously or unconsciously) by writers and caricaturists alike – signal the relationship of the wig to the phallus. The wig was both the essential component in the maintenance of a social order for which the economy of the fashionable male body provided a metaphor *and* the vulnerable part of the body through which authority and power could be undermined or destroyed. It is to this prosthetic ambiguity that its particular power in discourse is owed. Equally we may recognise in the vulnerability of the wigless head exposed by Beetham, by Burney in the incident at the Portman Square Ball and by Hogarth, the male member exposed to the castrating gaze of public scrutiny. The disjuncture between the hairless head and the phallic wig from which all these accounts derive their narrative climax is the gap between masculine identity endowed by culture and the nameless state of what is constructed as the natural body.

The wig's prevalence as a major item of male attire for over a hundred years, and its dominance in visual representation of the period, must therefore be understood within the context of forms of self-enactment that served to define masculinity politically and culturally. Discourses of the wig, some of which have been examined in this chapter, demonstrate the head to be a particular field of inscription. As historians, we should notice not only how an item of fashion like the wig is endowed with mythic and symbolic properties that work to define and safeguard a gendered national order but also how this item refuses to be accommodated within the boundaries that academic disciplines have used to separate actuality from representation, as well as those that have been constructed to distinguish between different kinds of artifact. The human body is, as Barkan aptly puts it, 'simultaneously abstract and concrete, general and specific' (1975, p. 3). Similarly, the wig from the late seventeenth century until the early nineteenth century is both of the

body and not of it, natural and a work of art, an object to be portrayed and an economically valuable possession to be worn, a culturally dynamic abstract concept of extraordinary versatility and a material artifact subject (like the biological body) to the ravages of time.

Notes

1. Body languages: Kahlo and medical imagery

1 I would like to thank Dawn Ades, Kathy Adler and Ludmilla Jordanova for their comments on drafts of this essay. For Kahlo images not reproduced here the reader should consult H. Prignit-Poda (ed.), *Frida Kahlo. Das Gesamtwerk* (the relevant plate numbers are provided in my text).

2 Joan Borsa remarks that 'What is missing is a more *critical* reading of *gaps* between the author and the text, constructions of the author and Kahlo's specific social location' (1990, p. 27).

3 A loose definition is justifiable because the different senses intertwine. The occasion of representing her illnesses and operations permits Kahlo to bring together contrasting modalities of power-knowledge about the body: citations from medical or anatomical sources clash with artistic, popular and religious iconographies.

4 For the following section, and more generally for my understanding of medical images as representations, I am indebted to Ludmilla Jordanova (1985 and 1989).

5 I would like to thank Dawn Ades for kindly sharing this information with me.

6 *Scylla*, also of 1938, by the English Surrealist painter Ithell Colquhoun, is a remarkably similar motif (Chadwick 1985, Plate 88). The artist recalled that it too was 'suggested by what I could see of myself in the bath – this with a change of scale due to "alienation of sensation" became rocks and seaweed'. Both works engage with the topos of the bathing female figure, generally depicted as naked and self-absorbed, the oblivious object of a voyeuristic male gaze. Kahlo and Colquhoun submit to this visual logic in so far as they portray themselves in an unmediated rapport with the body, but, through various strategies of distancing, effect a subversive transformation of their assigned position. I am aware of no precisely comparable instances in the work of male artists; even the *Ulysses* etchings by Richard Hamilton in which he depicts the auto-erotic musings of Bloom do not implicate the artist or viewer in the same way.

7 Smith (1983, pp. 12–13), for example, convincingly argues that *On the Borderline* of 1932 parodies Rivera's Utopian synthesis of machinist imagery and archaic Mexican motifs in the *Detroit Industry* murals.

8 This wilful hybridisation would be an instance of 'double-voiced' discourse as Bakhtin defines it: 'a mixture of two social languages within the limits of a single utterance, an encounter, within the arena of an utterance, between two different linguistic consciousnesses, separated from one another by an epoch, by social differentiation, or by some other factor' (1981, p. 358). This notion may also afford a useful model for understanding the ambivalent dialogue Kahlo engages in with the work of the Mexican muralists.

9 Reproductivity as the main yardstick of a woman's worth is not restricted to traditional or Catholic cultures alone. The universality of this criterion may explain the observation of Hall *et al.* that 'guilt is an almost universal feeling experienced by women who miscarry' (1987, p. 413).

10 My attention was drawn to this source by Greer *et al.* 1988, p. 161. The snail is described as a female sexual symbol by Freud (*Penguin Freud Library*, vol. IX, p. 306), a further possible resonance in the Kahlo image.

11 To view her imagery in terms of its oppositional strategies demonstrates the falsity of the cliché

that Kahlo was frustrated in childbearing but able to find solace in painting. In reality her attitude to pregnancy was highly ambivalent. More than one of her pregnancies were terminated by therapeutic abortion, and the best-documented pregnancy was proceeded with only after much equivocation and weighing the potential risks of a caesarian section. However, it ended abruptly in the miscarriage of 1932.

12 Her plaintive remark about the accident – 'I lost my virginity' – makes explicit the reading that is proposed here (Herrera 1983, p. 49).

13 It might be objected that claims cannot be made about such a slight and insignificant drawing, yet a similar strategy can be discerned elsewhere. In *My Birth*, Herrera (1983, p. 157) notes that the scene is examined from the position of a medical attendant, a viewpoint that is naturalised in medical texts. Here the divide also heightens the shocking candour of the image.

14 It may be inferred that her artistic vocation betokens an identification with her photographer father whom Kahlo comes increasingly to resemble in late self-portraits by accentuating her naturally hirsute appearance. Conversely, in other images she wears elaborately ornamented Mexican costumes which, by their excess, become an almost sham masquerade of femininity. This pattern of behaviour – an oscillation between a notionally masculine position (as an artist) and an overcompensated femininity – was described by the English psychoanalyst Joan Riviere in a paper on female masquerade in 1929. It may be ascribed to the contradictory predicament of female intellectuals in that era.

15 The fact of her alienation and division in language raises the question of a restitutive tendency, which *My Nurse and I* of 1937 (Prignit-Poda 1988, Plate 49) poses in terms of national identity. It evokes a pre-Oedipal relation to the maternal body of Mexico prior to the violent interposition of the *Nom du Père*, the language of the European coloniser. But, as Jean Franco remarks, the discourse of Mexican nationalism itself was intensely patriarchal: 'national identity was essentially masculine identity' (Franco 1989, p. xxi). Kahlo counters her marginality to this discourse (nationalism) by recasting it, in *My Nurse and I*, as a relation to the mother tongue of Mexico.

16 Hall *et al.* (1987, p. 412) note that early in pregnancy the foetus is not clearly distinguished from the self as a separate entity, so that miscarriage at this stage may be felt as the loss of a part of oneself. Kahlo seems to register this indeterminacy of ego boundaries.

2. The ambivalence of male masquerade: Duchamp as Rrose Sélavy

1 Canaday's phrase comes from an official obituary for Duchamp; the surrounding text reads as follows: 'There is hardly an experimental art movement of recent years that cannot trace down through the branches of its family tree to find Marcel Duchamp as its generative patriarch'. Canaday's claims for Duchamp are typical of post-1960 understandings of his place in American postmodernism.

2 J. Laplanche and J.-B. Pontalis define ambivalence as follows: 'The simultaneous existence of contradictory tendencies, attitudes or feelings in the relationship to a single object – especially the coexistence of love and hate' (Laplanche and Pontalis 1973, p. 27). The place of ambivalence in Freud's work is linked to his account of the phenomenon of negative transference, which occurs, in Freud's words, 'alongside the affectionate transference, often both directed on to the same person at the same time . . .' This ambivalence – both 'love' and 'hate' towards the same object existing simultaneously – accounts for the ability of neurotics to 'make the transference a form of resistance' (Freud 1963b, p. 113).

3 I use the masculine gender pronoun to connote the artist and interpreter in as much as artistic and interpretive authority have traditionally been masculine prerogatives.

4 According to Freud, Schreber's desire to be a woman stemmed from the fact that Schreber remained in the narcissistic stage of ego development – thus maintaining a homosexual love of his own genitals. What Schreber really desired was to make love with his own father and brother. This desire was so forbidden that Schreber repressed it, but it returned in the form of paranoid fantasies. I am in no way claiming that Duchamp fills the clinical scenario by which Freud characterises Schreber's fantasies – determining them as symptoms produced by repressed homosexual desires; I draw on this case study because it allows me to examine the

relationship between the shifting poles of transference and the non-fixed nature of gender identity.

5 I have not been able to verify whether Duchamp wrote this text or not. It has been attributed to Duchamp in Sanouillet and Peterson (1989, p. 185); and, given his committed involvement in the marketing of his objects and readymade schemes, it seems likely that he did 'author' the advertisement.

6 The title itself also plays with the gendered nature of the object commodified through the female image. 'Belle Haleine,' or 'beautiful breath', references one of history's most famous women – 'belle Hélène' or 'beautiful Helen'. (It was Helen of Troy's abduction by Paris that began the Trojan war; Helen herself was the daughter of Zeus and Leda. Furthermore, 'Hélène' was the Greek goddess of light.) This is a reference to the Offenbach operetta *La Belle Hélène* as well (Sanouillet and Peterson 1989, p. 109). And the reference relates to another quip of Duchamp's relating to the perfume-bottle text: 'Avoir de l'haleine en dessous' (Duchamp frequently reused and recycled his own works and texts).

7 The bottle itself existed both as a found object – a Rigaud perfume bottle – appended with the fake label, and as a photo collage, reduced to diagrammatic form. According to one source, the collage existed before the actual object, which was 'rectified' by reference to the earlier two-dimensional image (Duchamp 1984, p. 243). Robert Lebel, however, states that the bottle, which still exists, was produced first and the collage was made from a photograph of the bottle (Lebel 1959, p. 170). Arturo Schwarz notes that the original label of the Rigaud perfume bottle had the phrase 'Un air qui embaume' ('an embalming [or perfumed] air') written on it (Schwarz 1969, p. 484). 'Embaumer' also suggests 'to embalm' (a corpse) and 'l'air' signifies 'appearance' or 'look': 'a look that embalms'.

3. The forbidden gaze: women artists and the male nude in late nineteenth-century France

1 I would like to express my gratitude to Paul Smith whose generous gift to me of an original edition of the Charles Aubert story set me thinking in this direction. I am grateful, too, to Katie Scott for alerting me to some of the caricatures in the *Estampes* collection of the Bibliothèque Nationale and for the comments made on an earlier draft of this essay by Kathleen Adler, Tag Gronberg, Alex Potts, Abigail Solomon-Godeau, Neil MacWilliam, Marcia Pointon and Rasaad Jamie.

2 The title of the short story will be revealed in the course of this article.

3 See my chapter 'Reason and Resistance: The Entry of Women into the Ecole des Beaux-Arts' (Garb 1991). For empirical accounts of the events leading up to the admission of women into the Ecole, see Yeldham 1984, vol. I, pp. 53–9, and Radycki 1982, pp. 9–13.

4 See, for example, Audouard 1882, p. 461, and Camille 1882, p. 1.

5 For representative views, see 'Les femmes à l'Ecole des Beaux-Arts', *Journal des Artistes*, 37, 28 September 1890, 293; Gérôme 1890; anonymous article from *L'Union Franco-Russe* reprinted in *Moniteur des Arts*, 1925, 28 November 1890, 109.

6 For a discussion of the Medusa myth in relation to broader questions about narrative, see de Lauretis 1984, pp. 109–11.

7 For a discussion of academic principles and the centrality of the life-class to academic training, see Vaisse 1980, pp. 217–22.

8 Among women's supporters there was the feeling that even though the bulk of women were not suited to such elevated aspirations, there were exceptional women like Rosa Bonheur and Henriette Browne who were capable of this and who should not be discriminated against. See speech by M. Georges Berger in the debate on the budget for 1897, *Journal Officiel*, 29 November 1896, 1824.

9 See speech made by M. Gerville-Réache in which he described the position in the USA: 'Women are admitted to the Fine Art schools under the same conditions as men; they work together with men in the same studios, except in drawing classes in front of the nude. For these special studies, the studios are reserved for women only who are admitted there with their professors alone. The male models have their faces covered with a mask' (*Journal Officiel*, 31 January 1893, 304).

10 For a report on the riot which greeted women's entry, see 'La manifestation anti-féministe à l'Ecole des Beaux-Arts', *L'Eclair*, 16 May 1897, 1.

4. Out of the body: Mark Rothko's paintings

1 Quoted in Rosenberg 1975, p. 71.
2 Personal interview with Shirley Climo, sister of Rothko's second wife, Mary Alice ('Mell') Beistle, 15 October 1986.
3 Dvinsk is now Daugavpils, located in southwestern Latvia. Just before migrating to America, Rothko's family had lived at 17 Shosseymaya Street (now Sarkanarmijas – or Red Army – Street). Rothko's eldest brother, Moise Roth, remembered the name of the street, and Rothko's sister Sonia, a dentist, is listed at that address in *Dvinchanin, A Reference Calendar of 1914*, ed. E. V. Tseitel, a copy of which is held by the Daugavpils Museum. Only 12,000 of the town's 55,000 Jews survived the First World War; during the Second World War, about 120,000 people – some of them prisoners of war, some of them politically suspect, most of them Jewish – were murdered in the Wood of Meshiems, just north of the town.
4 Personal interview with Murray Israel, a student of Rothko's when he taught at Brooklyn College in 1951–4, 20 May 1988.
5 Sophie Tracey, 'Hommage à Mark Rothko', unpublished essay, 1976, p. 5.
6 In *Mark Rothko, A Retrospective*, the date of Rothko's mother's death is incorrectly given as early 1950 (p. 273). The correct date is 10 October 1948 according to an obituary in the *Oregonian*, 13 October 1948.
7 Personal interviews with Ben Dienes, a painter who knew Rothko in the 1950s and 1960s, 19 January 1987; and with Hedda Sterne, 22 January 1986.
8 In his diary, the painter Ulfert Wilke records a lunch with Rothko: 'Being brought up as the youngest child when his father was an orthodox Jew, Mark during the first nine years of his life was a Hebrew infant prodigy. All the rules and rigor of religion were never sufficiently observed by his mother, not sufficiently to Mark's rigid father. And then a complete blank came into his life – oblivion of the Hebrew language and a complete break with temple rigor – after having gone 100 times to the temple during holidays one day at the age of nine he came home and announced to his mother he would never set foot in a temple again' (Diary of Ulfert Wilke, 28 September 1965, Archives of American Art, Smithsonian Institution, Washington DC).
9 In his 'From Eastern Europe to Paris and Beyond', Arthur A. Cohen points out that 'nowhere is the prohibition of the representative imaging of God explicitly expressed in either the Hebrew Bible or its rabbinic exegesis'. What is forbidden is the *worship* of such images – idolatry. But Mr Cohen also observes that by the second century AD, this careful distinction was lost, producing 'the unexpressed but well-diffused taboo against all iconic representation' (Silver and Golan 1985, p. 61).
10 Stanley Kunitz, interview with Avis Berman, 8 December 1983 and 22 March 1984, Archives of American Art, Smithsonian Institution, Washington DC, p. 8.
11 Rothko's portrait of his mother, probably done in the late 1920s, is reproduced in *Mark Rothko* 1987, Fig. 1.
12 Quoted in Robert Morrow, personal interview with Barbara Morrow (Price) and Robert Morrow, 12 January 1990. Barbara Morrow was an old and close friend of Mell Rothko.
13 Personal interview with Herbert Ferber, 27 January 1987. Ferber was also interviewed by Phyllis Tuchman, 2 June 1981, Archives of American Art, Smithsonian Institution, Washington DC. Other interviews utilised in this essay are with Regina Bogat, who worked in a studio across the hall from Rothko's at 222 Bowery, New York City, in the late 1950s and early 1960s (5 February 1986); with Robert Motherwell, 20 January 1987; and with Moise Roth, 27 June 1985.

5. Muscles, morals, mind: the male body in Thomas Eakins' *Salutat*

1 My thanks to Marcia Pointon, and especially Lynda Nead for their invaluable help and support.

2 Following Elizabeth Johns' analysis of the painting (Johns 1983, p. 48) I take it that the female figure is the patient's mother, or at least a female relation, but for an alternative view see Pointon 1990, p. 42.

6. Body and body politic in Edvard Munch's *Bathing Men*

1 Research for this article was originally conducted with the generous assistance of an Edvard Munch Stipend from the Oslo Kommunes Kunstsamlinger and with funding from Wellesley College. I would like to thank Robert S. Lubar of the New York University Institute of Fine Arts for his editorial suggestions. I would also like to thank Julie S. Drucker, Robin M. Akert, Kathy Adler and the anonymous Cambridge University Press reader for their comments.

2 See Sørensen 1981, pp. 26–42 for an excellent survey of this phenomenon. The present paper is formulated in accordance with several of Sørensen's arguments about 'Vitalism' and Nietzscheanism as pan-Scandinavian movements.

3 Even Max Beckmann's eroticised painting *Youths by the Sea* (1905), which has been suggested as a source for Munch's painting (Vehmas 1964, p. 27), conforms to the distancing mechanism of Antique youthful beauty. See also Buenger 1983, pp. 134–44.

4 The high purchase price of 100,000 Finnish Marks, and what were perceived to be the formal transgressions of the painting, prompted a wave of protest in the Finnish press. Some of this criticism is summarised in Kruskopf 1979, pp. 5–20.

5 Munch wrote, '[it] amused me to see that Jansen [sic] has painted a bathing picture. I painted a large bathing man in Warnemünde during the summer' (letter from Munch to Thiel, dated Berlin 10 February 1908, Munch Museum archives).

6 Letter from Munch to Thiel dated 6 August 1907, Munch Museum archives, quoted in Eggum 1989, p. 133. The version of *Sick Girl* to which he refers hangs in the Thielska Galleriet in Stockholm.

7 Perhaps in an attempt to de-emphasise the erotic content of the painting, Munch painted side panels to accompany *Bathing Men* in the summer of 1908, one representing a young boy and the other an old man. In a letter to Gustav Schiefler dated 26 June 1908, Munch indicated that he had plans to increase the format to five paintings – 'on one side childhood and youth, on the other old age – In the middle Man in full power' (Eggum *et al.* 1987, p. 285). When Munch sold *Bathing Men*, the central painting, to the Helsinki Ateneum, he painted a less eroticised second version of the motif. This version, as well as the side paintings, are in the Munch Museum, Oslo.

8 See, for example, Heinrich Pudor, *Nacktkultur*, Berlin, 1906, one of the most comprehensive chronicles of nudism published in the early twentieth century.

9 *The Riddle of the Universe at the Close of the Nineteenth Century*, published in 1899, sold over 100,000 copies and had been translated into fourteen languages within a decade of its publication.

10 Munch owned a copy of Wilhelm Bölsche's book, *Ernst Haeckel* (Berlin and Leipzig, 1900), which, judging by its worn appearance, was well read in certain sections. Munch may have read the book while staying in Warnemünde, because an announcement for a local concert and art exhibition from Monday, 12 August (1907) was inserted between the pages.

11 For an overview of Haeckel's theories and their interpretations and applications, see Gasman 1971.

12 In a letter to Johan Roede from 1893, Munch professed great admiration for Nietzsche (see Svenæus 1953, p. 32). Munch's library contains numerous works by and about Nietzsche, including Elisabeth Förster-Nietzsche's controversial biography, *Das Leben Friedrich Nietzsches* (Leipzig, 1895). Many of Munch's friends and contacts in Norway likewise were enthusiasts for Nietzsche's writings. See for example Hofmiller (1903), which Munch also owned in offprint form.

13 In his two-volume survey of Nietzscheanism in Scandinavia, Harald Beyer cites virtually every major author and political theorist who, at one point or another in their careers, interpreted Nietzschean ideals in their work (see Beyer 1958, vols. I and II).

7. The fine art of gentling: horses, women and Rosa Bonheur in Victorian England

1 Portions of this essay were first presented in postgraduate seminars in art history at Leeds University and at Middlesex Polytechnic. I would like to thank Griselda Pollock, Lisa Tickner and the faculty and students in those seminars for their many helpful comments and suggestions.

2 Bonheur began her intensive study of the horse and its anatomy in 1844. The catalogue for the sale of work from her studio after her death in 1900 included some 109 paintings and studies of horses, in addition to many sheep, oxen and other animals, both wild and domestic (*Atelier Rosa Bonheur* 1900). Her love of horses is well documented and she preferred the half-breeds of the country to thoroughbreds. A note found in her papers after her death indicates her view of the symbiotic relationship between horse and man: 'The horse is, like man, the most beautiful and most miserable of creatures, only, in the case of man, it is vice or poverty that makes him ugly. He is almost responsible for his decadence, while the horse is only a slave that the creator has given to man, who abuses it out of his ingratitude and his worldly and egotistic poverty, until he becomes lower than the animal itself' (cited in Ashton and Hare 1981, p. 140).

3 Like its predecessor, *Ploughing in the Nivernais* (Musée National du Château de Fontainebleau), which won a gold medal for Bonheur at the Salon of 1849, *The Horse Fair* was intended as a monument to nature harnessed to the demands of labour (Ashton and Hare 1981, p. 69). Bonheur's own views on portraying animals were strongly influenced by Georges Cuvier's pioneering work on comparative anatomy, as well as by the anti-materialist, anti-industrialist philosophy of France's best-known scientist and naturalist, Etienne Geoffroy de Saint-Hilaire, who in the 1830s had employed Raymond Bonheur to illustrate his work at the zoological gardens. Napoleon III was not only quick to perceive Bonheur's naturalism as an acceptable alternative to Courbet's more radical realism, he also recognised in Bonheur's choice of the Percheron, the native breed identified with Normandy and prized by the Emperor, a direct link between the Second Empire and a highly conservative and agriculturally productive region of the country. For further information on this point, see Boime 1983, pp. 96–9.

4 Privately published by 'Nassau Steam Press', 60 St Martin's Lane; now in the collection of the National Art Library, London.

5 Bonheur herself periodically identified social constraints placed on women with being 'in harness'; see Stanton 1976, pp. 161, 211; see also Saslow 1992.

6 Among the artists and critics who met Bonheur in London, apparently only Ruskin was unmoved by her achievement. To Ruskin, who dined with Bonheur at Gambart's country home on 26 October 1856 and whose idea of beauty rested on a belief in a universal, divine order in which art was transcendental, Bonheur was a naturalist, not an artist. In 'Academy Notes of the French Exhibition of 1857', he noted that:

> Mdlle. Bonheur may rely upon this ... that if she cannot paint a man's face, she can neither paint a horse's or a dog's ... There is in every animal's eye a dim image and gleam of humanity, a flash of strange light through which their life looks out and up to our own great mystery of command over them, and claims the fellowship of the creature, if not of the soul. I assure Mdlle. Bonheur, strange as the words may sound to her, after what she has been told by huntsmen and racers, she has never painted a horse yet. She has only painted trotting bodies of horses. (*Works*, 34, 641)

7 Sherry Ortner's article 'Is Female to Male as Nature is to Culture?' in Rosaldo and Lamphere 1974, pp. 67–87 was one of the first to address the social meanings of these terms. For more recent discussion, see Pilkington 1986; Williams 1983; Carol P. MacCormack, 'Nature, Culture and Gender: A Critique' in MacCormack and Strathern 1980, pp. 1–24.

8 Mrs Trimmer, whose *History of the Robins* (1786) was the first children's book to anthropomorphise animals and a classic throughout the nineteenth century, and Mary Howard preached kindness to dumb creatures as a necessary part of a wider social project. For additional information, see Singer 1976, Rupke 1976, pp. 259–94, Fairholme and Pain 1924, Turner 1980. For children and animals, see Avery 1965, p. 37 and *passim*.

9 For women and medicine in the nineteenth century, see Oakley 1980; Jordanova 1989; Laqueur

1990, pp. 148–92; Graham 1960; Carroll Smith-Rosenberg and Charles E. Rosenberg, 'The Female Animal: Medical and Biological Views of Woman and Her Role in Nineteenth-Century America', in Leavitt 1984; Barker-Benfield 1976; Mary Poovey, 'Scenes of an Indelicate Character: The Medical Treatment of Victorian Women', in Poovey 1988, pp. 24–50.

9. Movement and gender in sixteenth-century Italian painting

1 This and all subsequent translations are the author's own.
2 The overlap between the language of art criticism and that of texts on behaviour has been acknowledged by various writers, including Shearman (1963), Summers (1981), Monk (1944) and Blunt (1940, pp. 93–8), but the precise implications of this for the description and perception of images have rarely been pursued. A notable exception is Cropper (1976). For a discussion of the relationship between manners, literature and the perception of visual images, although only marginally concerned with texts on art, see Rogers (1988).
3 There are no comprehensive studies of Italian Renaissance dance. For a general account see Dolmetsch (1954), and for a more detailed analysis of fifteenth-century Italian dance see Michel (1945). Also useful, although with some inaccurate documentation, is Castelli *et al.* (1987). Some interesting observations on the aesthetics of Renaissance dance are provided by Franko (1986). A brief guide to sixteenth-century dance, although mainly concerned with the later part of the century, can be found in the introduction to Caroso (1986).
4 For a brief account of the galliard see the entry in Sadie, ed., *The New Grove Dictionary of Music and Musicians*, 1980, vol. VII, pp. 105–7.
5 See, for example, Shearman (1967, p. 58), where the figure is described as 'tall of stature, impeccably composed in emotion and movement'. I have discussed this figure in greater detail elsewhere (Fermor 1983, pp. 15–21).
6 In his rewriting of Boiardo's *Orlando innamorato*, for example, Francesco Berni described the galliard as 'un modo molto adorno' (a very ornate way of dancing) (Berni, vol. IV, p. 239).
7 Castagno's *David*, painted on a leather shield, and now in the National Gallery of Art, Washington, forms a useful point of comparison with Titian's *Adonis*, as it displays very similar qualities of movement.

10. The in visibility of Hadji-Ishmael: Maxime Du Camp's 1850 photographs of Egypt

1 I would like to thank the Florence J. Gould Foundation of Princeton University for providing a time and place to work on this material during the 1988–9 academic year. I am also very grateful to the organisers of the 'Body in Representation' symposium for the opportunity to present an earlier version of this paper in an especially stimulating public forum. My particular thanks to Marcia Pointon for her many insightful comments and practical suggestions.

11. The hat, the hoax, the body

1 I would like to thank Tag Gronberg, Marcia Pointon and Adrian Forty for their comments in the preparation of this essay.
2 The dissolution of Paris Dada in 1922 was also marked by the split between Tzara and Breton. Tzara was not a member of the Surrealist group during its early years but became a signatory of the Surrealist programme in the first number of *Le Surréalisme au Service de la Révolution* in 1930, following Breton's *rapprochement* with Tzara in the Second Manifesto of Surrealism. Tzara contributed to several of the magazines associated with Surrealism, including *La Révolution Surréaliste*, *Le Surréalisme au Service de la Révolution* and *Minotaure*. Tzara's links with Surrealism are discussed in Ades 1978.
3 Tag Gronberg proposed a reading of Purism in psychoanalytic terms in 'Speaking volumes: Le Pavillon de L'Esprit Nouveau', a paper given at the Association of Art Historians' Conference, London, 1991.
4 I discuss Breton's *Nadja* in detail in the forthcoming essay 'Surrealism, myth and psycho-

analysis' in vol. III of *Modern Art: Practices and Debates*, to be published by The Open University and Yale University Press, 1993.

5 On this question see in particular Laura Mulvey's essay 'The Oedipus myth: beyond the riddles of the Sphinx' in Mulvey 1989. Laura Mulvey's work on feminist theory and fetishism, from her early essay 'Fears, fantasies and the male unconscious' (originally published 1973) to her more recent concerns with curiosity as a drive which can work against the grain of fetishism (see Mulvey 1989, p. xi), has been influential on my thinking in this paper.

6 Rosalind Krauss has observed, for example, how in Surrealist photography 'We see the object by means of an act of displacement, defined through a gesture of substitution. The object, "straight" or manipulated, is always manipulated and thus always appears as a fetish' (Krauss 1986, p. 91).

12. The case of the dirty beau: symmetry, disorder and the politics of masculinity

1 I would like to thank Kathleen Adler, Ludmilla Jordanova and Patricia Simons for their very helpful comments on this chapter.

2 Victoria and Albert Museum, E1652–1926–E1681.

3 J. P. de Castro, 'Wigs and perukes', MS, 1945. National Art Library, London, ch. ii.

4 Tailpiece to *The History of British Birds*, vol. 1, London, 1826.

5 Hair and teeth are linked in discourses of health and fashion as well as by profession. See, for example, *The Lady's Head Dresses: or Beauty's Assistant, for 1772; containing Observations on the Hair . . . also a Dissertation on the Teeth and Gums, by David Ritchie, hair-Dresser, dentist &c.*, 1772. The most extensive Freudian exploration of the sexual connotations of dress is to be found in Flugel 1930.

6 *Christ's Teares over Jerusalem*, quoted in de Castro 1945, ch. i.

7 The *Oxford English Dictionary* suggests that 'merkin' was a variant of 'malkin' in the sixteenth and seventeenth centuries, meaning the hair of the female pudendum but that in the eighteenth century it specifically came to mean counterfeit pubic hair (1796 'counterfeit hair for a woman's privy parts'). It also seems that the merkin was seen as analogous to the beard.

8 De Castro, ch. i.

Bibliography

Ades, D., 1978, *Dada and Surrealism Reviewed*, London

Aducco, V., 1890, 'Action de l'anémie sur l'excitabilité des centres nerveux', *Archives Italiennes de Biologie*, 14, 136–41

Alfred de Dreux, 1810–1860, 1988, Paris, Galerie de la Cimaise

Alpers, S. L., 1960, 'Ekphrasis and aesthetic attitudes in Vasari's Lives', *Journal of the Warburg and Courtauld Institutes*, 23, 190–215

Annual Register, 1861

Antoine, J., 1890, *L'Art et critique*, reprinted in *Moniteur des Arts*, 1917

Aragon, L., 1987, *Paris Peasant* (*Le Paysan de Paris*, 1926), London

Arbeau, T., 1967, *Orchésographie*, Lengres, 1588, trans. M. Stewart Evans as *Orchesography*, intro. J. Sutton, New York

Arcangeli, F., 1973, *L'Opera completa di Segantini*, Milan

The Architecture of Adolph Loos, 1985, Arts Council of Great Britain

Arte e socialità in Italia dal realismo al simbolismo 1865–1915, 1979, Milan

Ashton, D., 1983, *About Rothko*, New York

Ashton, D. and Brown Hare, D., 1981, *Rosa Bonheur: A Life and a Legend*, New York

Aubert, C., 1883, 'L'aveugle', *Les Nouvelles Amoureuses*, Paris

Audouard, O., 1882, 'Les Femmes au salon', *Le Papillon*, 6, 28 May, 461

Avery, G., 1965, *Nineteenth Century Children*, London

Bakhtin, M. M., 1981, *The Dialogic Imagination*, trans. C. Emerson and M. Holquist, Austin, Texas

Barkan, L., 1975, *Nature's Work of Art: The Human Body as Image of the World*, New Haven and London

Barker-Benfield, G. J., 1976, *The Horrors of the Half-Known Life: Male Attitudes Towards Women and Sexuality in Nineteenth-Century America*, New York

Barocchi, P., 1960–2, *Trattati d'arte del Cinquecento fra Manierismo e Controriforma*, 3 vols., Bari

Barthes, R., 1975, *The Pleasure of the Text* (1973), trans. R. Miller, New York
 1981, *Camera Lucida: Reflections on Photography*, trans. R. Howard, New York

Baudelaire, C., 1961, *Fusées*, in *Œuvres complètes*, ed. Y.-G. le Dantec, Paris

Baxandall, M., 1980, 'Doing justice to Vasari', *Times Literary Supplement*, 1 February, 111

Beetham, E., 1780, *Moral Lectures on Heads*, Newcastle upon Tyne

Begun, H., 1980, 'Krankengeschichte Frida Kahlos', in *Frida Kahlo*, ed. R. Tibol, Frankfurt

Bembo, P., 1961, *Gli Asolani*, in Pietro Bembo, *Opere in Volgare*, ed. M. Marti, Florence, pp. 9–163

Benjamin, W., 1978, *One Way Street and Other Writings*, trans. E. Jephcott and K. Shorter, New York; London 1979

Bernal, M., 1987, *Black Athena: The Afroasiatic Roots of Classical Civilization*, vol. 1. New Brunswick, NJ

Berni, F., 1781, *Orlando innamorato* (1542), 4 vols., Masi

Bettini, P., 1891, 'Attilio Pusterla', *Cronaca dell'Esposizione di Belle Arti*, 22–43

Beyer, H., 1958, *Nietzsche och Norden*, 2 vols., Universitetet i Bergen Arbok

Bizet, R., 1925, *La Mode*, Paris

Blanc, C., 1867, *Grammaire historique des arts du dessin*, Paris

1877, *Art in Ornament and Dress* (*L'Art dans la parure et dans le vêtement*, 1875), London

Blunt, A., 1940, *Artistic Theory in Italy 1450–1600*, Oxford

Blythe, H., 1970, *Skittles: The Life and Times of Catherine Walters*, London

Boase, T. S. R., 1979, *Giorgio Vasari. The Man and the Book*, Princeton, NJ.

Bobbin, T., 1819, *The Flying Dragon and the Man of Heaton* in *The Works of Tim Bobbin, Esq., in Prose and Verse with a Memoir of the Author by John Corry*, Manchester

Bock, H. and Busch, G., eds., 1973, *Edvard Munch – Probleme – Forschungen – Thesen*, Munich

Boime, A., 1981, 'The case of Rosa Bonheur: why would a woman want to be more like a man?' *Art History*, 4, 384–402

 1983, 'The Second Empire's official realism', in *The European Realist Tradition*, ed. G. Weisberg, Bloomington, IN

Bois-Gallais, F. L. de, 1856, *Biography of Mademoiselle Rosa Bonheur*, trans. J. Perry, London

Bolsche, W., 1900, *Ernst Haeckel*, Berlin and Leipzig

Borland, H., 1956, 'Nietzsche's influence on Swedish literature, with special reference to Strindberg, Ola Hansson, Heidenstam, and Frodig', *Göteborgs Kungel. Vetenskaps- och Vitterhets samhalles Handlingar*, ser. A, vol. IV, no. 3, 7–107

Borsa, J., 1990, 'Frida Kahlo. Marginalisation and the critical female subject', *Third Text*, 12, Autumn, 21–40

Boswell, J., 1924, *Letters of James Boswell*, ed. C. B. Tinker, 2 vols.,

Breton, A., 1964, *Nadja*, Paris (1st edn 1928)

 1972a, 'Frida Kahlo De Rivera', in *Surrealism and Painting*, London, pp. 141–4

 1972b, *Manifestos of Surrealism*, Ann Arbor, MI

Bryson, A., 1990, 'The rhetoric of status: gesture, demeanour and the image of the gentleman in sixteenth- and seventeenth-century England', in *Renaissance Bodies*, ed. L. Gent and N. Llewellyn, London, pp. 137–53

Budigna, L., 1962, *Giovanni Segantini*, Milan

Buenger, B., 1983, 'Beckmann's beginnings: Junge Manner am Meer', *Pantheon*, 41, 134–44

Burney, F., 1889, *The Early Diary of Frances Burney 1768–1778*, ed. A. R. Ellis, 2 vols., London

 1986, *Cecilia. Or Memoirs of an Heiress* (1782), London

Butler, J., 1990, 'Gender trouble, feminist theory and psychoanalytic discourse', in *Feminism/Postmodernism*, ed. L. J. Nicholson, New York and London, pp. 324–40

Bynum, W. and Porter, R., eds., 1985, *William Hunter and the Eighteenth-Century Medical World*, Cambridge

Caillois, R., 1933, 'Spécification de la poésie', *Le Surréalisme au Service de la Révolution*, 5, 30–1

Calmeta, V., 1959, 'Della ostentazione', in *Prose e lettere edite e inedite*, ed. C. Grayson, Bologna

Calmo, A., 1888, *Lettere*, ed. V. Rossi, Turin

Camille, 1882, 'L'Ecole des Beaux-Arts', *La Citoyenne*, 48, 9–15 January, 1

Camporesi, P., 1984, *Il sugo della vita*, Milan

Canaday, J., 1968, 'Iconoclast, innovator, prophet', (obituary 'appraisal') *New York Times*, 3 October, p. 51

Caroso, F., 1986, *Nobilità di dame*, ed. and trans. J. Sutton, Oxford

Carré, J.-M., 1956, *Voyageurs et écrivains français en Egypte*, Cairo

Castelli, P. et al., eds., 1987, *Mesura et arte del danzare. Guglielmo da Pesaro e la danza nelle corti italiane del XV secolo*, Pesaro

Castiglione, B., 1964, *Il libro del cortegiano* (1528), ed. B. Maier, Turin

Cecchi, G. M., 1883, *Commedie*, ed. O. Guerrini, Milan

de Certeau, M., 1986, 'The institution of rot' (1977), in *Heterologies*, trans. B. Massumi, Minneapolis, pp. 35–46

Chadwick, W., 1985, *Women Artists and the Surrealist Movement*, London

Chavez, I., 1946, *Diego Rivera: sus frescoes en el instituto nacional de cardiologia*, Mexico City: Sociedad Mexicana de Cardiologia

Chevreul, M.-E., 1839, *De la loi du contraste simultané des couleurs et de l'assortiment des objets colorés*, Paris

Clyfford Still, 1976, San Francisco: San Francisco Museum of Modern Art

Corbett, J. J., 1910, *My Life and Fights*, London

Le Corbusier, 1987, *The Decorative Art of Today* (*L'Art décoratif d'aujourd'hui*, 1925), trans. and intro. J. I. Dunnett, London

Corriere della Sera

Croak, T. M., 1979, 'The professionalization of prizefighting: Pittsburgh at the turn of the century', *Western Pennsylvania Historical Magazine*, 62 (4), 333–43

Cronaca d'Arte

Cropper, E., 1976, 'On beautiful women. Parmigianino, Petrarchismo and the vernacular style', *Art Bulletin*, 58 (3), 374–95

The Daily Telegraph, 1861

Damigella, A. M., 1981, *La Pittura simbolista in Italia 1885–1900*, Turin

Davidoff, L., 1973, *The Best Circles: Women and Society in Victorian England*, Totowa, NJ
1976, 'Landscape with figures: home and community in English society' in *The Rights and Wrongs of Women* ed. J. Mitchell and A. Oakley, Harmondsworth, pp. 139–75

Dawes, C. R., 1943, 'A study of erotic literature in England considered with especial reference to social life', MS 364.d.15, British Library, London

Demont-Breton, V., 1926, *Les Maisons que j'ai connues*, Paris

Derrida, J., 1987, 'Cartouches' (1978), in *The Truth in Painting*, trans. G. Bennington and I. McLeod, Chicago and London, pp. 183–247

Description de l'Egypte, ou recueil des observations et des recherches qui ont été faites en Egypte pendant l'expédition de l'armée française, 1809–22, Paris

Dijkstra, B., 1986, *Idols of Perversity: Fantasies of Feminine Evil in Fin-de-Siècle Culture*, New York

Doane, M. A., 1982, 'Film and the masquerade: theorising the female spectator', *Screen*, 23 (304), 74–87

Doin, J., 1921, 'Alfred de Dreux', *Gazette des Beaux-Arts*, pp. 237–51

Dolce, L., 1960, *Dialogo della pittura* in *Trattati d'arte del Cinquecento*, ed. P. Barocchi, Bari, vol. 1, pp. 142–206

Dolce, L., ed., 1559, *Lettere di diversi eccellentissimi huomini*, Venice

Dolmetsch, M., 1954, *Dances of Spain and Italy from 1400 to 1600*, London

Douglas, M., 1966, *Purity and Danger: An Analysis of the Concepts of Pollution and Taboo*, London

Dubbert, J., 1979, *A Man's Place: Masculinity in Transition*, Englewood Cliffs, NJ

Du Camp, Maxime, 1853, *Le Livre posthume, mémoirs d'un suicidé*, Paris
1855, *Le Nil*, Paris
1857, *Les Six Aventures: Reis-Ibrahim; L'Âme errante; Tagahoh; L'Éunuque noir; La Double Aumone; Les Trois Vieillards de Pierre*, Paris
1867, *Les Beaux-arts à l'exposition universelle et aux salons de 1863, 1865, 1866, et 1867*, Paris
1882–3, *Souvenirs littéraires*, Paris

Duchamp, M., 1962, 'Marcel Duchamp', interview with Katherine Kuh in her *The Artist's Voice . . .*, New York, pp. 81–93

Duchamp, 1984, Madrid: Sala de Exposiciones de la Caja de Pensiones

Earland, A., 1911, *John Opie and his Circle*, London

Eastlake, E., 1895, *Journals and Correspondence of Lady Eastlake*, ed. C. Eastlake Smith, 2 vols., London

L'Eclair, 16 May 1897 ('La Manifestation anti-féministe à l'Ecole des Beaux-Arts')

Edvard Munch. Malningar och Grafik, Helsinki, 1979

Eggum, A., 1984, *Edvard Munch Paintings, Sketches and Studies*, Oslo
1989, *Munch and Photography*, New Haven, CT

Eggum, A., with S. Baumbach, S. Biornstad, and S. Bohn, 1987, *Edvard Munch/Gustav Schiefler Briefwechsel*, vol. 1, Hamburg

Ehrenreich, B. and English, D., 1972, *Complaints and Disorders: The Sexual Politics of Sickness*, Old Westbury, NY

Eitner, L., 1983, *Géricault: His Life and Work*, London

'En strid om Edvard Munch', *Morgenbladet*, Kristiania, 16 April 1911

L'Esprit Nouveau, 1920–5, vols. 1–28; facsimile reprint, New York, 1968

Fabian, J., 1983, *Time and the Other: How Anthropology Makes its Object*, New York

Fairholme, E. G. and Pain, W., 1924, *A Century of Work for Animals*, London

Falnes, O., 1933, *National Romanticism in Norway*, New York

Fermor, S., 1983, 'On the description of movement in Vasari's Lives', in *Acts of the Twenty-Fifth International Congress of the History of Art* (1982), Vienna, vol. II, pp. 15–21

Figlio, K., 1978, 'Chlorosis and chronic disease in nineteenth-century Britain: the social constitution of somatic illness in a capitalist society', *Social History*, 3, 167–97

Filene, P., 1986, *Him/Her/Self: Sex Roles in Modern America*, 2nd edn, Baltimore and London

Firenzuola, A., 1548, *Dialogo delle bellezze delle donne* in *Prose di M. Agnolo Firenzuola Fiorentino*, Florence

Fischer, J., 1970, 'Mark Rothko: portrait of the artist as an angry man', *Harper's Magazine*, 241, pp. 16–17, 20–3

Flaubert, G., 1971, *Œuvres complètes*, vol. XIII, Paris

Flax, J., 1990, *Thinking Fragments: Psychoanalysis, Feminism, and Postmodernism in the Contemporary West*, Berkeley, Los Angeles and Oxford

Flugel, J. C., 1930, *The Psychology of Clothes*, London

Forty, A., 1990, 'Industrial design and prosthesis', *Ottagonó*, 96, 114–29

Franco, J., 1989, *Plotting Women. Gender and Representation in Mexico*, London

Franko, M., 1986, *The Dancing Body in Renaissance Choreography (c. 1416–1589)*, Birmingham, Al

Freud, S., 1955a, 'Dreams and telepathy' (1922), in *The Standard Edition of the Complete Psychological Works of Sigmund Freud*, ed. J. Strachey, vol. XVII, London

 1955b, 'Medusa's Head' (1940/1922), in *The Standard Edition of the Complete Psychological Works of Sigmund Freud*, ed. J. Strachey, vol. XVIII, London

 1957, 'A connection between a symbol and a symptom' (1916), in *The Standard Edition of the Complete Psychological Works of Sigmund Freud*, ed. J. Strachey, vol. XIV, London

 1963a, 'Psychoanalytic notes upon and autobiographical account of a case of paranoia (dementia paranoides)' (1911) in *Three Case Histories*, ed. P. Rieff, New York

 1963b, 'The dynamics of transference' (1912) trans. J. Riviere, in *Therapy and Technique*, New York

 1971, 'Femininity' (1933), in *The Complete Introductory Lectures on Psychoanalysis*, ed. J. Strachey, London

 1977a 'Three essays on the theory of sexuality' (1905), *The Pelican Freud Library*, vol. VII, *On Sexuality*, Harmondsworth

 1977b, 'Some psychical consequences of the anatomical differences between the sexes' (1925), in *The Pelican Freud Library*, vol. VII, *On Sexuality*, Harmondsworth

 1977c, 'Fetishism' (1927), in *The Pelican Freud Library*, vol. VII, *On Sexuality*, Harmondsworth

 1977d, 'Female sexuality' (1931), in *The Pelican Freud Library*, vol. VII, *On Sexuality*, Harmondsworth

 1984, 'On metapsychology: The Theory of Psychoanalysis (Beyond the Pleasure Principle, the Ego and the Id, and other works)', *The Pelican Freud Library*, vol. XI, Harmondsworth

Frido Kahlo and Tina Modotti, Whitechapel Art Gallery, London, 1982

Friedmann, G., 1936, *La Crise du progrès esquisse d'histoire des idées 1895–1935*, Paris

Fulford, R., ed., 1976, *Darling Child: Private Correspondence of Queen Victoria and the Crown Princess of Prussia, 1871–78*, London

Gallop, J., 1982, *The Daughter's Seduction: Feminism and Psychoanalysis*, Ithaca, NY

 1988, *Thinking through the Body*, New York

Garb, T., 1991, Sœurs de pinceaux: the formation of a separate women's art world in Paris, 1881–1897, PhD, University of London, Courtauld Institute of Art

de Garsault, M., 1767, *Art du perruquier, contenant la façon de la barbe; le coupe des cheveux; la construction des perruques d'hommes et de femmes en vieux; et le baigneur-étuviste, par M. de Garsault*, Paris

Gasman, D., 1971, *Scientific Origins of National Socialism: Social Darwinism in Ernst Haeckel and the German Monistic League*, New York

Gavel, J., 1985, 'I Havsbandet och I Skogstemplet', *Studier i Konstvetenskap Tillagnade Brita Linde*, Stockholm, 82–93

Gerdts, W. H., 1974, *The Great American Nude*, London

Gérôme, J. L., 1890, 'Les Femmes à l'Ecole des Beaux-Arts', *Moniteur des Arts*, 12 September, 318

di Giacomo, S., 1946, 'Le bevitrici di sangue', in *Le posie el le novelle*, ed. F. Flora and Vinciguerra, Milan, vol. 1, pp. 698–700

Gilbert, S. and Gubar, S., 1989, *No Man's Land: The Place of the Woman Writer in the Twentieth Century*, vol. 11, *Sexchanges*, New Haven

Glaser, C., 1922, *Edvard Munch*, Berlin

Gorn, E. J., 1986, *The Manly Art: Bare Knuckle Prize Fighting and the Rise of American Sports*, Ithaca, NJ

Graham, H., 1960, *Eternal Eve: The Mysteries of Birth and the Customs that Surround It*, London

Greer, G., Hastings, S., Medoff, J. and Sansone, M., eds., 1988, *Kissing the Rod: An Anthology of Seventeenth-Century Women's Verse*, London

Grimschitz, B., 1921, 'Edvard Munch Manner am Meer', *Die Bildende Kunste*, Vienna, 57–8

Grover, K., ed., 1989, *Fitness in American Culture: Images of Health, Sport, and the Body, 1830–1940*, Amherst and Rochester

Gubar, S., 1986, '"The blank page" and the issues of female creativity', in *The New Feminist Criticism*, ed. E. Showalter, London, pp. 292–313

Haeckel, E., 1900, *The Riddle of the Universe at the Close of the Nineteenth Century*, trans. J. McCabe, New York

Hall, C., 1979, 'The early formation of Victorian domestic ideology', in *Fit Work for Women*, ed. S. Burman, London

Hall, R. C., Beresford, T. P. and Quinones, J. E., 1987, 'Grief following spontaneous abortion', *Psychiatric Clinics of North America*, 3, 405–20

Hall, T., 1654, *The Loathsomenesse of Long Haire; or a Treatise wherein you have the Question stated, many Arguments against it produced, and the most material Arguments for it repell'd and answer'd, with concurrent judgement of Divines both old and new against it. With an Appendix against painting Spots, Naked Breasts etc., by Thomas Hall, BD and Pastor of Kings Norton (1653)*, London

Harrell, B., 1981, 'Lactation and menstruation in cultural perspective', *American Anthropologist*, 83, 796–823

Hasvold, E. L., 1905, *Svommefardigheden blandt Kristiania Skoleungdom*, Kristiania

Hausenstein, W., 1913, *Der nackte Mensch in der Kunst aller Zeiten und Völker*, Munich

Hay, D., 1975, *Albion's Fatal Tree: Crime and Society in Eighteenth-Century England*, London

Heath, S., 1981, 'Body, voice', in *Questions of Cinema*, Bloomington, IN, 176–93

Heller, R., 1984, *Edvard Munch: His Life and Work*, London

Héritier-Augé, F., 1989, 'Semen and blood: some ancient theories concerning their genesis and relationship', in *Fragments for a History of the Human Body, Part Three*, M. Feher with R. Naddaff and N. Tazi, New York, pp. 159–75

Herrera, H., 1983, *Frida: A Biography of Frida Kahlo*, New York

Hingston Fox, H., 1919, *Dr Fothergill and his Friends*, London

Hofmiller, J., 1903, 'Nietzsche und Rohde', *Die Zukunft*, 14 November 1903, 241–51

Hudson, R. P., 1977, 'The biography of disease: lessons from chlorosis', *Bulletin of the History of Medicine*, 51, 448–63

Hunter, W., 1774, *Anatomia Uteri Humani Gravidi*, Birmingham

The Illustrated London News, 1858

Irigaray, L., 1977, 'Women's exile. Interview with Luce Irigaray', *Ideology and Consciousness*, 1
1978, *Les Femmes, la pornographie, l'érotisme*, ed. M.-F. Hans and G. Lapouge, Paris, 1978; trans. S. Heath in 'The Question Oshima' in *Questions of Cinema*, Bloomington, IN, 161
1985a, *This Sex Which Is Not One* (1977), Ithaca and New York
1985b, 'The blind spot of an old dream of symmetry' (1974), ch. 1 in *Speculum of the Other Woman*, trans. G. G. Gill, Ithaca, NJ

Irwin, J. T., 1983, *American Hieroglyphics: The Symbol of the Egyptian Hieroglyphics in the American Renaissance* (1980), Baltimore and London

Johns, E., 1983, *Thomas Eakins: The Heroism of Modern Life*, Princeton, NJ

Jones, A. R., 1987, 'Nets and bridles: early modern conduct books and sixteenth-century women's

lyrics', in *The Ideology of Conduct: Essays in Literature and the History of Sexuality*, ed. N. Armstrong and L. Tennenhouse, New York and London, pp. 39–72

Jordanova, L., 1985, 'Gender, generation and science: William Hunter's obstetrical atlas', in *William Hunter and the eighteenth-century medical world*, eds. W. Bynum and R. Porter, Cambridge.

Jordanova, L., 1989, *Sexual Visions: Images of Gender in Science and Medicine between the Eighteenth and the Twentieth Centuries*, Hemel Hempstead

Jordanova, L. J., ed., 1986, *Languages of Nature: Critical Essays on Science and Literature*, London

Journal des Artistes, 37, 28 September 1890 ('Les Femmes à l'Ecole des Beaux-Arts')

Journal Officiel

Kelly, M. 1984, 'Desiring Images/Imaging Desire', *Wedge*, 6, 4–9

Kelso, R., 1956, *Doctrine for the Lady of the Renaissance*, Urbana, IL

Kessler, C. S., 1952, 'Sun worship and anxiety. Nature, nakedness and nihilism in German Expressionist painting', *Magazine of Art*, November, 304–12

Klumpke, A., 1940, *Memoirs of an Artist*, ed. L. Whiting, Boston

de Kooning, E., 1958, 'Two Americans in action: Franz Kline and Mark Rothko', *Art News Annual*, 27, 86–97, 174–9

Krauss, R., 1986, 'Corpus delicti', in *L'Amour Fou. Photography and Surrealism*, Arts Council of Great Britain, London

Kristeva, J., 1982, *Powers of Horror: An Essay in Abjection* (1980), trans. L. Roudiez, New York

Kruse, E., 1893, *Ueber Seeluft- und Seebadkuren bei Nerven-Krankheiten*, Norden

Kruskopf, E., 1979, 'Edvard Munch och Finland', in *Edvard Munch: Malningar och Grafik*, Helsinki

Kuh, K., 1962, *The Artist's Voice: Talks with Seventeen Artists*, New York

Lacan, J., 1977, 'On a question preliminary to any possible treatment of psychosis' (1955–6), in *Ecrits*, trans. A. Sheridan, New York and London, p. 179–225

 1980, *De la psychose paranoïaque dans ses rapports avec la personnalité* (1932), Paris

 1981, 'Of the subject who is supposed to know, of the first dyad, and of the good' (1964), in *Four Fundamental Concepts of Psychoanalysis*, trans. A. Sheridan, New York and London, pp. 230–43

Lagerlöf, E., 1959, *J. A. G. Acke*, Stockholm

The Lancet, 1850

Lansbury, C., 1985, *The Old Brown Dog: Women, Workers and Vivisection in Edwardian England*, Madison, WI

Laplanche, J. and Pontalis, J.-B., 1973, *The Language of Psychoanalysis*, trans. D. Nicholson-Smith, New York and London

Laqueur, T., 1990, *Making Sex: Body and Gender from the Greeks to Freud*, Cambridge, MA and London

de Lauretis, T., 1984, *Alice Doesn't*, London

Leavitt, J. W. ed., 1984, *Women and Health in America: Historical Readings*, Madison, WI

Lebel, R., 1959, *Marcel Duchamp*, trans. G. H. Hamilton, New York

Lemoine-Luccioni, E., 1983, *La Robe: Essai psychoanalytique sur le vêtement*, Paris

Lennie, C., 1976, *Landseer: The Victorian Paragon*, London

Leonardo da Vinci, 1956, *Trattato della pittura*, ed. A. P. McMahon, 2 vols., Princeton, NJ

Lewis, E., 1976, 'The management of stillbirth. Coping with an unreality', *The Lancet*, 18 September, pp. 619–20

Lomazzo, G. P., 1584, *Trattato dell'arte della pittura, scultura ed architettura*, Milan

Lombroso, C. and Ferrero, G., 1893, *La donna delinquente: la prostituta e la donna normale*, Turin and Rome

London, J., 1905, *The Game*, New York

London Society, 1862

Loos, A., 1920, 'Ornement et crime' *(1908)*, in *L'Esprit Nouveau*, 2, 159–68

 1982, 'Men's fashion' (1898) and 'Ladies' fashions' (1898), in *Spoken into the Void: Collected Essays 1897–1900*, Cambridge, MA and London

Loudon, L.S.L., 1980, 'Chlorosis, anaemia, and anorexia nervosa', *British Medical Journal*, 281, 1669–75

Lovell, A., 1983, *A Bereavement with a Difference: A Study of Late Miscarriage, Stillbirth and Perinatal Death*, London: Social Sciences Dept, Polytechnic of the South Bank

Maas, J., 1975, *Gambart: Prince of the Victorian Art World*, London

MacCannell, J. 1986, *Figuring Lacan: Criticism and the Cultural Unconscious*, Lincoln, NB

McCauley, E. A., 'The photographic adventure of Maxime Du Camp', *Library Chronicle of the University of Texas at Austin*, 19, 19–51

MacCormack, C. P. and Strathern, M., eds., 1980, *Nature, Culture and Gender*, Cambridge

McGregor, D. K., 1989, *Sexual Surgery and the Origins of Gynecology: J. Marion Sims, His Hospital, and His Patients*, New York and London

Maclean, I., 1980, *The Renaissance Notion of Woman*, Cambridge

Mark Rothko, 1903–1970, 1987, London: Tate Gallery

Michel, A., 1945, 'The earliest dancing-manuals', *Medievalia et Humanistica*, 3, 117–31

Millingen, J. G., 1848, *The Passions; or Mind and Matter. Illustrated by Considerations on Hereditary Insanity*, London

Mitchell, J. and Rose, J., 1982, *Jacques Lacan and the Ecole Freudienne*, London

Mitchell, S., 1985, *The Dictionary of British Equestrian Artists*, Woodbridge

Modleski, T., 1989, 'Some functions of feminist criticism, or the scandal of the mute body', *October*, 49, summer, 3–24

Moniteur des Arts

Monk, S. H., 1944, 'A grace beyond reach of art', *Journal of the History of Ideas*, 5 (2), 131ff.

Morello, I., 1553, *Le lalde, e le Sbampuorie, della unica, e virtuliosa Ziralda: Ballarina e Saltarina Scaltrieta*, Venice, 1553

Morning Advertiser, 23 July 1855

Moscucci, O., 1990, *The Science of Women. Gynaecology and Gender in England, 1800–1929*, Cambridge

Moser, C., 1983, *Eugene Jansson. The Bath-House Period*, London

Mosse, G. L., 1985, *Nationalism and Sexuality: Middle-Class Morality and Sexual Norms in Modern Europe*, Madison, WI

Mott, M., 1980, 'The British Protestant pioneers and the establishment of manly sports in Manitoba, 1870–1886', *Journal of Sport History*, 7 (3), 25–36

Mrozek, D. J., 1983, *Sport and American Mentality, 1880–1910*, Knoxville

Mulliner, J., 1677, *A testimony against Periwigs and Periwig-Making, and Playing on Instruments of Musick among CHRISTIANS, or any other in the days of the Gospel. Being several Reasons against those things. By one who for Good Conscience hath denyed and forsaken them*, Northampton

Mulvey, L., 1989, *Visual and Other Pleasures*, London

Mysteries of Flagellation, or a History of the Secret Ceremonies of the Society of Flagellants, 1863, London

Nasgaard, R., 1984, *The Mystic North: Symbolist Landscape Painting in Northern Europe and North America, 1890–1940*, Toronto

Nead, L., 1988, *Myths of Sexuality: Representations of Women in Victorian Britain*, Oxford

Neale, S., 1983, 'Masculinity as Spectacle', *Screen*, 24 (6), 2–16

Newsweek, 57, 23 Jan. 1961

New York Times Week in Review, 8 July 1990

Nichols, J., 1966, *Literary Anecdotes of the Eighteenth Century; comprising Biographical Memoirs . . .* 8 vols. (1782; London 1812) Facsimile KRC: New York

Nordau, M., 1895, *Degeneration* (1892–3), London

Nystrom, P., 1928, *Economics of Fashion*, New York

Oakley, A., 1980, *Women Confined: Towards a Sociology of Childbirth*, New York

Oldroyd, D. and Langham, I., eds., 1983, *The Wider Domain of Evolutionary Thought*, Dordrecht

O'Reilly, J. B., 1888, *Ethics of Boxing and Manly Sport*, Boston

Ortner, S., 1974, 'Is female to male as nature is to culture?', in *Woman, Culture and Society*, ed. M. Rosaldo and L. Lamphere, Palo Alto, CA

Osborne, D., 1888, 'A defence of pugilism', *North American Review*, 146, 430–5

Padel, R., 1980, 'Saddled with ginger: women, man, and horses', *Encounter*, 47–53

The Pearl, A Monthly Journal of Facetiae and Voluptuous Reading, 1879–80

Pelissero, G., 1977, 'Le genesi del Quarto Stato', in *Pellizza per il Quarto Stato*, Turin, pp. 24–35

Pennant, T., 1812, *British Zoology: A New Edition*, London

Pepys, S., 1972, *The Diary of Samuel Pepys*, ed. R. Latham and W. Matthews, 11 vols., London

Pick, D., 1989, *Faces of Degeneration: A European Disorder, c. 1848–c.1918*, Cambridge

Pierrot, G. F. and E. P. Richardson, 1934, *The Diego Rivera Frescoes*, Detroit

Pilkington, A. E., 1986, '"Nature" as ethical norm in the Enlightenment', in *Languages of Nature: Critical Essays on Science and Literature*, ed. L. J. Jordanova, London, pp. 51–85

Piper, D., 1978, *The English Face* (1957), London.

Pointon, M., 1990, *Naked Authority: The Body in Western Painting, 1830–1908*, Cambridge

Pollock, G., 1988, 'Modernity and the spaces of femininity', in *Vision and Difference: Femininity, Feminism and the Histories of Art*, London, pp. 50–90

Poovey, M., 1988, *Uneven Developments: The Ideological Work of Gender in Mid-Victorian England*, Chicago

Popham, A. E., 1971, *Catalogue of Drawings by Parmigianino*, 3 vols., New Haven

Potts, A., 1990, 'Natural order and the call of the wild: the politics of animal picturing', *Oxford Art Journal*, 13, 12–33

Prignit-Poda, H., ed., 1988, *Frida Kahlo. Das Gesamtwerk*, Frankfurt

Pudor, H., 1906, *Nacktkultur*, Berlin

Punch or the London Charivari, 1864

Quinsac, A.-P., 1972, *La Peinture divisioniste italienne. Origines et premiers développements 1880–1895*, Paris

Radycki, D., 1982, 'The life of lady art students: changing art education at the turn of the century', *The Art Journal*, Spring, 9–13

Ramsbottom, F., 1861, *The Principles and Practice of Obstetric Medicine and Surgery, in reference to the Process of Parturition*, London

Riat, G., 1906, *Gustave Courbet, peintre*, Paris

Richards, E., 1983, 'Darwin and the descent of woman', in *The Wider Domain of Evolutionary Thought*, ed. D. Oldroyd and I. Langham, Dordrecht

La Riforma

Ring, N., 1990, 'The politics of identification: Duchamp's femininity', unpublished paper

Ritchie, D., 1770, *A Treatise on the Hair*, London

Ritvo, H., 1987, *The Animal Estate: The English and Other Creatures in the Victorian Age*, Cambridge, MA

Rivera, D., 1986, 'Frida Kahlo y el Arte Mexicano' (1943), *Textos de Arte*, Mexico City, pp. 282–93

Riviere, J., 1986, 'Womanliness as masquerade', *International Journal of Psychoanalysis*, 10, 1929, 303–13. Reprinted in *Formations of Fantasy*, ed. V. Burgin, J. Donald and C. Kaplan, New York and London

Rogers, M., 1988, 'The decorum of women's beauty: Trissino, Firenzuola, Luigini and the representation of women in sixteenth-century painting', *Renaissance Studies*, 2 (1), 47–89

Rood, O., 1879, *Modern Chromatics*, New York

Roosevelt, T., 1897, *American Ideals and Other Essays Social and Political*, New York and London
1899, *The Rough Riders*, New York
1901, *The Strenuous Life: Essays and Addresses*, London

Rosaldo, M. and Lamphere, L., eds., 1974, *Woman, Culture and Society*, Palo Alto, Stanford, CA

Rosenberg, H., 1975, 'The art world: death and the artist', *The New Yorker*, 101, 69–75

Roskill, M., 1968, *Dolce's 'Aretino' and Venetian Art Theory of the Cinquecento*, New York

Rothko, M., 1947/8, 'The Romantics were prompted', *Possibilities*, 1, 84. Reprinted in *Mark Rothko, 1903–1970*, London, pp. 86–7
1958, 'Lecture' (Pratt Institute), 29 October 1958; notes taken by Dore Ashton. Reprinted in *Mark Rothko 1903–1907*, London, pp. 86–7

Rotundo, E. A., 1983, 'Body and soul: changing ideals of American middle-class manhood, 1770–1920', *Journal of Social History*, 16, 23–38

Rupke, N. A., ed., 1976, *Vivisection in Historical Perspective*, London

Ruskin, J., 1903–12, *The Works of John Ruskin*, ed. E. T. Cook and A. Wedderburn, 39 vols., Library Edition, London and New York

Sadie, S., ed., 1980, *The New Grove Dictionary of Music and Musicians*, 20 vols., London

Sainville, 1890, 'Chronique de la semaine', *Moniteur des Arts* 1913, 325

Sanouillet, M. and Peterson, E., eds., 1989, *The Writings of Marcel Duchamp*, New York

Sanudo, M., 1879–1903, *Diarii autografi di Marin Sanudo*, ed. R. Fulin *et al.*, 58 vols., Venice

Saslow, J., 1992, '"Disagreeably hidden": construction and constriction of the lesbian body in Rosa Bonheur's *Horse Fair*', in *The Expanding Discourse: Feminism and Art History*, ed. Norma Broude and Mary Garrard, New York

Saunders, G., 1989, *The Nude: A New Perspective*, London and New York

Scarry, E., 1985, *The Body in Pain*, New York and Oxford

Schor, M., 1988, 'Representations of the penis', *M/E/A/N/I/N/G*, 4, 3–17

Schwarz, A., 1969, *The Complete Works of Marcel Duchamp*, New York

Seldes, L., 1978, *The Legacy of Mark Rothko*, New York

Sennett, R., 1977, *The Fall of Public Man*, Cambridge (1974)

Shearman, J., 1963, '*Maniera* as an aesthetic ideal', *Acts of the Twentieth International Congress of the History of Art* (1961), II, Princeton, NJ, 1963, 200–21. Reprinted in *Renaissance Art*, ed. C. Gilbert, New York, 1970, pp. 181–221

 1967, *Mannerism*, London

Showalter, E., ed., 1986, *The New Feminist Criticism*, London

Shuttleworth, S., 1986, 'Fairy tale or science? Physiological psychology in *Silas Marner*', in *Languages of Nature: Critical Essays on Science and Literature*, ed. L. J. Jordanova, London

Silver, K. and Golan, R., 1985, *The Circle of Montparnasse: Jewish Artists in Paris 1905–1945*, New York

Singer, P., 1976, *Animal Liberation: Towards an End to Man's Inhumanity to Animals*, London

Smith, G. and Smith, J., eds., 1972, *The Police Gazette*, New York

Smith, J. T., 1920, *Nollekens and his Times* (second edn, London 1829), W. Whitten, ed., 2 vols., London

Smith, T., 1983, 'From the margins. Modernity and the case of Frida Kahlo', *Block*, 8, 11–23

Smith-Rosenberg, C. and Rosenberg, C., 1984, 'The female animal: medical and biological views of woman and her role in nineteenth-century America', in *Woman and Health in America: Historical Readings*, ed. J. W. Leavitt, Madison, WI

Solomon, D., 1987, *Jackson Pollock, A Biography*, New York

Sørensen, G., 1981, 'Vitalismens ar?', *Cras*, 26–42

Spackman, B., 1989, *Descendant Genealogies: The Rhetoric of Sickness from Baudelaire to D'Annunzio*, Ithaca and London

The Spectator, 631, 10 December 1714

Spivak, G., 1983, 'Displacement and the discourse of Woman', in *Displacement: Derrida and After*, ed. M. Krupnick, Bloomington, IL

Spivey, D. ed., 1985, *Sport in America: New Historical Perspectives*, Westport, CT, pp. 193–217

Stallybrass, P. and White, A., 1987, *The Politics and Poetics of Transgression*, London

Stanton, T., ed., 1976, *Reminiscences of Rosa Bonheur* (1910), New York

Starobinski, J., 1981, 'Sur la chlorose', *Romantisme*, 31, 113–30

Steegmuller, F., 1972, *Flaubert in Egypt: A Sensibility on Tour*, Boston

Sterling, C. and Salinger, M. M., 1966, *French Paintings: A Catalogue of the Metropolitan Museum of Art*, vol. II, New York

Stransky, E., 1974, 'On the history of chlorosis', *Episteme*, 8, 26–45

Summers, D., 1981, *Michelangelo and the Language of Art*, Princeton, NJ

Svenæus, G., 1953, *Ide och Innehall i Edvard Munchs Konst. En analys av aulamalningarna*, Oslo
 1973, 'Der heilige Weg. Nietzsche-Fermente in der Kunst Edvard Munchs', in *Edvard Munch – Probleme – Forschungen – Thesen*, ed. H. Bock and G. Busch, Munich

Taylor, I. and Réybaud, L., 1839, *La Syrie, l'Egypte, la Palestine et la Judée*, 2 vols., Paris

Terdiman, R., 1985, 'Ideological voyages: concerning a Flaubertian dis-orient-ation', in *Europe and Its Others*, ed. F. Barker, Colchester: University of Essex

Tibol, R., ed., 1980, *Frida Kahlo*, Frankfurt

Tracey, S., 1976, 'Hommage à Mark Rothko', unpublished essay

Turner, J., 1980, *Reckoning with the Beast: Animals, Pain and Humanity in the Victorian Mind*, Baltimore and London

Twin, S. L., 1985, 'Women and sport', in *Sport in America: New Historical Perspectives*, ed. D. Spivey, Westport, CT, pp. 193–217

Tzara, T., 1933, 'D'un certain automatisme du goût', *Minotaure*, 3–4, 81–4

Vaisse, P., 1980, La Troisième République et les peintres: recherches sur les rapports des pouvoirs publics et de la peinture en France de 1870 à 1914 (Thèse Doctorat d'Etat, Paris IV)

Vasari, G., 1878–85, *Le vite de' più eccellenti pittori, scultori ed architettori*, ed. G. Milanesi, 9 vols., Florence

Vehmas, E. J., 1964, 'Edvard Munchin kylpevia Meihia, Ateneumin Taidemuseo', *Muscojulkaisu*, 9, 2–6

Villari, L., 1901, *Giovanni Segantini*, London

Villari, P., 1844, *Introduzione alla storia d'Italia*, Milan
 1933, *Scritti e discorsi per la 'Dante'*, Rome

Vita Moderna

Waldman, D., 1978, *Mark Rothko, A Retrospective*, New York

Walters, M., 1978, *The Male Nude*, London

Warner, M., 1976, *Alone of all Her Sex: The Myth and Cult of the Virgin Mary*, London

Weininger, O., 1906, *Sex and Character*, London

Weisberg, G., 1982, *The European Realist Tradition*, Bloomington, IL

Williams, R., 1983, *Culture and Society: 1780–1950*, New York

Willumsen, J. F., 1953, *Mine Erindringer fortalt til Ernst Mentze*, Copenhagen

Wohl, A., ed., 1978, *The Victorian Family: Structure and Stresses*, New York

Wolff, J., 1990, *Feminine Sentences: Essays on Women and Culture*, Berkeley and Los Angeles

Yeldham, C., 1984, *Women Artists in Nineteenth-Century France and England*, New York and London

Zuccollo, S., 1549, *La Pazzia del Ballo*, Padua

Index

Abstract Expressionism, 45
Achilles, 40
Acke, J. A. G., 75, 81
Adduco, V., 119
Alger, Horatio, 58
allegory, 6, 12, 76, 116
amazone, 99
amputation, 7
 Kahlo's leg, 14
 see also mutilation
Annual Register, 100
anthropology, 86, 113, 121, 123, 149, 156
antique, Antiquity, 53, 66, 71, 72, 81, 83, 126, 131,
 143, *see also* classical
anti-semitism, 46
anti-vivisection, 96
Antoine, Jules, 40
Aragon, Louis, 168, 172
Arbeau, Thoinot, 132–3, 139
Arcangeli, F., 114
archaeology, 150, 154
architecture, 47, 147, 150, 153, 154, 159, 167
 scale, proportion, 128, 153, 154, 160
Aristotle, 121, 131
L'Art et Critique, 40
Art Nouveau, 75
The Athenaeum, 95, 99, 104
athlete, athletic, 54, 59, 66, 71–3, 75, 77, 78, 80, 81,
 144
Aubert, Charles, 2, 3, 33–42 *passim*
Austin, Alfred, 103–4
autobiography, 4, 24, 48, 66, 160, *see also*
 biography

Barbizon, 89
Barkan, Leonard, 188
Barthes, Roland, 149
Baudelaire, Charles, 21, 26–7
Beckmann, Max: *Youths by the Sea*, 195n3
Beetham, Edward, 176, 180, 188
Bembo, Pietro, 137, 138, 143
Benjamin, Walter, 21
Bennett, Henry, 105
Berkeley, Theresa, 106
Bernal, Martin, 158

Bettini, Pompeo, 117–18
Bible, 178
 Exodus, 182
 Psalms, 12
biography, 4, 5–6, 17, 19, *see also* autobiography
Bizet, René, 163
Blanc, Charles, 163, 165, 166
blood, 12, 86, 87, 109, 116, 117, 120
Bobbin, Tim: *The Flying Dragon*, 185, 188, pls. 41,
 42
Bogat, Regina, 45
Boiffard, J. A., 168
Bonheur, Rosa, 85, 89–107
 The Dual, 92
 The Horse Fair, 85, 89–107, 196n3, pl. 19
 Ploughing in the Nivernais, 196n3
 Study for The Horse Fair, 92, pl. 20
Boone, Daniel, 59
Boswell, James, 127, 178
boundaries, 1–2, 9, 31, 42, 47, 48, 49, 65, 67, 121,
 123, 127, 188
 ego, 192n16
 gender and class, 87, 180
 national, 110, 113
boxing, 54, 55, 59–69 *passim*
Breton, André, 5, 19, 163, 168, 197n2
Bridewell, 104
British Society for the Prevention of Cruelty to
 Animals, 96
Browning, Elizabeth Barrett, 96
Burney, Fanny, 179, 188

Cagnoni, Amerino: *Gioie Materne* (Maternal
 Joys), 111
Caillois, Roger, 167
Calmeta, Vincenzo: *Della Ostentazione*, 133–4
Calmo, Andrea, 144
cannibalism, 42, 119
Carey, Mary, 11
caricature, 33, 34, 35, 40, 73
Carson, Kit, 59
cartoons, 87, 98, 101, 102, 104
Castagno, Andrea del, 139, 144
 David, 197n7
Castiglione, Baldassare, 131–4, 138, 139, 142, 145

castration, 7, 17, 18, 26, 36, 41, 127, 157, 167, 169–72
 passim, 188
Catholic, 11, 14
Cecchi, Giovanni Maria, 144
Champollion the Younger, 149
charade, 42
chastity, 143–5
Chevreul, Michel Eugène, 110
childbirth, 9, 10, 105, 106
 parturition, 87
children, 35, 90, 96, 97, 98, 107, 117, 130, 141, 180
Christian, Christianity, 9, 57, 66, 83, 114, 128, 182
 the church 183
 see also Catholic, Puritan, Quaker
class, 1, 33, 39, 60, 63, 64, 65, 87, 90, 96, 101, 104,
 105, 131, 132, 150
classical, 53, 54, 66, 71, 80, 83
 images, 80
 pose, stance, 153, 158, 159
 proportion, 128, 166
Clercq, Louis de, 154
colonial power, 147
Colquhoun, Ithell: *Scylla*, 191n6
Contarini, Alessandro, 129
contrapposto, 130, 138, 153, 158
Corbett, Jim, 66
Corriere della Sera, 113
Courbet, Gustave: *Nude Bather*, 91
'The Critic Foiled at Rosa Bonheur's Great
 Horse Fair', 93–4
Cronaca d'Arte, 110, 113
Cropper, Elizabeth, 137
Cuyp, Jacob, 89

daguerreotype, 154, 155
The Daily Telegraph, 104
dance, 125, 126, 127, 130–4, 138, 139, 142–5
Davidoff, Leonore, 96
De Koonig, Elaine, 51
Demont-Breton, Virginie, 41
deportment, 131, 137
Derrida, Jacques, 26, 29, 31
Deverell, Walter: *A Pet*, 96
Diderot, Denis, 177
disease
 chlorosis, 86, 109, 118, 120
 eye, 122
 nervous, 76–7
 plague, 180–1, 183
 smallpox, 181
dissection, 85
divisionism, 85, 110, 112, 113, 116, 117, 122
Doane, Mary Ann, 170
Dolce, Ludovico, 129, 130, 141–2, 143
Douglas, Mary, 121–2
dress, 2, 19, 22, 38, 43, 63, 92, 155, 163, 165, 167,
 175–8 *passim*, 183, 185
Dreux, Alfred de: *amazone* paintings, 99
Duchamp, Marcel, 2, 3, 4, 21–31
 Anémic Cinéma, 28

 Belle-Haleine, Eau de Voilette, 28, 193n2
 Etant donnés, 29
 Large Glass, 29
 The Little Review, 28
 Monte Carlo Bond, 28
 Rotative Demi-Sphère, 28
Du Camp, Maxime, 126, 147–60
 The Black Eunuch, 157
 Egypt, Palestine, Nubie et Syrie, 147–60, pls.
 33–6
 The Posthumous Book: Memoirs of a Suicide, 160

Eakins, Thomas, 57–69
 The Agnew Clinic, 68
 The Gross Clinic, 65, 66
 Salutat, 53, 57–69, pl. 13
 *William Rush Carving His Allegorical Figure of
 the Schuylkill River*, 62, 68
Ecole des Beaux-Arts, 35, 38, 39, 40, 41
empiricism, 6, 7, 19, 149
L'Espirit Nouveau, 166, 167
ethnicity, 60, 64
eugenics, 58
exhibitions, 9–10, 54, 87, 110, 112, 113, 122, 123
Expressionism, 47, 83

Fabian, Johannes, 149
Fåhræus, 76
Fascism, 112
fashion, fashions, 103, 127, 161–3, 166–7, 169–71,
 176, 177, 178, 183, 185
father, 22, 29, 91, 102, 192n14
fatherland, 81
Ferber, Herbert, 46
Ferragutti, Arnaldo: *Alla Vanga* (Spadework), 117
Ferrero, Guglielmo, 118–19
fetish, 127, 163, 172, 188
fiction, 2, 3, 4, 33, 36, 38, 41, 62, 97, 104, 118, 144
 novels, 48, 58, 62, 157, 160
figure painting, 1, 117
Firenzuolo, Agnolo, 137, 138, 143
flagellation, 106
flâneur, 103, 168
Flaubert, Gustave, 149, 150, 154, 155, 156, 159
Flugel, John Carl, 163
Förster-Nietzsche, Elisabeth, 80
Fothergill, John, 181
Freud, Sigmund, 126, 169–72, 178–9
 on castration, 188
 and 'femininity', 169–70
 and Freudian perspective, 3
 on hats, 171
 and Oedipus complex, 169–70
 on the penis, 38
 on 'prehistory' of women, 167, 170
 on Judge Schreber, 24, 25, 27, 192n4
 on sight, 36–7, 171
 on symbols, 171, 172, 191n10
 and transference, 22, 24, 25, 192n2
 on trauma, 16, 17

Friedmann, Georges, 166
Frith, Francis, 154

galliard, 132–3, 134, 139, 144
Gallop, Jane, 3, 22, 25
Gambart, Ernest, 90, 93
gambling, 62, 63
Gardner, Augustus Kinsley, 106
Garnier, Charles, 41
Garsault, M. de, 177, 184
gaze, the, 2, 6, 7, 30, 33–42, 54, 55, 62–3, 65, 68–9, 73, 159
 the look, 3, 27, 30, 36
genitals, 25
 female, 8, 18, 28, 127, 162, 169
 penis, 26, 29, 38, 41, 188
Géricault, Théodore, 89, 91, 99
 Race of the Barberi Horses on the Corso, 91
Gérôme, Jean-Léon, 38, 66
gestation, 9, 10
Giacomo, Salvatore di, 119, 120
Gierløff, Christian, 77
Gil Blas, 35
Glaser, Curt, 73
Greenberg, Clement, 22
grotesque, 176
Grubicy, Vittore, 110, 113, 116
Gubar, Susan, 16–17
Gueldry, Joseph-Ferdinand: The Blood Drinkers, 116
Guillaume, Henri, 41
gynaecology, 85, 96, 104–7 passim

Hadji-Ismael, 127, 153–60 passim
Haeckel, Ernst, 79
hair, 103, 106, 127, 168, 171, 172, 175–89
Hall, Catherine, 96
Hall, Thomas, 182–3, 185
Hamilton, Richard: Ulysses, 191n6
Hanriot, Jules-Armand, 33, 34, pl. 6
Harpers Weekly, 59
Harvard, 60
Hasvold, E. Leonard, 77
hat, 104, 127, 128, 161–73
Hausenstein, Wilhelm, 83
Hedberg, Tor, 76
Heine, Heinrich, 170
Héritier-Augé, Françoise, 121
Herrera, Hayden, 18
Herring, Benjamin (Jnr): Going to the Horse Fair, 93
Herring, John Frederick: The Horse Fair on Southborough Common, 93
hieroglyphs, 155, 165, 170
Hippocrates, 105, 121
Hofmann, Ludwig von, 71
Hogarth, William, 178, 188
 An Election Entertainment, 178, pl. 39
 The Five Orders of Periwigs, 177
 A Midnight Modern Conversation, 177

John Wilkes, Esq., 181
Homer, Winslow: Undertow, 68, pl. 14
Hosmer, Harriet, 90
Hunter, William, 6–7, 17
hysteria, 119, 122, 168

Illustrated London News, 101
L'Illustrazione Italiana, 122
industry, 9, 12, 14, 35, 96, 112, 166
infanticide, 118, 119
Irigaray, Luce, 3, 12, 17, 18, 30
Itier, Jules, 154

Jansson, Eugène, 75–6, 81, 83
 The Navy Bath House, 76, pl. 17
jealousy, 132
Jews, Jewish, 4, 46, 48, 194nn3, 4
Jordanova, Ludmilla, 19

Kahlo, Frida, 1, 3–4, 5–19
 The Broken Column, 16, pl. 4
 Frida and the Miscarriage, 10, 18–19
 Henry Ford Hospital, 1, 11, 12, 14, pl. 2
 My Birth, 11, 13, 14, 192n13, pl. 3
 My Nurse and I, 192n15
 On the Borderline, 191n7
 Remembrance of an Open Wound, 17
 Roots, 16
 Self-Portrait with Cropped Hair, 3, 18
 Self-Portrait with Dr Farill, 17
 Self-Portrait with Monkey, 14, 19
 The Two Fridas, 18
 What the Water Gave Me, 7–9, 18, 19, pl. 1
Kelly, Mary, 2–3, 27
Krauss, Rosalind, 163
Kristeva, Julia, 120–1
Kruse, E., 77
Kunitz, Stanley, 48

Lacan, Jacques, 6, 11, 22, 24, 25
The Lancet, 105
Landor, Walter Savage, 178
landscape, 12, 16, 83, 114, 155
Landseer, Edwin, 90, 100
 The Shrew Tamed, 99, 103, pl. 22
Lansbury, Coral, 96
Laplanche, Jean, 16
Laqueur, Thomas, 121, 123
law, 14, 22, 29, 38, 48, 59, 126
 legal wigs, 177, 178
Le Corbusier, 128, 166
Leech, John, 87, 98, 102
 'The Nursery Four-in-Hand Club – The First Meet of the Season', 97, pl. 21
 'Husband Taming', pl. 24
Lemoine-Luccione, Eugénie, 26
Leonardo da Vinci, 141
Lepsius, Richard, 149
Lettsome, Dr, 180
Life, 43

life-class, life-drawing, 35, 36, 38–9, 40, 41
Logoni, Emilio, 110
Lomazzo, Giovan Paolo, 139
Lombroso, Cesare, 87, 118–19, 122
London, Jack, 68
London Society, 103
Longoni, Emilio: *L'Oratore della Sciopero*
 (Addressing the Strike), 117
Loos, Adolf, 166–7
love, 73, 99, 113, 117, 132
Lysippos, 81

MacCannell, Juliet Flower, 25, 28
male bonding, 39
Man Ray, 2, 21, 29, 126, 161–5 *passim*, 171–2
 New York Dada, 29
 Rrose Sélavy, pl. 5
 Untitled, pls. 37, 38
Marxism, 112
masks, 41, 51, 165, 172, 193n9
 African, 167
masquerade, 1, 2, 3, 18, 19, 21–3, 29, 35, 38, 95,
 192n14
Medical Times, 106
Medical Times Union, 106
medicine, 9, 11–12, 87, 104–5, 106, 123, 143
 cosmetics, 182
 discourse, 87
 doctor/surgeon, 17, 65, 66, 106, 181
 imagery, 5–18 *passim*
 orthodoxy, 118
 texts/writings, 1, 10, 12, 16, 18, 19, 24, 131
 theory/debates, 109, 143
 wigs, 181
 see also disease
Medusa, 36–7, 171–2, 183, 185
menstruation, 87, 119, 120
merkin, 180, 198n7
metaphor, 12, 87, 105, 127
 animals, in particular horses, 86, 90, 91, 95, 107
 artistic creation, 10
 authority, 177, 188
 body, 4, 7, 18, 19, 188
 body and nation, 123
 castration, 17
 economic, 63
 gestation and birth, 9, 10
 healing, 19
 masquerade, 25
 potence, power, 157, 170
 room as, 64
 sexual difference, 168, 173
 sexuality, 120
 Tzara on, 172
 use of, 7, 91
 violation, 16
 woman as, 29–30
 women and horses, 103, 107
mimeticism, 17
Minotaure, 161, 163

miscarriage, 1, 3, 5–19 *passim*, 192nn11, 16
model, 40, 55, 73, 77, 147
 female, 37, 39
 male, 2, 37, 38, 41
Modleski, Tania, 27
modernism, 14, 29, 48, 81
Monism, 79
Moniteur des Arts, 41
Montagu, Lady Mary Wortley, 180
Morbelli, Angelo, 110, 111
Morland, George, 93
Morley, George, 93
Morning Advertiser, 93
Morning Post, 95
Moscucci, Ornella, 119
Mosse, George, 78, 79
mother, 1, 11, 13, 14, 47, 49, 65, 109, 111–19 *passim*,
 150
 maternalism, 86, 113
 maternal body, 2, 7, 49
 maternal instincts, 109
 maternal love, 113, 117
 motherhood, 1, 11, 14
Motherwell, Robert, 48
Mulliner, John, 175
Mulvey, Laura, 198n5
Munch, Edvard, 54, 55, 71–83
 A Bathing Establishment, 81, pl. 18
 Bathing Men, 53, 55, 71–83, pl. 15, 195n7
 Death of Marat I, 77
 Sick Girl, 76–7
music, 48, 133
 singing, 143
Music Hall, 176
mutilation, 1, 17, 47
 Pollock's severed finger, 45
 see also amputation *and* castration
Muzii, Alfonso, 111

Namuth, Hans, 4, 45, 47
Napoleon III, 91, 104, 196n3
Napoleon Bonaparte, 153
narcissism, 22, 25, 170, 172
Nash, Thomas, 180
nationalism, 13, 54, 55, 64, 71, 79, 80, 83, 85, 110,
 112, 113, 122, 123, 188, 192n15
naturalism, 89, 90, 110, 113
nature, 16, 54, 71, 73, 75, 77, 78, 79, 85, 90, 92, 93,
 94, 96, 104, 105, 175
 and culture, 78, 81, 86, 94, 95, 96
 defined, 71, 73
 into art, 40, 93
 of legibility, 125
 'open nature', 75, 77, 78
 and woman, 6, 16, 97, 134
Nazis, 46
Nead, Lynda, 103
New York Athlete Club, 60
New York Times, 10, 12, 91
New York Tribune, 68

Newsweek, 48
Nietzsche, Friedrich, 54, 80–1, 83, 195n12
Nollekens, Joseph, 176
Nordau, Max, 122
North American Review, 60
nude, the, 40, 67, 68
 female, 7, 16
 male, 2, 35, 41, 53, 54, 62, 66, 67, 68, 71, 75, 76,
 80
nudism, 77, 78, 79, 83
Nya Pressem, 73
Nystrom, Paul, 166

obstetrics, 6, 7, 10, 11, 104
 obstetric imagery, 19
Opie, Amelia, 178
The Ordinary, 181
O'Reilly, John Boyle, 60
orientalism, 128, 150, 153, 180
Osborne, Duffield, 60
Oxford English Dictionary, 14, 64, 177

Panghiavahli, 114
parade, 1, 21, 29, 31
Parmigianino (Francesco Mazzola), 134, 137, 138
 The Foolish Virgins, 134, pl. 30
Parthenon, 89
parturition, 87, *see also* childbirth
Pellizza da Volpedo, Guiseppe, 110, 112
 La Processione (The Procession), 112
 Il Quarto Stato (The Fourth Estate), 111–12
 Lo Specchio della Vita (The Mirror of Life), 86,
 112
Pennant, Thomas, 96
Pepys, Samuel, 180–1
phallic, phallus, 3, 16, 22, 26, 27, 28, 29, 30, 169,
 188
 imagery, 185
 order, 36, 41
 signifier, 17
photographs, photography, 2, 21, 26, 43, 45, 125,
 126, 127, 147–60 *passim*, 161–5, 168, 171
physical culture, 57, 58, 59
Plato, 94
pointillism, 110
poise, 137, 143
Police Gazette, 60, 66, 67
Pollock, Jackson, 4, 43, 45
 Number 1, 45
 photograph of, 43, 45, pl. 10
Pontalis, Jean Bertrand, 16
Popham, Arthur, 138
pornography, 96, 104, 106, 107
postmodernism, 3, 21, 22, 29, 31
Potter, Paulus, 89
Potter, Sarah, 106–7
Potts, Alex, 94, 95
Previati, Gaesano, 110, 112
 Maternità (Maternity), 112
prohibition, 1, 2, 4

proportions, 128, 147, 153, 165, 166
prostitute, prostitution, 21, 27, 87, 103, 107, 114,
 118, 119
 courtesan, 103, 104
 harlot, 180, 183
psychoanalysis, psychoanalytic, 3, 22, 24, 30, 125,
 126, 169, 178–9
Punch, 87, 97, 101, 104
Purist, 166, 167
Puritan, 53, 57, 58
Pusterla, Attilio, 109–11, 113–14, 116, 117, 119, 120,
 123
 Le Cucine Economiche alla Porta Nuova (The
 Soup Kitchen at Porta Nuova), 116, pl. 28
 La Cura di Sangue (The Blood Cure), 85, 109,
 112, 114, 116–20 *passim*, pl. 25
Puvis de Chavannes, Pierre, 122

Quaker, 175, 181

race, racism, 65, 126, 147
Ramsbotham, F., 7, 17, 19
Raphael (Raffaello Sanzio): *Ecstasy of Saint
 Cecilia*, 134, 138, pl. 29
Rarey, Samuel, 100–1, 107
realism, 5, 6, 7, 67, 68, 90, 109, 116, 118, 120
realismo and *idealismo*, 111, 118
reform campaigns, 96
Reinhardt, Max, 76
Renaissance, 94, 122, 126, 127, 128, 129, 130, 145
Reynolds, Joshua, 180
 Dr Johnson, 176
rhetoric, 72, 76, 110, 122, 125–6, 177
Richardson, J.: *Alexander Pope*, 176
La Riforma, 113
Ritchie, D., 175, 176
Ritvo, Harriet, 96
Rivera, Diego, 6, 9, 10, 11, 13, 18, 19
 Detroit Industry, 9, 12
Roberts, David, 153
Romney, George, 176
Rood, Ogden N., 110
Roosevelt, Theodore, 59, 60, 64, 66
Rosenberg, Harold, 22
Rosso Fiorentino, 139, 143
 Moses Defending the Daughters of Jethro, 139,
 pl. 31
Rothko, Mark, 1, 4, 43–55
 Number 10, 49, pl. 12
 photograph of, 43, 45, pl. 11
Rothkowitz, Kate, 47–8
Rotten Row, 87, 103, 104
Rowlandson, Thomas: *Six Stages of Mending a
 Face*, 175
Rrose Sélavy, *see* Duchamp, Marcel
Ruskin, John, 95, 182, 196n6

Salon, 89, 158
Sanudo, Marin, 143–4
Sartorius, Francis, 93

Saslow, James, 92
Sassetti, Louis, 154
Scarry, Elaine, 64–5
Schiefler, Gustav, 76
Schopenhauer, Arthur, 114
scopophilia, 24, 172
sculpture, 55, 67, 68
Sebastian, St, 2, 16, 33
Secession, 71, 112
seduction, seductive, 21, 22, 24–7 *passim*, 33, 35, 38
Segantini, Giovanni, 109–10, 113, 114, 116, 117, 118, 120, 123
 L'Angelo della Vita (The Angel of Life), 114, pl. 27
 Le Cattive Madri (The Wicked Mothers), 85, 87, 109–14 *passim*, 118–21 *passim*, pl. 26
 Castigo delle Lussoriose (The Punishment of Lust), 113–14
 Dea d'Amore (Goddess of Love), 114
 Le Due Madri (The Two Mothers), 117
self-representation, self-presentation, 2, 4, 6, 19, 30, 31, 178
semiology, 125
Smith, John Thomas, 182
Society for the Protection of Females, 106
Southey, Robert, 178
Spivak, Gayatri Chakravorty, 29–30, 31
sport, 54, 58–62, 66, 67
 fencing, 134
 riding, 101–3
 swimming, 54, 77
 see also athlete *and* boxing
'squeezes', 155–6
Still, Clyfford, 48
Stubbs, George, 93
suffrage campaigns, 101
Sullivan, John L., 67
The Sunday Times, 95
surrealism, 19, 161, 163, 165, 167, 172
Swift, Jonathan, 91

symbol, symbolic, 6, 11, 14, 17, 18, 30, 90, 93, 94, 156, 171, 172, 177, 178
symbolism, 112, 113, 169, 172

Taylor, Baron, 153
Taylor, Frederick Winslow, 166
Terdiman, Richard, 150
Thiel, Ernest, 76, 80, 81
Titian (Tiziano Vecellio): *Venus and Adonis*, 127, 129, 130, 141–3, pl. 32
'Tootsie Syndrome', 2, 29
transference, 3, 22, 24, 26, 31, 192n2
 counter transference, 3, 22, 24
Turner, Frederick, 59
Tzara, Tristan, 127, 161–3, 167–72, 197n2

Union des femmes peintres et sculpteurs, 35
urban, 58, 77, 78, 86, 95, 118, 168

vampires, 120
Vasari, Giorgio, 129, 130, 134, 137, 139, 141, 144, 145
veil, 6, 22, 25, 26, 28–9, 33, 36
Victoria, Queen, 93, 102, 105
Villari, Luigi, 112
Villari, Pasquale, 112, 116, 122, 123
Vitalism, 79, 83

Walters, Catherine, 103
Webb, Edward Walter: *Barnet Horse Fair*, 93
Weininger, Otto, 78
Welch, Mary, 176
whip, whipping, 42, 87, 104
wigs, 126, 127, 175–89 *passim*
Wilkes, John, 181
Willumsen, Jens Ferdinand, 73–5, 81, 83
 Studio Exhibition of 1910, 73, pl. 16
 Sun and Youth, 73, 75
World War I, 46, 166
World War II, 46
wound, 7, 17, 120